Splendours
of an
Islamic World

Mamluk Art
in Cairo
1250 – 1517

Published in the UK in 1997 by
Tauris Parke Books
an imprint of I.B.Tauris and Co. Ltd
Victoria House
Bloomsbury Square
London WC1B 4DZ

First published as *L'Égypte des milles et une nuits* by
Imprimerie Nationale
27, rue de la Convention
F-75732 Paris Cedex 15
France

A full CIP record is available from the British Library

ISBN 1 86064 219 5

Colour separation and printing by Imprimerie Nationale

Henri and Anne Stierlin

SPLENDOURS
OF AN
ISLAMIC
WORLD

TAURIS PARKE BOOKS
LONDON • NEW YORK

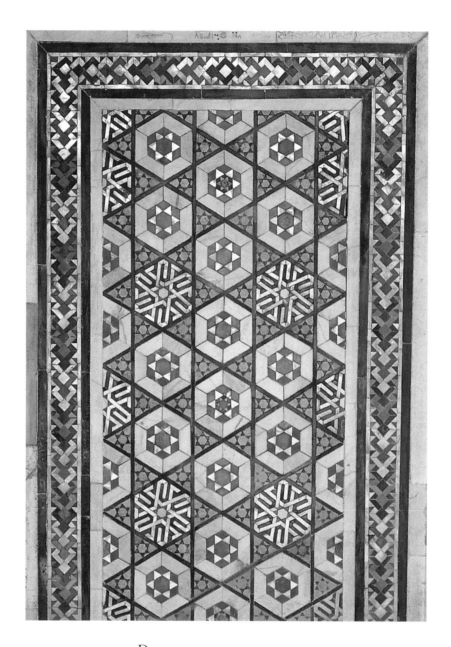

Detail from a mosaic panel decorating the
mausoleum of Sultan Kalaoun (1279–1290).
The hexagonal motif is executed in coloured
stone and mother-of-pearl.

Table of Contents

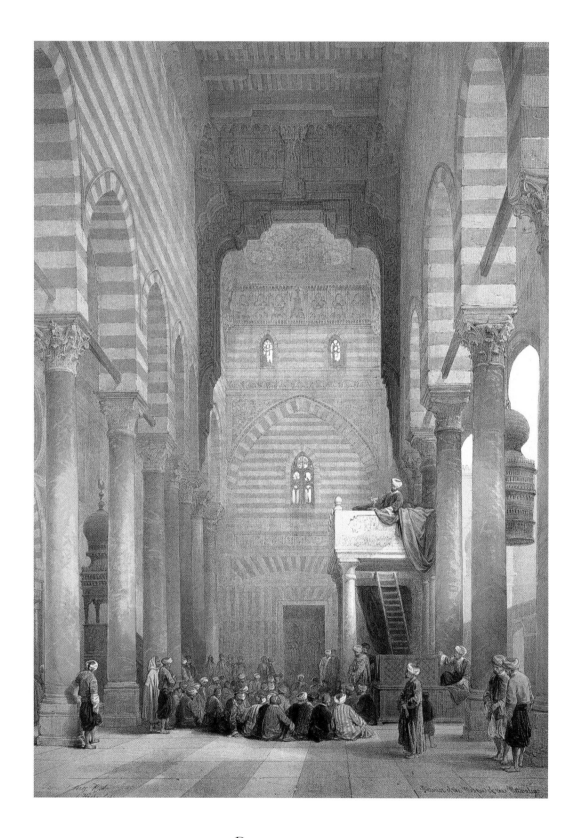

During his stay in Egypt,
in the first half of the nineteenth
century, the British painter
David Roberts was captivated
by Mamluk art.
Above: The Mosque of
Muayyad (1415–1420).

THE GLORY OF
MEDIEVAL CAIRO

In the Middle Ages, the glory of Cairo fascinated the West. Christian and Muslim travellers, Crusaders returning from the Holy Land and other chroniclers were all struck by the sumptuous and rich city that Saint Louis had dreamed of possessing, and which was, in the words of the great Arab historian Ibn Khaldun (1332 – 1406), 'the metropolis of the universe and the garden of the world'. A city both mythical and sensual, where Sultans and sufis, merchants and soldiers were drawn together in a whirlpool of activity, at the crux of the Orient and the Occident, of Africa and Asia, of the Mediterranean and the Red Sea, Cairo is the very definition of a meeting point, a place where art and imagination come together. *The Thousand and One Nights* found form there, while the traders exchanged the produce of Asia for the riches of Europe.

The walls of the city rang with the trumpets of the troops that had stopped the Mongols, the streets bustled with artisans, the bazaar overflowed with jewels and valuable cloths, libraries brimmed with rare manuscripts, scented depots stocked cinnamon and pepper, cardamoms and cloves, incense and myrrh; here, the tailors collected the furs and precious skins required by court protocol, embroiderers and carpet-makers offered rich materials and rugs, bronze and coppersmiths decorated ewers and bowls with gold, silver and enamel, showing scenes of court ritual, or galloping royal hunts...

The works created between 1250 and 1517, in the time of the Mamluk Sultans, unquestionably represent the pinnacle of medieval Islamic art in Egypt. The Mamluks, who went on to form the Bahrid and Circassian dynasties, originated in far-off central Asia, on the plains of Kipchak, catchment area of the Volga, the Cherkez valleys lived in by the nomads who roamed the slopes of the Caucasus. They were Turks, who spoke a Turkic language. They had been brought, still very young, as the captives of slave traders, and sold to Arab masters who used them to found a professional army. They were of a solid, uncultivated stock, issued from Shamanistic tribes, and, studying in various 'houses', they learned to handle arms – a skill in which they quickly excelled, dominating their adversaries on battlefields throughout the Near East. These powerful lords, the Mamluk Sultans, were in fact nothing more than former slaves, bought by local dynasties as a sort of praetorian guard. As time went by, they learned to take advantage of the internal struggles dividing Egypt at the end of the Ayyubid period. One of them, clever and opportunist, seized supreme power, and became Baibars I, Sultan of Cairo.

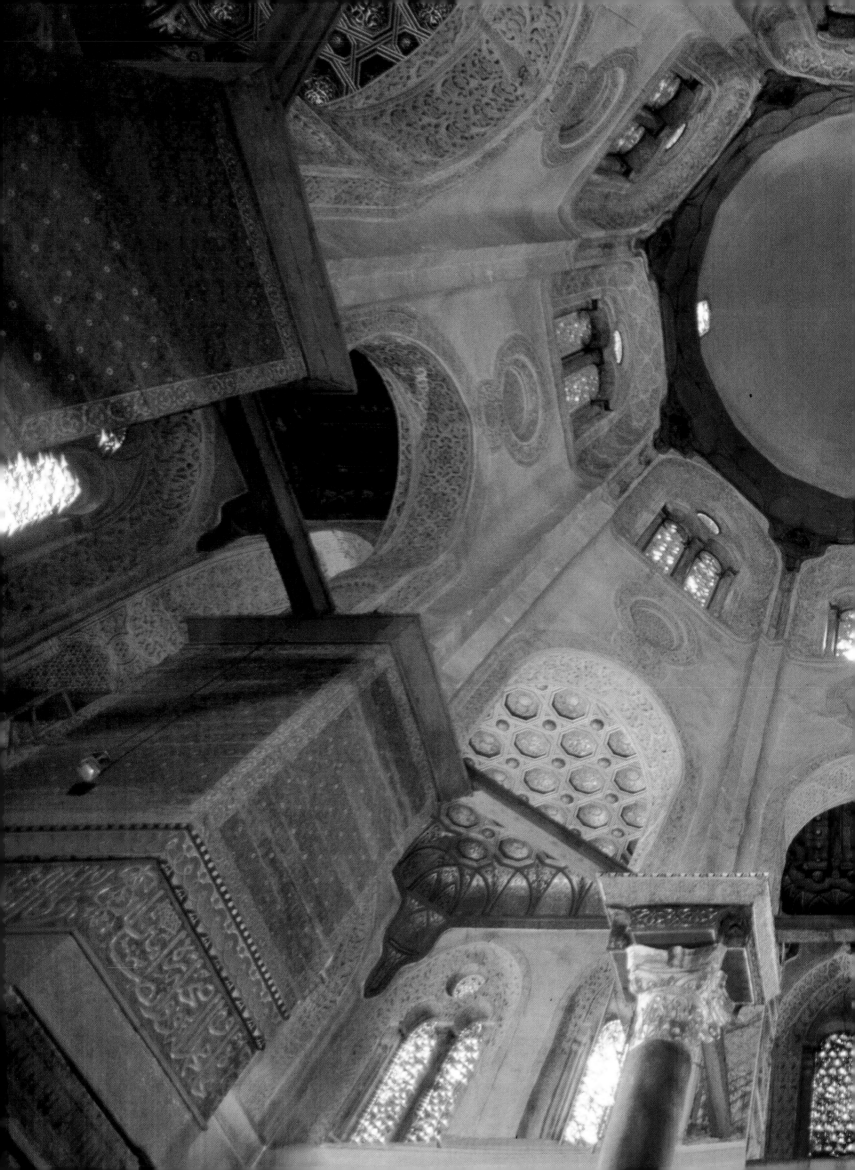

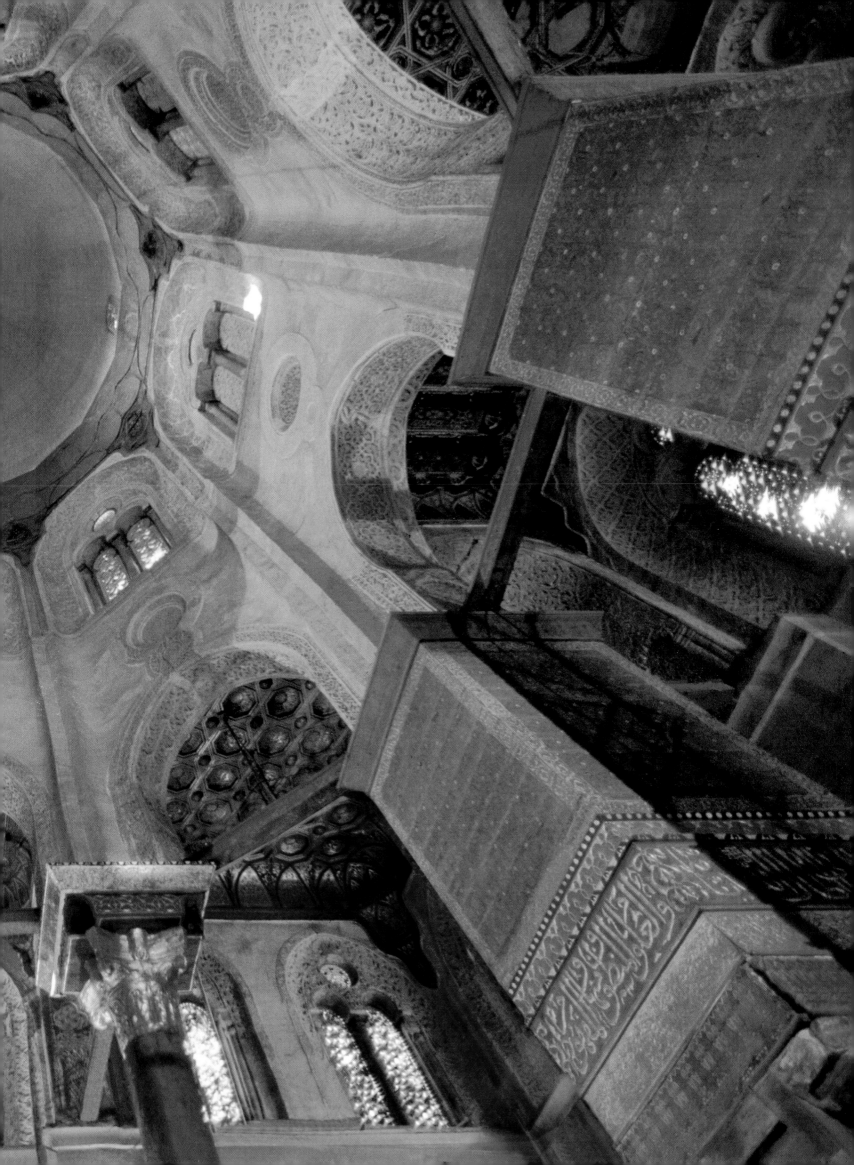

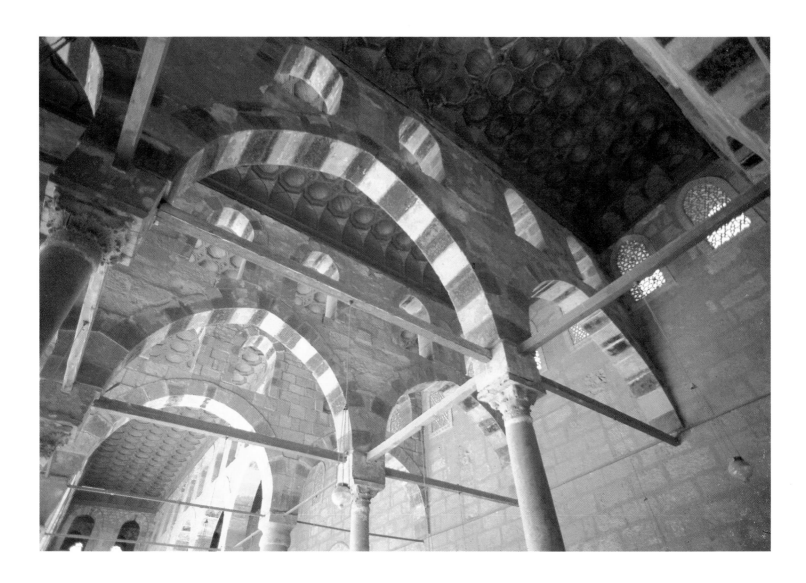

Previous two pages:

Mausoleum of Kalaoun: From 1284, the Sultan had constructed a high dome, recalling the Dome of the Rock in Jerusalem, with its fabulous ambulatory, designed for the circumambulation ritual. Supported by two pairs of strong pillars alternating with two pairs of monolithic columns of red granite taken from ancient buildings, the lantern is lit by eight twin bays.

Following the example of the Great Mosque at Damascus, the prayer room built by Mohammed el-Nasir on the Citadel is hypostyle, consisting of wide arcades surmounted by rows of bays. The handsome two-tone arches (*ablak*) are mainly carried by rehabilitated columns. The springers are linked by tie-beams, necessary to ensure rigidity.

This 'dynasty of slaves' quickly came to occupy a key position on the political chess-board of the Near East. Its sovereigns became masters of the territory stretching from the Euphrates to Nubia. As protectors of the Holy Places, they provided shelter for the Caliph, spiritual leader of the Islamic world. But in no way must these particular Mamluks be confused with their later, pale descendants, brought face to face with Napoleon's troops in the bold, epic expedition launched in Egypt at the end of the eighteenth century.

During the thirteenth and fourteenth centuries, while the West was building its multicoloured cathedrals with arrow-like towers piercing the sky, Mamluk architecture underwent an astonishing development. In Cairo alone, in a scant two and a half centuries, the frenzy of building initiated by these powerful soldier-slaves, so quickly integrated into Egypt, flowered into around 700 monuments. Slightly more than two hundred of these are still standing, including about 40 glorious, scarcely known masterpieces. Their elegant minarets, the froth of ochre domes that dominate the capital's skyline, bear witness to the enthusiasm of an army of architects, creators of a genuinely 'national' authentic art, enriched by a multitude of perfectly assimilated influences. Melting pot of ideas, philosophy and forms, Cairo gave birth to a new style that was both refined and vigorous. The aim of this book is to seek out the magnificently decorated mosques and *madrasas*, to bring to life the glory of a prestigious court and give voice to this art of the Mamluks.

The medieval civilisation created in Egypt by the Mamluk Sultans deserves as wide a recognition as that of Timurid and Safavid Persia, Ottoman Turkey or Nasrid Andalucia. The long eclipse of the style is difficult to comprehend, when faced with the marvels it produced. Mamluk architecture is in some ways the Near Eastern equivalent of European Gothic. Both styles are the proud exaltations of a faith. Mamluk architecture glorified the power of the soldiers engaged upholding Sunni Islam. Holding high the green banner of the Prophet, these soldiers constituted a 'foreign legion' launched in a veritable 'crusade' against the Alids and the Ismailis, against the Franks and the 'pagan' Mongols. They are the valiant knights, invested guardians of three great centres of pilgrimage: Jerusalem, Mecca, and Medina.

In their glorious capital, theologians and philosophers from Morocco rubbed shoulders with their fellows from Persia and Anatolia. Scholars from Maragha and Samarkand, Damascus, Tabriz and Granada met together there. Poets and historians had their works copied there. Astrologers and doctors enjoyed the favours of the ruling caste, which spoke Turkish and Arabic, and practised Persian and Mongol.

For the Mamluk Empire traded and treatied with the Ilkhans of Amou-Daria, the Basileis of Constantinople, the Sultans of Granada, the Princes of Lesser Armenia, the knights of the Crusades, King Saint Louis, captured after Mansourah, and the ambassadors of Venice and Genoa. Cairo restored the ancient spice route, which had, since Roman times, linked India and south-east Asia to the Mediterranean, and which the Mongols had for a time short-circuited via Persia, the Euphrates and the Black Sea. The prosperity of the Mamluk capital can only be explained by its military successes and the strict organisation of its international trade. Thus, in the fourteenth century, Cairo was truly at the centre of the world. What could be more natural, then, than the creation of the high art represented by its architecture? There can be no other explanation for the building sites which renewed entirely the appearance of the city: their immensely prosperous trade and commerce gave the masters of Egypt the resources to lead policies turning on magnificence and splendour. From then on, the hammering of stonemasons, sawing of carpenters, the glow of ovens lighted by bronze-workers and glass-blowers, the rumble of forges combining peaceful produce with preparations for military campaigns, and the cavalry exercises on the hippodrome, transformed Cairo into a veritable bee-hive of activity. It was the biggest town in the western world, with perhaps more than 200,000 inhabitants.

The job of bringing this fabulous culture back to recognition has been passionately exciting. Several photographic campaigns have been needed to reflect properly the essence of the subject. An ever increasing specialised bibliography – itself a sign of research's re-awakened interest in this remarkable flowering of medieval art – has been consulted. The monumental whole that comprises the Mamluk architecture of Cairo, contemporary in date to the Alhambra at Granada, the Seljuk caravanserais of Anatolia and the Mongol and Timurid mosques of Persia, can only inspire our wonder and admiration. And this not only in terms of ground-plan, spacial concept and assembly of volumes, but also in the construction techniques using superbly faced cut stone, decoration, sculpture, glazing, bronze doors, etc.

The monuments erected under the Mamluk Sultans of Cairo can be compared with the very best products of the Islamic Middle Ages. They are a part of the scheme designed to provide a background of dignified magnificence and display for the Mamluks, as much to exalt their own dynasty as to exalt the name of God.

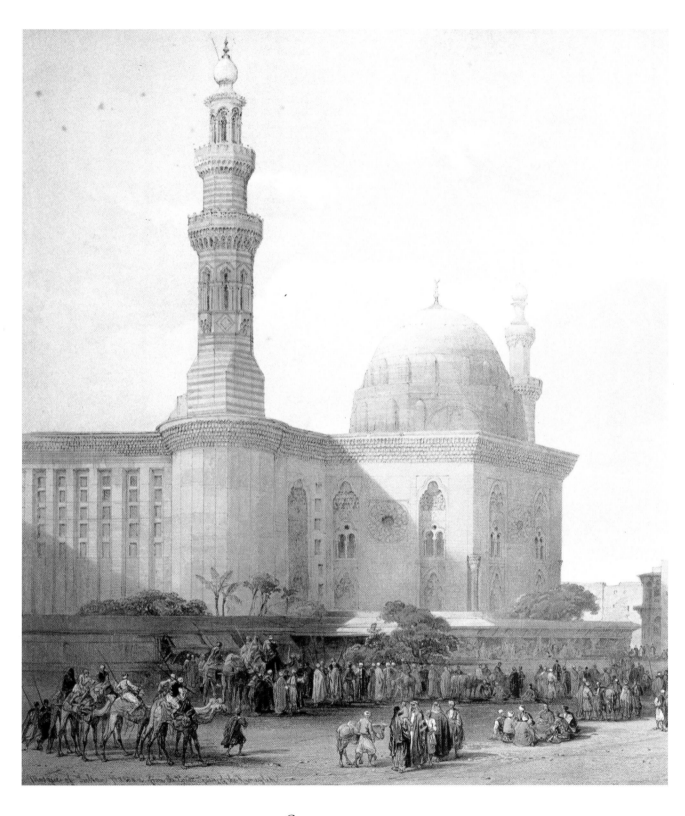

General view of the apse of
the *madrasa* of Sultan Hasan,
from a lithograph by David
Roberts, illustrating his *Egypt
and Nubia,* three volumes in
folio, published 1849.

The Eventful
Reign of
The Mamluks

AFFIRMING THAT the Mamluk Sultans were formerly Turkish or Circassian slaves, who took power for themselves, may give rise to a certain misunderstanding. The Mamluk institution cannot be viewed in the light of modern concepts of nationalism and ethnic origin; nor does the notion of slavery in this instance imply an individual deprived of all his rights and liberties, and considered as the personal property of his master. The idea of a class of people simply there to provide service, and being considered inferior, even despised, was not applicable to the slaves who constituted the armed bodyguard of the prince.

From Slave to Sultan Quite distinct from Greek or Roman slaves, deemed the exclusive property of their masters, to be dealt with as he might see fit, as was also the case with black slaves in the New World, the social level of the Mamluk was not considered dishonourable, degrading or ignominious. His status was that of a proud member of an elite fighting corps.

These slaves belonged to a group of young people of Turkish or Mongol origin, purchased within their own countries and enrolled from adolescence in the militia of an Arab sovereign. Well trained and armed, they formed formidable battalions: they were a sort of 'Praetorian Guard', made up entirely of professionals. These warriors enjoyed the prestige of arms and of military successes. They were just as proud of their condition as would be the (generally Christian) Janissaries who filled the ranks of the Ottoman army. After being freed, they very often acceded to posts of the highest authority. When they took supreme power to rule the country which had trained them, they were not regarded as belonging to a 'class', and did not suffer from the low esteem attached to the condition of servitude. These were slaves who commanded respect. Considering themselves to be a 'nobility' of soldiers, it was they, the knights of Islam, who countered the Christian knights of the Crusade: such was the status of the

Mamluk in the medieval Near East. This recourse to a 'foreign legion' had been constant amongst the Muslim sovereigns since the time of the Ghaznevids, then under the Buyids of Persia, who ended up 'protecting' the Abbassid caliphs of Baghdad. In the times of the Ayyubids of Syria and Egypt, these soldiers already had real experience of power, before assuming the glory of Cairo with the Mamluk Sultans. Other 'Mamluks' reigned almost simultaneously in India, with the dynasty of slaves created by the Sultans of Delhi. It is none the less true that these slaves, originally natives of the Steppes of Central Asia, from Kirghizistan and Kazakhstan, between Lake Balkhach and Syr-Daria on the one hand, and the Danube on the other, had been purchased from their tribes by Greek, Armenian, Arab or Turkish merchants. Their groups, closely guarded, passed through the Byzantine ports, or by the Seljuk caravan routes, crossed Anatolia and arrived at the ports on the south coast of Asia Minor, in transit for Egypt or Damascus.

They received a complete education from the Arab lords. They were converted to Islam, given rigorous training from arms masters, became skilled horsemen and members of a troop they considered to be their 'family', their 'house'. These Mamluks were the fierce Sunni defenders of Muslim 'orthodoxy', as opposed to the Shiite currents of the Ismailis and the Twelver Shia Persians with whom they came into conflict. Besides the fact that the supreme chief, in the person of the Sultan, came from their ranks, Mamluks filled important state positions in the military and administrative domains. They occupied highly responsible posts, such as that of provincial governor, even if, in respect of trade, business and taxation, other diverse elements of society, Arabs, Copts and Jews also fulfilled roles of importance, depending on their particular spheres of competence.

For the Mamluks, social advancement and access to higher grades depended on merit and seniority. Military achievement counted heavily in their promotion. Decisions taken on the battlefield, or a favourable strategic choice, were important criteria. They then became Emir of ten, 40, 100 or 1,000 soldiers, making a regiment. Finance for these troops came from the revenue from the villages and lands attached to each charge, the profits of which were given over to the chiefs. Each great Emir, or even General, or Atabeg, of a troop, with his men, made up a 'house'. The most important house was, of course, that of the Sultan: earlier authors refer to these Mamluks as Sultanian, royal or imperial. Competition was strong between these various 'houses', under the control of

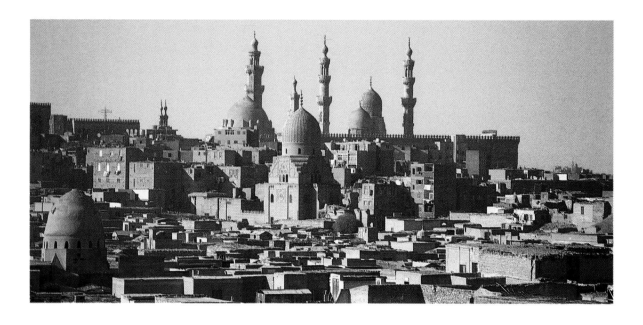

Among the cupolas and minarets of medieval Cairo, the crenellated walls of the Madrasa of Sultan Hasan rise like a fortress, in the area dominated by the surrounding wall of the Citadel of Saladin (to the left)

Facing page:

Detail of the decoration on the surroundings to the entry of the Madrasa of Sultan Hasan. Tracery, foliage, a network of stars and small columns make a sumptuous frame to the monumental gateway to the building, constructed from 1354.

war lords who were at the head of thousands of disciplined soldiers, devoted to the cause of their chief. The law of either the strongest or the most cunning prevailed, sharpening appetites, conferring an unequalled efficiency on this troop. Conflicts could arise should a lord die, or could be produced by plots or intrigues developing into an attempted *coup d'état*. Because of the absence of an hereditary character to power, the Sultan was always open to an uprising, a 'putsch', a rebellion or revolt led by one of the Mamluk chiefs wishing to seize the throne for himself.

This inherent fragility of high power remains one of the most paradoxical aspects of the Mamluk regime in Cairo. It explains the number of sovereigns succeeding each other as Sultans over two and a half centuries, adding up to some 47 reigns for the two dynasties, the Bahrids and the Circassians, with an average of five years each. It is true that some strong personalities lasted much longer than this average would suggest, even if their reigns were disrupted from time to time by usurpations. For example, Baibars was master of the empire he constituted for 17 years. Kalaoun reigned for 11 years, Mohammed el-Nasir, in three periods, occupied the throne for a total of 41 years; Barkuk, in two periods, lasted 16 years, Farag 13, Barsbey 16, and Kait Bey attained 28 years in power.

In Cairo's medieval society, the Mamluks who spoke Turkish were the highest social group. But, notwithstanding a large Egyptian mass of *fellah*s and Arabs, the population was made up of diverse groups, such as the Copts (Christians), farmers and clever artisans; Jews, often doctors or businessmen; Armenians and Greeks (Syrian or Byzantine), either remaining Christian, or converted to Islam. This last group often played a role in art and architecture.

We are dealing therefore with a multi-racial society containing many different religions that, despite inevitable conflicts, attained a level of tolerance. This aspect is all the more surprising when one considers that the vocation of the Mamluk Sultans as defenders of the Sunni faith could have turned them into fanatics. Naturally, with an eye both to religious propaganda as well as to the glorification of the sovereigns, the enormous production of new buildings for which the Mamluks are responsible is essentially religious: mosques, *madrasa*s, *khanka*s, pious foundations and charitable works.

In the majority of cases, it was the Sultans and Emirs who decided on the building of the most important civil and religious monuments. These they financed from their own purses, as a mark of piety and power. The work of these great builders amounts to a total of some 200 places of prayer in the city of Cairo alone. To this considerable figure, result of the length of the Mamluk epoch, must be added public service buildings including hospitals, *hammam*s or baths, fountains, schools, and of course, state buildings, such as the Sultans' palaces, monumental tombs and, finally, fortifications and strategic constructions.

One of the first Mamluk monuments of Cairo: the *madrasa* constructed in 1262 by Sultan Baibars I, founder of the Bahrid Mamluk dynasty. The voussoirs of the arch above this lintel with its frieze of hexagonal tracery-work are decorated with 'lance point' motifs. Between these two elements is the highly stylised silhouette of two lions, passant and affronté, heraldic representation of the Sultan.

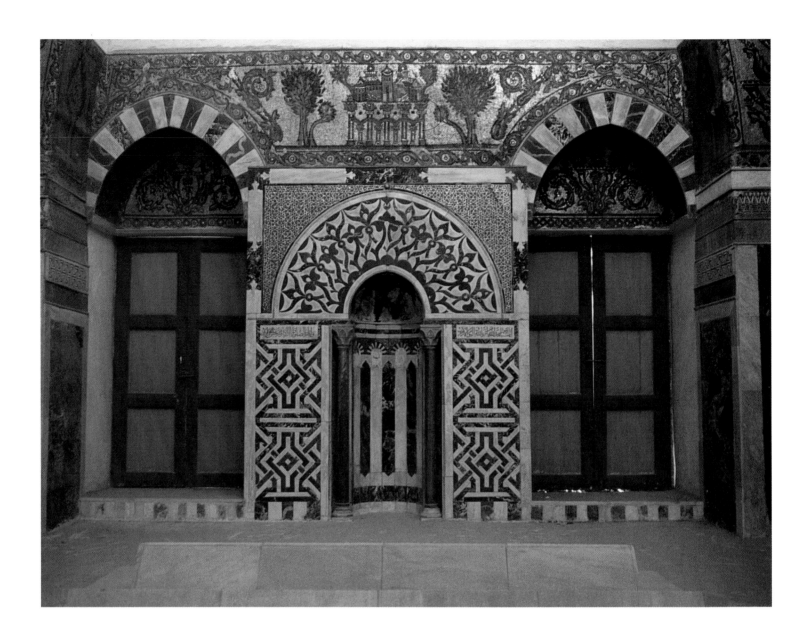

Birth of the empire No attempt will be made here to give even the broadest of outlines of the history of the two and a half centuries of Mamluk power in Cairo. This grandiose and turbulent period was marked by a convulsive international environment, too many wars and *coups d'état*, too many conspiracies and usurpations – inevitable given the lack of a system controlling the succession to the throne of the Sultans. The period saw the last attempts by the Franks to maintain a presence in the Holy Land, while the terrifying waves of Mongols were sweeping across Syria. Only the 'knights' of Islam, squadrons of Mamluks of Cairo, were able to face up to these Mongols and obtain victory in battle. Thus, the Sultans of Cairo became the defenders of the Muslim faith against the assaults of non-believers. It was also a period of great expansion in trade. The most important of the markets nourishing the exchanges between Orient and Occident were to be found at Alexandria and the Delta, where Venetians came together with Genoans.

The Mamluks arrived at the head of an empire centred upon Cairo both by chance, and quite naturally. In retrospect, the process seems like an inevitable development, due to the size of the regiments of slave-soldiers in the service of Muslim sovereigns

from the Abbassid period onwards. This increased still further under the Ayyubids of Damascus. A war-honed, highly trained soldier would be likely to take power, should the circumstances be favourable to him. These war-lords knew full well how to take advantage of a confused situation.

The turning point was perhaps when the Christian forces disembarked at Dammietta for the seventh crusade, led by Louis IX (Saint Louis). The vanguard, under the command of Robert d'Artois, was overrun by the Mamluks of the Ayyubid Al-Malik Salih at Mansourah in 1250. The death of Sultan Salih, kept secret, did not prevent a second Muslim victory: the Ayyubid Sultan Turanshah arrived opportunely from the far banks of the Tigris, to continue operations and rout the King of France, who was made prisoner. In fact, the victory was won by squadrons of Mamluks. These, not recognising Turanshah, decided to get rid of him. They assassinated him, and, by electing the Salih's widow, Shagar el-Durr, as successor to the throne, to all extents and purposes seized power. Aybak, husband of the Sultana, had been a powerful Mamluk under the late Sultan Salih, and he lost little time in taking the supreme post. Maintaining this position led to violent opposition amongst the ranks of ousted Mamluks. At this point the

coming of the Mongol peril worked to the advantage of the valliant Mamluk horsemen, by bringing the troops and rival bands into a unified force, under the command of the Mamluks Kutuz and Baibars. At the battle of Ain Jalut, in 1260, the Mongol army was defeated and Damascus retrieved. This checked the advance of the forces of Hulagu, grandson of Gengis Khan. This was no *ipso facto* check to the Mongol raids, which continued up to 1313, but nevertheless, it became apparent that the Mamluks, children of the Steppes of Asia Minor, were the only troops capable of facing up to their Mongol 'cousins' on the battlefield: the combat techniques of these horsemen of the same origin were identical.

The dynasty of the Bahrids

Baibars stole a march on his ally, Kutuz, with whom he had won the glorious victory of Ain Jalut: he assassinated him. From that moment, he can be considered as the true founder of the Sultanate of the Mamluks of Cairo, beginner, under the name of Baibars I, of the Bahrid dynasty, which ruled until 1382. Baibars consolidated his power by cleverly taking advantage of favourable circumstances. In one such move, he granted protection to the Abassid Caliph of Baghdad, a refugee since the capital had been captured by the Mongols. He was received with full honours by Baibars. The Caliph paraded the streets at the head of a sumptuous cortège, at the side of the Sultan: the whole population participated in the festival, with delegations of Christians and Jews bringing up the rear of the march. The presence in Cairo of a person who passed as the leader of the Islamic world was an advantage the Sultan understood well. The Caliph's purely symbolic role provided a religious legitimacy to Baibars' claim to the throne.

In the future, Egypt, already placed by Saladin at the centre of his Sultanate, was to gain still further preeminence over Syria. In fact, the entire region situated between the Suez Isthmus and the loop of the Euphrates was badly shaken up by the last struggles against the Franks, against the Armenians from Cicilia (Lesser Armenia), by the Mongol raids and then by the Ottoman threat. Under these circumstances, Syria, as Haarmann wrote, 'was reduced to the role of a buffer state for Egypt, a territory under the suzerainty of that country'.

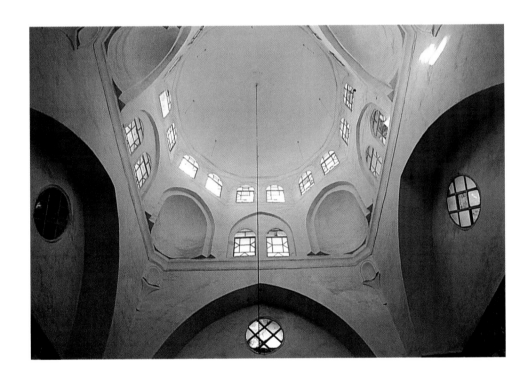

Above and Facing:

Paradoxically, Damascus, rather than Cairo, contains one of the first Mamluk monuments: the tomb of Baibars I. It was constructed in 1277, by his son, al-Said Barakhan. Not far from the Great Mosque of Omayyads, its square funeral chamber, surmounted by a cupola mounted on squinches, carried by four large, pointed arches, contains magnificent *ablak* decoration around the *mihrab* niche, as well as mosaics set on a gold background.

23

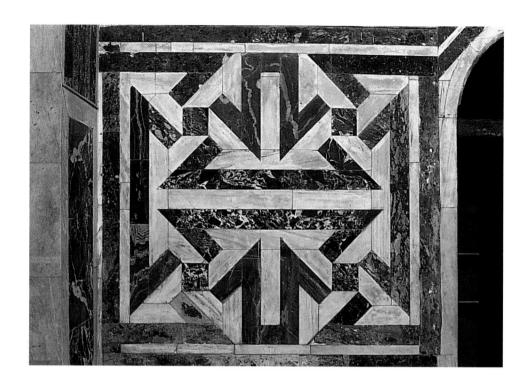

Baibars I succeeded in building a veritable empire around Egypt, stretching from Nubia to Mediterranean Anatolia, and from the Bedouin 'marches' of Libya to the province of Hejaz. His territory thus covered the three great Muslim pilgrimage destinations: Jerusalem, Medina and Mecca, which held the Kaaba. This fact, together with the presence of the Caliph, turned the Mamluk Sultanate into the defender of Sunni belief and the fortress of religious 'orthodoxy', against the Shiite movements. The Shiite doctrine had been eradicated in the Maghreb and in Egypt after the fall of the Fatimids, but it remained active in Persia, and took a more virulent form with the last partisans of the sect of 'Assassins'.

Baibars was aware of the need to give visible expression to the benefits of his reign. He therefore initiated a series of grandiose architectural constructions. Baibars alone left 264 monuments across the empire. The most striking, albeit in its very ruined state, is the mosque he erected in Cairo, based on a plan analagous to that at Fatimid al-Hakim. With its wide courtyard bordered by double or triple porticos, it is 110 metres long, and covers a square of over a hectare. In front of the *mihrab*, great cruciform piles hold up a wide dome about 15 metres across. Besides the main entry, treated in the manner of the gateway to a fortified town, there are two lateral entries, and the building must have been highly impressive. Baibars also constructed a vast palace, on the Citadel of Saladin, called Dar al-Dahab, the House of Gold, inaugurated in 1266. On the death of the Sultan, at Damascus in 1277, his son, al-Said Barakhan, who reigned for only two years, erected a domed mausoleum for him, in the immediate surroundings of the Great Mosque. This building, carried out by the architect Ibrahim, son of Garraim, probably also responsible for Baibars' mosque, was finished in 1278. Its slightly later decoration is composed of large areas of mosaic on a gold background, in the Byzantine tradition, which could already be seen in the Dome of the Rock in Jerusalem, at Al-Aksa, and in the Great Mosque at Damascus. The theme is a series of 'castles' amidst arches and foliage, which call to mind the Gardens of Paradise evoked in the Koran. Framing these figurative scenes are geometric motifs in alternately black and white marble panelling (*ablak*, in Arabic). This decorative system was widely used throughout the Bahrid dynasty.

We owe one account of Baibars' hectic reign to the pen of al-Zahir; the Egyptian historian, Makrizi, also deals with the major events of his rule. Finally, popular epics collected stories from an oral tradition, turning them almost into a sort of novel. These texts have been edited by Jacqueline Sublet, under the title: *Les Trois Vies du Sultan Baibars*.

Baibars' son was dethroned by Kalhoun, who took up the succession, having eliminated a Syrian rival. He reigned from 1279 to 1290, strengthening the administrative structures and the organisation of the empire and, most importantly, by obtaining another victory over the Mongols at Homs in 1281, before taking Tripoli from

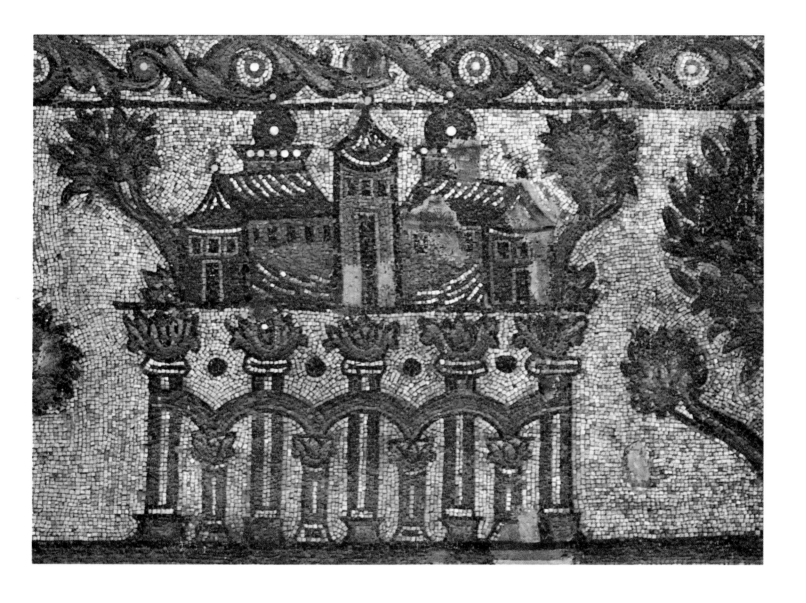

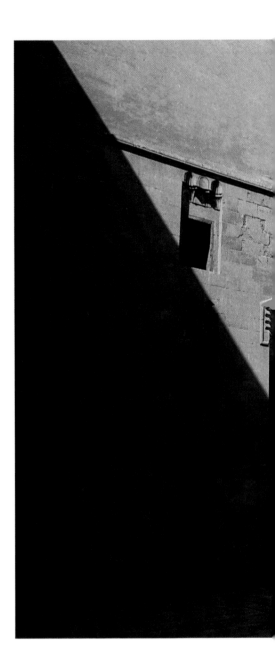

the Crusaders in 1289. His own son, Ashraf Khalil, put an end to
Frankish presence by defeating the last Christian bastion, Akka, or
Saint-Jean-d'Acre, in 1291.

Kalaoun, in a reign of about a dozen years, caused roughly 60
buildings to be built. The most important of these was his
madrasa (in ruins today), which, together with his splendid tomb
and a hospital (*maristan*), which has disappeared, formed a large
complex erected on the site of the palace of the Fatimid Sultans,
bordering the main Cairo road. Building began in 1284. It is one
of the masterpieces of Mamluk architecture.

Kalaoun, who named himself 'the Mamluk', did not impose
over-heavy taxes. According to Makrizi, his first official act was to
abolish a punitive tax which touched the entire population, and
also to stop a tax applicable only to the Christian (Coptic) com-
munity. The post between Egypt and Syria operated admirably in
his time, since it took only two days and seven hours to announce
his accession in Damascus. This organisation of the means of com-
munication was of paramount importance for trade, and also for
the movements of troops about the Near Eastern chess-board.

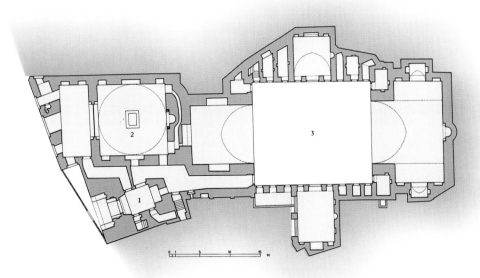

Plan of the *khanka* of Baibars II el-Gashenkir: except for a narrow facade on the road, with a bronze door opening into the entry hall (1), next to the Sultan's tomb (2), the building is structured around the cruciform plan of its courtyard (3), bordered with four *iwan*s. The side *iwan*s are masked by porticoes.

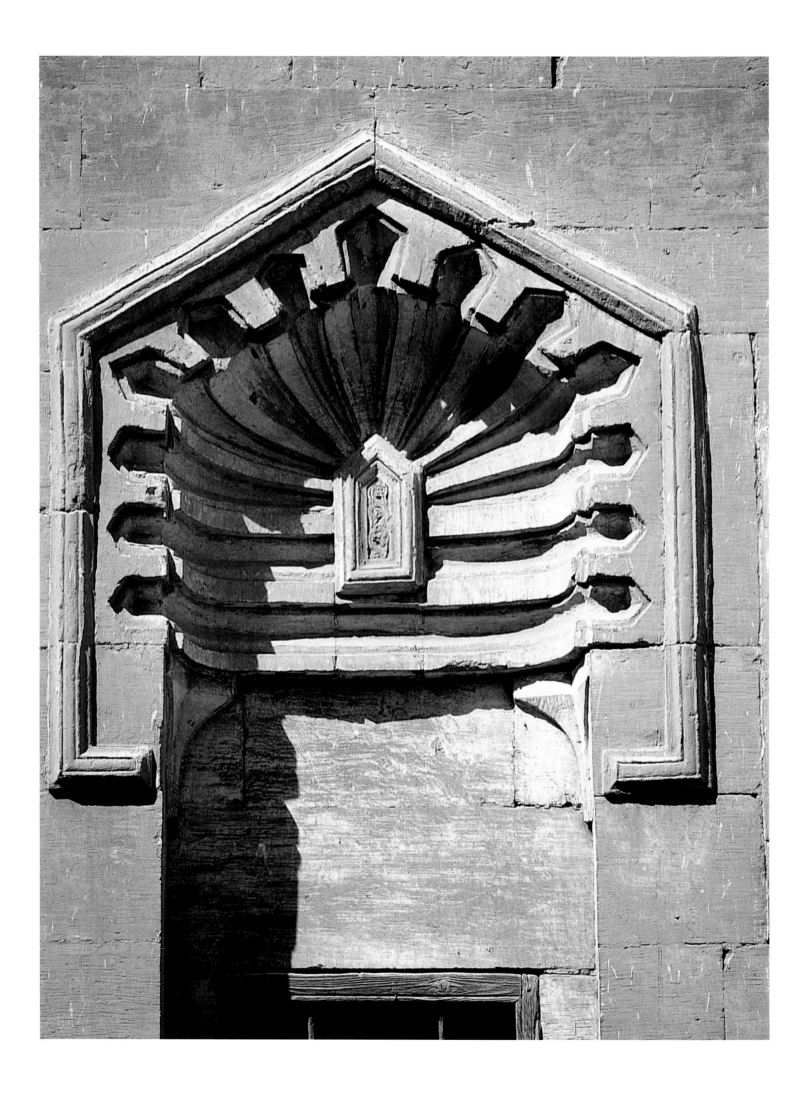

Under the reign of Kalaoun, the Tartars (Mongols), captured Aleppo. The Sultan raised an army and set off for Syria. A terrible battle ensued, and the Mamluks were obliged to fall back. But their tenacity paid off and 'the Muslims who were at first beaten, finally managed to snatch victory, inflicting dreadful carnage on the ranks of the Tartars' (Makrizi). Mangu-Timur was put to flight.

Mangu controlled the Mongols of the Golden Horde (1267–1280), who occupied the Steppe of Kipchak. There were numerous cultural links between his tribe and the Mamluks of Cairo. Their trade with Egypt was intense: 'precious material, rare fruit, scents [...] while the upper Volga region and the coast of the Black Sea supplied slaves (among them, future soldiers), to the banks of the Nile. Artisans and theologians arrived from Egypt, and their influence on the cultural development of the Mongols was important' (Bertold Spuler). It is therefore hardly surprising that Makrizi underlines the conversion of the the Mongols of Mangu to Islam in 1283.

Kalaoun signed a ten-year truce with Saint-Jean-d'Acre and with Boemond de Tripoli. But hostilities started up again between the Franks and the Mamluks: the Sultan captured the castle at Margat. He laid seige to Tripoli, leaving his son, Ashraf Khalil, to rule the Empire from Cairo, in the palace of the Citadel, referred to by Makrizi as the 'Castle of the Mountain'. Kalaoun attacked with machines of war, undermined the walls and mounted constant assaults. Tripoli fell after 34 days of resistance. The Sultan then went on to capture Beirut. At the same time, he had to deal with a plot by certain Emirs seeking to assassinate him. He overcame them, confiscated their goods and condemned them to death.

Finally, in 1289, Kalaoun organised a campaign in Upper Nubia, as far up as Dongola, to deal with a rebellious sovereign. Shortly before his death, Kalaoun excluded Christians and Jews from administrative posts. They had occupied the majority of these posts since the dawn of Islam in Egypt. He prepared to capture Saint-Jean-d'Acre and was beseiging the town when he fell ill and died.

Kalaoun's successor, his son Ashraf Khalil, reigned for only three years before being assassinated at the age of 30. Nor had his accession to the throne been easy – Emir Torontai had laid a trap for him, which the Sultan avoided, condemning the traitor to death. During his brief period of power, the literate Ashraf Khalil conquered Tyre and Saint-Jean-d'Acre. His assassin acceded to the throne in his place, but the Emirs faithful to Khalil cut his throat, then nominated Sultan Malik Naser Mohammed ben Kalaoun, known as Mohammed el-Nasir, another son of the deceased Kalaoun, aged only nine. The Emirs responsible for the plot were put to death after being tortured (their hands were cut off, and they were tied to the backs of camels until dead). The child-Sultan was soon moved further from the throne, which he occupied only symbolically (1294). Adil Katbuga, who replaced him for two years, was deposed at the age of 57.

In Baibars el-Gashenkir's *khanka*, the formula of pointed arches with straight vaults derives directly from the stucco decoration in the Mosque of el-Ashar. The rigid linear carving of the voussoirs, carried right into the heart of the niche, contrasts with the stalactite decoration in some of the bays (above).

In the wake of a catastrophically weak flood of the Nile, shortages, then famine, swept across Egypt. In Cairo alone there were 1,000 deaths a day. In 1295, common graves were opened, to be filled so quickly that it became necessary to throw the bodies into the Nile, or into wells. There were reports of dogs devouring children's bodies. Others spoke of men eating the dead (Makrizi). Egypt was depopulated, and entire towns were deserted.

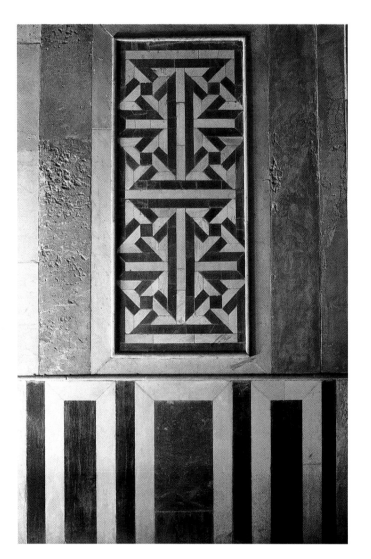

Drought also struck in Syria and Hejaz. Katbuga wished to go to Damascus, but he was massacred by his Mamluks. He was succeeded by Emir Lagin, who returned to Cairo and paraded the streets as Sultan with the Caliph. He then decided to undertake cadastral reform, with a sharing out of land. This move resulted in such discontent that some Mamluks conspired against Lagin and murdered him in 1299. The country was once again plunged into a state of unrest, with struggles between Emirs, pacts, plots and treason. At the end of 1299, Mohammed el-Nasir, now aged 15, returned to his throne, to remain there for nine years, although real power in the Castle of the Mountain was dispensed by Emirs Baibars el-Gashenkir and Salar el-Gauli. In 1300, the Sultan left for Syria, to confront Gazan and his Tartars (Mongols), who were on the Euphrates. The Egyptian army was put to flight, and the Mongols pillaged the treasures of the Mamluk Sultan at Homs. In 1301, the luxury and ostentation of the rich Christians and Jews of Cairo had reached such proportions that the rulers decided to act severely. For a second time an attempt was made to exclude them from official and administrative functions. The churches and synagogues were destroyed. The Christians were obliged to wear blue turbans and the Jews yellow turbans. In 1303, the Mongol peril returned again: a courier arriving from Syria announced that Gazan was preparing an assault on Aleppo. Baibars and Salar were given the order to stop him, and they distinguished themselves at the front. On returning to Cairo, Mohammed el-Nasir held magnificent festivities.

Shortly afterwards, Egypt was shaken by a violent earthquake: 'Just as morning prayer was being said, the whole ground started to shake. The walls could be heard cracking, while roofs produced terrifying sounds. Horsemen were thrown from their horses. The people believed that the sky was about to fall to earth. Men and women came rushing out into the streets. Dreadful tumult reigned everywhere. Cries and shouts came from all sides. Houses collapsed. The minarets of mosques and of *madrasas* were struck down [...] The citizens left Cairo and spent the night on the riverbanks. Few houses escaped destruction.' Makrizi continues, mentioning the damage to the principal buildings and mosques of Cairo, such as Amr, el-Azhar, Sunkur, the minaret of the *madrasa* of Kalaoun, etc.

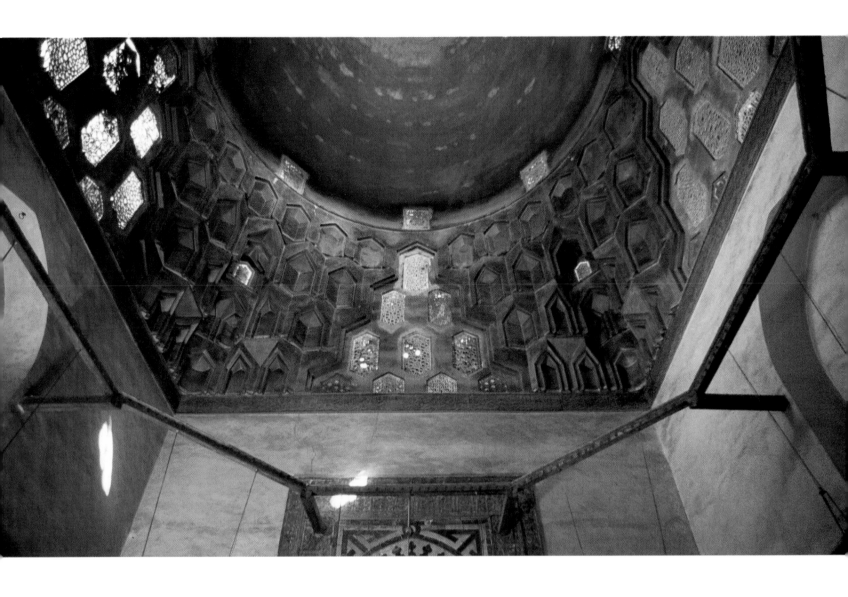

Above and facing:

The strengthening of the Mamluk style in the Mausoleum of Baibars II el-Gashenkir is shown in the *ablak* decoration of the marble panelling (the same motifs as in the tomb of Baibars I at Damascus can be seen), as well as in the treatment of the geometric stalactites used to make the joint between the square room and the round dome. This solution unifies the architectural elements by burying the windows in the network of *mukarna*s.

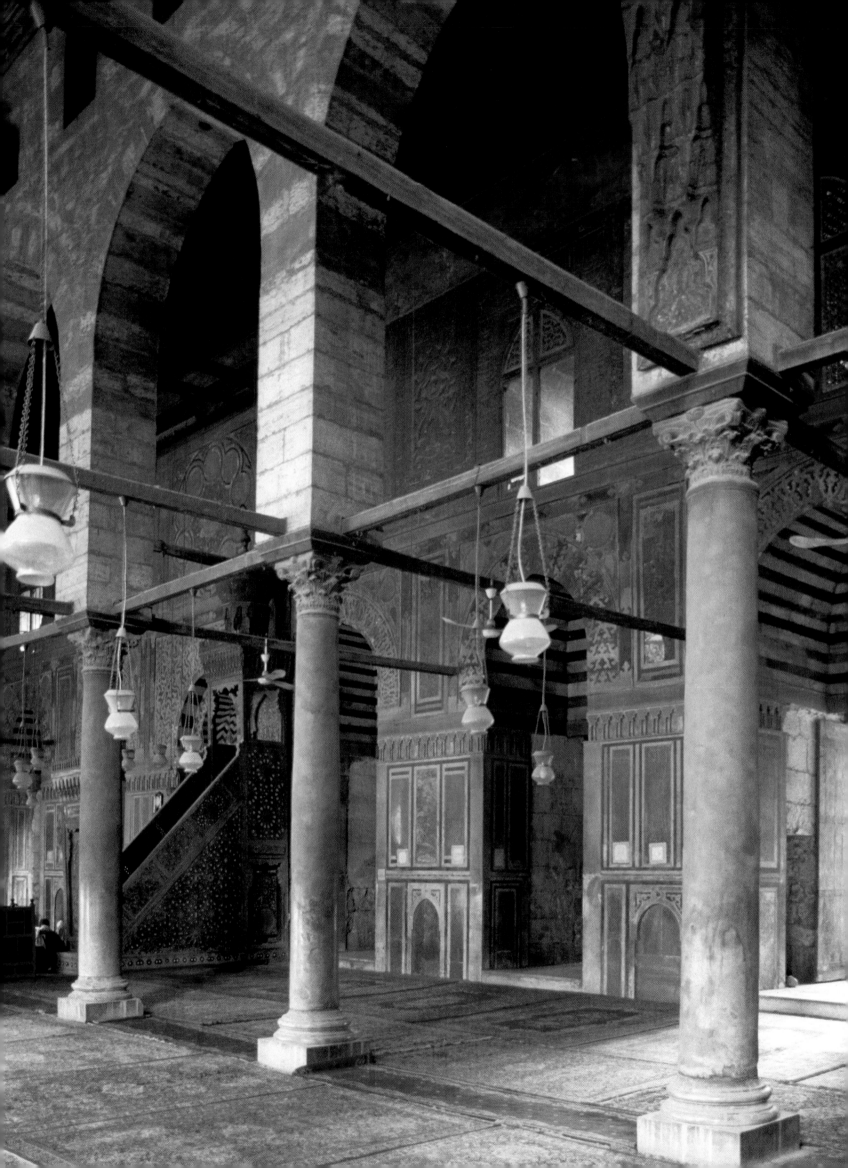

Mohammed el-Nasir was deposed again at the age of 24 by Baibars II el-Gashenkir, who only reigned from 1308 to 1310. Just before passing on power in his turn, this Sultan, apparently a refined man of letters, founded a *khanka*, or a monastery for soldier-monks, of great architectural interest. This building, fronted by a domed tomb, lies behind a fine gateway opening onto the street via a door of worked bronze. Construction began in 1307 and ended in 1310. A cruciform plan was used, with four *iwans* around a courtyard, clearly Iranian in type, influenced by Seljuk mosque-*madrasas*. The mausoleum has a dome of the traditional Egyptian sort. A clearly thought out system, using *mukarnas*, geometric stalactite motifs, has been used to solve the problem of uniting the square plan to the circular dome. Because of domestic problems, this *khanka* was not used until 1325. We know in particular that it was used by the famous historian Ibn Khaldun when he was active as the Grand Qadi of Cairo.

The apogee of Mohammed el-Nasir

As fate would have it, Baibars II el-Gashenkir was deposed in 1310 by Mohammed el-Nasir, who thus began his third reign, which was to last all of 32 years (1310–1341). This long period naturally strengthened the Bahrid dynasty greatly. It was brought to a close by the Sultan's death, at the age of 58, having occupied the throne for a total of 43 years. During this long period of peace and prosperity, the Mamluk Sultanate of Cairo reached its apogee. Mohammed el-Nasir's epoch is marked by a genuine fever of building. In the three periods of his reign 527 constructions came into being throughout the empire, with 135 in Cairo alone. The majority of

these buildings have disappeared, but the most remarkable remaining ones deserve attention, especially the *madrasa* begun in 1299, not far from the mausoleum of Kalaoun in the centre of Cairo. Entry to this building is gained through a Gothic gateway, taken from the Cathedral at Saint-Jean-d'Acre, carefully dismantled, transported and reassembled in the capital as a trophy, to commemorate the final victory over the Franks in the Holy Land. The magnificent mosque with courtyard, built in the Citadel from 1318 and decorated in 1335, is another significant building.

A vast scheme of work was undertaken in the palace, to complete or replace the alterations carried out by Baibars I, of which not a trace remained after the construction of the Mosque of Mohammed Ali in the Citadel. Other structures completed at this time include the aqueduct between the Nile and the Citadel (1312–1314), the Palace of Beshtak al-Nasiri, in the centre of Cairo (1332–1335), the Mosque of Maridani (1340–1341), as well as the *khan* or caravanserai of Emir Kausun al-Nasiri, of which the facade and gateway still exist. This immense architectural undertaking – often of buildings designed to glorify the ruling dynasty – is a sure sign of the economic and demographic dynamism of the Mamluk empire and its capital. Cairo, in the first half of the fourteenth century, was a city with a population of perhaps 200,000 inhabitants (André Raymond) – at a time when Paris had only 80,000, and London 60,000. Ibn Khaldun, describing the city in 1383, was understandably admiring. This prosperity, clear in the quality of its monuments, is partly the result of the huge international trade of which Egypt was the centre, and partly of intelligent management. Mohammed el-Nasir helped to reduce the quasi-feudal power of

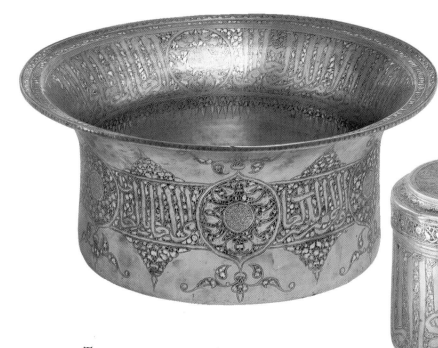

Facing page:

The prayer room from the Mosque of Muayyad, dating from 1415, supported by porticoes on monolithic columns. The height of the arches gives great elegance to the space, structured still further by the wooden tie-beams linking the springers. The alternating red and pale arch-stones harmonise with the fine marble panelling of the *kibla*. The minbar, left background, has a stellar decoration.

Two examples of Mamluk craftsmanship on engraved copper. Left, a bowl of 48 centimetres diameter, heightened in silver; the inscription, in Thuluth script, exalts the great Prince Mohammed el-Nasir, who reigned at the beginning of the fourteenth century (al-Sabah Collection, Kuwait).

Right, small box (height: 11.5 cm), in the same style, with an inscription to the glory of the Sultan (al-Sabah Collection, Kuwait).

the Mamluk Emirs, based on property received as a reward for victories in war. Within Egypt, their property was not made up of a single, large domain, depending on one person alone, but of parcels distributed along the whole length of the valley and about the Delta. In this way, the sovereign avoided the possibility of whole regions looking to one chief, tending to the creation of a competing power. The Sultan also made sure that he retained the majority of territory around Cairo. Land-ownership was generally well organised. The Sultan promoted output by pursuing a policy of irrigation, which made possible a clearly planned exploitation of the country. Considerable sums of money were spent on the construction and maintenance of a network of canals. The increase in agricultural production supported and encouraged the activities of artisans, and international trade supplied the Treasury with large sums in taxes. The Mamluk Empire could well afford to undertake very wide-ranging campaigns to construct anew or renovate considerable areas of the old urban fabric.

Catastrophe and crisis Following the death of Mohammed el-Nasir in 1341, catastrophe and economic crisis struck the country. In 1348, the black plague arrived. As throughout the whole of the ancient world, the great plague of the middle of the fourteenth century caused enormous loss in population. Cairo lost a third of its inhabitants and entire areas were abandoned. Parts of the countryside lay fallow, sometimes reverting to desert due to a shortage of *fellah*s. The sudden drop in agricultural output led to crisis and famine. The death-rate made manpower more scarce and correspondingly more costly. Loss of numbers in the ranks of the army meant that new Circassian slave-soldiers had to be imported to replace those struck down by illness. But their arrival possibly furthered the course of the disease, which originated in Central Asia. The plague reappeared in Egypt in 1374 and again in 1379. Reduced revenues weakened the central authority and opened the way for the emergence of powerful Emirs. These took over a large part of the architectural work and began operating in spheres of activity normally reserved to the Sultan. But the most important cause of regression was the instability of power. The absence of a strong personality at the head of the state was keenly felt. Several sovereigns acceded to the throne as minors, and remained there for only a matter of months, or years, thanks to influential protectors, then disappeared without being able to establish a clear policy for the empire.

After Mohammed el-Nasir, between 1341 and 1383 the list of Sultans reads like a caricature of power: Manur Abu Bakr was deposed at 20, less than a year after coming to the throne; Ashraf Khujuk gave way at the age of 7; Nasir Ahmad I only lasted a few months; Sheik Ismail died after occupying the throne for a scant year; Kamil Dhaban I was assassinated in the second year of his reign; Muzzaffar Hajadi was killed at 16; Sultan Hasan, removed at 16, returned after Salih, who was deposed at 17, only to be assassinated at the age of 26; Mansur Mohammed II was obliged to step down at 26; Mansur Ali II died aged 12, finally closing the chaotic last phase of the dynasty of the Bahrids of Cairo. But this dark picture should not give the impression that Egypt was also

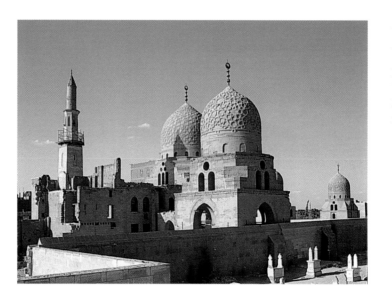

Tomb and minaret of Sultan el-Ashraf Barsbey (1422–1438) in the City of the Dead, east of Cairo. To the right lies the mausoleum of Emir Ganibak el-Ashrafi and the tombs of numerous members of his 'house'.

Facing:

The City of the Dead at Cairo, as seen by architect Pascal Coste at the beginning of the nineteenth century. The variety of motifs decorating the hemispherical domes of the Mamluk tombs fascinated the artist.

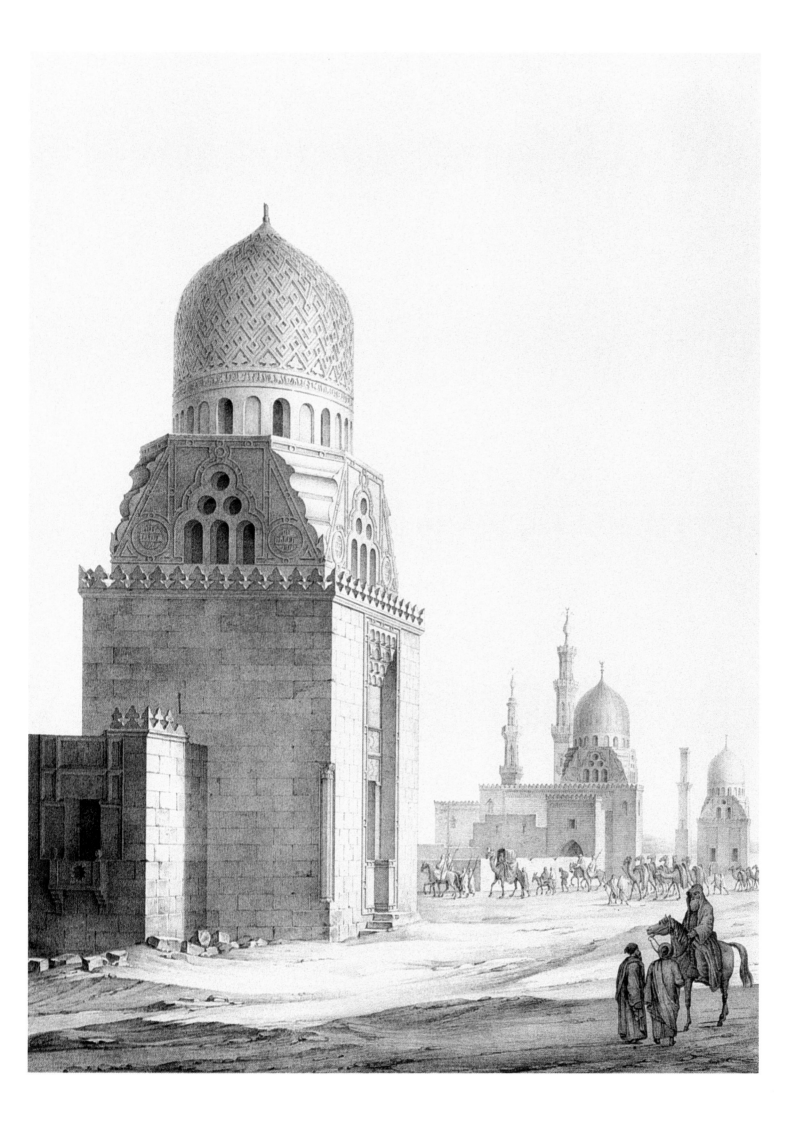

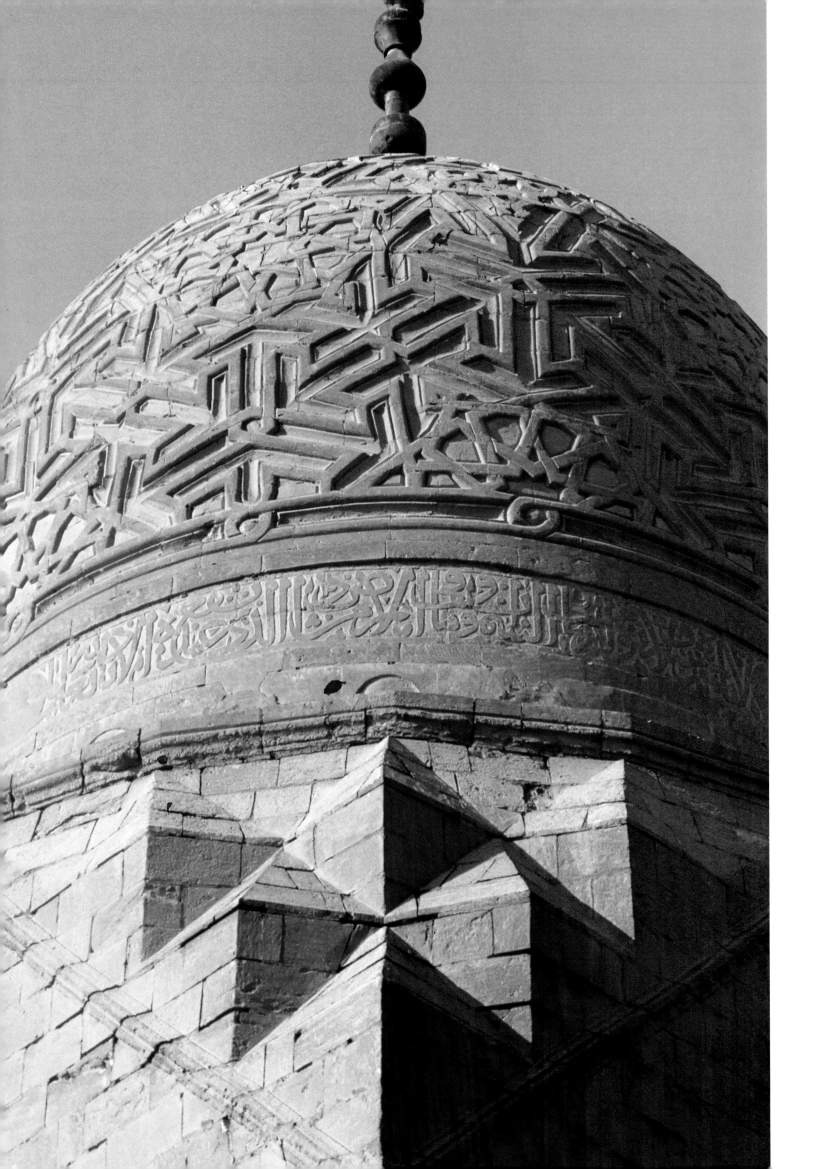

undergoing a period of artistic decadence. On the contrary, some major sites, such as the colossal *madrasa* of Sultan Hasan (1356), were undertaken during these troubled years. This *madrasa* can well be considered one of the most glorious masterpieces of Mamluk architecture in Cairo. Other buildings springing from the same period include the mosque of Emir Sightimish (1363) and the *madrasa* of Ashraf Shaban (1368). But the continuance of architectural activity should not disguise the very real difficulties that had to be dealt with by a country recently ravaged by the great plague. The weakness of the Mamluks caused the Christians to take courage. Although halted in the Near East, they still dreamed of recapturing Jerusalem. Pierre I de Lusignan (1359–1369), who had turned the island of Cyprus into the centre of Christian trade, did not hesitate to send his fleet to Alexandria in 1365, in support of his claim to be king of Jerusalem. The poet Guillaume de Machault tells us that, on disembarking, de Lusignan sacked the commercial city for a week, reawakening Frankish exploits.

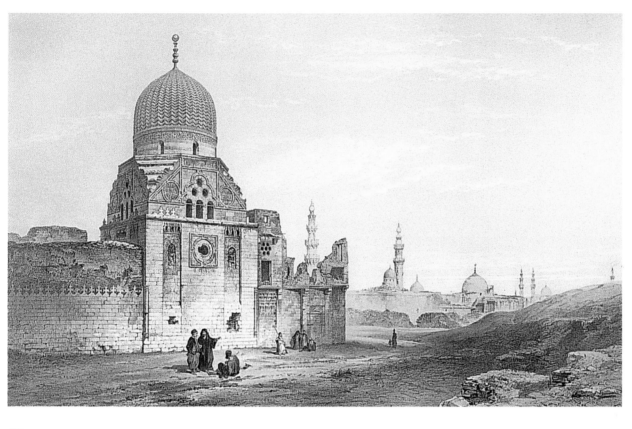

When Girault de Prangey visited Egypt, and Cairo in particular, before 1850, he was struck by the elegance of the Mamluk tombs in the City of the Dead. By that time, the majority of fifteenth- and sixteenth-century monuments were already partly ruined.

Facing page:

The superb starred cupola on the mausoleum of Kansuh, western extremity of the City of the Dead. Constructed in 1500, in the last years of Mamluk power, the work pushes the geometrication of forms to its limits – notably in the system of triangles linking the base of the cupola and the square room of the *qubbat*.

The grand Circassian style

Affairs began to improve slightly with the arrival of Sultan Baruk. His ascension to the throne took place amid furious struggles for power and the uprisings of various Mamluk groups that he had to put down with force. From this time on, the Cherkez, or Circassian Turks, were at the head of state, rather than the Kipchak Turks. The first part of Baruk's reign, from 1382 to 1389, was still marked by instability, and a plot placed Mansur Hajadi II on the throne. He was deposed in less than a year, however, at the age of 20, and Zahir Baruk resumed sovereignty until his death at 63. His son Nasir Farag succeeded him, but left the throne six years later, at the age of only 17, to Mansur Abd el-Aziz, 18. Nasir Farag returned to reign from 1405 to 1412, when he was assassinated. It was during Farag's first reign that Tamerlane, seeing that Egypt was in difficulty, attacked Syria in 1400, taking Aleppo and Damascus, which he sacked. But the danger was averted from Cairo: the Ilkhan attacked the Ottoman Sultan Bayezid I, whom he defeated and took prisoner outside Ankara in 1402. Farag was captured during the struggle

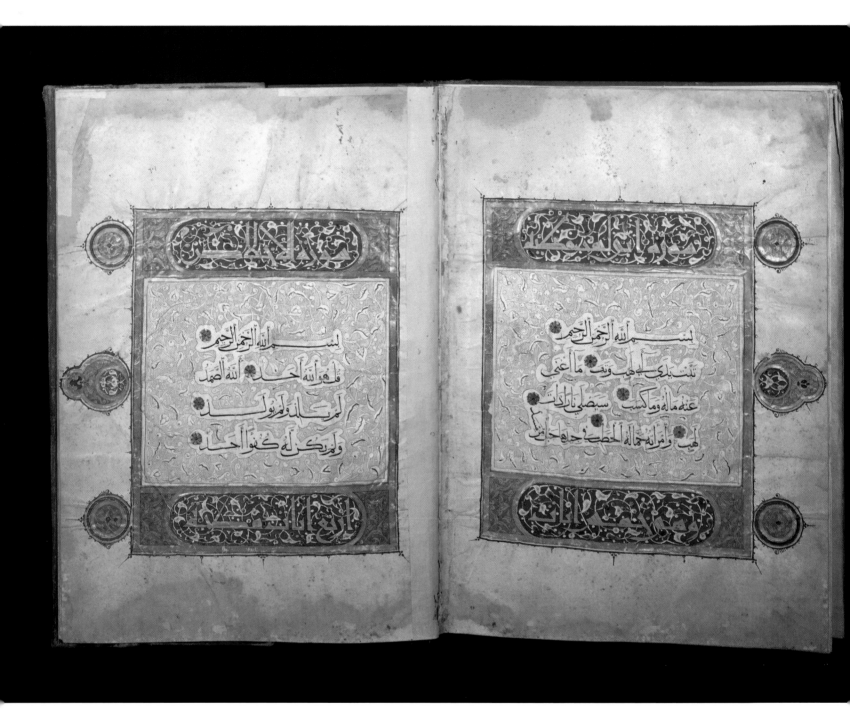

Mamluk manuscript of the Koran, dating from 1346, on paper illuminated in blue and pink, heightened in gold. The work is 51cm high, and was executed by Egyptian calligraphers shortly after the reign of Mohammed el-Nasir (al-Sabah Collection, Kuwait).

against the rebellious Syrians, judged and condemned to death in 1412, when he was only 24 years old. 'Farag was definitely one of the most interesting personalities on the throne of Cairo during the Mamluk period' (Haarmann).

Throughout the Circassian epoch, the Mamluk style was coherently strengthened, refined and enriched, both in terms of form and in terms of decoration. The authority of expression, and a simultaneous ability to make use of multiple sources of inspiration, without diluting the style, bears witness to an architectural concept of considerable force. In spite of the embarrassed financial situation, both Barkuk and Farag left monuments of a remarkable quality behind them. In the two reigns of the first Circassian Sultan, a total of 148 sites took form, with 45 of them in Cairo. Of these, the most important and the best preserved is Barkuk's mosque-*madrasa* situated right in the heart of Cairo, between the tomb of Kalaoun and the *madrasa* of Mohammed el-Nasir. Sultan Barkuk erected the place of prayer modelled on buildings with courtyards bordered with four *iwan*s. The building therefore resembles the *madrasa* of Sultan Hasan. The complex is edged by a domed tomb, with windows opening onto the main street of old Cairo. The foundations were laid in 1384, and the buildings were inaugurated in 1386, as soon as the major work was completed. Decorative work continued after this date. Farag, for his part, conformed to his father's will, by undertaking to construct a *khanka*, with mosque and double mausoleum for him in the City of the Dead, on the edge of the desert.

The site was invested in 1399, and work completed in 1411. This great symmetrical group, dominated by two very fine minarets, balanced on the far side of the courtyard by the two domes of the tombs, is an oasis of peace and serenity.

Farag's all-too-brief reign was marked by attempts to restore the empire after the havoc wrought by Tamerlane. It was true that the situation was far from easy. Makrizi draws particular attention to a terrible famine at the beginning of the fifteenth century. Even if the Arab historian was guilty of exaggeration when he deplored a drop in the number of weaving looms in Alexandria from 14,000 in 1338 to 800 in 1415 (A. Raymond), the facts were none the less dramatic. At this time the price of manpower had become so high in Egypt that Europe was able to export cheaper cloth than was produced in the Mamluk empire.

The swansong　　　　　After Farag, the history of the Mamluks of Cairo entered its ultimate phase. During this last century, their power shone as though nothing could ever threaten it. As often happens, the arts continued to develop and scarcely reflected the hard circumstances faced by the Sultans at the very height of their glory. The refinement and elegance, the constant search for opulence, had perhaps never reached such a pinnacle. Mamluk architecture produced a series of creations of unequalled perfection and originality, which admit no hint of the turbulent threat of destiny. In military affairs, the army rang the changes: it increased possession in the north and captured Cyprus, formerly held by the Lusignans, thus revenging the sacking of Alexandria,

and reinforcing Mamluk power in Arabia, shaken by Tamerlane's catastrophic incursions into Syria.

In order to solve profound financial problems – the treasury was constantly obliged to acquire new slave-soldiers – the spice trade was declared a state monopoly. Egypt had effectively lost a major part of this trade when the Mongols managed to substitute the overland route via Transoxiania and Iran for the sea route linking India to the Mediterranean through the Red Sea. With the decline in the Mongol armies following Tamerlane's death in 1405, the sea route gained in ascendancy. Egypt wished to profit from this. At that time, the spice route from India halted at Jeddah, where the precious provisions from the East were offloaded from the ships' holds into the caravans that crossed the Mamluk territories. It was at this point that the Mamluk Sultans could control the market. But the 'nationalisation' of trading houses soon tended to replace the courage and enterprise of merchants with the routine of civil servants, causing trade to fall off.

The influx of new contingents of Circassian slave-soldiers from Asia was also bound to cause fresh outbreaks of the plague in Egypt. There were violent epidemics in 1430, in 1460 and in 1492. The fifteenth century shows a continuous decline in population across the area.

Farag was succeeded by Sultan Muayyad Shaykh, who reigned from 1412 to 1421. His death in his bed at the age of 54 suggests a return to stability, albeit fleeting. The very religious Muayyad, frequenter of Turko-Syrian dervishes, managed temporarily to subdue Central Anatolia, where Haji Bektash taught (1248–1270). He displayed his piety by ordering the construction, in 1415, of a superb mosque with a square courtyard, positioned behind the gate known as Bab el-Zueila (1092), surmounted by an elegant pair of minarets. Of this building, raised up from Muizz Street which runs next to it, there now remains only a wide hypostyle prayer room, flanked by two tombs. The three other porticoes around the courtyard are ruined. This *haram*, roofed with gilded beams, has a fine *mihrab* set in the midst of panels of precious marbles, and displays similarities with the *madrasa*-tomb of Kait Bey. The buildings date respectively from 1480 and 1496.

Earlier, Sultan el-Ashraf Barsbey, who reigned from 1422 to 1438, had placed Cyprus under Mamluk control and organised an expensive expedition into Anatolia to obtain the wood needed by the Egyptian fleet. Apart from his decision to turn the spice trade into a state monopoly, he also legislated that the sugar industry should come under state administration. In the City of the Dead, he built a *madrasa* and a mausoleum not far from the *khanka* and the double mausoleum built by Farag. Both constructions date from 1425, and the Sultan was to be buried there himself in 1438. The small *madrasa* of Emir Gawhar al-Lala (1429), near Sultan Hasan, also dates from his reign. Sultan Kait Bey (1468-1496), who lived to the age of 86, was remarkable for several reasons. His 28-year reign enabled the country to find its feet again after a period of intense disruption between 1461 and 1468, which saw the succession of four Sultans in seven years, after the reign of Ainal. Above all, these years saw a fundamental change in combat techniques: the invention of firearms, with which the Ottomans very

quickly equipped themselves – coming from the master-forgers of Central Europe – totally altered the rules of war. The Mamluk horsemen, who scorned these new weapons, were no longer able to resist the victorious advance of the Turkish forces in the service of the Sultans of Constantinople (Istanbul).

The architecture of the close of the fifteenth century was characterised by a considerable refinement of the structures and by abundant and subtle ornamentation. Builders joined together structures with symmetric ground-plans together in an asymmetric whole. The uniting of a mosque-*madrasa*, a tomb, a gateway and a minaret opens up many possibilities. The vertical spring of the interiors, and the richness of decoration of the cupolas and ceilings, transform these buildings into a sort of swansong for Mamluk art. This is as true of the mosque of Emir Kigmas al-Ishaki, in Cairo, dating from 1479, as it is of the magnificent mausoleum, flanked by the mosque-*madrasa* of Sultan Kait Bey, begun just after his coming to the throne; the Sultan was buried in this tomb in 1496.

Turning history

One year after the death of Kait Bey, Vasco da Gama sailed from Portugal to India via the Cape of Good Hope and, returning in 1499 to his home port, showed once and for all that it was no longer necessary for the import-export spice trade to pass across the counters of the Mamluk empire. This had the result of throwing Egypt into economic decline, which, taken with the general depopulation of the country, made the Sultanate a relatively easy picking for the young Ottoman Empire.

No more than a few years before the fall, however, Cairo, under the reign of Sultan el-Ghuri (1501–1516), was still undergoing a considerable programme of town-planning and administrative alterations, accompanied by important new works. Various restoration projects were set in motion: the palace and the mosque of the Citadel, and also the great hippodrome, known as the Maydan, where the Mamluks exercised their horses and festivities and official ceremonies were held. On the banks of the Nile, an enormous tower to bring water from the river and lift it through six storeys, using chains of buckets borne by oxen, served to fill a new aqueduct, built entirely from stone, which ran to the Citadel.

During the reign of Kait Bey, some 230 interventions and constructions were executed throughout the entire empire (Meinecke). El-Ghuri continued in the same vein, adding more than 100 sites. In Cairo, the main buildings were the *madrasa* and mausoleum of Emir Khairbak al-Ashrafi (1502); the *madrasa* and tomb of Emir Kanibey Kara al-Rammah, known as the *madrasa* of Emir Akhor (1503); the *madrasa* and the mausoleum of el-Ghuri (1501–1504); the *khan*, or caravanserai, of el-Ghuri (1504); the *madrasa* and tomb of Emir Kurkmas (1506–1510), and so on. These last works carry still further the search for greater refinement, height, elegance and concentration of architectural decoration. In the aesthetic vision adopted by Kait Bey, the *madrasa* and tomb of el-Ghuri can be seen to a certain extent as the 'Roccoco' of Mamluk art. This desire to create more and more light and airy structures resulted in a weakening of buildings, which became easily subject to accidents. The dome on the tomb of el-Ghuri looked likely to collapse, and had to be demolished in the lifetime of the Sultan. Numerous minarets were also knocked down, since they were considered a public danger. These same over-delicate structures payed a heavy price in the 1992 earthquake.

During the reign of el-Ghuri, a far-sighted policy led the Sultan to enter into an alliance with the Venetians to oppose the installation of the Portuguese in India. Unfortunately the Mamluk fleet carried insufficient fire-power and was overcome by the Portuguese viceroy, Albuquerque, in the Indian Ocean in 1509. Ottoman pressure on Egypt and its possessions continued to rise. The reasons for the struggle went a long way back. In 1481, Kait Bey had already met with Prince Jem in Cairo. The Prince was disputing the throne of Constantinople with his brother Bayezid II. Selim, known as Selim the Terrible, the Ottoman Sultan from 1512 to 1520, wished to capture Cairo. In 1516, he entered Syria and beat the Mamluks in a battle near Aleppo, where el-Ghuri lost his life. From then on, the Ottoman troops were at the very gates of Egypt, and Sultan Tuman Bey II, defeated outside Cairo in 1517, was hanged on the order of Selim. The Egypt of the Mamluks had reached its term.

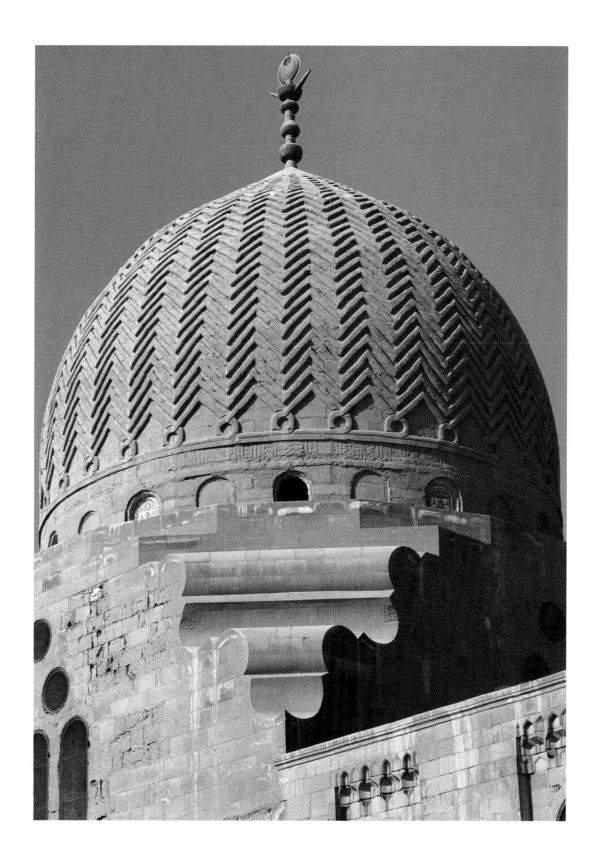

Constructed between 1399 and 1410 by Sultan Farag to honour his father, Baruk (1382–1389 and 1390–1399, founder of the Circassian dynasty), the tomb of the Sultan in the City of the Dead has two identical domes. Herringbone motifs enliven the hemispherical surfaces. Highly original large horizontal mouldings ornament the external angles of the *qubbat*.

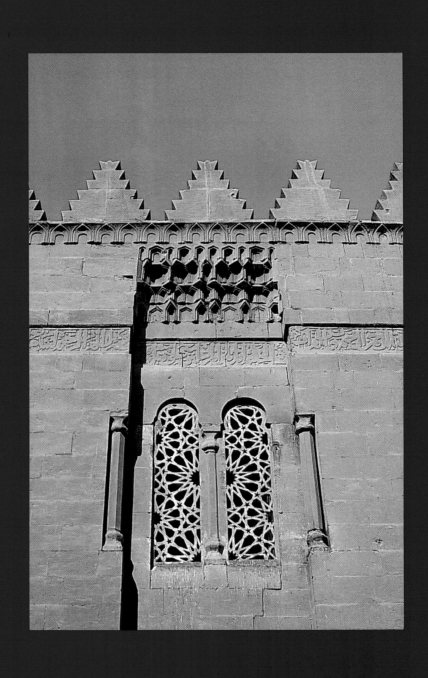

THE ANCIENT WORLD: CRUCIBLE OF MAMLUK ART

The situation in the Near East at the time when the Mamluks took power in Egypt and built an empire which included Syria, Palestine, and Hejaz – containing the Holy Sites of Jerusalem, Mecca and Medina – must be viewed against an historical background that has to cover almost the entire ancient world, from China to the Mediterranean.

It was the time of great population shifts. At the heart of the Asiatic Steppes, for climatic, economic and demographic reasons, populations of semi-nomadic stock-breeders began to move, as during the age of invasions, which, six centuries earlier, submerged the Roman Empire. From the eleventh century, tribes of Turko-Mongol horsemen, united under the command of intrepid chieftains, invaded the territories occupied by non-migrant people. Their warlike and brutal expansion overthrew the hard-attained order constituted since the Arab conquest of the seventh century. The political environment in Egypt around 1250 is essentially the result of violent transformation stemming from the Central Asian Steppes. Successive waves of invaders flooded across these limitless plains, descending on China and on India, as well as on the Near East and the confines of Europe. Their incursions mark the history of the eleventh to fifteenth centuries. Their result was a complete redistribution of boundaries, and a profound transformation of the political landscape.

The Turko-Mongolian invasions In 1051, Tugrul Bey, chief of the Seljuks, an Islamised Turkish tribe, invaded Persia and took Ispahan and Baghdad. Alp Arslan conquered Aleppo and Armenia between 1063 and 1073. In 1071, his forces defeated the Byzantines at Mantzikert, and captured Anatolia and Edessa. In 1078, the Seljuks took Damascus. They reached Jerusalem in 1079, an event felt sorely in the Christian West, and which ultimately provoked the Crusades. Kilich Arslan I (1156–1192) established his court at Konya (Iconium), and founded the Sultanate of Rum. His successor, Kilich Arslan II, unified the country.

D ouble windows in the facade of the Mosque of Maridani (1338–1340), with small columns and a stellar network of stucco to hold the glazing. Stalactite corbelling hangs above the sunken openings, surmounted by a projecting frieze. Stepped merlons stand out against the sky.

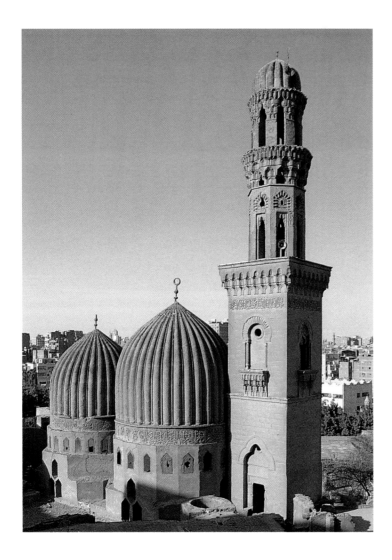

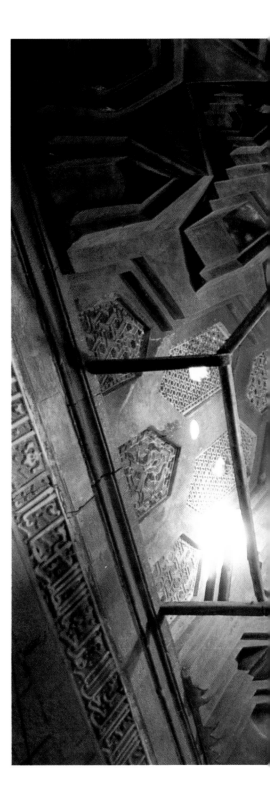

But at the end of the twelfth century, Konya fell to the Crusaders (1190) led by Emperor Frederick I (Barbarossa), whose armies were on the way to the Holy Land. Shortly afterwards, Keyhusrev regained possession of Asia Minor, and began to establish the trans-Anatolian caravan route between Antalya and Sinop, linking the eastern Mediterranean and the Black Sea. A chain of fortified caravanserais, encouraging international relations, lined this great trade route; the caravans carrying their cargoes of produce or slaves passed through these trading posts.

In spite of its Mongol rule, Anatolia covered itself with interesting buildings: mosques, *madrasa*s, *turbe*s, etc., which have a good deal in common with the Mamluk buildings of Cairo. The architects and workforce in the service of the Seljuk Dynasty were working for Sultans still close to the nomadic traditions of their origins. On the whole, these builders came from the Armeno-Byzantine world, that is, Christian Asia Minor, Cappadocia, and from the Kingdom of Lesser Cilicia or northern Syria. The forms of their creations frequently reflect these origins, though the applied decoration gives a new feeling to the constructions. During this period, other tribes from Central Asia forged their unity: the Mongols, called to a role of considerable importance across the face of the ancient world, achieved a kind of 'federation' under Gengis Khan from 1188 on. They beat the Seljuks six years later,

The two cupolas and the elegant minaret of the mausoleum of Emirs Salar and Sanjar, built in 1303 in the quarter of the Mosque of Ibn Tulun at Fustat. Mamluk art shows clearly in its vertical trend.

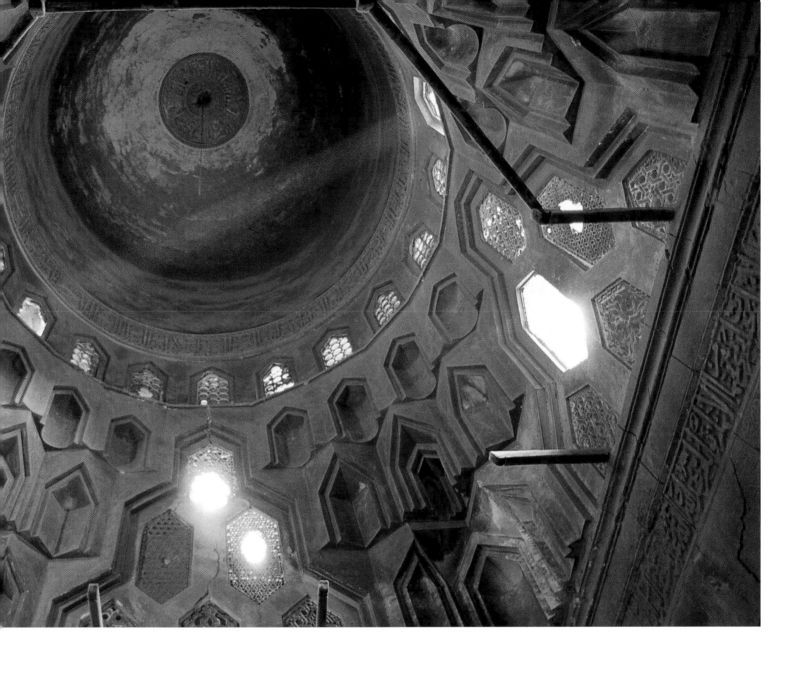

The system of geometric stalactites in the funerary chapel of Emir Sanjar harmonises with the 20 window openings in the dome. Arabic inscriptions run around the square chamber.

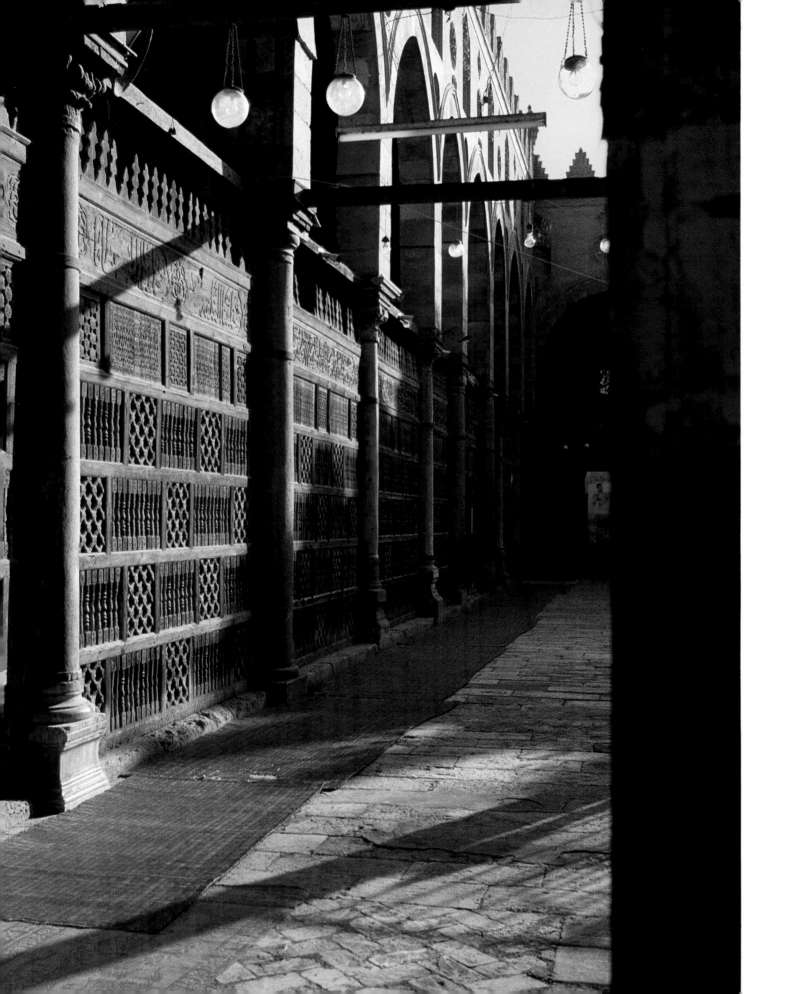

entered India in 1206 and occupied Iran in 1220, founding the dynasty of the Ilkhans of Persia. They took Baghdad and, in 1258, threw the Islamic world into a stupor by executing the Caliph, the spiritual leader of Muslims. Still they advanced, moving westwards, taking Aleppo and Damascus in 1259. The Mamluks Kutuz and Baibars checked their career in 1260 at Ain Jalut. A new Mamluk victory in 1272 managed to halt their advance, but it still needed the victories by the Sultans of Egypt in 1281 and 1303 against the successors of Gengis Khan to eliminate completely the Mongol threat to the Near East.

One and a half centuries later, Tamerlane (Tamberlaine) set out to take over Gengis Khan's grand scheme. At the head of Turkish tribes from Central Asia, he captured Ispahan and made his capital at Samarkand in 1390. After ravaging the majority of the Muslim kingdoms and plunging the Middle East into disorder, he surrounded himself with scholars, artists and craftsmen taken, on the whole, from the conquered towns, and turned Samarkand into an intellectual and artistic metropolis. The dynasty of the Timurids that he founded represents one of the high points of Persian culture. In the Near East, his conquests continued with the taking of Aleppo in Syria, then Damascus. However, by choosing to attack the Anatolian Ottomans, he renounced an assault on Mamluk Egypt.

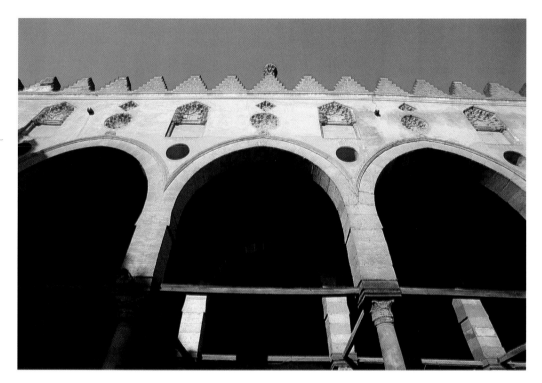

The courtyard facade of the Maridani prayer room overhung by stepped merlons. The large pointed arches are raised on columns, many of which are re-employed from ancient times.

Facing:

The prayer room of the Maridani Mosque, built by Emir al-Tubunga el-Maridani, is separated from the courtyard by a pierced wooden screen, in the *mucharabieh* fashion.

The Crusades

In the Near East, expansionist conquest took another form: the Crusades. These were launched by the Occident to capture the Christian holy sites – Jerusalem, scene of Christ's Passion, and Nazareth, traditional birthplace of Jesus. As a reaction to the entry of the Seljuks in Jerusalem, the movement of the Crusades was initiated by a papal decision in 1095. Christian forces passed through Cappadocia and Lesser Armenia, captured Edessa, Antioch and Tripoli, and finally reached the Holy City in 1099, founding the Kingdom of Franks which joined in alliance with the Armenians in Cilicia.

The struggle between Muslim and Christian forces, with each army supported by a powerful network of fortresses, hung in the balance for a long time, until the arrival of the Kurd Saladin (Salah el-Din), Ayyubid Sultan of Egypt and Syria (1171–1193). His victory over the Crusaders at Hattin in 1187 enabled him to recapture Jerusalem. From that moment the great military thrust from France, England and the Holy Roman Empire began to run out of steam. The Franks were rebuffed by the combined Arab forces, and now only occupied a narrow strip of land between Tripoli and Saint-Jean-d'Acre, together with the city of Antioch.

With Frederic II, Jerusalem returned to the Christians from 1229 to 1244: a well negotiated agreement with the Ayyubid al-Malik al-Kamil led to the treaty of Jaffa. However, the Frankish knights were still on the defensive in the Holy Land, and Jerusalem was to fall once again into Islamic hands, with the assault of the Kwarezmiens under Saladin II.

The position of the Christians became desperate after the victory of Arbiyya in 1245 by the Mamluk Baibars. These dramatic events sparked off the seventh Crusade. The Christian fleet, led by King Louis IX of France, set sail for Egypt. The knights disembarked in the Nile Delta and captured Damietta in 1249. The Muslim reaction was brutal. The Christians suffered a heavy defeat at the hands of the Mamluks in 1250 at Mansurah, and King Louis was taken prisoner. Thereafter, disaster piled on disaster in the face of Mamluk power established at Cairo.: Antioch fell in 1289, then Acre and Tyre in 1291. The Frankish presence in the Near East was ended.

Soon, the only territories remaining in Christian hands were Cyprus, which became a major trading centre for Islamic and Christian kingdoms, and also Morea (the Peloponnese), where the Franks were little by little replaced by Byzantines. At the same time, Venice and Genoa, economic competitors, negotiated with the Muslims and managed to establish trading posts on the international trading routes. On the Muslim side, Alexandria and Gaza were among the most important trading centres to contribute to the wealth of Mamluk Egypt.

Amongst the powers of the thirteenth century, the Byzantine world cut the smallest slice for itself. The last two centuries before the fall of Constantinople to the Ottomans in 1453 represent a critical period in Byzantine history. In 1204, the Venetians and the Crusaders captured Byzantium, and sacked it. They remained there, forming the Oriental Latin Empire, until 1261, at the time that the Basileis, sheltering in their last Anatolian possessions, ruled in Trebizond and Nicea. They no longer played a role against the Mamluks, and sank still further with the rise of Ottoman power, soon to eclipse the old imperial city. In 1308 the Seljuk Keykubad III was defeated and put to death by the Ottomans, who went on to gain ascendancy in West Asia Minor, and establish their capital there at Brusa.

Such was the background to the arrival of the Mamluks. In one sense it is possible to maintain that the accession to the throne of the Sultans of Cairo was caused by the intrusion of the Crusades

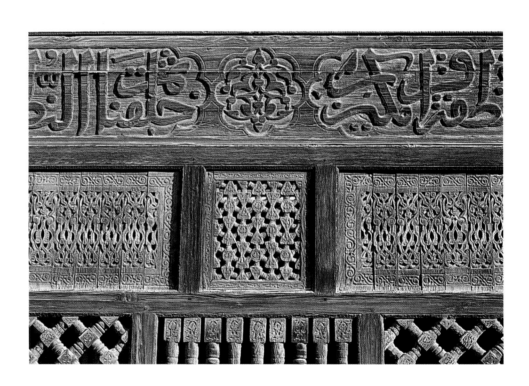

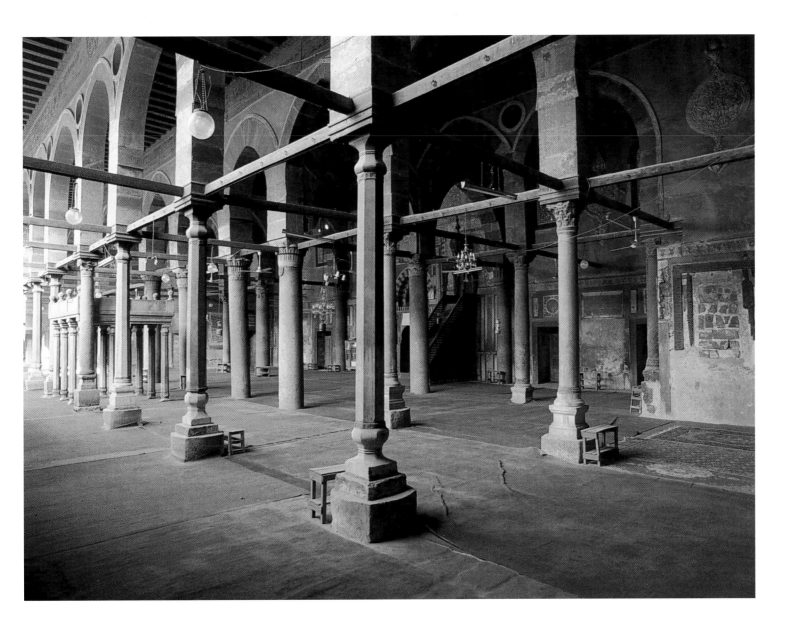

into Egypt, first under the command of Jean de Brienne (1218) – enabling Saint Francis of Assisi to attempt the conversion of Sultan Malik al-Kamil – then under the command of Saint Louis. These two unfortunate military adventures certainly showed the Franks the danger of such interventions. But more importantly, they allowed Egypt to measure the weakness of their defences and to see the need for a strong Islamic power, soon to be incarnated by the Mamluk Sultans of Cairo.

The influences on Mamluk art This rapid voyage across the centuries before the arrival of the Mamluks in Egypt gives an idea of the cultural background to the art of the Bahrid and Circassian Dynasties. It shows that many factors came to play in the evolution of the Mamluk architectural style, from the middle of the thirteenth century up to the beginning of the sixteenth century. The Mamluk Sultans, doughty chieftains of war, were none the less recently cultivated soldiers, with no real artistic past of their own. These warriors, originating from Central Asian tribes, removed from their tradition of semi-nomadic stock-breeding, did not bring with them an artistic heritage to develop in the lands they came to control. All the more reason, then, for them to feel

the influence of the style already existing in Egypt, since the emergence of Islamic architecture on the banks of the Nile in the middle of the seventh century.

Since the Islamic architecture of Cairo before the Sultanate of Cairo is dealt with in the appendix (pages 192–205), we will just recall here some of the major sources that touched Mamluk art. One of the principal characteristics of Muslim architecture in Egypt, immediately echoed in Cairo buildings from the middle of the thirteenth century, was the technique of using recycled architectural elements. The first builders who founded the Mosque of Amr ibn el-Ass used antique columns and capitals. This led to the initiation of an arcaded, hypostyle form for the prayer rooms, a notable inspiration in the Mamluk Mosques of Mohammed el-Nasir and Muayyad; much recycling is evident at the mausoleum of Kalaoun, and at the *madrasa* of Barkuk, using pillars of pink granite from Aswan.

The eleventh-century Tulunid period gave Mamluk art the techniques of dressing-brick laying and of stucco application; the pointed arches used at both the Mosque of Ibn Tulun (built in brick after the fashion of the mosques of Samarra) and in the nilometer of Rawda (built in stone with keyed vaults). From the

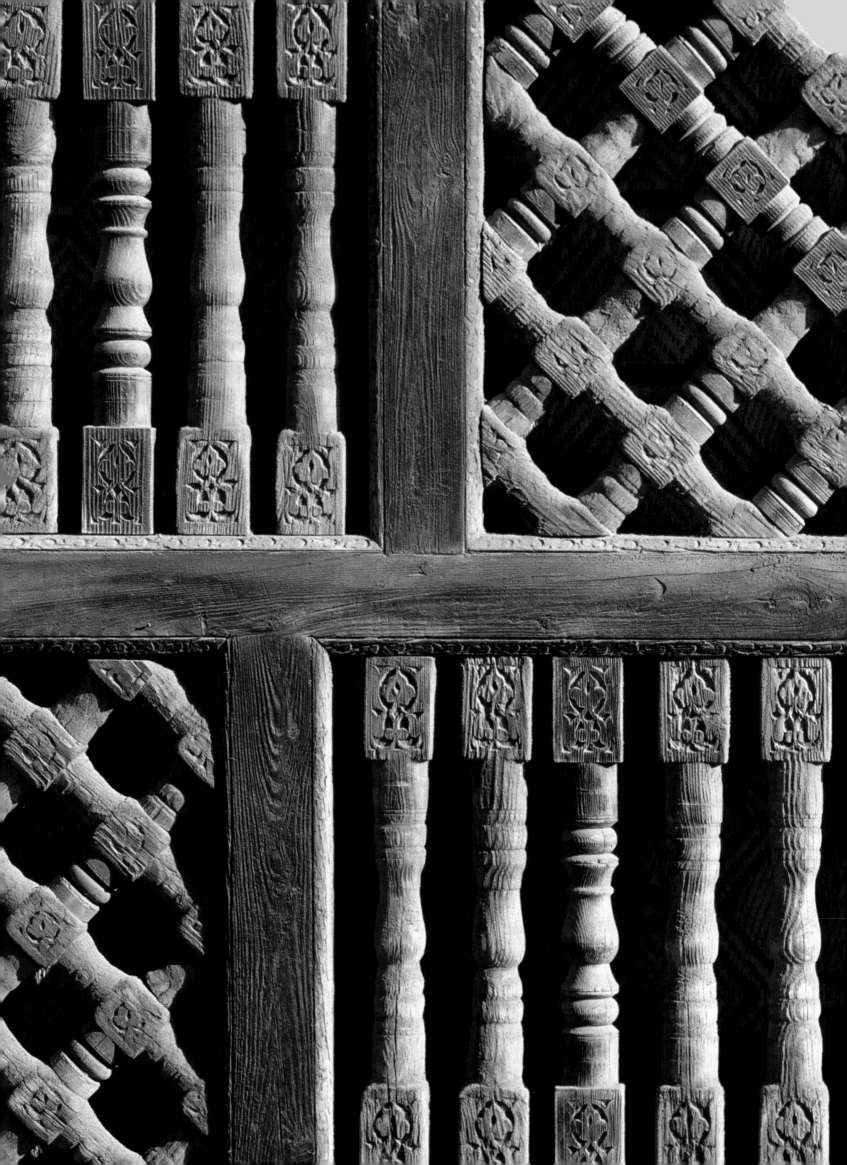

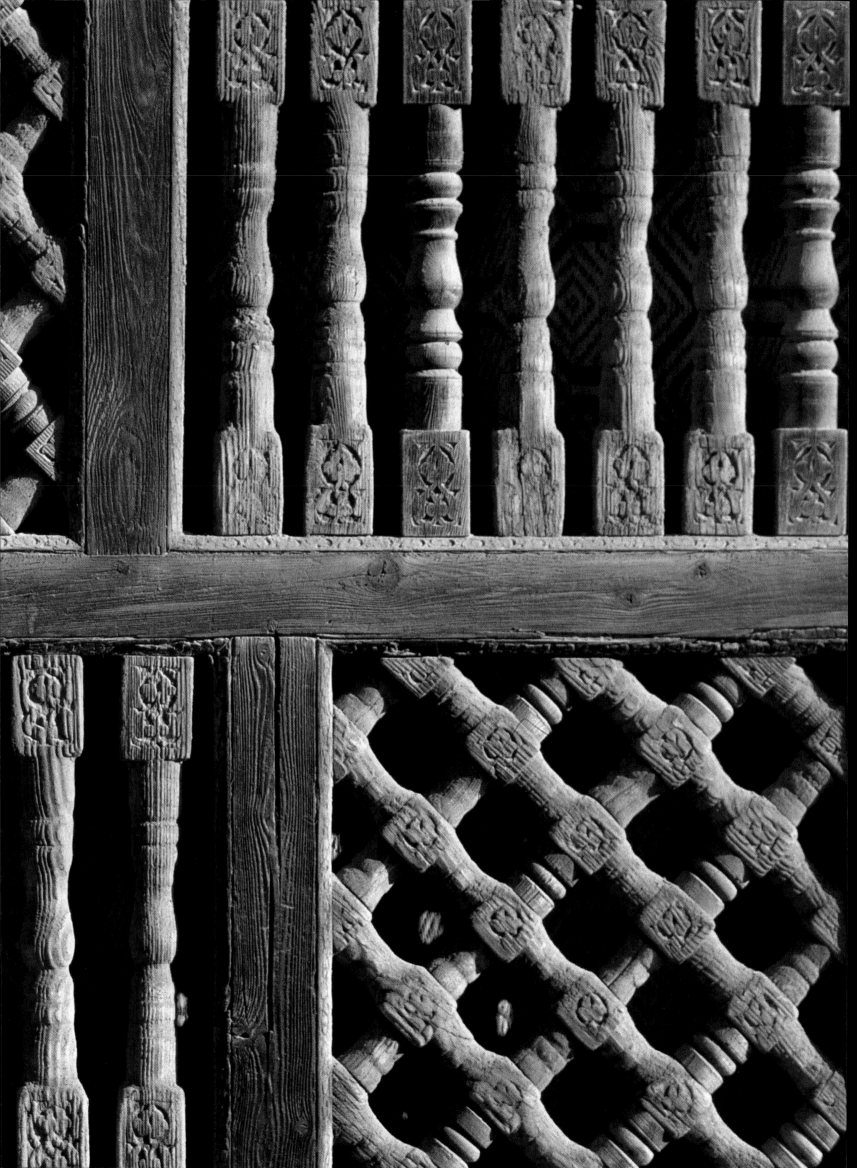

Fatimid period (tenth to twelfth centuries) come various ornamental themes, generally treated in stucco; the legacy of Badr Gamali, a builder of Armenian origin, who constructed a defensive wall around Cairo, was a remarkable mastery of regular stone laying, which left its mark on Mamluk buildings everywhere.

But the empire constituted by the Sultans of Cairo, following the Ayyubids, also included Palestinian and Syrian provinces, which contained Jerusalem and Damascus, both high centres of classical Muslim art. From these Omayyad works, Mamluk art was enriched by the adoption of the Byzantine techniques of mosaics on a gold background, such as were to be seen in the Dome of the Rock at Jerusalem, and in the Great Mosque at Damascus. Very few examples exist of this technique using polychrome glass tessala. The Byzantine architecture of the Omayyad monuments also provides the use of large areas of coloured marble panelling in Mamluk mosques and mausolea. The builders of Cairo adopted a style from the north of Syria which is easily recognisable in the polychrome decoration of the *mihrab*s. This style flourished during the Ayyubid epoch, and a good example is the Firduz *madrasa* at Aleppo.

Lastly, the Mamluk Sultans' armies also campaigned in Anatolian regions, from whence they brought back the construction technology of vaults and cupolas, and a decorative vocabulary that is identical in Turkey to that in Cairo. These various themes come together and form a very striking common stylistic ground between the art of the Seljuks of Rum and Mamluk edifices. From the Seljuks of Persia were to come a number of other essential features: firstly, the formula of the *iwan* – a wide, covered niche, open to the front. The main use of the *iwan* is in the great gateways, or *pishtak*, of the mosques and *madrasa*s; it is also an essential part of the cruciform courtyards with four *iwan*s, characteristic of the Iranian era since the epoch of the Ghaznevids. This solution found particular expression in the Persian mosques during the Seljuk and Mongol periods, before coming to Egypt, where, now constructed in stone, it came to its apogee in the *madrasa* of Sultan Hasan. The alveolate geometric system of stalactites (*muqarna*), forming a decorative bees-nest pattern to be found inside *iwan*s and in the angles of cupolas, also originated in Seljuk Iran. Equally, Mesopotamia and Persia provide the source for the decoration in polychrome china which sometimes appears in Mamluk art.

One last, capital source should not be omitted from this list: the influence of the Crusades on the Near East. The influence of the techniques of Gothic Europe can be felt particularly in military architecture, developed reciprocally during the struggles between the Crusaders and the Ayyubids. Religious architecture, with formulae such as pointed arches, ogival vaults, thrust-bearing systems, cruciform pillars, etc., also reflects techniques in use amongst the Christians of the Holy Land. On the other hand, it is also true that the Crusaders themselves were enriched by contact with the Islamic world, a notable example being the tierce-point arch. It seems that the use of coloured glass in leaded windows was probably introduced by Romano-Gothic glass-makers. From this description of sources, it might appear that the architecture of the Sultans of Cairo has a heteroclite character; that the numerous origins of the elements means the buildings have a patchwork, mixed, jumbled appearance. Does the art consist of nothing more than a series of quotations? Are we dealing with a hybrid? It must be stated that nothing could be further from the truth. In reality, the Mamluk art that brings all these diverse elements into play is totally original, profoundly unitary and coherent. It is neither pastiche nor amalgam. Everything is mastered, in a homogeneous and vigorous fusion of the different currents. The result is a brilliant harmony, which testifies, without a shadow of doubt, to a strong and individual style.

A world in motion It might perhaps appear surprising that all these sources of influence, coming from all points of the horizon, from far off countries, should come together to exercise a force on this Mediterranean and Near Eastern region which was the Mamluk empire. Sight must not be lost of the vast cultural community that the Islamic world represented in the Middle Ages, and that ideas and people were voyaging across lands stretching from the Atlantic to Persia and to the furthest Orient beyond...

In this way, a man such as Ibn Khaldun, – Arab philosopher, historian and sociologist, born at Tunis in 1332 – was Sultan Nasrid Mohammed V of Granada's ambassador to Peter the Cruel in Seville, before a period in merinid Morocco, where he became interested in the history of the Berbers. Then, passing via Tunis, he visited the Cairo of the Mamluks, where he became Grand Malekite Cadi. He died there in 1406. Similarly, Ibn Batuta, an Arab traveller and geographer born in Tangiers in 1304, made the pilgrimage to Mecca in 1325, visiting Syria and Upper Egypt, then the western coast of Africa and Persia, before returning to Arabia. From there, he made his way to Anatolia and the Crimea, calling in on the Genoese trading posts on the Black Sea, and penetrated Tartar country, travelling through Afganistan to see India, Ceylon and Sumatra. He finally arrived in China, before returning to the land of his birth, from whence he set out again, for the Sahara and the Niger. It seems he was in Morocco again in 1352, to dictate his *Travel Journal*, before dying between 1368 and 1377.

In this way, usages, customs, forms, ideas all circulated intensely about this ancient world, so great an area of which was covered by Muslim territories. In this context, the importance of the obligation to make pilgrimages inherent in the Muslim faith also plays an estimable role, encouraging, as it does, travel and individual mobility. Concepts are distributed, just as are precious commodities. Aulic rituals of Sassanid origin were brought to the court in Persia, where they survived, to be passed into Egypt and Andalucia. Surely the *Pax Mongolica* was a formidable aid to the transfer of both technologies and of exotic products? It must certainly have helped Marco Polo in his journeys, whose beginnings coincided precisely with the Mamluk Sultanate.

The Venetian actually took the route that his father and uncle had taken once previously in 1255. They had left Constantinople by land for Peking, crossing Siberia and the deserts of China.

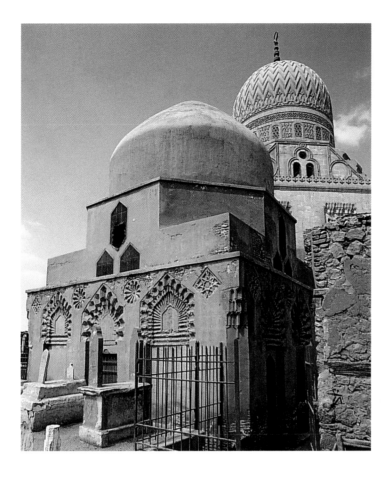

Constructed immediately after Sultan Baibars took power, the Mausoleum 'of the Abbasids' (1242) is a transitional monument, showing the influence of Ayyubid art, but giving a preview of Mamluk constructions. It reveals the importance which the Cairo Dynasties attached to the descendants of the Caliphs of Baghdad, viewed as gauges of orthodoxy.

Marco Polo, in the voyage he made with them in 1271, chose a more mediterranean route. From Saint-Jean d'Acre, via Sivas and Tabriz, he reached Ormuz and Balkh, Khotan, Ganzhu, and Peking. The three 'Latin' voyagers spent 17 years in the service of the great Kublai Khan, grandson of Gengis Khan, then returned home by sea, in 1292, after passing through the Straits of Malacca, touching Sumatra, and the shores of India. In prison in Genoa, Marco recounted his incredible adventures, which his companion in misfortune, Rusticello, transcribed in Italian and published under the title *Il Milione* . Marco Polo himself then gave a second version of the events, entitled *Divisament du Monde*.

It was an extraordinary period, when humanity discovered the planet, where spices and theories circulated, instruments of navigation advanced apace – compasses, astrolabes etc. – and long-distance trading methods, such as bills of exchange, recognised by bankers, and insurance on the transported products, came into being. Long haul trading began, to obtain products like camphor, bamboo, aloes, ivory, cloves, sandalwood, nutmeg, cardamoms, silk and porcelain from China, not to mention furs from Siberia. And to promote transport by land, the Sultans constructed cara-vanserais (*khans*) along the great trading routes, every 30 or 40 kilometres, to provide a shelter for a break in the journey, with a supply of water or a well for men and animals, and a place for prayer, making respect of the rites possible. This mobility also affected craftsmen and labourers: entire workshop teams, some-times of several hundreds of specialists, of the best craftsmen in each branch, would move about the country, or come from con-quered territories at the will of a sovereign, in order to work on

great building sites. Already Badr Gamali had brought teams of architects and builders from Armenia with him into Egypt, shortly after the Byzantine defeat at Mantzikert. They were put to work on the construction of the wall around Cairo. But the custom became more general: Syrians and Anatolians converged on the Mamluk capital. Sculptors, glass-makers and bronze-workers, not forgetting the copyists and illuminators requisitioned by the Sultans and Emirs, came from all corners of the globe to assist in the con-struction of the great buildings, works of art designed to glorify and commemorate the names of the masters of the Mamluk empire. This habit was in fact very widespread among Muslim sovereigns. It can be found in Ottoman Turkey, with the hundreds of earthenware-makers brought from Tabriz to Iznik by Selim I, after the victory over Shah Ismail I at Chaldiran in 1514. They were immediately employed to establish the workshops which were to produce not only the multi-coloured dishes, vases and ewers of Iznik, but also the beautiful polychrome tiles that so fea-tured in Ottoman architecture. The Turkish Sultan who was to take Cairo three years later was also to employ the same tactics as had the Mongols and Mamluks before him.

While it is fascinating to seek the origins of the plans and tech-niques which gave birth to the architectural style of the Mamluks of Cairo, it should not be forgotten quite how faithful this art is to Islamic sources. At the same time as innovating, it remains both traditionalist and respectful of the secular acquisitions of the Muslim builders. It conforms scrupulously to the spirit of Islamic forms. The Mamluk Sultans took power in Egypt more than six centuries after the Prophet erected his own place of prayer at

Medina. During this generous half-millennium, Islam had already forged its own language, asserting itself in original forms. It is therefore interesting to underline the continuity in Mamluk art, by contrasting it with the original aspects to which it gives concrete form, which will be dealt with in the next chapters.

The classic mosque and the madrasa In the conception that the Mamluk builders adopted to construct their mosques, the works of the Mamluk Sultans of Cairo conformed to the precepts of classic Islamic art. The places of prayer that they erected, apart from the *madrasa*s and *khanka*s, in general follow the plan of the mosque built around a courtyard, consisting of a hypostyle hall, bordered by the *kibla*, with porticos around the edge, of which the one facing the *haram* is perhaps the most developed.

This conception derives directly from the first prayer room built by Mohammed himself, in his dwelling at Medina, where he taught. Its form, with two covered zones on either side of a square courtyard, reflects its history: The Prophet himself orientated a first 'hypostyle hall' towards Jerusalem, built with the aid of trunks of palm trees supporting a palm roof. Then, following the split with the Jews, he turned his mosque towards the holy town of Mecca, and more exactly, toward the *Kaaba*, or Black Stone, venerated since pre-Islamic times. The original building thus had a covered space to the north, and another, which was to become the larger, to the south.

Mosques with courtyards would reflect this formula for a long time. The ancient Omayyad mosques at Medina, Mecca, Damascus and Cordoba all adopted this solution, as, in the time of the Abbasids, did those at Baghdad and Samarra, as well as the mosque at Kairouan, without omitting, in Cairo, the Amr, Ibn Tulun, el-Azhar and el-Hakim mosques, to list only the most prestigious. Of the Mamluk buildings corresponding to this traditional system, the Baibars I, Maridani, Mohammed el-Nasir, Muayyad and Barsbey Mosques are all examples to be found in Cairo. The prayer rooms of these structures are generally made up of arcades, with the bays running parallel to the *kibla* – the wall containing the *mihrab* niche, indicating the direction of prayer. In Cairo, the notions of mosque, *madrasa* or Koranic school are often confused and applied indiscriminately to a series of buildings, such as those of Sultan Hasan, Barkuk or Kait Bey. This has happened gradually, as people have slowly become accustomed to frequenting these places and using them for prayer.

Above and facing:

In Muizz Street (al-Muizz al-Din Allah), the main street of Cairo, is the beautiful door to the el-Ashraf Barsbey Mosque, constructed in 1423. Its surface is ornamented with fine bronze open-work, fitted into an *ablak* frame, of dark and light coloured layers. The motifs are similar to those found in rugs, with a central medallion and elaborately worked corners, inscribed within a series of borders.

54

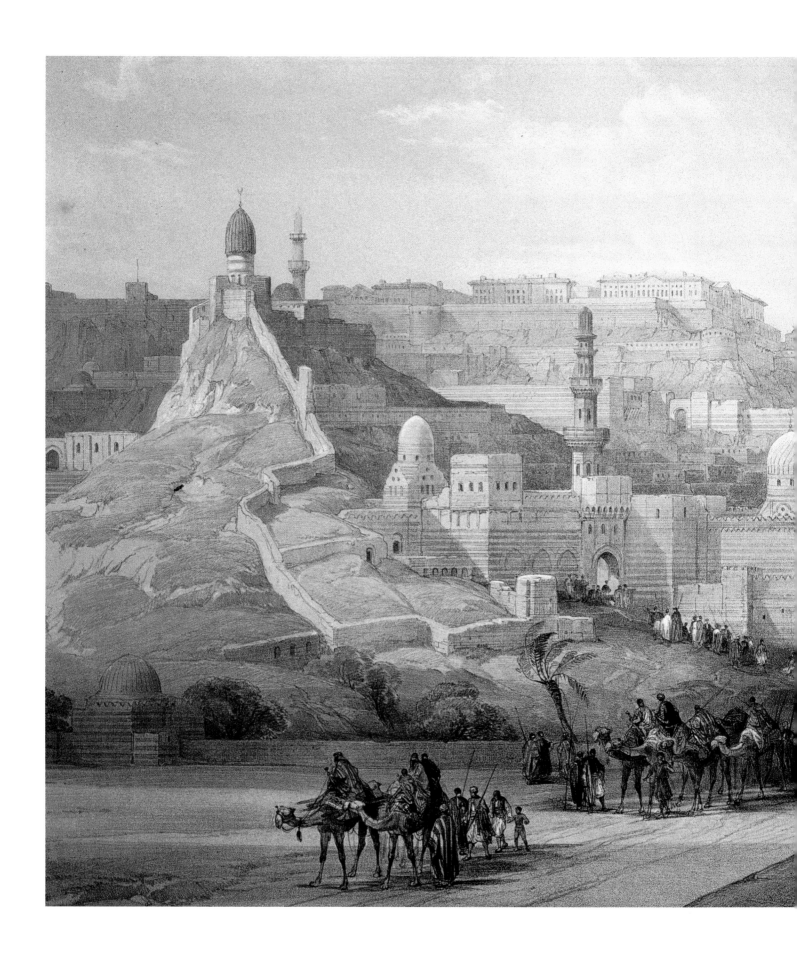

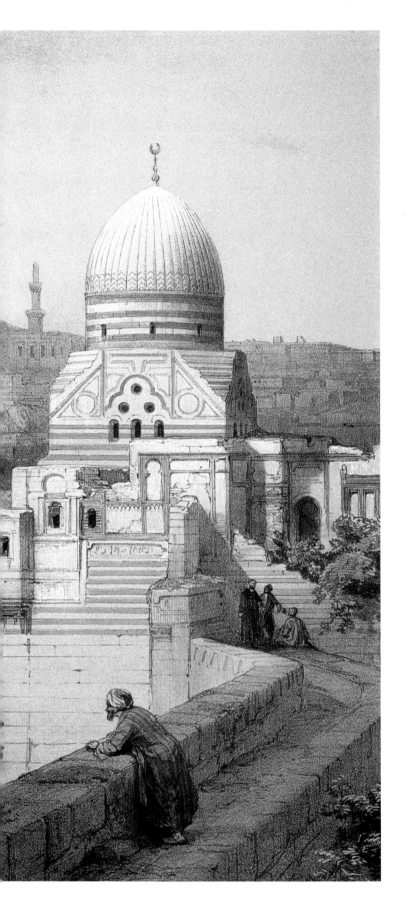

The arrival of the Turko-Mongol Sultans, including the Mamluks, brought into Egypt by force the idea of the *madrasa*, a place where instruction in the strict Sunnite observance of the Koran was given, whereas in Persia and Anatolia, in Syria and Iraq, under the Seljuks, these places had died out. It consecrated the domination of Islam by the 'orthodox' Sunnites, countering the Ismaili Shiite current of the Fatimids, subsequently considered to be an aberration in Egypt. The Mamluk sovereigns took very seriously this role of guardian of the faith, and, in assuming the protection of the Caliph, also became the defenders of the Muslim community. It should not be forgotten that the Shiite Fatimid Dynasty had ruled North Africa and Cairo between 909 and 1171, when Saladin (Salah el-Din) put an end to their domination of Egypt. Since the fall of the Fatimid anti-Caliphs took place only 80 years before the arrival of the first Mamluk Sultan of Cairo, the Turkish Sunnites' eagerness to erect a large number of *madrasa*s is understandable.

The Seljuks absorbed the influences of Persian architecture in their move across from Central Asia to Egypt, and introduced the formula of the *madrasa* into the Near East. After the Ayyubids, the Mamluks became champions of the characteristic plan of the buildings. *Madrasa*s effectively follow the Iranian layout of an edifice with a courtyard of four *iwan*s. This cruciform disposition lent itself to the teaching of the four Muslim rites – Shafi, Hanefi, Hanbali and Maliki. Clearly, this form did in fact pre-date the function of a *madrasa*, but did none the less perfectly suit the coexistence of these four currents of Sunnite theology. Because of this, it was widely adopted across the Muslim world.

The Mamluks built dozens of *madrasa*s in Cairo. These include independent *madrasa*s (el-Malik, el-Ebzek, el-Ghuri), buildings combined with a mausoleum (Kalaoun, Mohammed el-Nasir, Salar and Sanjar, Barkuk, Sultan Hasan, etc.), or buildings which may be confused with a *khanka*, which could also be constructed on a cruciform plan with four *iwan*s (Baibars II). At all events, the four *iwan* scheme is not always strictly followed: in some instances, the *iwan* containing the *mihrab* (in Cairo, to the south-east side of the structure), and the *iwan* facing it (north-west), are clearly dominant, to the extent that the lateral *iwan*s are atrophied, or even disappear on either one or both sides (as at the *madrasa* of Kalaoun). In certain cases, as already mentioned, this originally Persian ground-plan also spread into mosques, as it frequently did in Iran (the Friday Mosque at Ispahan, at Zavare, at Kerman, at Ardestan, etc.). Sometimes it is no longer clear whether we are dealing with a local mosque, or a *madrasa* given over to the role of public prayer.

Tombs and Mausolea

Originally, the notion of a magnificent tomb was banished from strict Islamic observance. Only with the construction of the Qubbat al-Sulaibiya in Samarrah in 862 did the idea of a mausoleum become possible. The mother of Caliph al-Muntsir (of Christian Greek origin) had this monument erected, basing it on the octagonal plan with ambulatories of the Dome of the Rock in Jerusalem (Qubbat al Sakhra), which followed the typical form of a shrine, conceived in the Byzantine

View of the Citadel of Cairo at the beginning of the nineteenth century, with Mamluk mosques and tombs lining the slope. The Turkish barracks crown the esplanade. This picturesque impression by the British artist, David Roberts, shows how the ancient town must have looked.

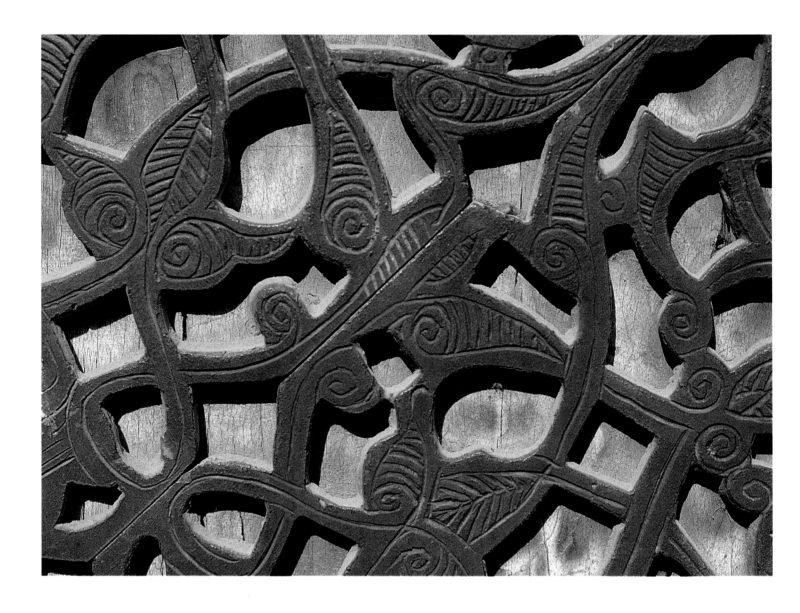

tradition. The first large mosque in Cairo, the Mosque of Sultan Kalaoun, also has an octagonal ground-plan. In a square room, with a central tomb, the architect has designed a high structure supported at eight points: four large, rehabilitated columns of pink Aswan granite and four solid pillars hold up a sort of lantern tower, supported on eight wide, raised arches; the cupola, lit by eight bays, dominates the sepulchre. From now on, the association of a square room, alluding to the cubic shape of the *Kaaba*, and a hemispheric dome, symbolising the sky, was to be a constant of Mamluk mausolea. Notable examples of cube and dome tombs are those of Mohammed el-Nasir, Baibars II, Sultan Hasan, Barkuk, Farag, Emir Akhor and Kait Bey, to mention only the best known.

The minarets It is customary to suggest that minarets, from where the ringing calls to prayer sound out, derive from the bell towers of the Christian churches of Syria. Their existence in fact derives from a high Muslim tradition. Mohammed refers to the first muezzin – a black man called Bilal – whose duty was to summon the faithful of Medina. Sixteenth-century Turkish miniatures show Bilal performing this office from the top of the *Kaaba* in Mecca. In Omayyad mosques, for example at Damascus, the corner towers of the ancient temenos – which had been fortified during the Romano-Byzantine period – were used as minarets. But the Arabs did not wait long before building their own towers: the one at the Mosque of Kairouan (836) seems to be inspired by the formula used in the Hellenistic period for the lighthouse in Alexandria. The Seljuks of Persia refined the proportions of the minarets, building high, often round towers, using brick. At Aleppo and in Anatolia, the Seljuks of Rum built similar high towers, but in stone, and with a square section.

In Cairo, at Ibn Tulun, the present helical minaret would appear to be a copy in stone of an earlier version in brick, which in turn was derived from the models of Abu Dolaf and Samarra (the Malawiya), inspired by Babylonian ziggurats. At the time of the Fatimids, the high octagonal minarets of the Mosque of al-Hakim crowned towers fortified in brick. Their surface was lightened with stalactite decoration, and the top was surmounted with a bulbous cover. The Mamluk epoch saw a veritable forest of minarets of great elegance spring up in Cairo. While it may be true that the minaret of Kalaoun is still earthbound, with its two square sections below a round top section, that of Mohammed el-Nasir, constructed in brick with its very refined ornamentation cut into the stucco has already started to soar. The use of faced stone

entailed technical advantages: minarets in several stacked sections, divided up by balconies decorated with stalactites, achieved a remarkable degree of refinement, and a boldness only surpassed by the Ottomans. The minarets of the buildings constructed by the Circassian Dynasty, from Barkuk onwards, stand like arrows against the sky. The harmony of their proportions and the subtlety of their decoration is masterful. A great many, however, have been shaken by earthquakes and have required restoration, at least when the decision was taken not to demolish them, despite the risk to which they put the inhabitants. Stacking square bases under octagonal or cylindrical middle levels, and placing a bulb-like cupola supported on a range of delicate columns at the summit, these Mamluk minarets provide a wonderful contrast to the waves of stone domes that stand out against the skyline of medieval Cairo.

Buildings within the fabric of the town The architecture of the Islamic world was as much an expression of the Sultans' desire for pomp and magnificence as it was of their will to make pious actions for the good of the community of believers.

The great and powerful most often chose to construct places for prayer, for Koranic instruction and for public good.

Mosques, religious schools (or *madrasa*s), monasteries and convents (or *khanka*s), hospitals and refuges (or *maristan*s), public baths (or *hammam*s), as well as primary schools with a public fountain (or *sebil-kuttab*), caravanserais (or *khan*s and *okella*), and even aqueducts all come into this category.

At the same time, desire for personal glory on the part of the sovereigns and their close circle found expression not only in the construction of palaces (or *serai*s), and of sumptuous tombs (or *turbe*s), but also in the fortresses (or *kasr*), and the enormous city walls required for defence purposes. In this, the Mamluk Dynasty of Cairo was no different from the other Muslim powers of the Middle Ages, in Persia, India, Turkey, in Andalusia as well as in the Maghreb.

In Mamluk architecture buildings combining several functions in a coherent whole are frequently found. A *madrasa* doubles as the local mosque, a public fountain flanks a primary school, a tomb is linked with a *madrasa* or with a *khanka*. These solutions can also often be found among the Seljuks and the Ottomans.

This forged iron grille guards the bays of the Mosque of Kigmas al-Ishaki, built between 1479 and 1483. Emphasis is given to function rather than ornamentation.

Facing page

Detail of the floral open-work arabesques decorating the door of the Mosque of el-Ashraf Barsbey (1423). The metal-work is also engraved with leaves and spirals, enlivening the symmetry of the motifs.

The interest in Mamluk monuments and their insertion into the urban context around them is partly derived from the decisions taken by the builders to solve the problem of erecting a building in the space available to them. A number of mosques, *madrasas* and tombs found places on the principal highways of the capital, often at the expense of earlier buildings. These older structures had to be removed to make way for the architectural reflection of the power and glory of the new regime. The architects were therefore required to deal with areas of land which posed particular problems. It was not always easy to install the required building into these frequently irregularly shaped parcels, especially when it was necessary to take account of the obligatory orientation of the *kibla* in structures intended for prayer. The *madrasas* and mosques have often only one facade giving onto a street, while the others are hemmed in against other buildings.

The ground plans were therefore tightly squeezed into the urban fabric. This was achieved either forcefully or harmoniously. Their peripheries could take on unexpected forms and their common walls often followed a zig-zag line. Within this type of parcel, resulting often from gifts, from unassignable pious foundations (see glossary: *wakf*), and from seizures, the various constituents, such as courtyards, *iwans* or tombs, struggle for better or worse to

attain a rigorous geometry in spite of a disorganised context. Obviously the ground-plan, and above all the aspect of a building, was influenced by these contingencies. Their effect can be noted in the Kalaoun group, in the *khanka* of Baibars II el-Gashenkir, and in the Barkuk *madrasa*. The situation was quite different for the creations erected on open land, such as the large number of tombs built in the Necropolis of Cairo. There, the architects could fully respect their symmetrical, orthogonal formulae for free-standing facades entirely surrounding the construction (as in the mausoleum constructed by Farag for Baruk, his father, in the western cemetery).

Halfway between these two formulae, a building such as the *madrasa* of Sultan Hasan, erected on a wide allotment at the foot of the Citadel of Cairo, conforms to the relatively untortuous line allowed by the land, but is none the less ruled by an area without either parallels or axes, apart from the projecting part of the tomb. The various currents of the four traditional schools of Koranic instruction manage to find their spaces in the four angles, between the arms of the cruciform courtyard, while access, behind a high, offset gateway, follows a twisting route. The planning problems of Mamluk buildings could be anything from slight to amongst the most difficult imaginable, depending on the topography and the

surrounding urban structures. A good deal of their interest and diversity derives from this: the architects were constantly called on to demonstrate a spirit of great innovation and adaptation if they were to satisfy the demands of their powerful employers.

Ornamentation The areas for decoration on the Mamluk monuments of Cairo were carefully chosen, in relation to the function of each part of the edifice. Essentially, the decorated areas are the gateway, the vestibule, the *mihrab*, the *minbar*, as well as the tomb and its covering, the dome, the minarets, the capitals on the columns, pillars and pilasters, and the lines of merlons making mock crenellations running along the top of the walls, etc. From this point of view Mamluk art conforms to medieval traditions. The same system was followed in Anatolia, Persia and the Maghreb. This decoration affects the principal elements of an architectural vocabulary based on solutions elaborated by the Roman-Byzantine world. But its contributions are the coherence of the motifs, and the abstract character of the ornamentation. The interest of Mamluk decoration depends on its well-judged use of repetitive rhythms, set up by the disposition of geometric elements. Large areas are left unadorned, with the plain surface of the ashlar alone to enliven the surface, while borders, tracery, friezes, lintel courses, niches, stalactites and rosettes are limited to precise zones of the construction. By creating these bare areas, contrasting with the ornamental sections, treated with generosity, the architect highlights the quality of the decoration. This restraint is one of the most attractive aspects of Mamluk art. The medieval architecture of Cairo is in this way similar to the architecture of the Seljuks of Rum, which also uses beautifully faced stone interspersed with areas of exuberant sculpture.

One characteristic that makes Egypt stand out from the Iran, Northern Africa and Spain of the time, is the rare use of earthenware. In Egypt the builders preferred to work the stone, by sculpting motifs and frameworks, and leaving visible the material over large architectural areas. The motifs worked in the stone itself, sculpted or encrusted (borders of white marble or red sandstone), the stalactite decorations carved in the mass of the stone, the intertwining tracery around the doors, all come together to highlight

Facing page:

Detail from a frieze of stalactites surmounting the street frontage of the Kigmas al-Ishaki Mosque. The rigorously geometric *mukarna*s stand out from a finely sculpted base.

Reaching ever higher, on the Kigmas al-Ishaki Mosque, the narrow minaret with double corbelled gallery ends in a graceful columned pavilion, surmounted by a dome and bulb. This is Circassian Mamluk art at its purest. Cairo's characteristic skyline is the result of just such elegant buildings as these.

precise points of the building, to give them greater architectural weight. Only arabesques and repetitive rhythms could find favour in the eyes of these decorators, who refused representations drawn from the living world.

When dealing with this abstract decoration, special attention should be given to the treatment of arch-stones and lintel courses, since these two areas fall between architectonic and ornamentation. The visible face of the arch-stones, often in red, black or white, contrasting colours which relate to the alternate courses of the structure of the wall, present a very complex cut profile. They can mimic the design of highly wrought scrolls, tenons and wedges. But this is, in fact, simply a polychrome panelling on top of a far simpler system of ordinary arch-stones. This technique features above doors and windows and around the arch of the *mihrab*. It gives a 'mannerist' quality to the ornamentation.

Marble panelling is also used to adorn the walls of the tomb, or the *kibla* wall containing the *mihrab*. The craftsmen installed this panelling on large orthogonal surfaces of the wall, succeeding thereby in creating a remarkably vigorous rhythm, enriching the proportions of the space treated. It is a technique derived directly from Rome and Byzantium, which gives a grandiose aspect to the rooms of the buildings intended for prayer and to funerary monuments. The most sacred areas of the monument are covered with iridescent panels of very sophisticated mosaic, mixing semi-precious stones, glass and mother-of-pearl together in strict and subtle rhythms. The artists who composed these motifs gave free rein to the geometric imagination stimulated by the Islamic condemnation of figurative images.

Two details of the cut and engraved bronze ornamentation on the gate to Kigmas al-Ishaki: the stellar network and the floral borders combine with the delicate script of the texts.

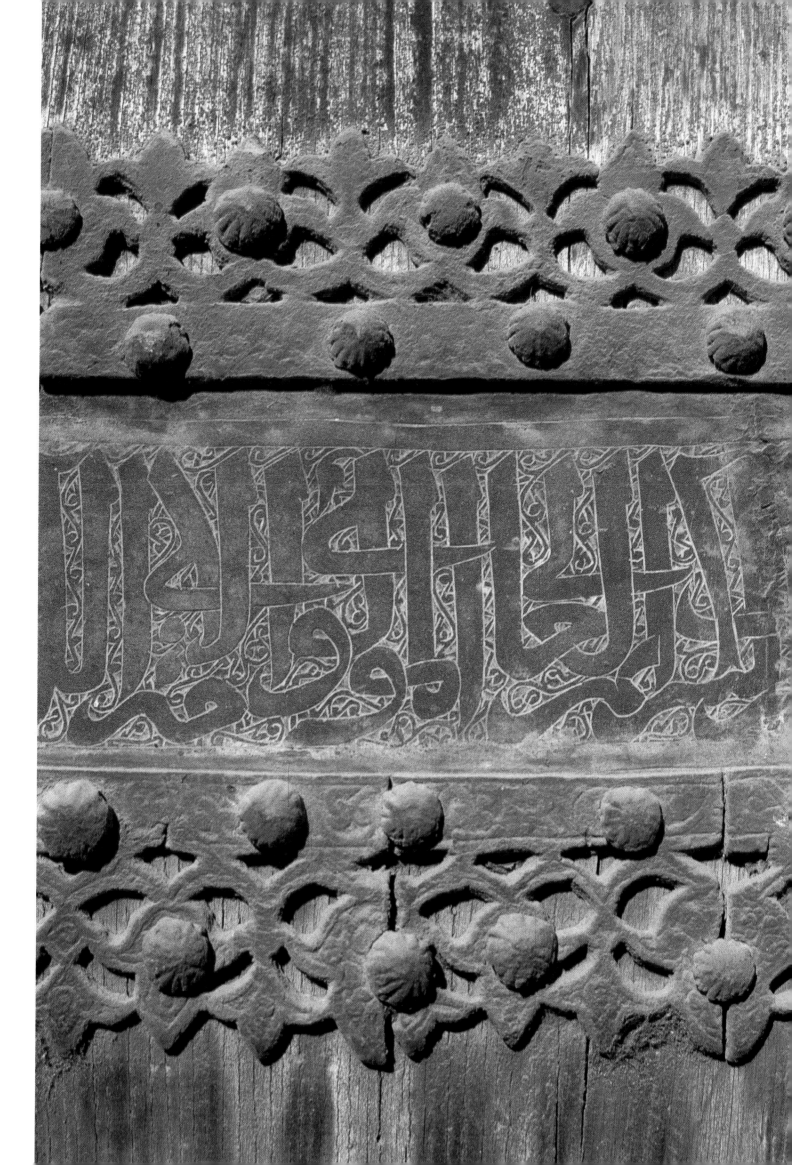

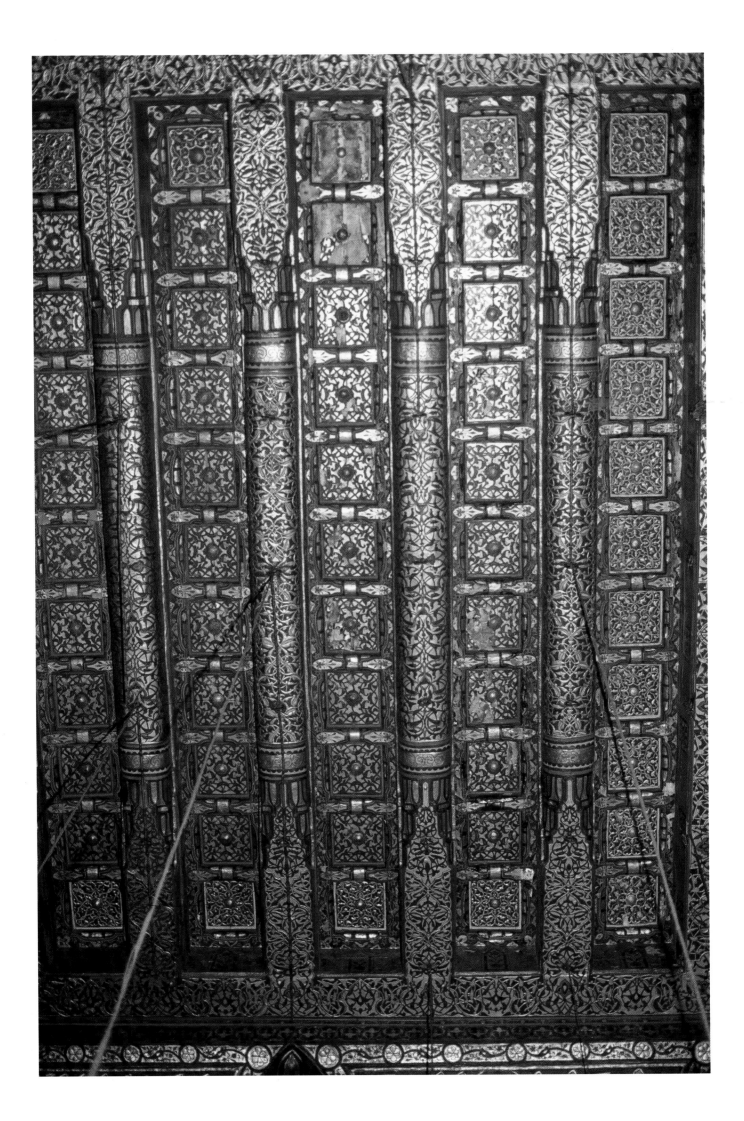

The large paved motifs so skilfully used on the floor surfaces relate to the magnificent treatment of the walls. They find their echo in the polychrome wood ceilings and the stalactite angles, both brightly coloured and gilded. These wooden *mukarna*s have a purely ornamental function: they imitate the decoration covering overhanging areas of stone and uniting the walls and the hemispherical domes. The effect created resembles great clusters of grapes hanging down, reducing till they disappear, seemingly absorbed into the walls.

The work on the wooden screens and the *minbar*s, heightened with fillets of ivory, ebony, mirror or mother-of-pearl, provides the finishing touch to this rich and sumptuous decoration. Finally, the monumental inscriptions in Islamic art add very specific elements to the buildings, because of the sacred nature of the texts. The bands of *nashki* or Kufic script around the *mihrab* or at frieze level, reproduce the verses of the Koran. Their religious importance is considerable. But the texts also have an historical value. In both cases, writing became essential in decoration. Arab characters of the most highly stylised and elegant forms run half way up the walls, on doors or around domes. Quotations from the Koran stand next to benedictions and texts commemorating the founder of the monument. Apart from the stonework carried out directly on the structure, mention should be made of the ornamental mosaic work around the *mihrab*, the ebony and mother-of-pearl inlaid work on the *minbar*s, the stained glass, in which coloured glass is set into plaster, the motifs carved in stucco, the polychrome paving, the marquetry or bronze doors, decorated with tracery or stars, glass and copper lamps, etc. To appreciate the atmosphere that emanates from all this decoration, you have also to take into account the prayer rugs, with their lively or sombre colours, the light filtering through coloured glass, the 'pointillist' effect achieved by illumination from many lamps, hanging in rooms or *iwan*s, as well as the furniture – the baldacchinos surmounting the tombs, the stands and cupboards for the Koran, etc.

The ceiling of the prayer room in the Kigmas al-Ishaki Mosque. A remarkable restoration has returned this coffered ceiling, with its gilded and polychrome motifs, to its original condition.

Double page overleaf

A side of the chair, or *minbar*, from the Kigmas al-Ishaki Mosque. This detail of a gorgeous Mamluk liturgical furnishing, in wood, decorated with ivory and mosaic, demonstrates the great geometric skill of the 'abstract art' proper to the world of Islam.

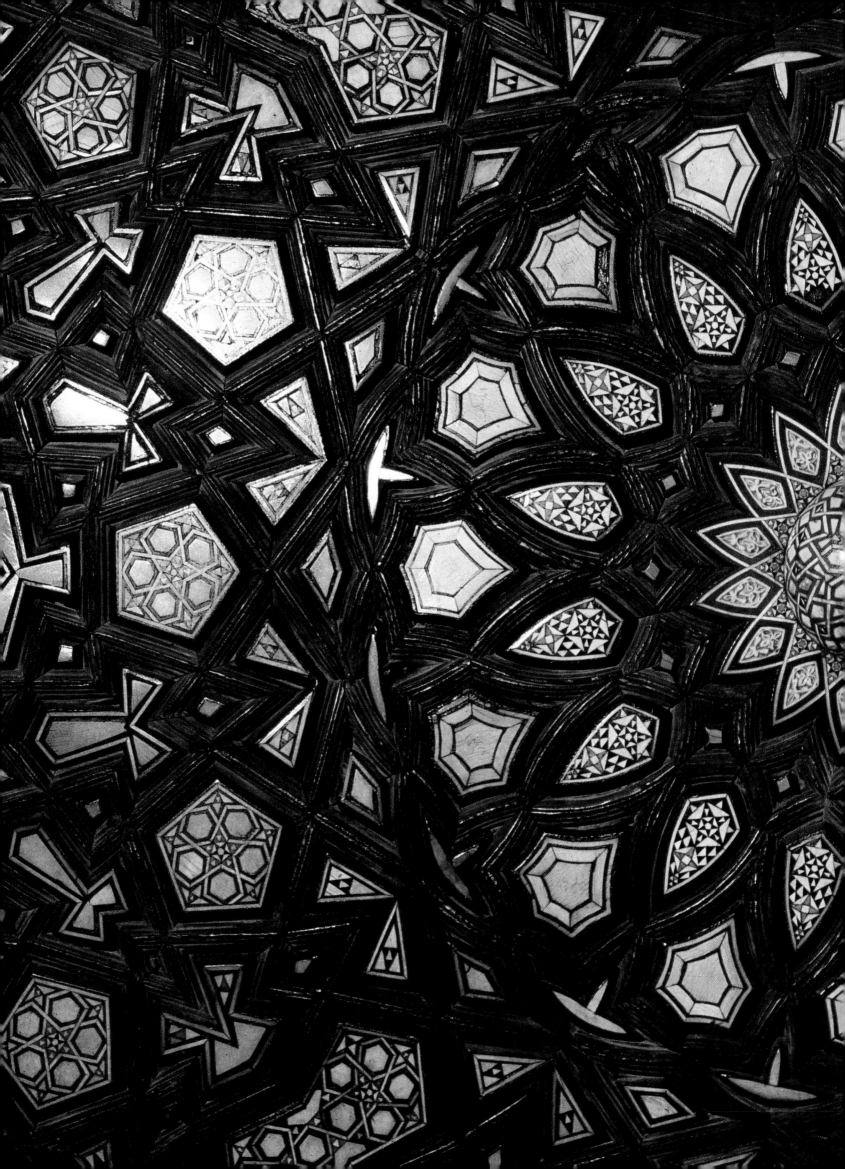

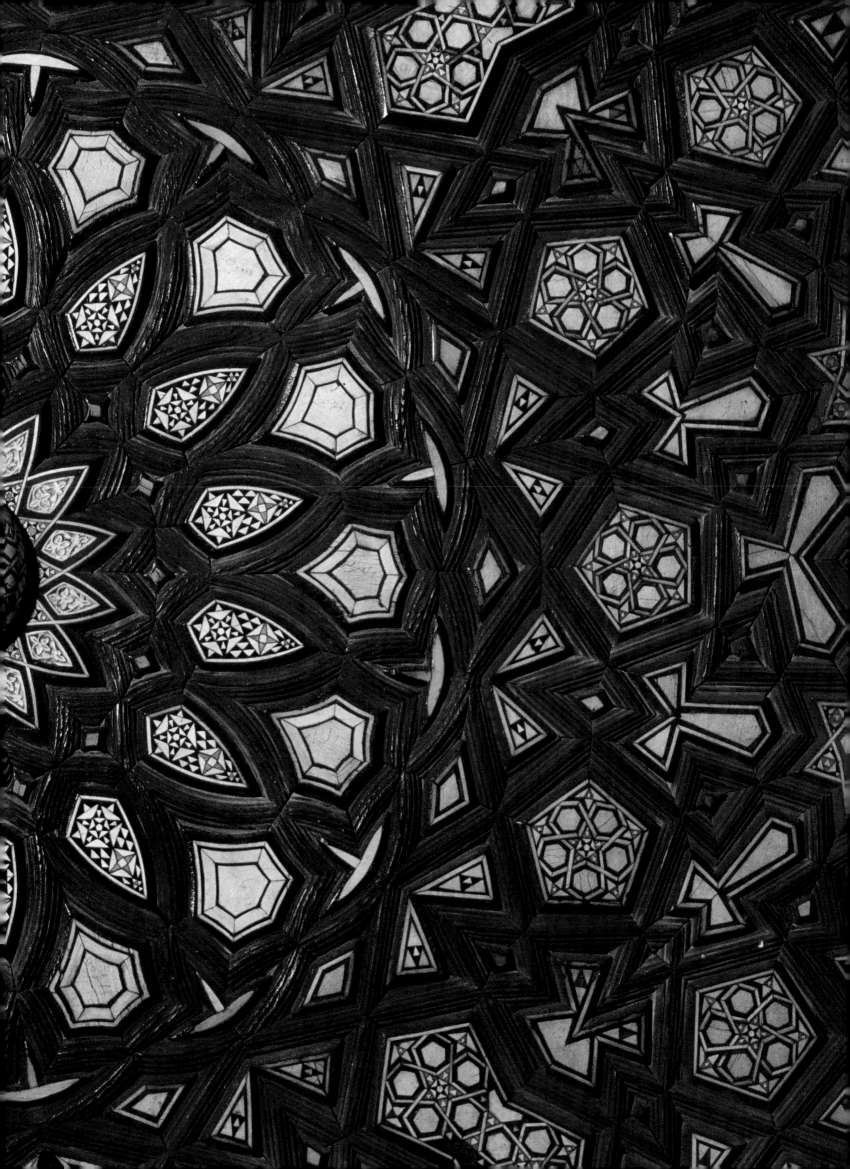

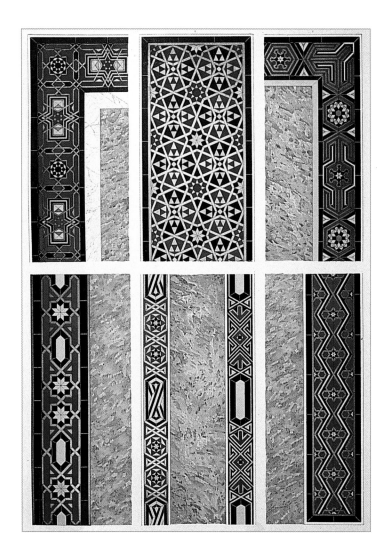

Noted by Prisse d'Avennes, these examples from the tomb of Barsbey (1438) illustrate the prodigious formal invention of ornamental mosaic in the art of the Circassian Sultans.

Facing page:

This other example of Mamluk inlay work shows the ease with which the craftsman who executed the chair of the Kigmas al-Ishaki Mosque, mastered penta- and heptagonal systems. The skilful assemblies of wood and ivory are visually fascinating.

The effect of the ornamental aspect is to counterbalance the often massive and powerful, high and mighty character of the constructions in stone and, by its refinement and delicacy, to humanise the spaces, adapting them marvellously for prayer and meditation.

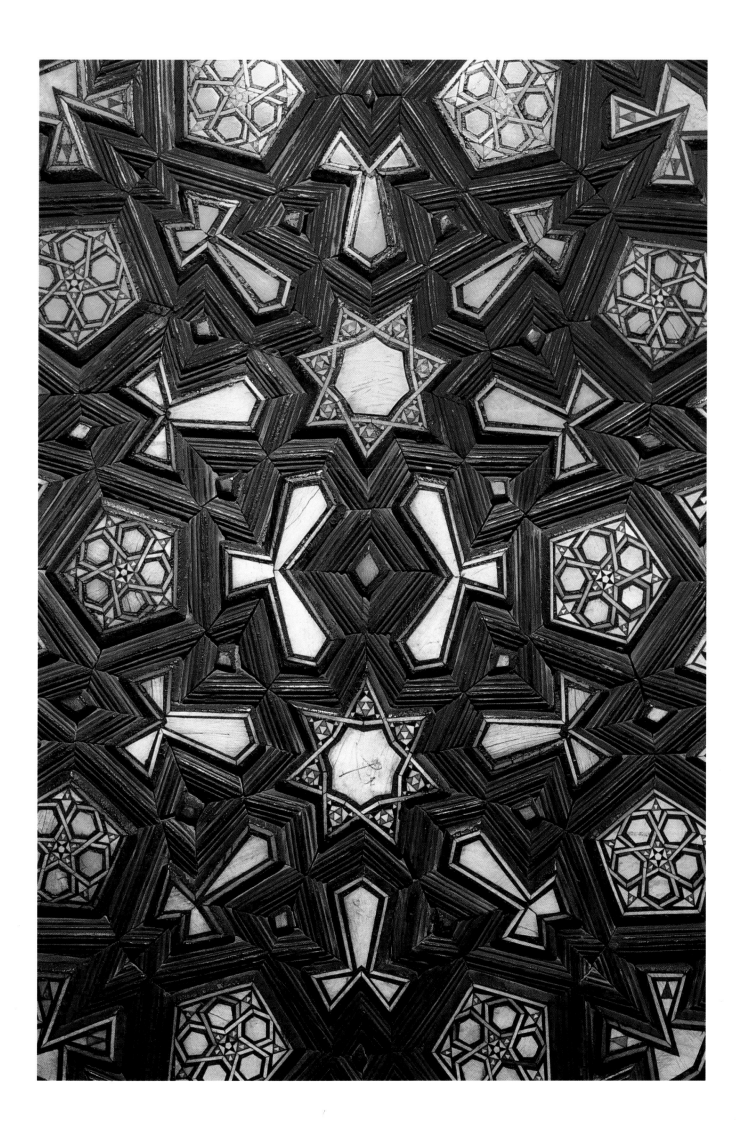

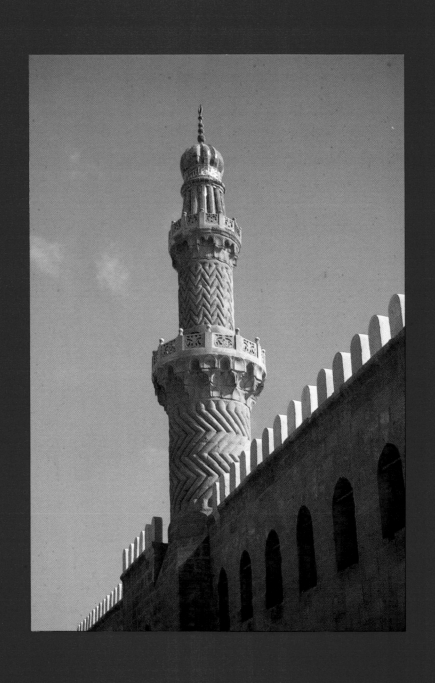

THE TOMB OF KALAOUN
AND THE MOSQUE
OF THE CITADEL

BAIBARS I constructed too few works in Cairo for any to have survived to our times. After his brilliant and eventful reign, the most significant of the Sultans from the early period of the Bahrid dynasty is unquestionably Kalaoun (1297–1290).

In his 11 years at the head of the Mamluk empire, he constructed 68 buildings (Meinecke), with 20 of them in Cairo. His principal work is the mausoleum he constructed for himself, lying on Avenue Muizz, on ground previously occupied by the Fatimid Palace. This is in fact nothing less than a major complex, which includes a *madrasa*, or Koranic school, a *maristan*, or hospital, and a minaret, aside from the Sultan's own magnificent domed tomb.

Work began in 1284. Three hundred prisoners of war participated in the construction. By 1286 the site structure was already finished, with the possible exception of the decoration of the tomb. The Mausoleum and the *madrasa* are fitted into an irregular parcel measuring about 4000 m²; the *maristan*, in a very ruined state today, covers a roughly equal area. The whole building was therefore an immense undertaking – it spreads over almost a hectare – and constitutes a true masterpiece: as such, it must have necessitated significant investment.

An architectural success The Kalaoun group immediately displays one of the characteristics peculiar to Mamluk architecture: the buildings are slotted into the fabric of the town. The building is not in fact an isolated monument, but a closely integrated component of the constructions at the city centre. While requiring a grandiose and magnificent effect, the Sultan nonetheless fitted his building into the surrounding urban context, although at the cost of the demolition of the earlier ruined buildings he was replacing. The facade of Kalaoun's complex highlights the close relation between Mamluk art and the religious edifices built by the Franks in the Holy Land. The bays giving onto the

The curious cylindrical minaret of the Mosque of Mohammed el-Nasir, erected from 1318 in the Citadel of Cairo. Its two cylindrical sections, decorated with sculpted chevrons, are developed both horizontally and vertically, separated by balconies underhung with rows of stalactites, showing the Irano-Anatolian influence of the Seljuks.

street all have pointed arches, some of which are columned double openings, surmounted by an *oeil-de-boeuf* oculus. This is clearly very similar to the layout of Gothic windows. These openings are sunken within deeply arched embrasures and are covered by a traceried screen, behind which polychrome glass is inserted into plaster (in place of the lead used in the Occident). Between these bays, the overhang of the wall is supported on rehabilitated antique pillars, set against the lower wall of the building. The purpose of these elements, which are brought forward, is to stiffen the construction. The crest of the facade is crowned with stepped merlons of the Achemenid type – a recurrent motif which is known as far away as Andalucia.

This totally asymmetrical frontage is the only visible part of the building; it gives onto the principal Cairo avenue. The facade covers two buildings – to the east, the mausoleum, and to the west, the *madrasa*. A built out arch covers the gateway about which the facade is balanced. This is decorated in black and white *ablak* decoration, and the door carries a remarkable covering of bronze, with particularly fine studded star motifs. The door opens onto a long corridor which separates the mausoleum from the *madrasa*. Strangely, it is necessary to follow this dark passageway to the end before reaching the tomb, on the right. Across a small columned courtyard, still on the right, is the tomb. Above its entrance the pointed arches of the window bays are decorated with finely sculpted stucco, and covered with stellar screenwork.

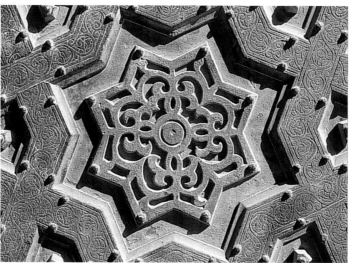

Three close-ups of the sumptuous bronze doors at the entrance to the mausoleum of Sultan Kalaoun, standing on Muizz Street. Incorporating cast, engraved and open-work elements, this door, produced around 1284–1294, shows the heights attained by bronze-workers at the time of the Bahrid Sultans. The geometry of hexagonal and octagonal forms is brilliantly controlled.

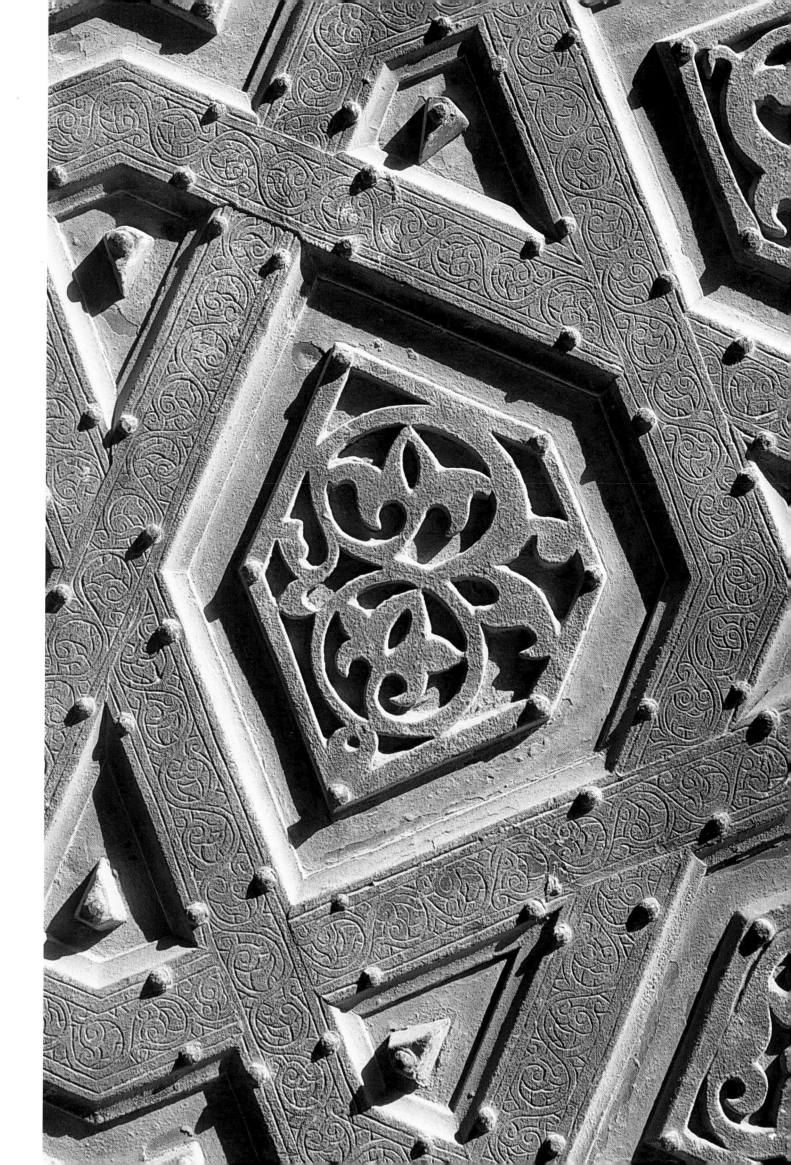

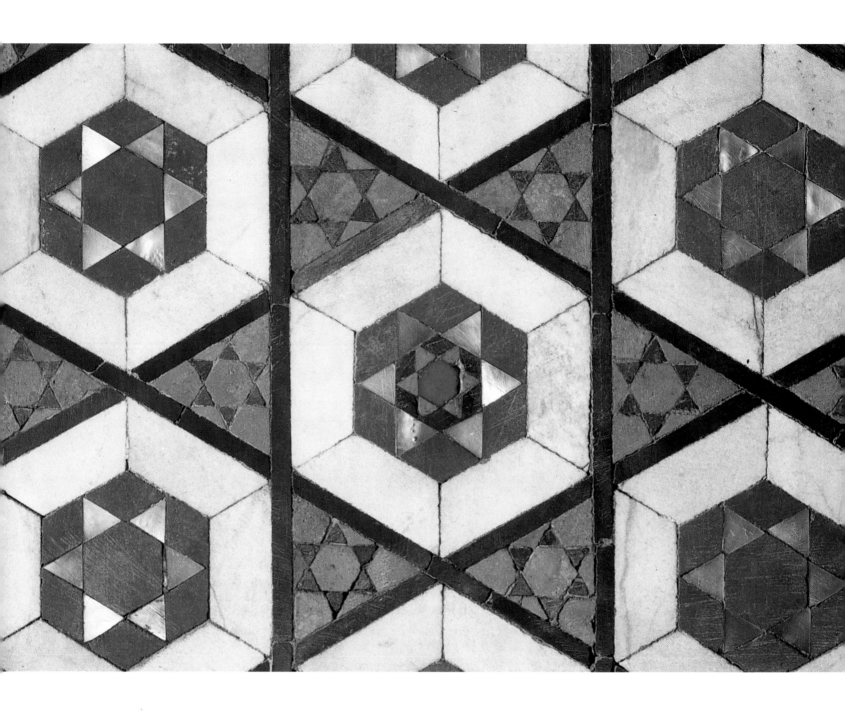

The holy of holies of the Kalaoun tomb is decorated with magnificent mosaics. The motifs, in this instance hexagonal, unite mother-of-pearl with coloured stones.

Plan of the tomb and *madrasa* of Kalaoun.
1. the entrance corridor.
2. the small courtyard preceding the octagonal mausoleum.
3. On the west side of the corridor, the *madrasa* and courtyard.
4. The central fountain.
5. The double arcaded prayer room. The very ruined hospital, or *maristan* would appear at the bottom of the plan.

Whoever entered this tomb would find the obscurity striking. In a space measuring 22 square metres, two pairs of enormous red granite columns (rehabilitated antiques) can be discerned, corresponding, at the sides, to two pairs of solid pillars, set round with smaller columns. These eight supports, disposed octagonally, hold up a drum on wide, raised arches. The eight double windows around the drum are decorated with stucco, studded with coloured stained glass. A brick cupola, 12 metres in diameter, surmounts the catafalque. This dome was erected in 1903, since the original roof had collapsed in 1776. It is part of a serious restoration which respected the essence of the building. This original plan, with its central cupola supported by an octagonal system, sets out an ambulatory, with a coffered wood ceiling which runs around the catafalque, which is in turn surrounded by wooden screens (*mucharabiehs*). This made it possible to carry out the ritual of circumambulation proper to Islamic mausolea. The presence of the central octagon is an allusion to the venerable Dome of the Rock, in Jerusalem, which inspired a number of Muslim tombs. The interior of the building is magnificently decorated. The walls are covered with fine coloured geometric mosaics and gilded inscriptions. Gold is everywhere present: it heightens the screenwork, the antique capitals, the coffered wood ceilings, and so on. And the darkness, transpierced with rays of coloured light falling from

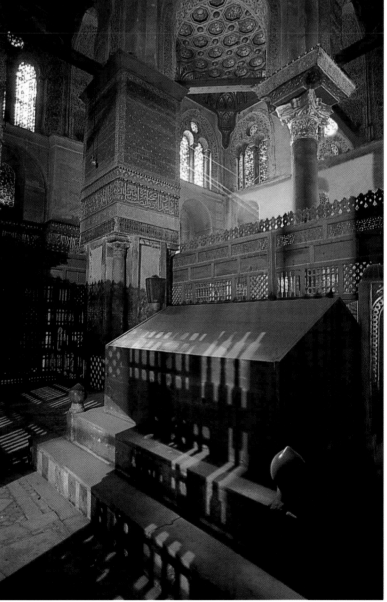

the stained glass windows, creates an atmosphere of contemplation and richness. This tomb, not dissimilar to a Christian shrine in the Gothic style, is one of the finest examples of late thirteenth-century architecture in Cairo. The *madrasa* on the left-hand side of the entry corridor is in too dilapidated a state to highlight anything but the spatial formula of the prayer room. This room pre-empts, one century earlier, the type of neighbouring *madrasa* that Sultan Barkuk was to build, also in Muizz Street. Opening through arches into the central courtyard, the space containing the *mihrab* is made up of three naves divided by two arcades perpendicular to the *kibla*. Six antique columns support these two porticoes. Great masonry pillars take the thrust on the courtyard wall. The central bay is in turn subdivided into three openings by two small columns. On the far side of the courtyard, a large *iwan* prefigures the formula of the cruciform *madrasa* of Persian origin. However, the lateral *iwan*s are still small and asymmetrical. Finally, at the bottom of the entry corridor, the hospital, or *maristan*, makes use of wall conserved from the Fatimid palace (966). The remaining buildings are grouped around a courtyard bordered with porticoes, in which the doctors gave their consultations. Thus, the hospital follows a cruciform plan, a system probably contemporary with that at Lashkari Bazaar, in Afghanistan, with which the Fatimid residence had a certain amount in common.

Interior of the tomb of Kalaoun, with the funeral chamber, intended for the ritual of circumambulation, and, at the centre, the catafalque of the Sultan, surrounded by wooden screens. Above is a high octagonal cupola.

Double page, following:

The vigour and refinement of the bronze door to the tomb of Kalaoun demonstrates the authority of the Mamluk style in the applied arts. Various techniques are used together to complete this wonderful door.

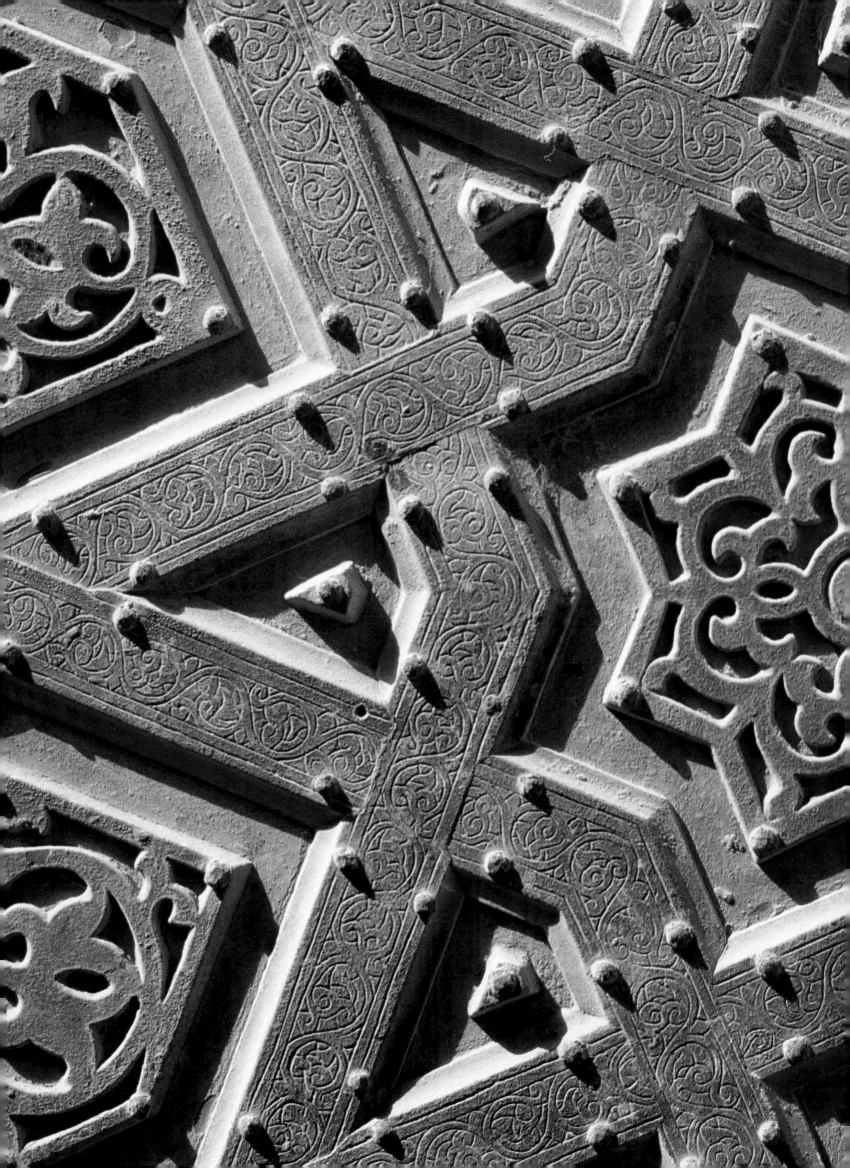

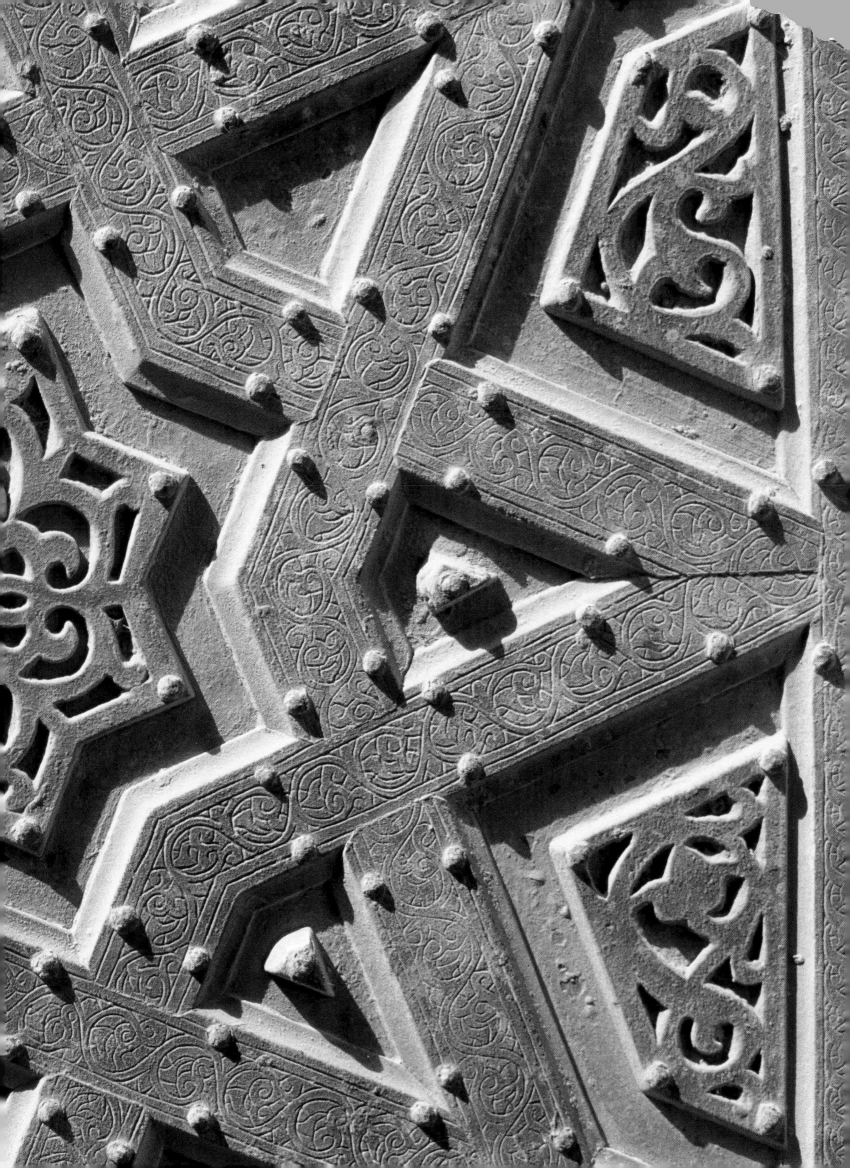

الشراب في اعلى الخزانة
وعليه ﮐﻪ فمن الواضح انه
متى ملئت الخزانة نشرا
فانه يقطر الى الكفة فتمتلئ
في مدة ثمن ساعة و تفرغ
ما فيها الى الحوض الكفة
فينصب دفعة واحدة الى
قدح زجاج و ﻛﻒ الجارية
فيثقل القدح و يرفع عطفه
القضيب من السفود فتجري
الجارية و تدفع المصراع
الايسر بيدها اليسرى
و فيها المنديل فينفتح المصراع
الايمن و لا يأس القدح
و تقف بحالها في اخذ للملك
القدح من يدها و يشرب
ما فيه و ان شارب مسح فاه
بالمنديل ثم يضع القدح في
يدها و يحطها الى اسفل
و يدفع الجارية بوثق الى
يمنها اما نع و يرفع يد عملها

Page from a Mamluk manuscript
dating from 1315 of al-Gazari's
treatise on mechanical inventions,
composed c.1200. The picture
shows an automaton – a young
girl mounted on wheels – offering
a glass of wine to the sovereign.
Height: 31 centimetres (al-Sabah
Collection, Kuwait.)

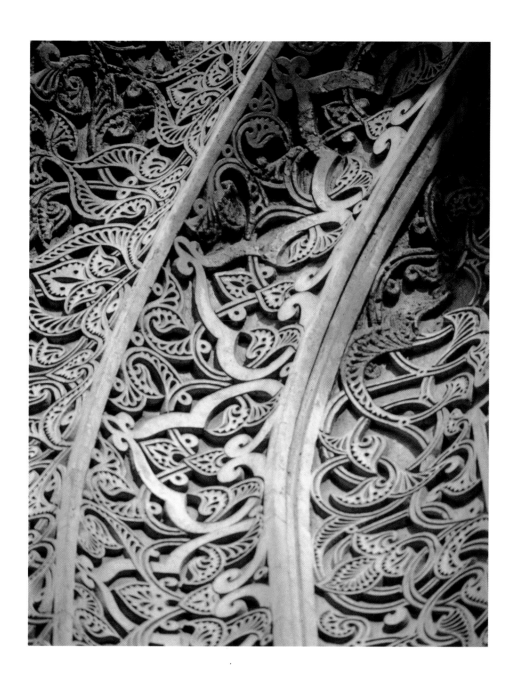

Muizz Street front of the
Mausoleum of Kalaoun; its double
windows under triple arches and
its stained glass set into stucco
suggest a Gothic influence.
Stepped merlons of Achemenid
origin cut into the sky.

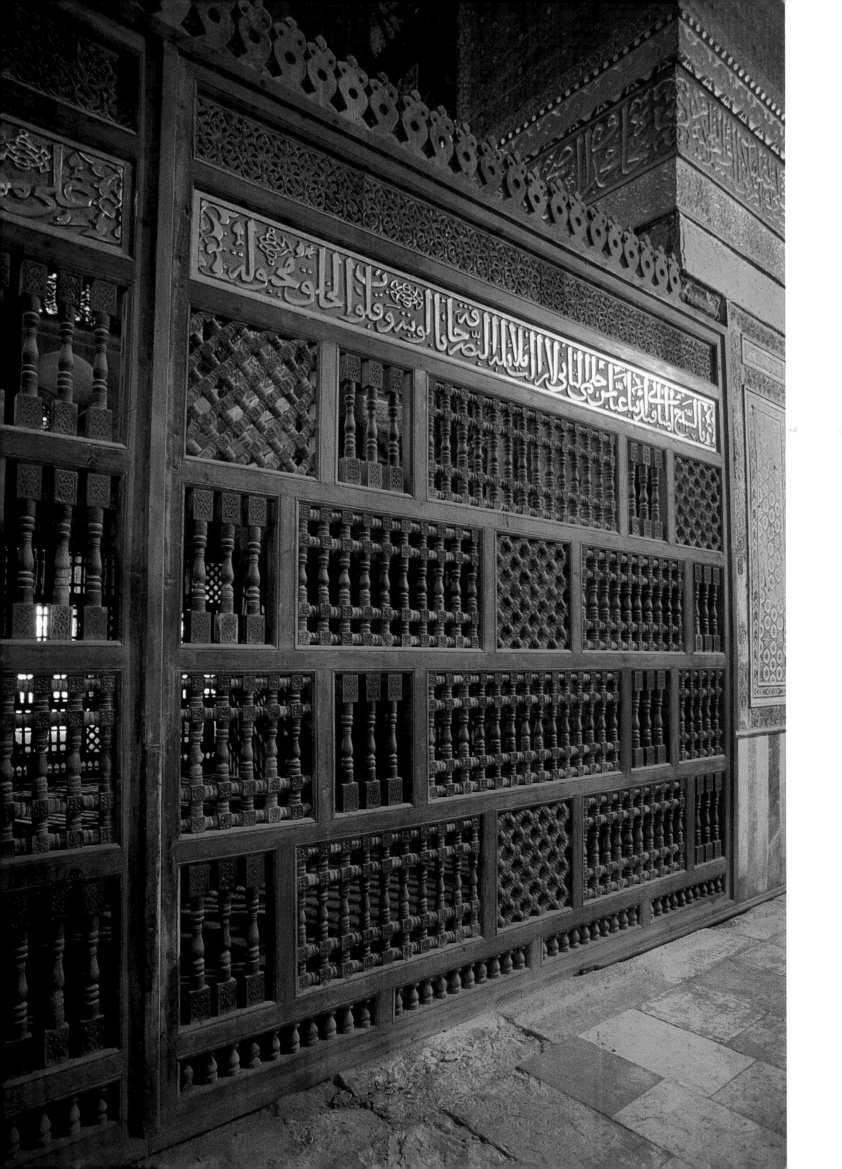

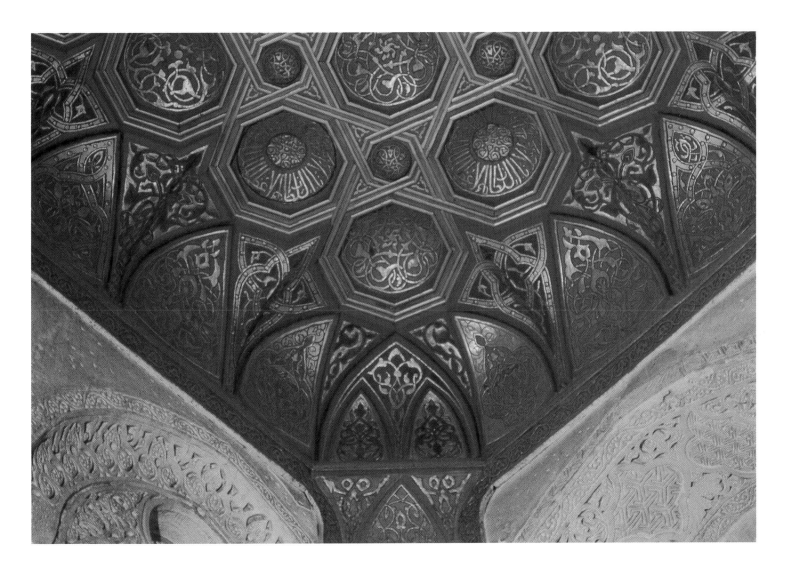

Facing page:

In the contemplative atmosphere of the mausoleum of Kalaoun, the tomb itself is surrounded by an enclosure of wooden screens, surmounted by a gilded inscription. The epigraphic elements alternate historical texts with verses from the Koran.

The work of Mohammed el-Nasir The reign of Kalaoun's son, Ashraf Khalil, was a short one (1290–1293). It ended with the assassination of the Sultan, plunging the country into a period of instability. His successor, Kalaoun's son as well, Mohammed el-Nasir, also known as el-Nasir Mohammed, was to have an eventful destiny, already outlined earlier, typical of the Mamluk court. In the total 42 years of his three reigns, 535 buildings were constructed, with 230 of them at Cairo. The Mohammed el-Nasir epoch represents the apogee of Bahrid Mamluk art. From all the works, perhaps the most important are the *madrasa* called el-Nasiriya, built on Muizz Street, next to Kalaoun's tomb, and the great mosque erected within the Saladin enclosure in the Citadel.

The first of these has a complicated history. Shortly after his second accession to the throne, Mohammed el-Nasir gave the order to complete, between 1299 and 1304, the construction of a *madrasa* begun shortly before by Adil Katbugha. As an entrance, he had erected a stone doorway from the Gothic cathedral of

The wooden ceiling above the Kalaoun funerary room is made up of rich octagonal coffering. Some of the coffers have stylised inscriptions. The work is a clear expression to the glory of a thirteenth-century Sultan.

Saint-Jean-d'Acre. This trophy commemorated Sultan Ashraf Khalil's victorious siege of the town. Dismantled stone by stone, this doorway was perfectly reconstructed in Cairo, in the middle of the facade of the el-Nasiriya college. With its ogival tympanum and its capitals, this typically western monument was positioned on Cairo's most populous street, to recall the victory of the Muslims over the Christians (see page 88).

Inside, on the left, and unfortunately in a very ruined state, is the first *madrasa* with four *iwan*s in a cruciform plan, designed with the four rites in mind. It is a large building, 50 metres long by 25 metres wide, laid out around a courtyard 23 metres long by 14 wide, after the manner of Iranian mosques. To the right of the entrance lies the mausoleum, its chamber measuring 9.30 square metres, surmounted by a cupola. This formula of a cubic tomb covered with a hemispherical dome alludes to the symbolism traditionally associating the image of the earth and the sky. The minaret, an octagon supported on a square section, with balconies underhung with rows of stalactites, has remarkable stucco decoration recently tastefully restored. Not far from the Mamluk palaces

Mamluk bottle, with highlights in coloured enamel, dating from the early fourteenth century. The inscription, between the two handles, glorifies the Sultan. The neck is decorated with a Phoenix, a symbol originating in Central Asia. Height: 29 centimetres. (al-Sabah Collection, Kuwait.)

Facing page:

Recently restored, the curious minaret of the *madrasa* of Sultan Mohammed el-Nasir, built between 1296 and 1303, dominates Muizz Street. It is embellished with a finely worked decoration in stucco.

Double page, following:

Detail of the abundant ornamentation on the minaret of the *madrasa* of Mohammed el-Nasir: the decorative motifs sculpted in the stucco are inspired by the Ayyubid repertoire: the rectilinear arches recall the small el-Akhmar mosque (1125).

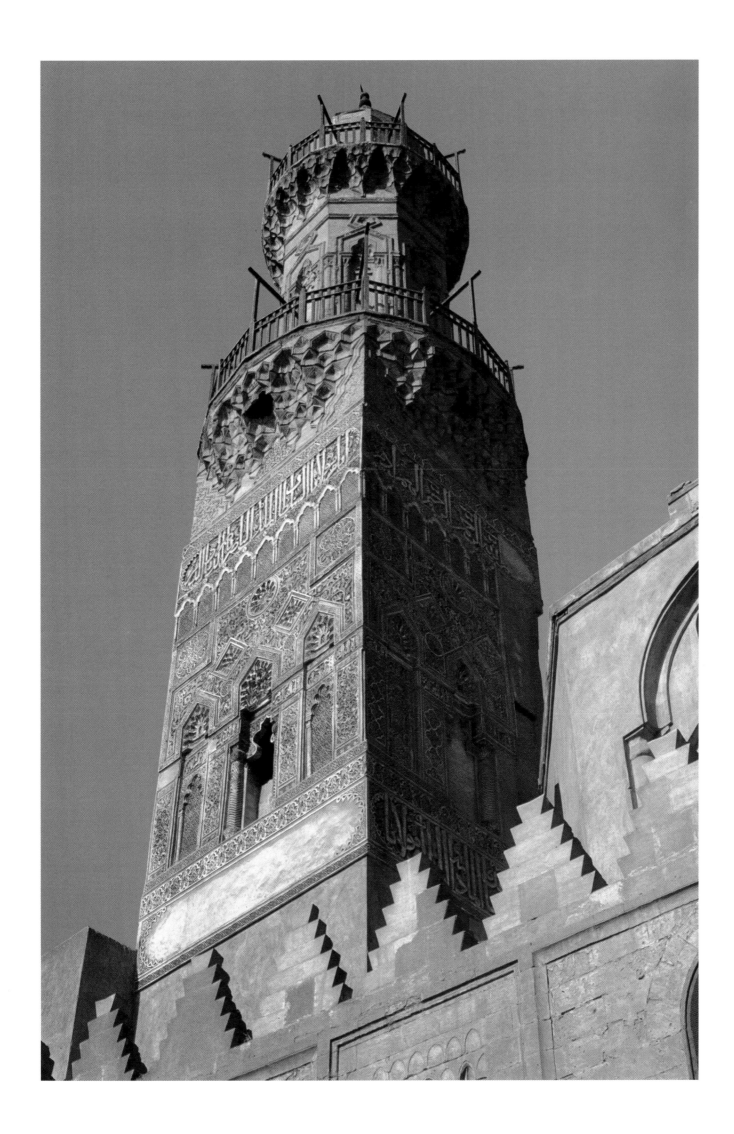

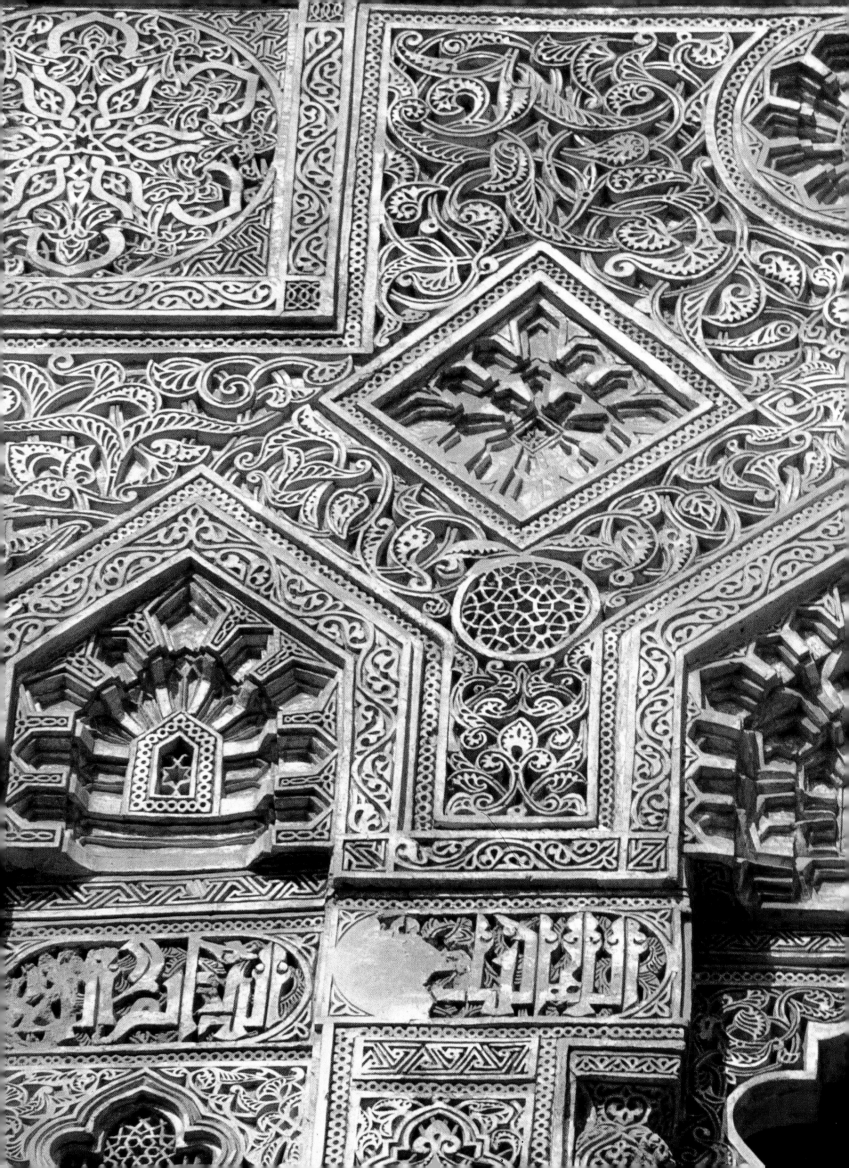

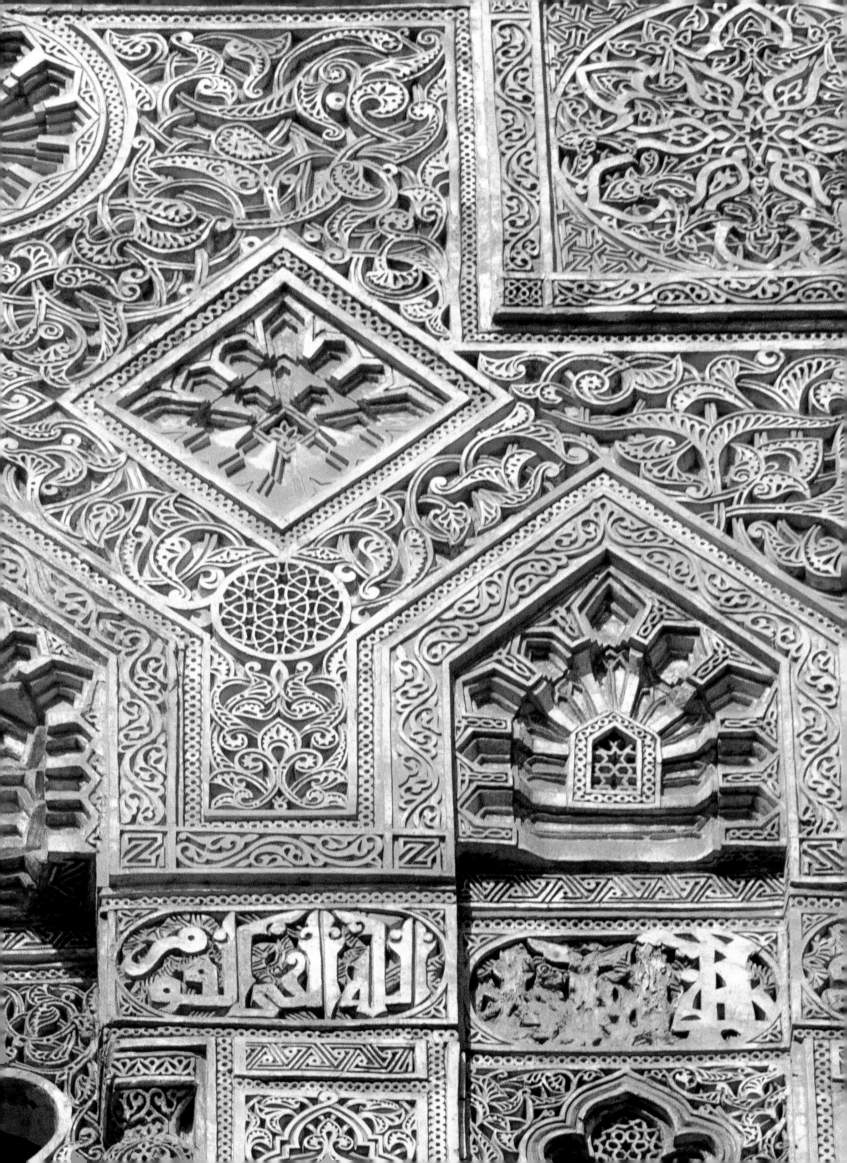

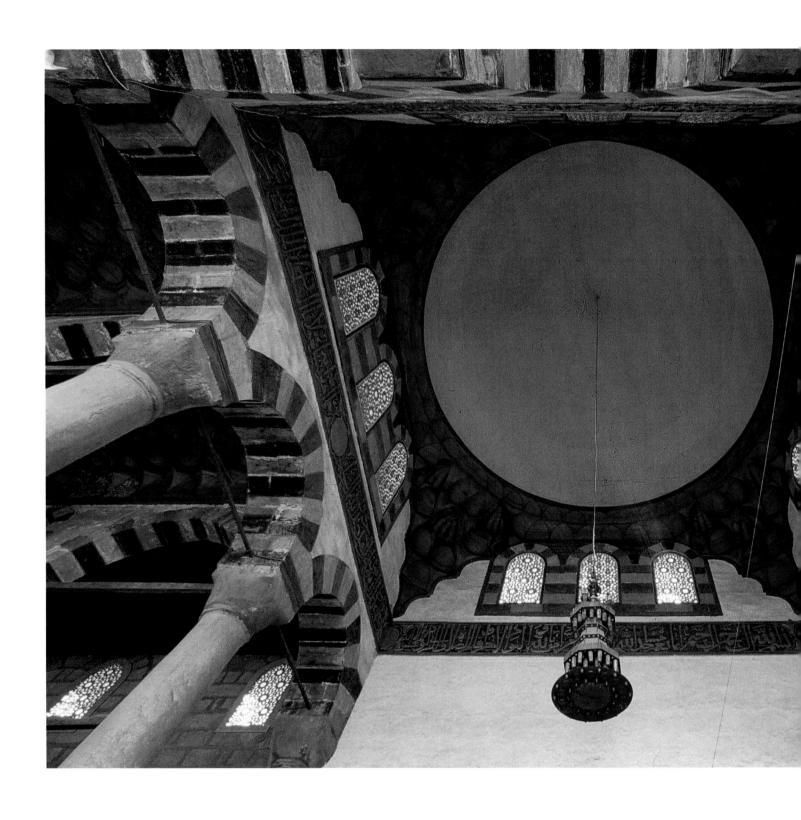

The mosque built 1334–1336 in the Citadel by Sultan el-Nasir during his third reign (1310–1341), was ruined at the beginning of the century but has now recovered its beautiful cupola with wooden pendentives, supported by powerful antique columns, bearing *ablak* arcades. The dome, over the *mihrab* niche, was one of Cairo's first domes to be covered on the outside with green ceramic, as in the Iranian tradition.

Plan of the Mosque of Mohammed el-Nasir, in the Citadel of Cairo: 1. Entries. 2. Courtyard. 3. Hypostyle room. Enclosed by high walls, with narrow openings, the stone building lines its courtyard with rows of porticoes.

Facing page:

Remarkably restored, the *mihrab* of the mosque of the Citadel vibrantly contrasts coloured marbles and includes metal and mother-of-pearl in the mosaic covering the sacred niche.

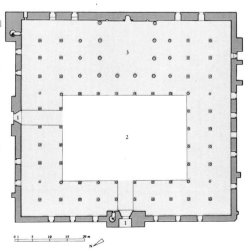

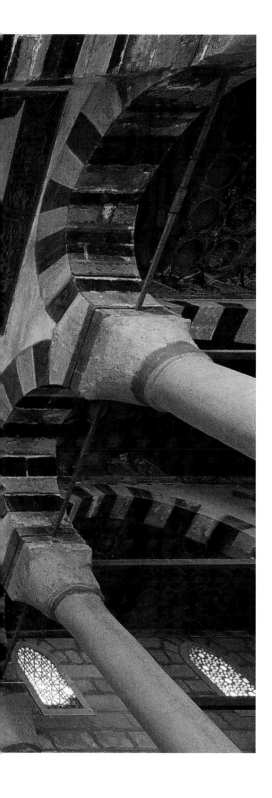

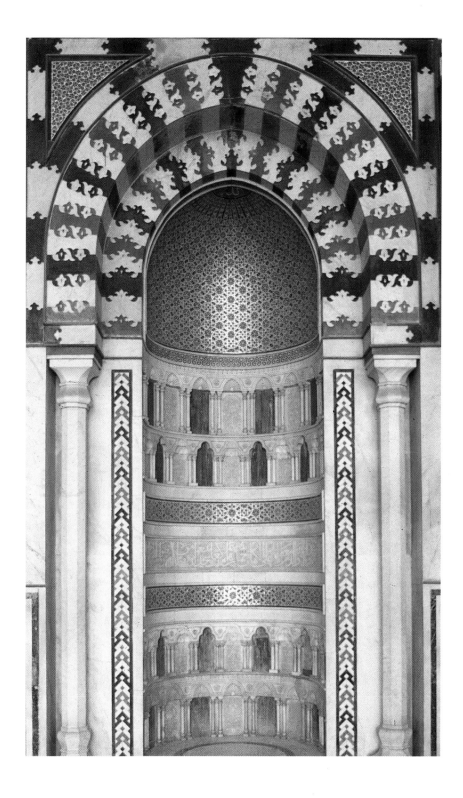

which have now disappeared from the Citadel, Mohammed el-Nasir constructed a great mosque. It was built in two stages, the first from 1318, and the second, repeating all the work it would seem, between 1334 and 1336. The building stood entirely free on all sides, so did not have to be fitted into existing urban surroundings; its high walls follow a rectangular plan, like a fortress. Apart from the gateways, only a series of high bays give rhythm to the vertical walls, surmounted by a cornice.

The inspiration comes from the principal mosques with courtyards of Fustat and Cairo, such as Amr, Ibn Tulun (876), el-Azhar (970), el-Hakim (990), and above all, Baibars I (1268). This imperial place of prayer covers a square space measuring 65 metres by 60, with a lopsided courtyard of 35 metres by 23. The *haram* is

made up of four arcades parallel to the *kibla*, punctuated with eleven arches on ten rehabilitated columns: a total of 54 monolithic shafts. In the middle of the *kibla*, the *mihrab* is surmounted by a large cupola measuring 15 metres across. Its drum, supported by ten heavy granite columns, has wooden pendentives carved with rows of stalactites. This structure, with its dome covered in blue-green ceramic of Persian origin, collapsed in 1531. It was reconstructed in 1935, while the octagonally coffered ceilings covering the porticoes were restored about 30 years ago.

A two-level system has been employed to construct the arcades: above the high pointed arches, their voussoirs alternately black and white, there are rows of small bays (at the height of the exterior windows).

This formula bears certain similarities to the porticoes of the Great Mosque at Damascus. All the supports are linked together by tie-beams, as they are at the mosque at Amr. It can be seen that Mamluk art, when confronted with a mosque of the type exemplified by the Friday Mosque, scarcely innovates at all. It remains respectful of tradition and adopts the same references. Originally, the interior walls of the mosque of Mohammed el-Nasir were gorgeously decorated: panels of coloured marble covered them to a height of over five metres. The *mihrab* was covered with magnificent mosaics in mother-of-pearl, glass and semi-precious stones. This decoration has been massively plundered. The mosaics to be seen there today have been reconstituted on the basis of what has remained intact.

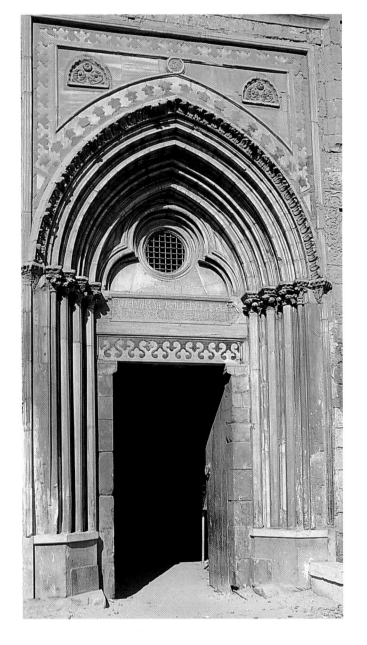

On Muizz Street, it is a surprise to come across this pure Gothic ogival doorway. It was the entry to the cathedral of Saint-Jean-d'Acre (Akka), carefully dismantled after the defeat of the Crusaders by the forces of el-Ashraf Khalil, son of Kalaoun. Mohammed el-Nasir had it re-erected in Cairo, at the entry to his *madrasa*, as a trophy marking the end of Crusades in the Holy Land.

In the monuments constructed
by Mohammed el-Nasir –
above – as in those by Kalaoun
– right – the decoration of
precious mosaics uses
coloured stones and mother-of-
pearl. In this way the walls of
the tombs and the *mihrab*s
constructed by the Bahrid
Mamluks glow with a lustre
designed to mirror the glory of
the slave-sultans.

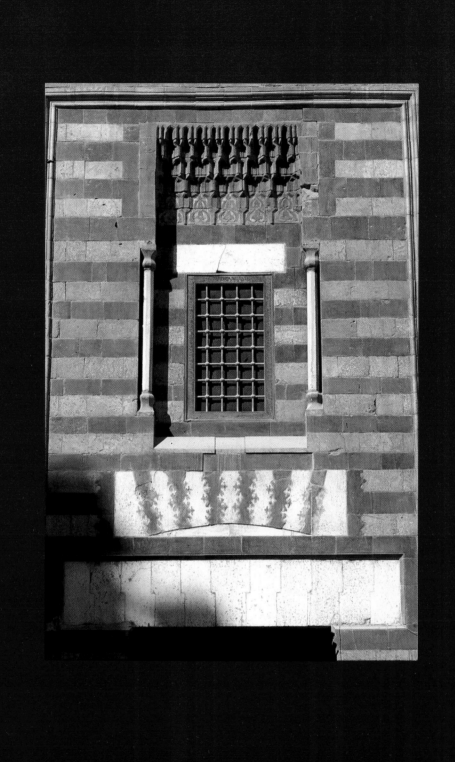

THE MADRASA
OF SULTAN HASAN

Decoration of a doorway
opening onto the courtyard with
four *iwans* in the *madrasa* of
Sultan Hasan, built between
1356 and 1361. Rigorous use of
ablak and alternate use of dark
and light layers of stone
characterises the work.
Octagonal marble columns and
a stalactite frieze surmount the
fret-worked voussoirs decorating
the bracing arch.

THERE IS no doubt that the *madrasa* of Sultan Hasan represents the summit of Mamluk architecture. It is the largest building undertaken during the reign of the slave-sultans, and the impression it gives of power and majesty does not depend merely on its exterior, on the high and mighty quality of its walls, but also on the perfection of the courtyard spaces, the high, elegant *iwans* of sober, restrained line. After a period of instability following the long reign of Mohammed el-Nasir, Malik Nasir Hasan, known as Sultan Hasan, the grandson of Kalaoun, was placed on the throne at the age of 12. He was deposed at 16, between 1347 and 1351, to make way for one of his brothers. He then returned to power three years later and removed Emir Sarghitmich, the power behind the throne in terms of the nominations and depositions of underage Sultans. However, he only maintained himself at the head of the empire for seven years (1354–1361), before falling from power in the face of a Mamluk uprising, ending in his assassination at the age of 26.

The divine fortress His reign, coming after the horrors of the great plague, nevertheless enabled him to realise, between 1356 and 1361, one of the most prestigious buildings of the Muslim Middle Ages – and this in a country ravaged by death and famine. The teams of builders took only three years to finish the main construction of this enormous building. Following on in the line of magnificent monuments created by the descendants of Kalaoun, Hasan provided Cairo with the last masterpiece of the Bahrid dynasty.

The architect who constructed this work for the young Sultan was probably of Syrian origin. It is the most finished example of a *madrasa* with four *iwans*, testifying to the influence of the Persia of the Ilkhanids. This formula of a building with a courtyard, supplying the Koranic school with the four teaching areas reserved for the Hanefite, Shafeite, Hanbalite and Malekite rites, translates into stone a cruciform schema from the Ghaznevid palaces and from Iranian mosques. In reality, the suitability of the four *iwans* traditional in Iranian architecture to the teaching of the four theological schools of Islam is simply the happy meeting of two four-based systems: in no case did a *madrasa* have four *iwans* specifically to

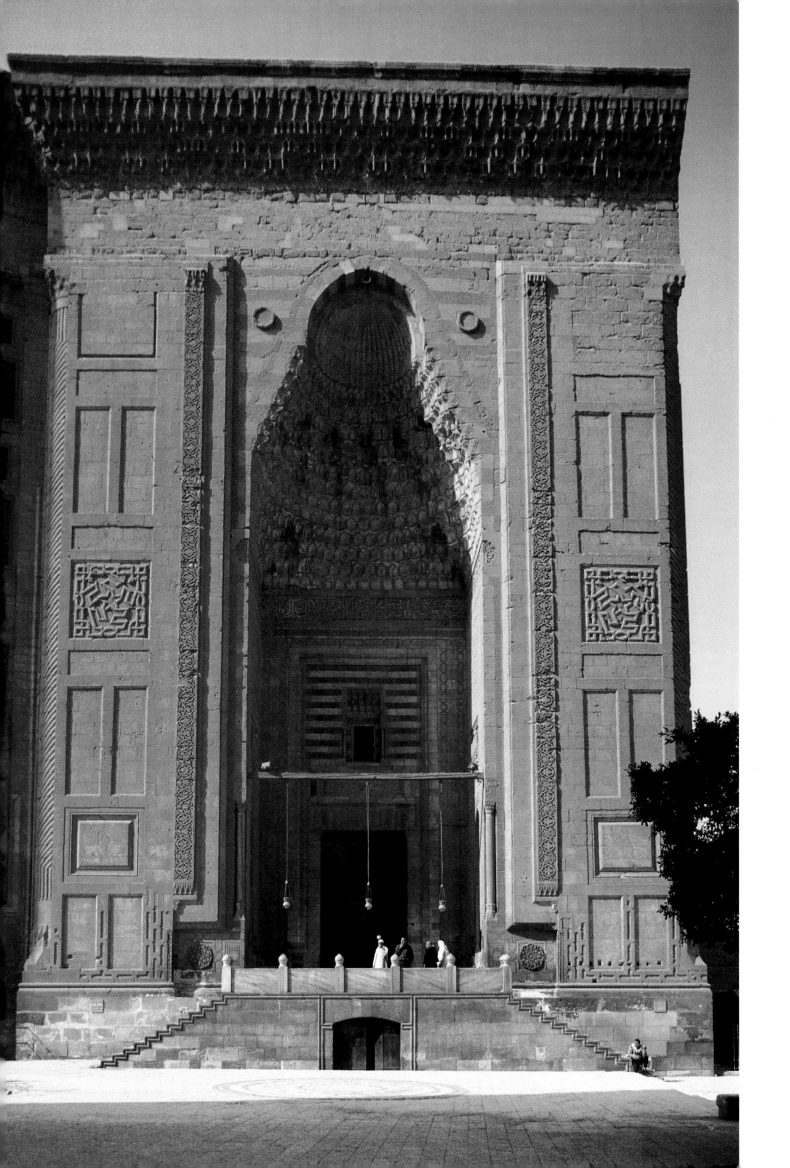

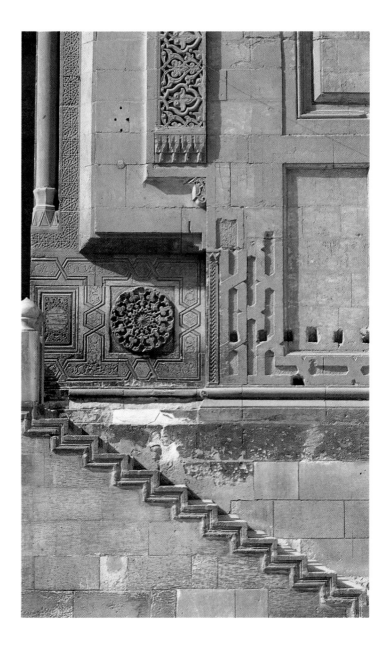

Facing page:

An entrance in the form of a Persian *pishtak,* 30 metres high, gives access to Sultan Hasan's *madrasa,* known as 'The Sumptuous *Madrasa'.* Framed by a facade surmounted by several rows of stalactites, the huge niche opens up. Its concave surface is covered, bee-hive fashion, by a fine tapestry of carved indentations.

Above:

The sculpted decoration at the entrance to Sultan Hasan's *madrasa* draws on the art of the Egyptian medieval stone-workers, and on Seljuk influences from Anatolia and Northern Syria.

answer to the quadruple needs of the teaching. It was more a mat-ter of a coincidence between the Persian architectural form and the various traditions of Muslim thinking, during the great return of Sunnism, following 260 years of Shiite power under the Fatimids of Egypt and North Africa.

The Seljuk Turks brought the Iranian ground-plan with them, and it was quickly adopted throughout the Near East, with the rise in the Sunnite doctrine. The *madrasa* began to play a critical role in controlling the various peoples. In a civilisation based on the Koran, it is quite logical that religious schools should impose their monolithic vision, in particular when dealing with social and legal problems. Mohammed's message was as legal as it was religious. There was no dichotomy between faith and law, between ethics and justice. From this time on, the *madrasa* grouped together all the sages and scholars, the religious and the doctors of law. It occupied a place of eminence in the city, both from the moral and political point of view.

Double page overleaf:

Roof of the magnificent entry vestibule behind the doorway to Sultan Hasan's *madrasa:* a ceiling of pendant keystone stalactites decorates the niche below the cupola covering the space.

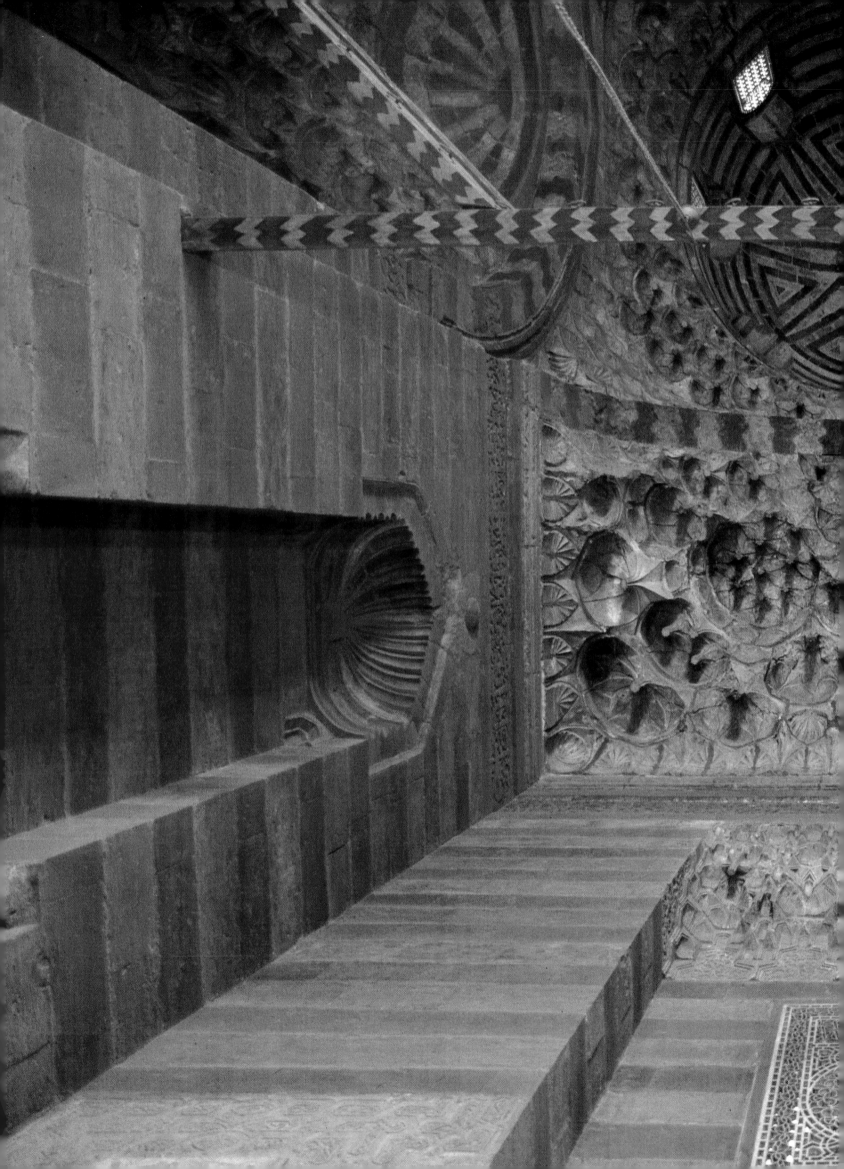

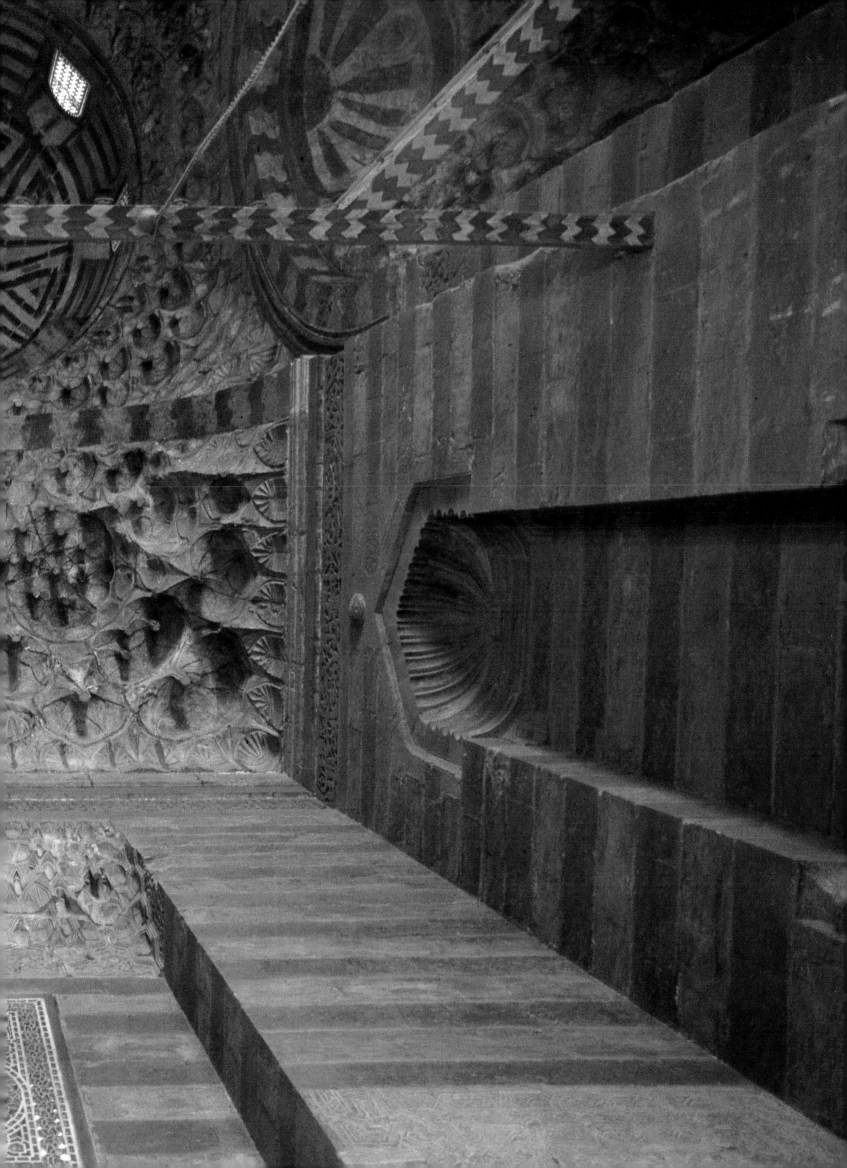

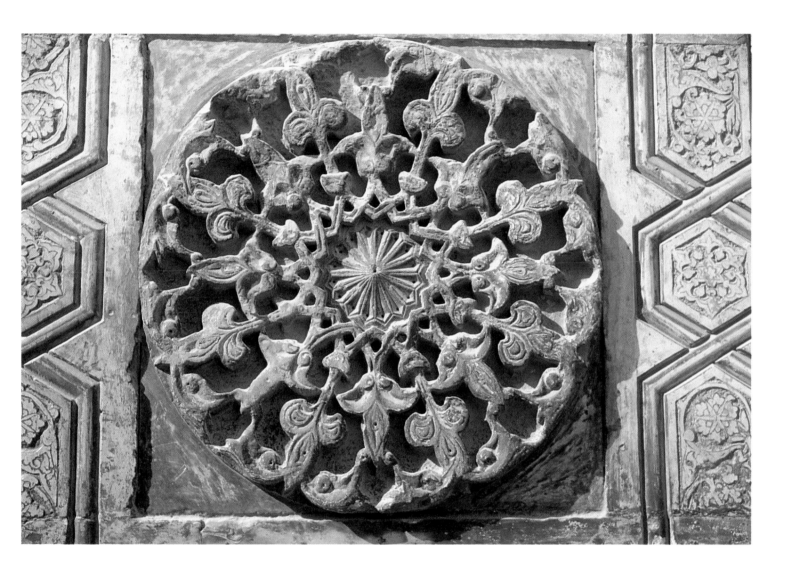

Two close-ups of the sculpted decoration from the entrance to Sultan Hasan: *facing page:* a system of intertwining straps, redolent of basket-work; *above:* a disc with floral motifs, suggesting an Anatolian influence.

Sultan Hasan's *madrasa* was designed for some 400 students, thus qualifying as a genuine 'fortress of faith', quite in line with the monumental aspect of its architecture. The school was intended to be for aspiring sufis, the soldiers of Muslim thought, but it also served as a citadel where the rebellious population took refuge during the numerous uprisings that ran through Cairo. With its crenellations at the top of high walls, its comparatively small door set into the enormous stalactite-decorated entrance (*pishtak*), with its narrow, hoop-like windows stacked one above the other for eight levels, and its high walls rising to 38 metres, with no apparent buttressing except for some lesenes in between the sunken windows, Sultan Hasan is indeed the Islamic stronghold in Cairo. Jurisprudence was forged there, judgements passed on acts and ideas, principles set forth and tradition interpreted.

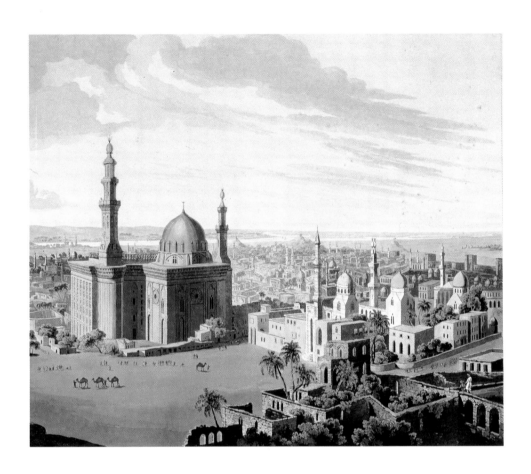

Entitled *View of Cairo*, this watercolour by Henry Salt, executed in 1820, represents the *madrasa* of Sultan Hasan seen from the Citadel. The edifice was completely isolated until the construction of the el-Rifai mosque, a pastiche begun by Khedive Ismail, who ruled Egypt from 1867 to 1879. The later monument, today facing the grandiose Mamluk *madrasa*, was only completed in 1912.

An island site At the foot of the 'Mountain' on which the Citadel of Saladin is built, where the Mamluk Sultans constructed their glorious palace, but situated between the walls of Cairo and Fustat, the *madrasa* of Sultan Hasan rises from open land. The building is not inserted between existing structures and, with the exception of its north front, its monumental elevations stand free. But the site chosen was irregular, and had no parallel sides. The 150 by 68 metre area is out of true. The architect had therefore to deal with a problem similar to that of working amongst existing structures, if his building was to have a rigorous and coherent aspect within the irregular limits of the land.

At the northern corner of the west elevation, he placed the grand entrance, in the form of an Iranian *pishtak*. The high niche of stalactites is framed by the facade. Once inside the door, the visitor is in a cruciform vestibule, with a cupola covered with pendentive *mukurna*s sculpted in stone. Directly to the left there is a winding passageway leading to the courtyard. After the dark and narrow access corridor, the light bursts gloriously into this great open-air well, contained between the four *iwan*s around the domed central fountain.

Facing page:

The cruciform courtyard at the heart of the *madrasa* of Sultan Hasan. Around a central fountain covered by a dome, rise the enormous pointed vaults of the *iwan*s, reaching up 26 metres – the height of an eight-storey building. The centripetal space lends itself to the teaching of the four theological schools of Islam.

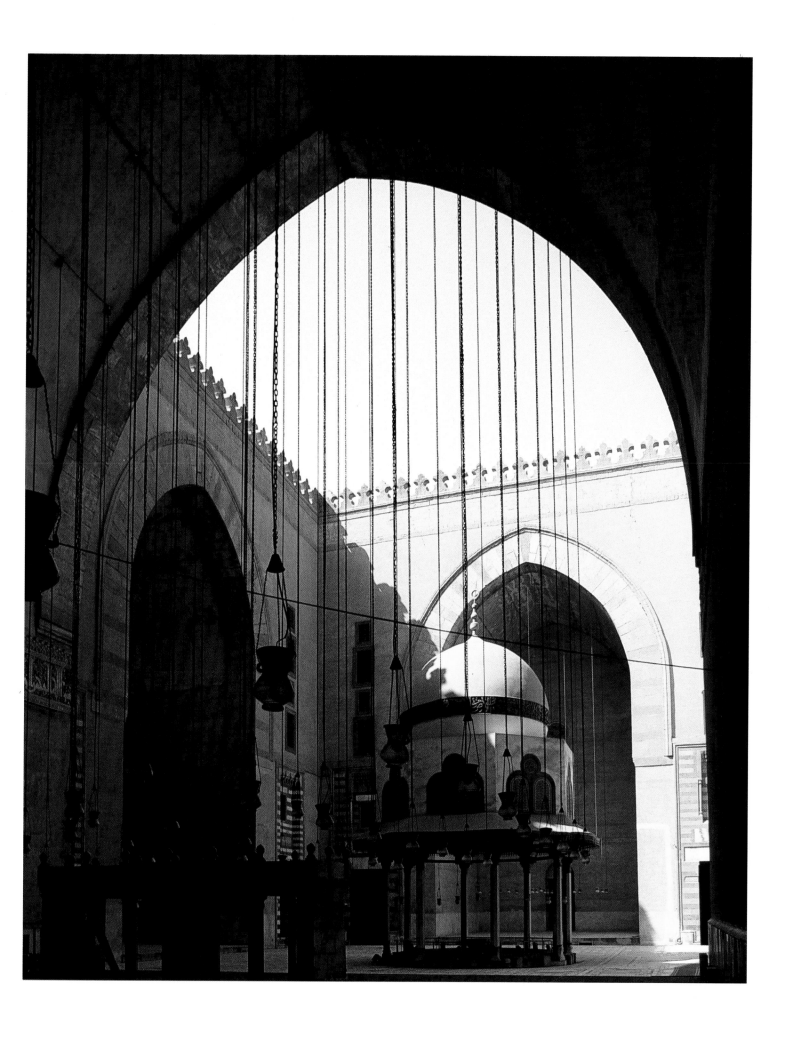

This central courtyard, measuring 35 metres by 32 metres, is at the centre of the architect's organisation of the building. He installed the cruciform system of the *madrasa* on the more or less pentagonal parcel of land. His aim was to give the largest proportions possible to the four *iwan*s; those to the east, west and north are equal, while the southern, or more precisely south-western (since the building is oriented around the *kibla*, looking towards the *Kaaba*), is markedly larger: 21 metres wide by 27 metres deep, and reaching a height of about 26 metres. The majestic flight of these smooth vaults, with their brick cradle vaults (indicating a direct link with Persian art), lightens the massiveness of the structure. The play of space in this courtyard highlights the potential of the four *iwan* plan. The spatial balance is regulated by the transition from internal spaces to those exposed to sunlight, from covered zones to those open to the sky. It contrasts perceptions of

inside and outside. It is a system well adapted to the ardours of the Egyptian climate and must have seemed ideal to the builders.

On the courtyard facade, the main arch of the four *iwan*s, treated in voussoirs of faced stone, maintains the visual unity. The building thus conforms to a truly Mamluk architectural dynamic by revealing the beauty of the basic, uncovered structure. In the zones left free by this plan, the architect has arranged floors of cells around small interior courtyards. He uses the same solution behind the entry vestibule, where he has installed the service premises around a pond. Finally, behind the great *iwan*, a square room measuring 21 metres by 21 (equal to the span of the great *iwan*) forms the monumental tomb of the Sultan. This juts out from the south-eastern elevation of the building. The space, covered with a brick dome, with wooden pendentives decorated with stalactites, reaches up 50 metres from the floor below. This dome

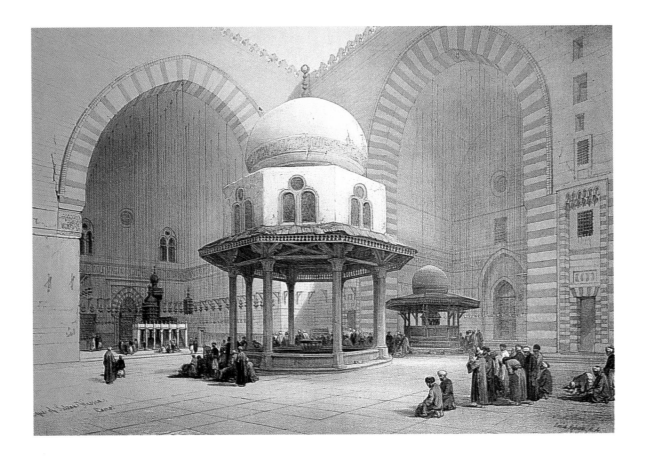

Engraving by David Roberts showing the courtyard of the *madrasa* of Sultan Hasan. To the left, the main *iwan* is sited to the south-west; in the centre is a domed fountain, used for the ritual ablutions. A secondary, smaller fountain was added around 1830, but no longer exists.

Facing page:

The prodigious richness of the polychrome decoration on the courtyard doors at Sultan Hasan: besides the *ablak* technique of alternate dark and light coloured layers of stone, the fret-worked keystones of the lintel are surrounded by a tracery of mosaic. Above, the bracing arch repeats the fretted motifs of the keystones below.

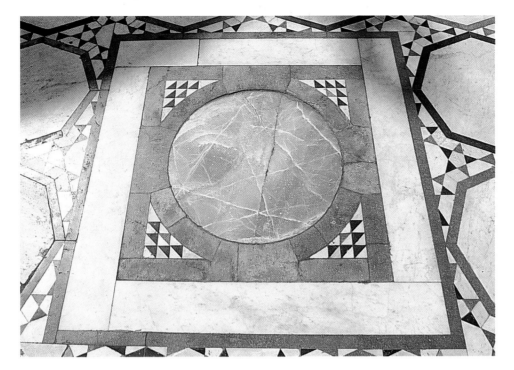

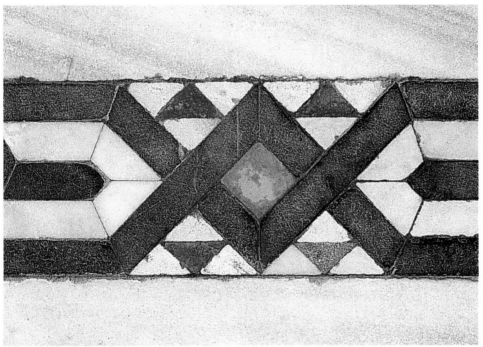

The polychrome paving which covers the courtyard of the *madrasa* of Sultan Hasan gives a delicate demonstration of the geometric finesse of Islamic art: this ornamentation plays on the subtle colours of the marbles. Here, the Mamluk aesthetic joins with the tradition of Byzantium and Rome.

replaced a first bulb-shaped cupola, made of wood, which collapsed in the eighteenth century. One of the two minarets, at 81 metres tall the highest in Cairo, fell down in 1361, killing 300 children. It was rebuilt on a smaller scale, only 55 metres tall. Early Arab authors inform us that the entry gate was to have been surmounted by two other minarets in a Seljuk and Iranian manner, as at the Cifte Minare *madrasa* at Erzurum, dating from 1253, and the Gok Medrese at Sivas, from 1271. But because of the terrible accident, the architect gave up this plan.

The richness of the decoration The premature death of the Sultan cut short the work of embellishing the *madrasa*. Only the decoration of the main *iwan* and the tomb gives an idea of what might have been. In the courtyard, the very fine paving in polychrome marble still exists, as does the decoration of the doors in the angles, with worked lintels, polychrome arch stones, stalactites and inscriptions. But the great marble panels which covered

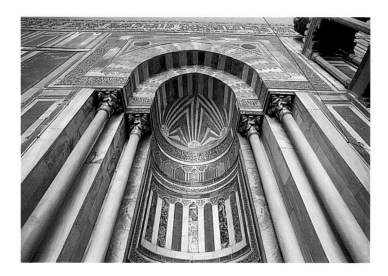

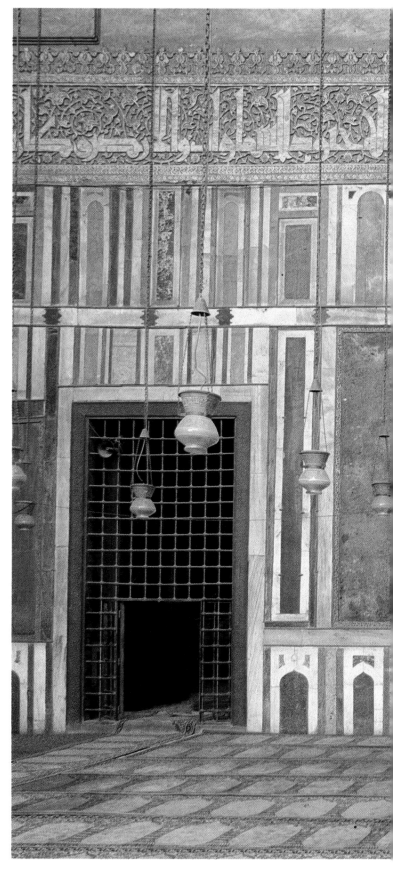

Detail from the *mihrab* niche, showing the direction of the *Kaaba*, to be faced by the faithful when kneeling at prayer. The richest materials and the finest ornamentation cover the surface, which shimmers in the darkness of the great *iwan*.

Right:

At the back of the main *iwan* in the *madrasa* of Sultan Hasan, the wall forming the *kibla* contains, against the richest of gilded and ornamented backgrounds, both the *mihrab* niche (in the centre) and the steps of the *minbar* (right). An inscription taken from the Koran runs around the consecrated space. To the left, the door gives access to the funerary chamber.

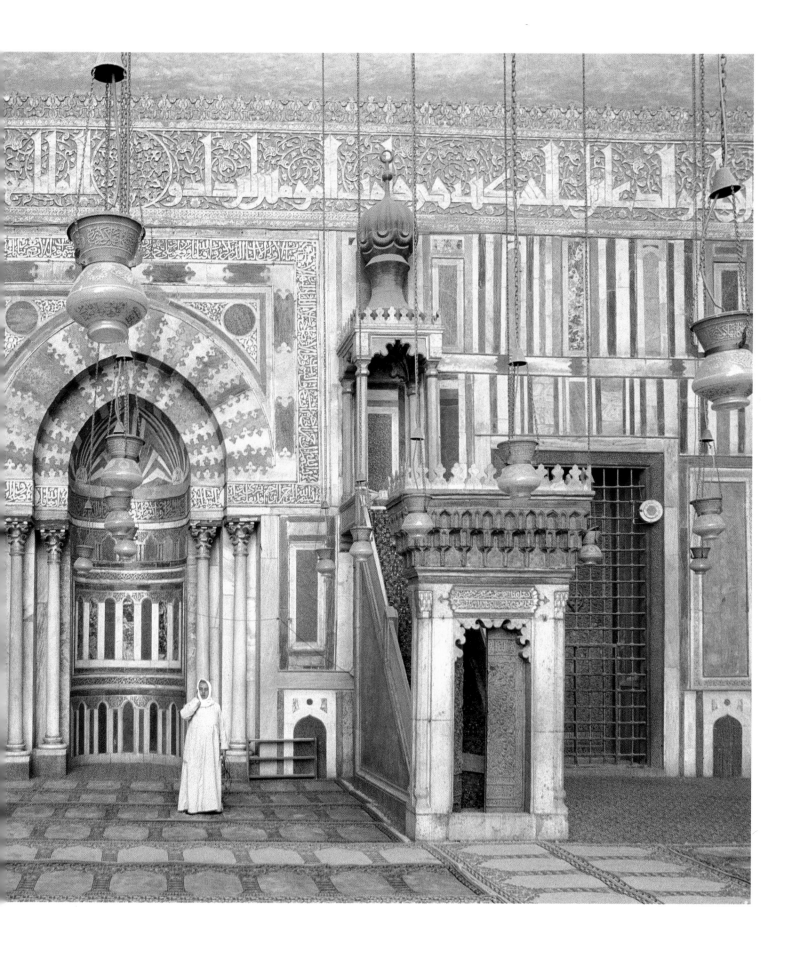

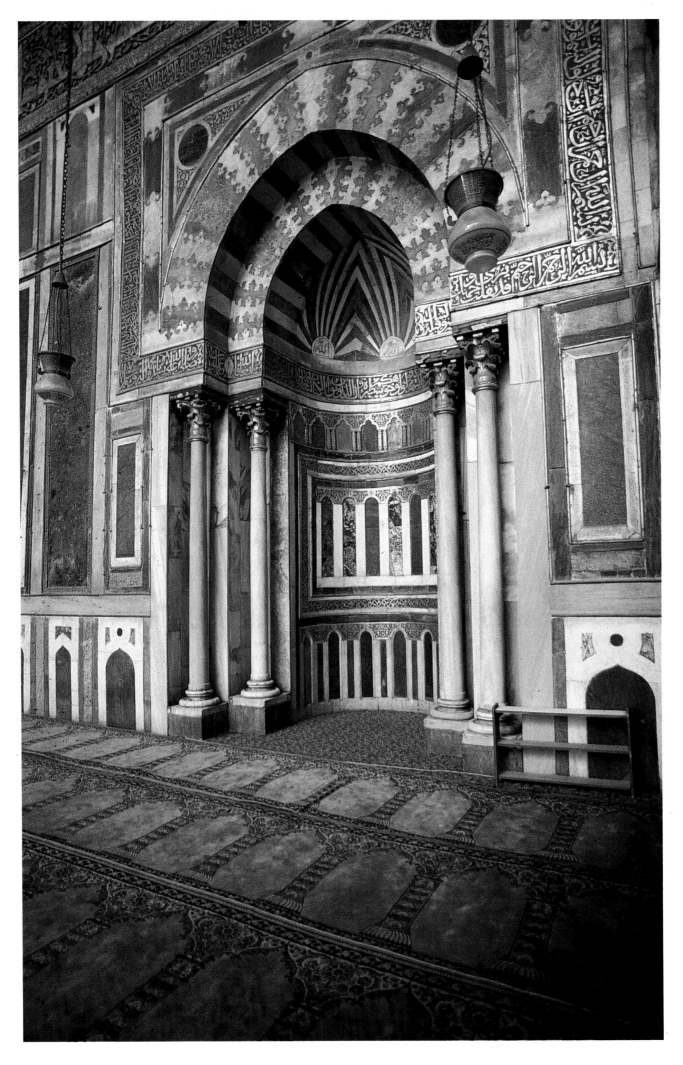

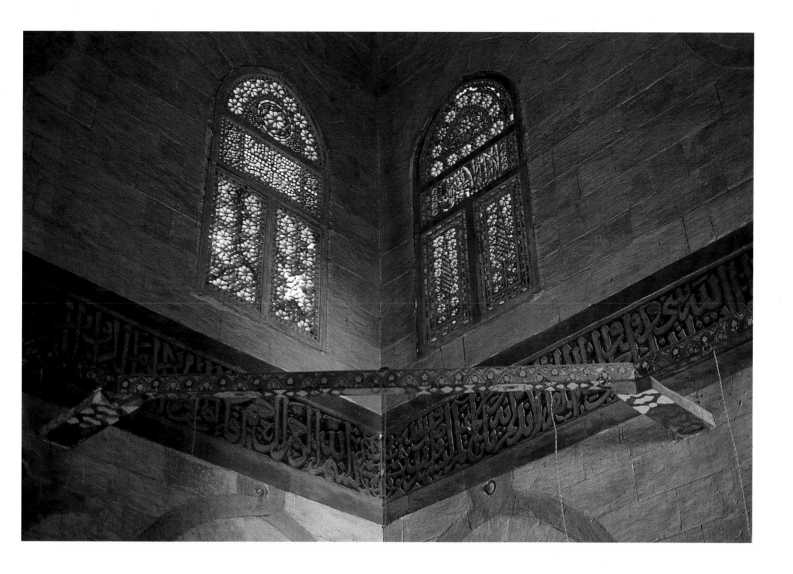

The *mihrab* of Sultan Hasan: on either side the two pairs of columns are a reference to Salomanic symbolism. Fretworked voussoirs in coloured marble decorate the double archivolt, heightening the general polychromatic effect. The *alfiz* that frames the vault of the semi-dome, carries a Koranic inscription, as do the archivolts.

the secondary *iwan*s, if they were ever carried out, have been removed. Moreover, half a century after the death of Hasan, Sultan Muayyad bought the magnificent bronze door as well as several lamps, also in bronze, which used to adorn this *madrasa*, to install as decoration in his own mosque, situated at the Bab Zuaila Gate. Finally, a series of lamps in enamelled glass, which were suspended in the *iwan*s for the nocturnal offices, are now to be found in the collection of the Cairo Museum of Islamic Art. The essential part of the decoration is based on the *ablak* system, laying alternate layers of white and black stone around the entrances provided in pairs around the four angles of the courtyard. Panels of

In Sultan Hasan, as in most Mamluk *madrasa*s, there is a funerary chamber destined to receive the founder. This space has bays glazed with stained glass set into stucco, a technique proper to the Islamic world. A monumental inscription runs around the square, domed room, or *qubbat*, placing the tomb under the invocation of the sacred verses of the Koran.

coloured marbles are also used, to set off the fret-worked voussoirs. Decorated lintels may also have a framework of mosaics, with white networks, strewn with stars and hexagons in red and blue. The polychrome marble panels which line the *kibla* wall and the *mihrab* are heightened in gold. Above this panelling, eight metres high, runs a large inscription on stucco in Kufic, going all the way round the *iwan*, in the Persian fashion. The stone *minbar*, on the other hand, is relatively restrained, as is the *dikka* in white marble. The officiant directs the ritual from this platform, while the imam recites the prayers.

Splendid stained glass windows light the mausoleum; stalactite pendentives in wood are successfully used to effect the transition from the square of the room to the circle of the dome. These have been well restored, and their brilliant colours have gilded highlights. Here also, a frieze of inscriptions runs all the way around the funerary chamber. In contrast to this rich and varied ornamentation, the decoration outside is more sober, but nonetheless carefully executed. The great entrance is covered with motifs sculpted in the stone: great circular designs, stylised floral friezes, tracery, *mukarnas* with deeply scooped concave centres, a cornice of stalactites over the top of the *pishtak*, whose rhythm is mirrored all round the mausoleum. At the very summit of the walls, merlons in the shape of fleurs-de-lis stand out against the sky.

In this way, the *madrasa* of Sultan Hasan manages to combine a mass of minutely detailed ornamentation with the restraint of a traditional plan and building materials. Here, Mamluk art fuses the haughty grandeur of a style turning around powerfully vertical themes with the delicate quality of a constantly contained and mastered ornamentation. Without shying away from glorious and magnificent effects, this is an architecture which also succeeds in exalting the rigour and austerity of an Islam seeking the orthodoxy expressed by the Sunnite doctrines.

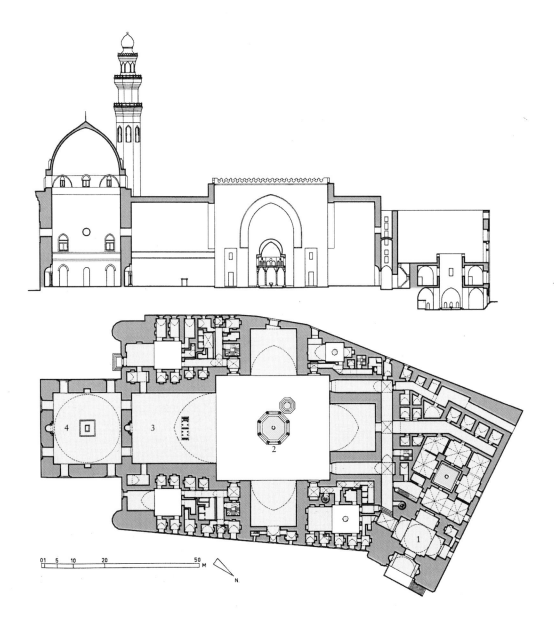

Facing page:

Beneath a cascade of stalactites in polychrome glided wood, their concave surfaces seeming to spring from the wall to make the joint with the circular cupola, the rich ornamentation of Sultan Hasan's funerary chamber is lit by a series of stained glass windows: high bays opening in the drum of the dome, *oeils-de-boeuf* at the sides, and angled windows.

Lengthways section and plan of the *madrasa* of Sultan Hasan, in Cairo: 1. Vestibule.
2. Central courtyard and fountain.
3. Great *iwan*.
4. Funerary chamber.

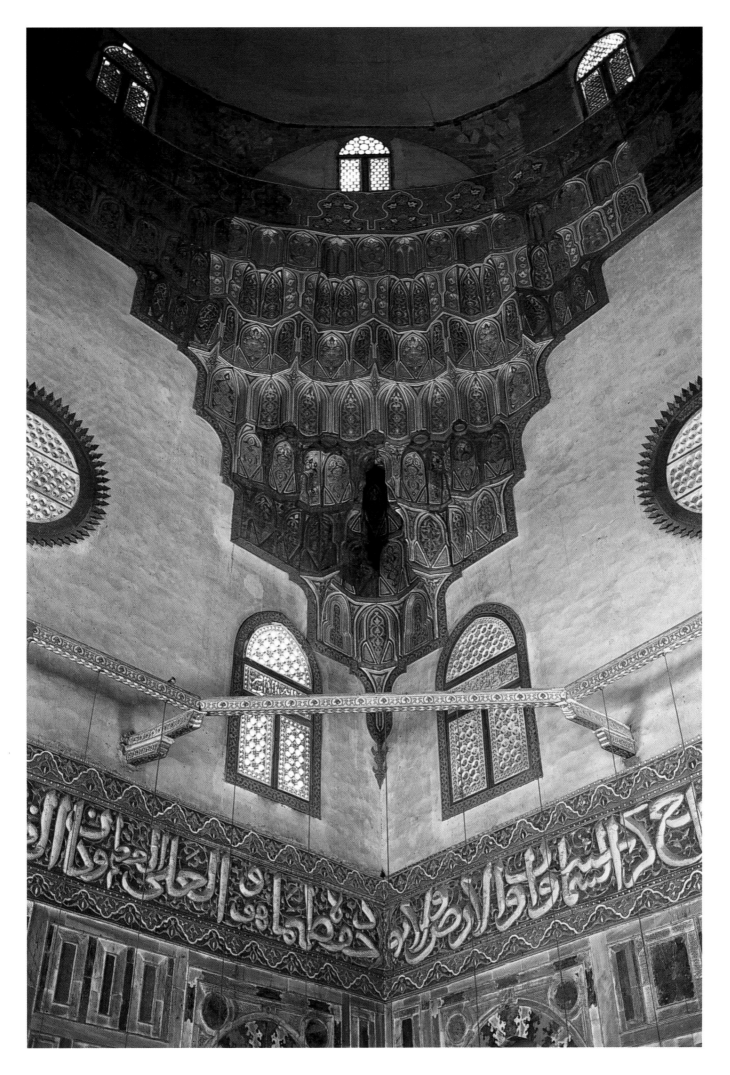

Ornamental inscriptions and
abstract designs punctuate the
severe and lofty walls of the
madrasa of Sultan Hasan.

Facing page:

Above and below a frieze of
stellar mosaic, panels of fretted
marble covering the lintel
voussoirs and the bracing arches
illustrate the imagination which
typifies Mamluk art.

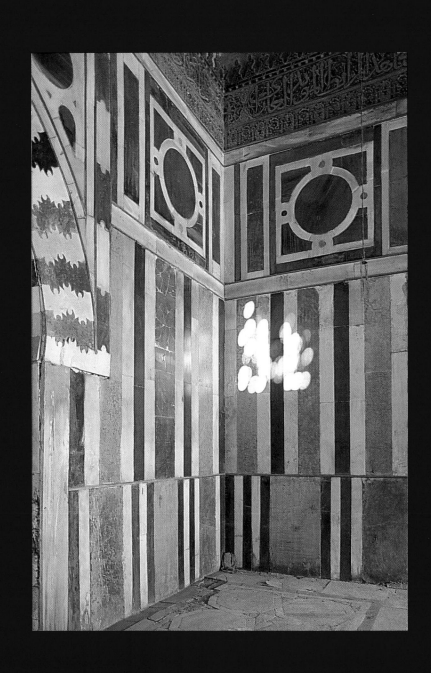

THE BARKUKIYA
OF CAIRO

Splendid polychrome panels
of marble create a rhythm
around the walls of the tomb
of the Barkukiya in Cairo. In
this *madrasa*, begun in 1384,
on Muizz Street, next to
Mohammed el-Nasir's *madrasa*,
the funerary chamber was
reserved for members of the
Barkuk family. The Sultan
himself was interred in the
City of the Dead, in the desert
to the west.

THE BAHRID dynasty derives its name from the word *bahr* in Arabic, meaning the river (the Nile), because the Mamluk squadrons were quartered on the Island of Roda (or Rawda), facing Fustat. The dynasty, of essentially Kipchak Turkish origin, began in 1250 and was solidified by Baibars I. It ended in chaos after the reign of Sultan Hasan. A new 'family', this time of Circassian origin, seized the opportunity to found the second dynasty of the Mamluks of Cairo.

The usurpation was the work of al-Zahir Barkuk, who was 46 when he took power in 1382. The reign of this Sultan was, like those of his predecessors, not uneventful. He occupied the throne until 1389, was then deposed at the age of 53, but returned to the palace a year later, to stay in power until his death in 1399. His reign totalled 16 years.

During this period, Cairo retained its role as a major centre of Islamic culture. Indeed, the Mamluk capital managed to maintain this eminent position until the fifteenth century. This was despite the powerful competition of Samarkand, under the Timurids, on the one hand, and of Constantinople, to become Istanbul after the Ottoman victory in 1453, on the other, which was soon to make itself felt. The commercial spice monopoly which filled the Egyptian state coffers was attracting more and more the covetous interest of other powers.

Following a tradition well established amongst the Sultans of Egypt, Barkuk built widely throughout the empire in his two reigns. The list drawn up by Meinecke points respectively to 64 and 84 constructions (a total of 148), of which 48 are in Cairo alone. During this period, which we cannot claim was breaking away from earlier forms, the style becomes firmer and more polished still. Decoration makes the fullest use possible of the means at its disposal: its repertoire is simplified, to use only a limited number of components. The polychrome technique, more perfectly mastered than ever, achieves a kind of sumptuous 'classicism', a balance to be maintained in the works of Sultan Farag, Barkuk's son and successor. Among the many constructions from the time of Barkuk, the most interesting and the best conserved is the *madrasa* built by the Sultan in Muizz Street.

Double page, overleaf:

The octagonal cupola surmounting the vestibule, at the entrance to the *madrasa* of Barkuk, Cairo. The treatment and disposition in space of the highly geometric stalactites are admirable. Above the eight windows opening from the drum, two large *oeils-de-boeuf* windows face each other on the right and left. The curious system of filling in between the reinforcements of the groins of the dome can be seen.

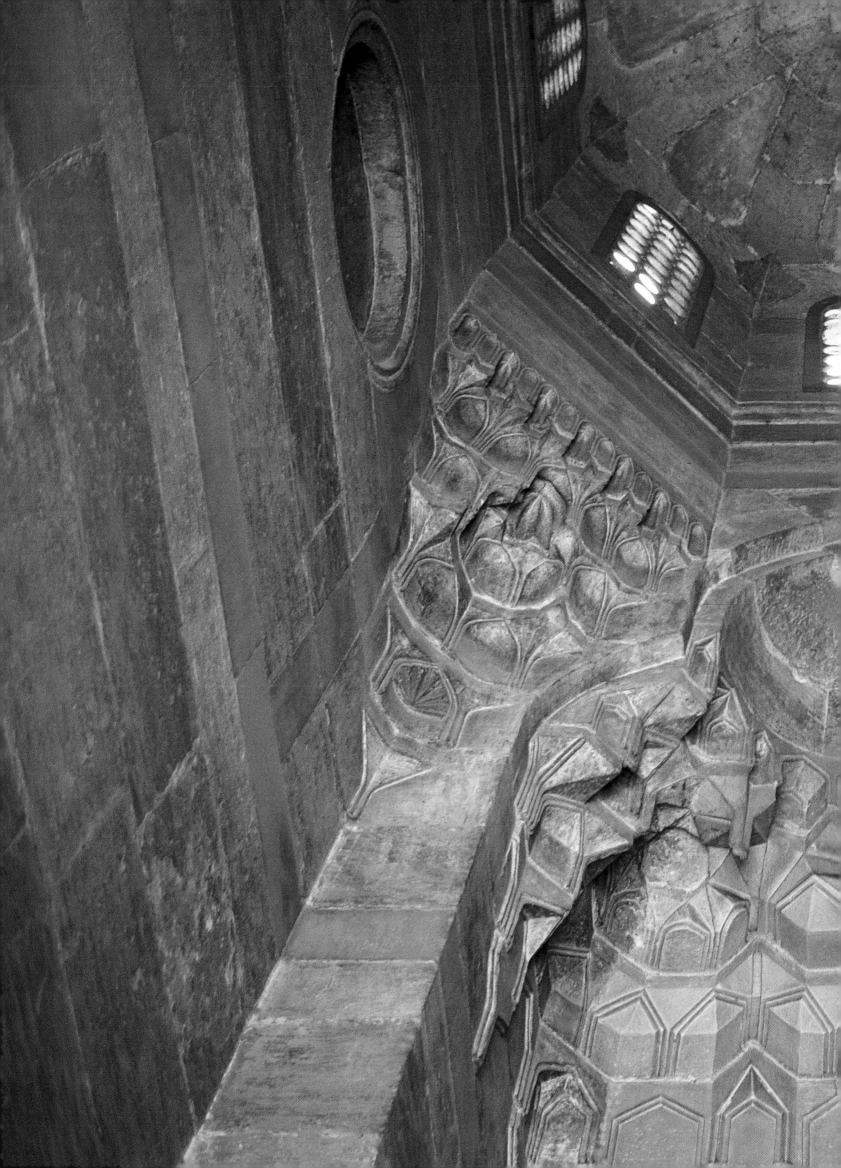

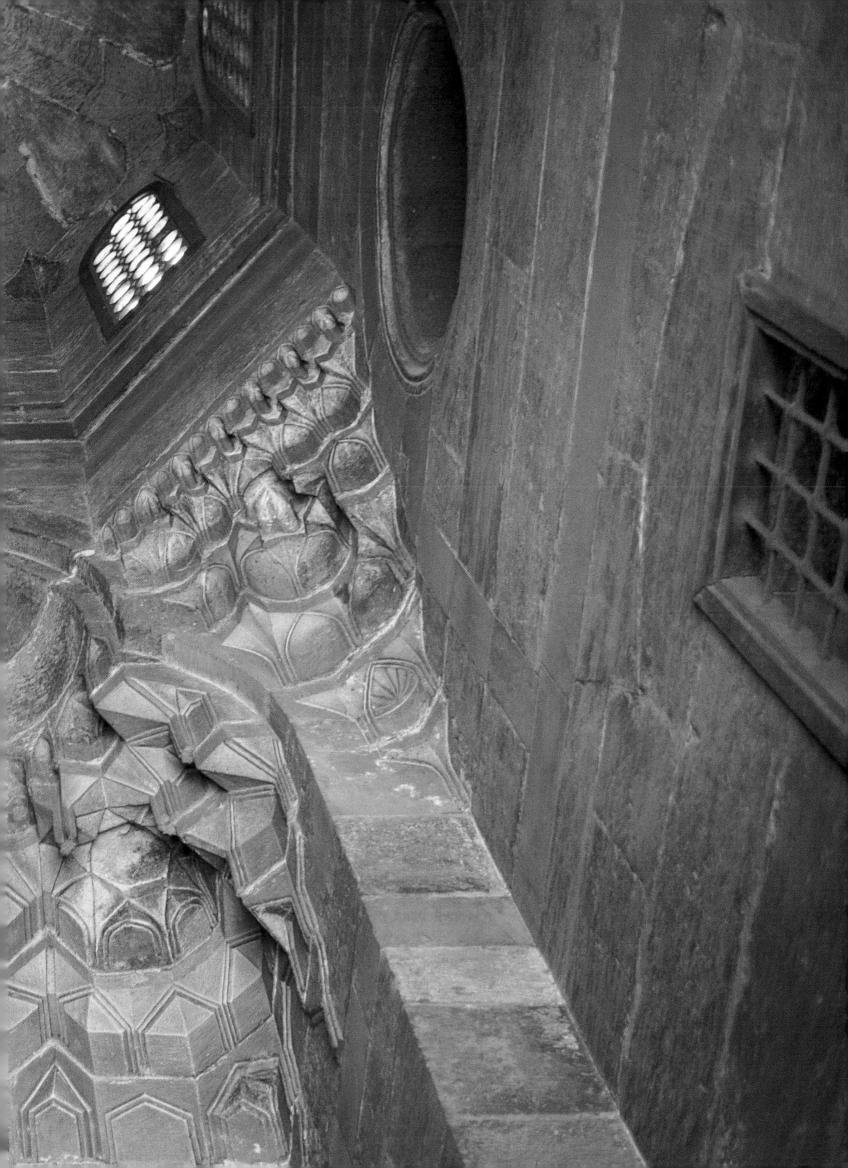

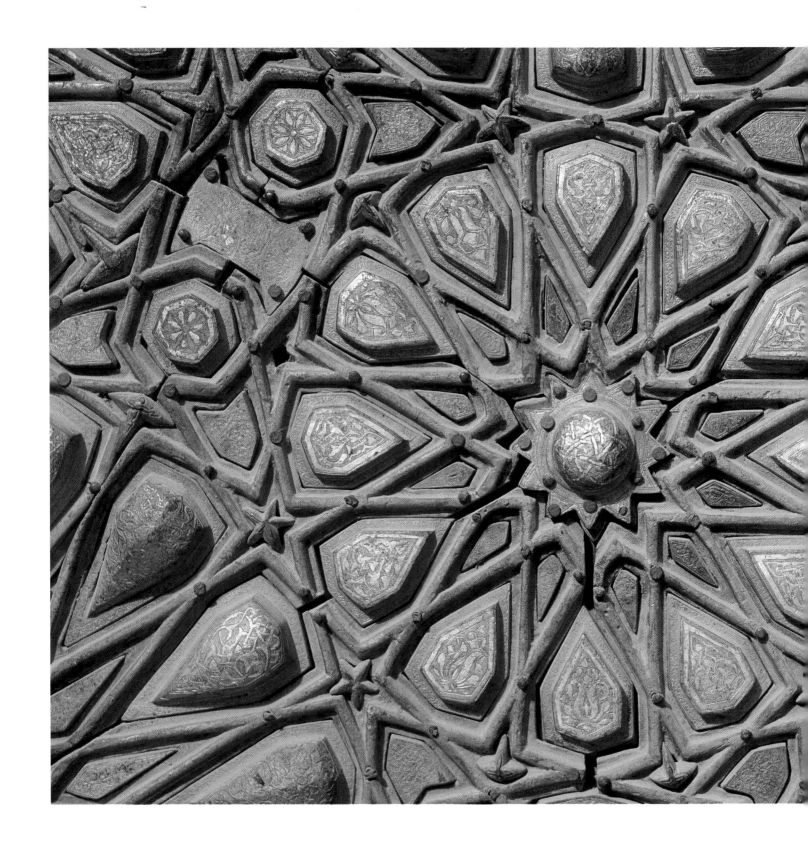

Close-up of the bronze door of the *madrasa* of Barkuk: a juxtapositioning of elements transposes the technique used by the cabinet makers responsible for the Mamluk *minbar*s (see pages 66–67, 69, and 162–163). The decoration of the doors follows a six- and twelve-sided line. Each of the elements in strong relief is decorated with engraved motifs, heightened in gold, silver and copper.

The building known as the Barkukiya was started in 1384; it stands next to the *madrasa* of Mohammed el-Nasir, or Nasiriya. The main body of work was completed in 1386. The decoration of the mausoleum was still in progress at the time of a number of interments of various members of the family.

Like the neighbouring Nasiriya, or the nearby Kalaoun complex, the Barkukiya was fitted into existing urban surroundings. The only visible facade gives onto the capital's principal avenue. Exceptionally, we know the name of the architect: he was Ahmed al-Tuluni al-Muhandis, and was an important person who was possibly related to one of the Sultan's wives. We also know that he died on the road to Mecca, while making the pilgrimage there. Our general ignorance of the names of the architects is most

likely due to the fact that they were not of Arab origin; sometimes, indeed, not even Muslims. They were quite often Christians (either converted or not), and included Syrians, Armenians, Anatolians or, quite simply, Copts from Egypt. Because of their own background, the Mamluks possessed neither architectural tradition nor knowledge. To create their magnificent structures they were obliged to make use of local or foreign craftsmen. These men, under the orders of an Emir, directed a group of workers who came, as did the architect himself, from various provinces around the empire.

The Barkukiya takes its cruciform layout from the *madrasa* of Sultan Hasan, but its proportions are considerably more limited: 55 metres long by 32.5 metres wide. Like the nearby *madrasas* of Kalaoun and Mohammed el-Nasir, in the place of the principal *iwan* there is a room covered by a beamed ceiling, carried by two arcades perpendicular to the *kibla*. These arcades are made from rehabilitated antique columns of the characteristic red granite which came from Aswan.

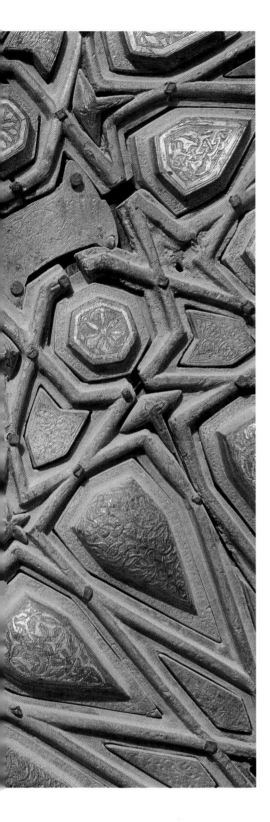

In the courtyard of the *madrasa* of Barkuk, the onion-dome of the covered fountain is ringed with an epigraphic band. The undulating archivolts over the openings to the arches sunk into the walls of the courtyard are reminiscent of a motif employed by the Seljuks of Anatolia.

117

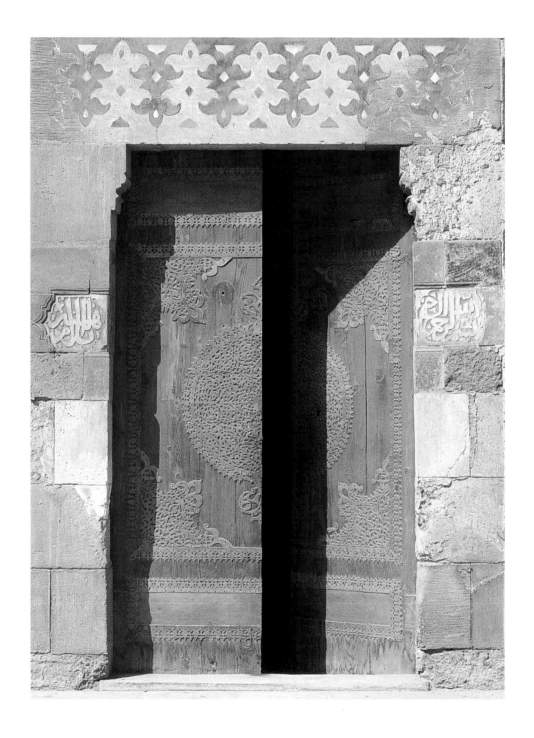

On the street front, there is a fine door with a niche surmounted by stalactites, and decorated with a geometric black and white panel. The door itself has a beautiful bronze covering, in which the elements in strongest relief are enriched with incrustations of silver and copper. The twelve-sided star motifs are fitted into a strict orthogonal system. The style of this door recalls the door panels from the *madrasa* of Sultan Hasan, now to be seen at the entry to the mosque of Muayyad. Through the door lies a vestibule which, after twice turning to the right, leads to the courtyard. But before embarking on this winding passage the visitors who raise their eyes to the ceiling will observe the beautiful stone dome, covered with a pattern of stalactites carved into the stone itself. Based on an octagon, this dome, which covers a cruciform structure, is remarkable for its restraint and sobriety, which under-

One of the four doors with bronze decoration, which give onto the courtyard of the *madrasa* of Barkuk on either side of the *iwan*s. The openwork of the bronze is finely engraved, and held in place on the door panels with large nails. It contrasts subtly with the *ablak* decoration of the door openings, especially with the lintel voussoirs.

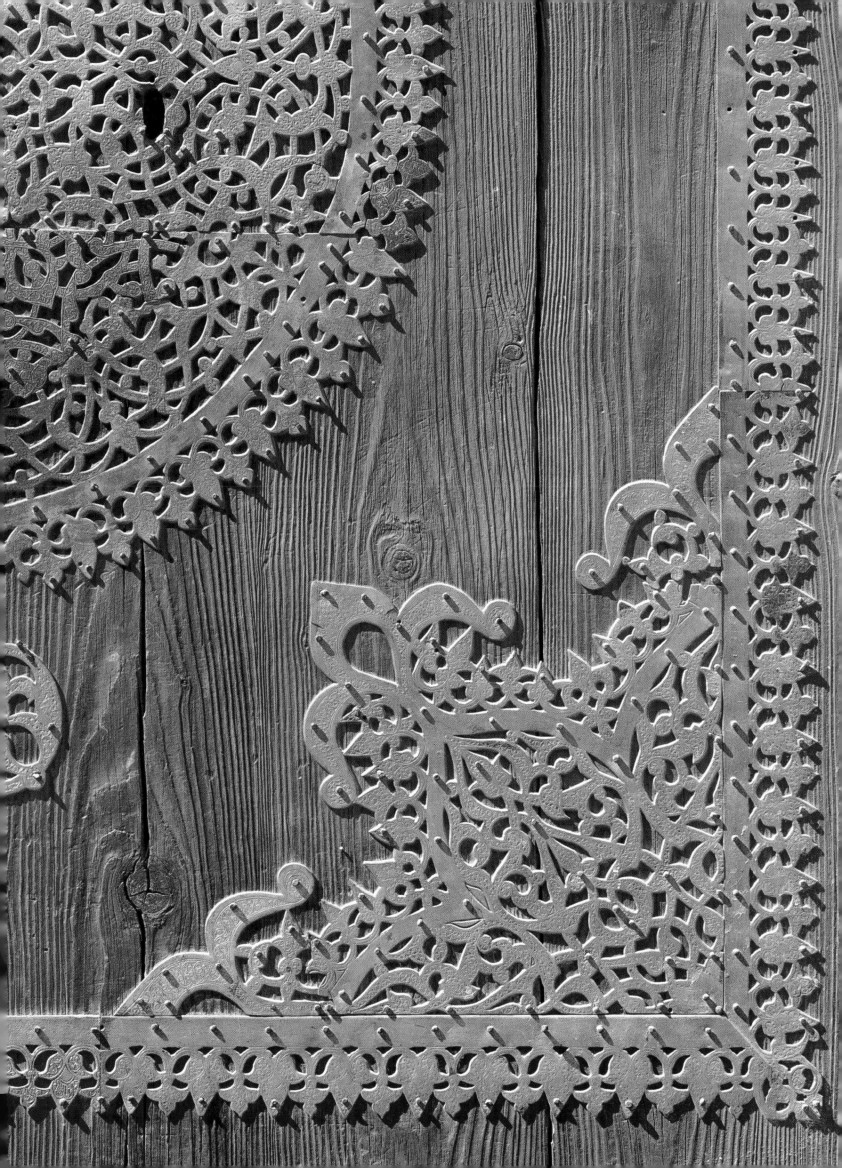

line the purity of the *mukarna*s. To reach the *madrasa* proper, it is necessary to pass through a door at the bottom of the corridor on the right; this opens onto the south-west corner of the courtyard. At first glance, this space resembles a smaller version of Sultan Hasan's *madrasa*, with its domed fountain. The three *iwan*s are equal in span (8 metres), while the one opposite the prayer room is deeper than the two side *iwan*s, accentuating the longitudinal axis. The vaults of these airy *iwan*s are pure and elegant.

The courtyard, paved in marble in geometric motifs, has a door at each corner, with a covering of bronze open-work on them. The arabesques of their decoration, executed in metal, bear a resemblance to motifs found in some Persian rugs. The circular central medallion, and the corners, reveal great mastery. The octagonal marble pillars of the fountain support an onion-dome emerging from a wide, lower roof, also octagonal. The structure fits harmoniously into the courtyard.

In the prayer room, two arcades of columns supporting pointed arches with alternate white and red voussoirs, carry a magnificent flat ceiling. This wooden roof, decorated with azure and gold motifs, was admirably restored some years ago. The *kibla* wall, with the *mihrab* at its centre, is richly panelled in marble of contrasting colours: white, yellow, brown and red. The play of warm colours in the ornamentation achieves an effect of iridescence.

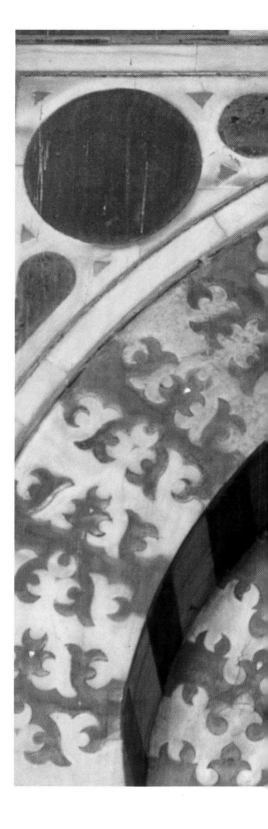

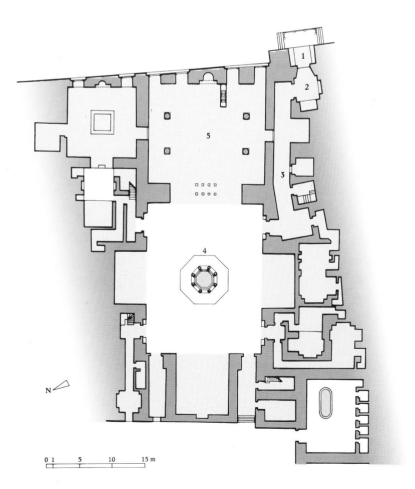

Plan of the *madrasa* of Barkuk, or Barkukiya of Cairo:
1. Entry.
2. Domed vestibule.
3. Corridor.
4. Courtyard with four *iwan*s.
5. Prayer room with two arcades perpendicular to the *kibla*.
6. The Sultan's family mausoleum.

120

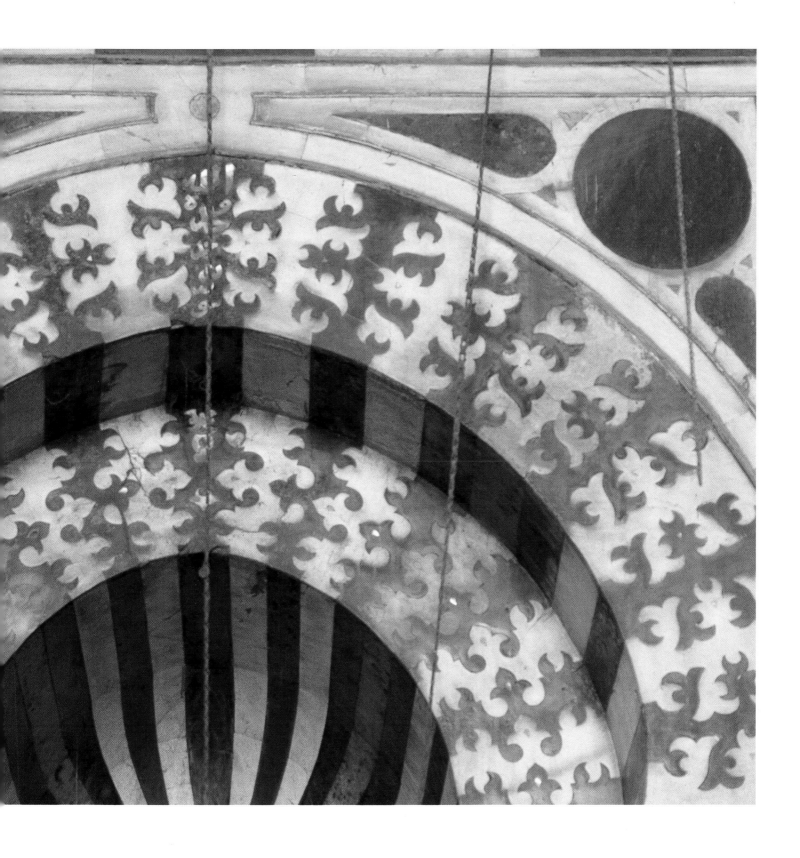

Voussoirs of the *mihrab* in the prayer room, with their extremely elaborately fretted arch stones, executed in alternately light and dark marble panels.

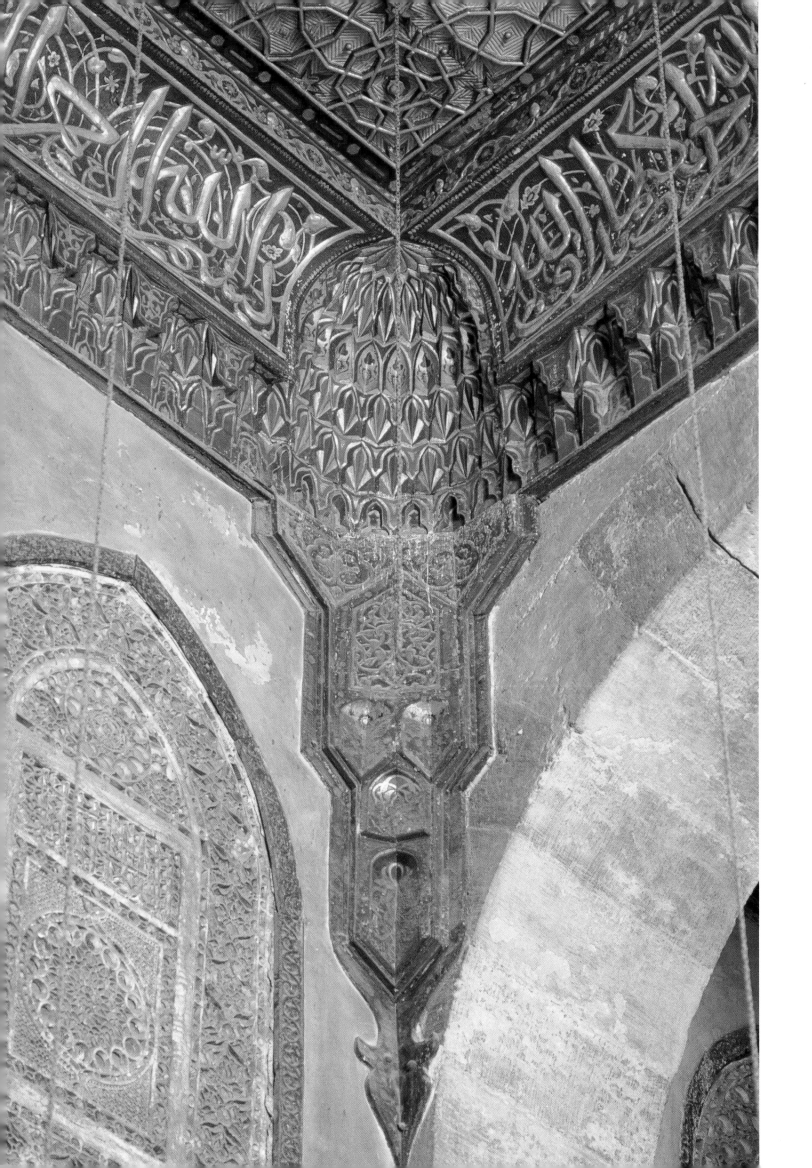

The *mihrab* at the centre is the most highly wrought element: the craftsmen showed proof of exceptional virtuosity in the fretwork of the voussoirs. The niche indicating the direction of prayer is supported by two pairs of white marble octagonal pillars and decorated with intricate motifs. A frieze stressing the concavity of the opening is ornamented in blue ceramic, suggesting the influence of Persian techniques.

The precious mausoleum

From the courtyard, the door in the south-east corner, opposite the entrance door into the courtyard itself, opens into a short passageway leading to the mausoleum. The tomb is a typical example of a *kubba*, a square tomb covered by a hemispherical dome. The space takes the form of a cube, with the diameter of the dome being equal to the length of the walls of the room, in this case 10 metres.

A small courtyard, open to the sky, precedes the funeral chamber, as in the tomb of Kalaoun. The interior of this exemplary mausoleum is reached through a *mucharabieh* door, surmounted by an arch with fretted voussoirs. The harmony of the space is immediately striking: the high polychrome marble covering is made up of vertical rectangular panels placed next to each other. The surfaces are white, brown, ochre or yellow.

Facing page:

Corner treatment in the prayer room of the *madrasa* constructed in the centre of Cairo by Sultan Barkuk. The transition from the wall to the flat gilt and polychrome ceiling is effected by a corner pendentive sculpted with stalactites crowned with a small squinch.

A Mamluk mosque lamp, coloured with polychrome enamel, dating from the fourteenth century: lithograph taken from *L'Art arabe*, by Prisse d'Avennes, Paris, 1877. Originally, all mosques had a number of glass oil lamps hanging in the rooms or *iwans*. They lit the faithful during nocturnal prayers.

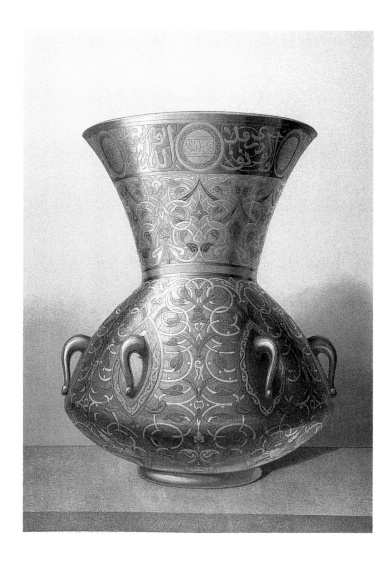

Double page, overleaf:

Close-up of the glorious wooden ceiling over the prayer room in the Barkuk *madrasa*: the union of wall and ceiling is achieved using a frieze of stalactites (at the bottom), followed by a concave cornice (a cavetto), bearing epigraphic texts. Above runs a framework made up of an octagon-based network in relief. Fixed to the last beam, which carries the weight of the ceiling, are the thick chains holding the oil lamps which provide a primitive lighting for the prayer rooms. The sculpted wooden ceiling is also treated in an extraordinary symphony of colour and gold.

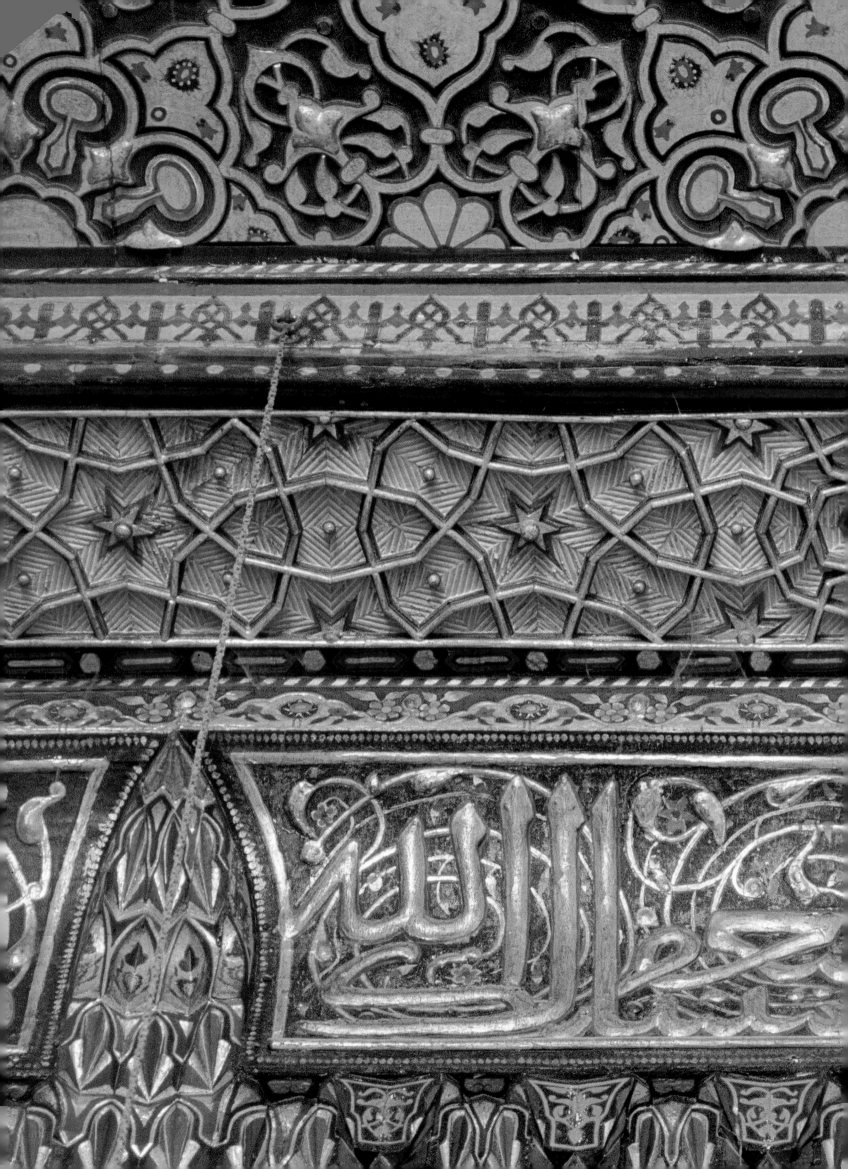

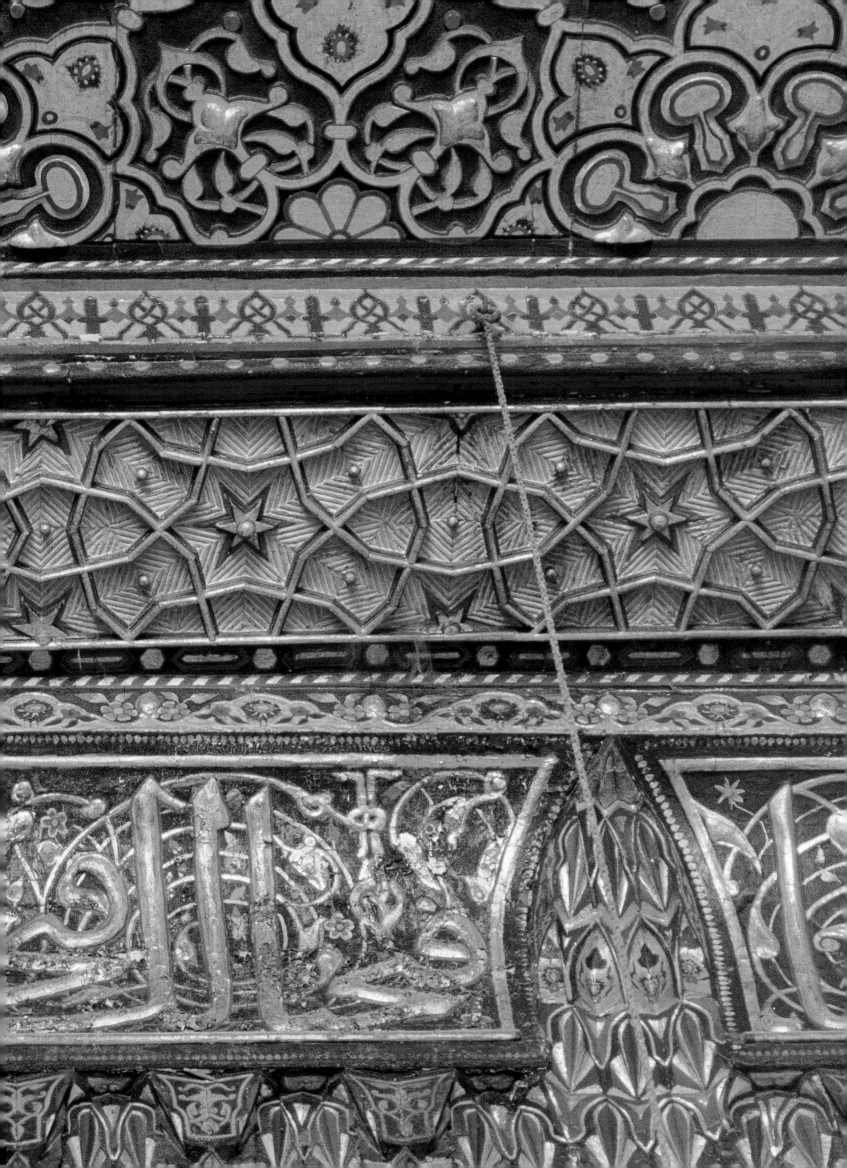

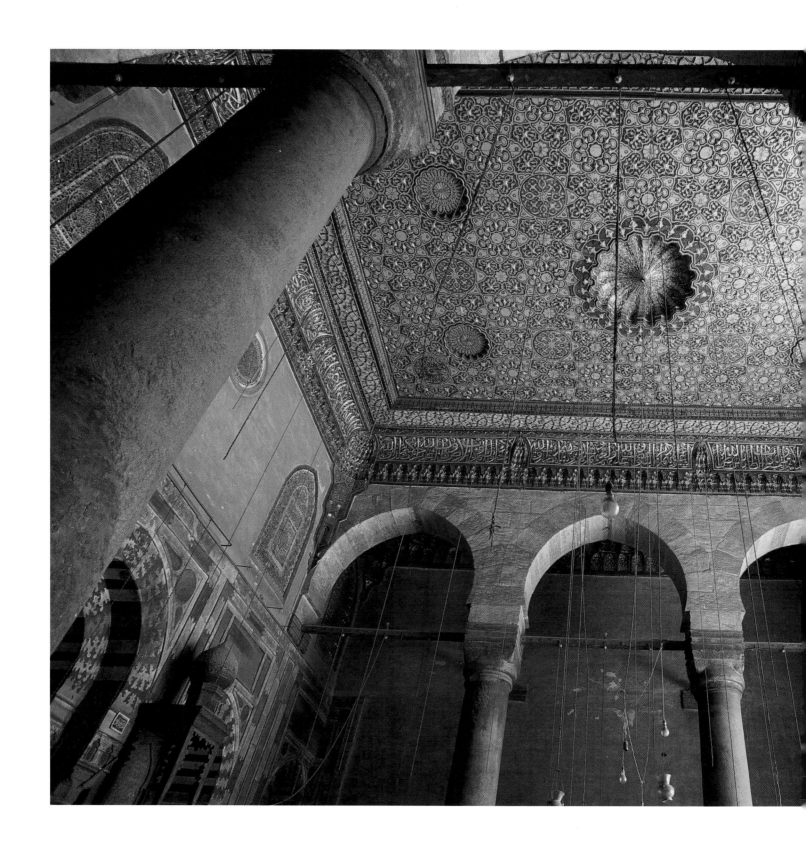

Side view of the prayer room in the *madrasa* of Barkuk, showing the two arcades at right angles to the *kibla*, and the remarkable polychrome wood ceiling, which has been beautifully restored. The heavy columns of pink granite from Aswan are re-employed pieces from ancient buildings. On the left is the *mihrab*, and to the right, the archway opening onto the courtyard.

The composition is redolent of skill and subtlety. A low skirting runs along the foot of the wall: its colours alternate with those at the mid-level on the walls; the upper band is panelled in large squares, containing black discs.

This magnificent panelling covers the room to the height of a frieze with an inscription in gilded *naskhi* writing. The corner pendentives from the dome fall to the level of this inscription. These pendentives, in polychromed and gilded wood, are carved with stalactites and make the joint between the base and the 16 sides of the dome. The drum stresses this plan by alternating eight windowless bays with eight glazed bays, the stained glass held in place by a network of stucco. Daylight also enters the room via

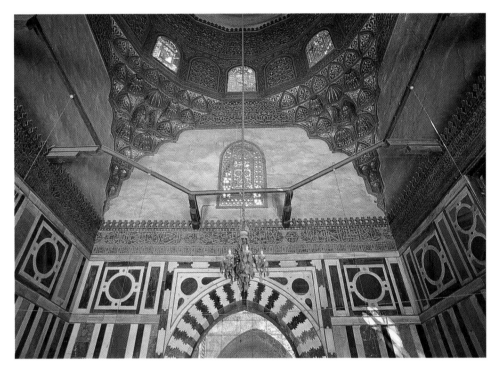

two large windows which give onto the street. These frame the central *mihrab*, traditionally placed in tombs to sanctify the space by a call to prayer, as well as indicating the direction of the *Kaaba*. The mausoleum, a pinnacle of refinement in Mamluk architecture with its characteristic use of polychrome panelling, is like a precious jewel box. The decoration, using rhythms created symmetrically or by a disruption of the symmetry, prevents any monotony. The abundant light, compared to the relative darkness of the tomb of Kalaoun, represents a new concept in illumination. The *madrasa* of Barkuk, even given its limited size, is a full real-isation of the potential of a sumptuous and refined art at the height of its quality. It is a glorious creation of the aesthetics which guided imperial productions.

The Cairo of The Thousand and One Nights

The existence of an art of the 'aristocratic' type incarnated by the monu-ments constructed by the Mamluk Sultans in no way precluded the appearance of a more popular movement and of a very

In place of a flat ceiling, the funerary chamber traditionally has a dome (*qubbat*). In the *madrasa* of Barkuk, the walls are covered with superb marble panelling. The corners are filled with stalactite (*mukarnas*) pendentives in gilded wood, which precede the cupola on a drum lighted by eight bays glazed with stained glass.

vibrant form of Arabic, of which Cairo, because of its central position in the Islamic world, became very much the standard bearer. It was in fifteenth-century Mamluk society that *The Tales of a Thousand and One Nights* – one of the most inspired literary works of the Arab world – reached its definitive form. Because Cairo was the crossroads of international trade, it also became the recipient of writings brought there by the merchants and travellers. *The Thousand and One Nights* is the product of exchanges and contact between the eastern nations. The compilation of adventures was of Indian origin: it was remodelled by a passage through the Iranian imagination and was translated into Arabic as early as 987, in Baghdad, at the time when the Caliphs were under the protection of the Buyid Emirs. At the same time, additions dating from the Abbasid epoch gave the tales an atmosphere which reflects the manners of Arab society at the end of the classic age.

When the manuscript of *The Thousand and One Nights* was copied in Cairo at the time of the second Mamluk Sultanate, the form was altered and a series of additions were made by Egyptian writers. Nevertheless, these authors respected the exoticism which the Cairo readership must have found in stories written five centuries earlier in an Abbasid environment. However, it is true that certain elements which cannot be placed geographically reflect life under the Mamluk empire: the descriptions of Baghdad are more evocative of Damascus or Cairo under the Circassian Sultans.

Facing page:

Light reflecting from the marble panelling of the funerary chamber next to the *madrasa* of Barkuk. Rays of sun come through the high windows and fall on the wall, covered with vigorously rhythmic geometric motifs.

Double page overleaf:

With their play of symmetry within asymmetry, the walls of the family tomb of Sultan Barkuk show an extraordinary 'modernism'. Such marble work was of Romano-Byzantine inspiration, but carried to great heights by the Mamluks in both religious and state constructions. They were not afraid to associate diverse materials – marble, granite, gilded wood, bronze, stained glass, etc.

THE 'DESERT' MAUSOLEUM
OF BARKUK

F ARAG WAS respecting a wish expressed in the will of his father, the late Sultan Barkuk, when he built a monumental mausoleum in the City of the Dead, to the south east of Cairo. The building served as a *khanka* (a convent for sufis), a *madrasa* and double tomb. This gigantic work was begun in 1399, and not fully completed until 1411, the year of its inauguration.

Farag's name and memory have been somewhat tarnished by his disastrous politico-military balance sheet, but with this building he signed one of the most fantastic works of all Mamluk architecture. The generous conception of the project, its coherent and powerfully articulated plan, its ample, balanced structure unite to make this a masterpiece for architect Cherkis el-Haranbuli. Once again the person responsible for the site has not remained anonymous. Could this be a sign that, under the Circassians, the designer of a building had become worthy of being recorded for posterity?

It should be stressed immediately that, in deciding to raise this tomb in the wide open spaces stretching from the gates of Cairo, where the Necropolis lay in the desert sand, Farag placed in the hands of his master-builder all the land that an architect ready to immortalise the memory of a Sultan could hope for.

The rule of symmetry In contrast to previous Mamluk constructions, Farag's complex to the memory of his father rises freely from the landscape. This presented an opportunity for setting out a monumental and majestic plan of great symmetrical rigour. The building covers a wide rectangle, 73 metres across. With its annexes (porch and outside gallery), it stretches to 115 metres in length. The heart of the complex turns about a system that is strictly duplicated on either side of the central courtyard: two enormous stone domes are located on the south-east corners of the structure. They are positioned at either end of a hypostyle prayer room, with its oriented *kibla*. Two elegant minarets balance these domes, marking the north-eastern limits of the square plan. The domes and the minarets thus act as very visible 'signal-markers' fixing the monument in space. Its form extends horizontally

Dome of the mausoleum of Barkuk, constructed by Sultan Farag from 1399. The deep carving in the stone is characteristic of Mamluk stone cupolas, here decorated with a herring-bone pattern developed over the spherical surface.

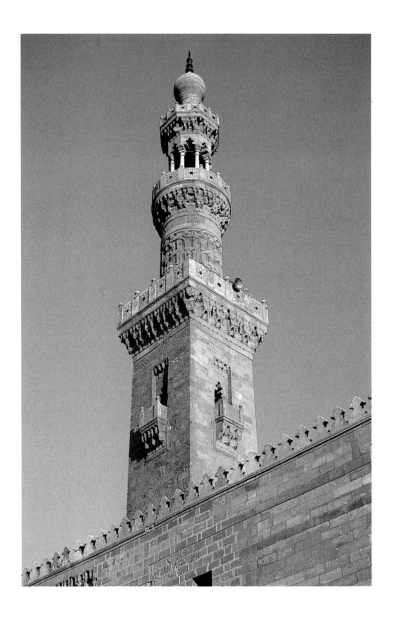

Facing page:

Opening in the beautiful, regular stonework of the mausoleum of Barkuk, an *oeil-de-boeuf* window lights the north-west prayer room. A discreet epigraphic band runs beneath the merlons, supported by a range of *mukarnas*.

Above the high walls of the tomb of Barkuk, crenellated in Fleurs-de-lis, towers the western minaret of the double mausoleum. Its structure is first square, then cylindrical. At the summit there is a pillared pavilion. Each level is marked by a balcony, underhung with carved stalactites. The pinnacle is in the form of an onion-bulb and reaches 52 metres high.

around the courtyard: to the south-east, the hypostyle rectangle has three arcades, with 18 pillars. It measures 35 metres by 18 metres, and is the prayer room proper. On the opposite side of the courtyard a smaller room (25 metres by 13), with 12 pillars, also serves as an area for contemplation, as in classical mosques. Behind the lateral porticoes – which mirror the arcades of the two hypostyle halls – there are two levels of *khanka* cells. In the centre there is an octagonal fountain for ritual ablutions. This is the general layout of the monument. Entry is gained through the gate which juts out from the north-west corner, while beyond the north-east corner lies a portico in the form of an open gallery, providing welcome shade and cool.

A mausoleum with a cupola in stone The great development in Mamluk architecture now touched the construction of the cupola. In place of brick cupolas, common during the Bahrid period, the Circassian dynasty adopted a more coherent system by building their cupolas from the same material used for the rest of the construction: stone. The whole structure gains in unity and solidity.

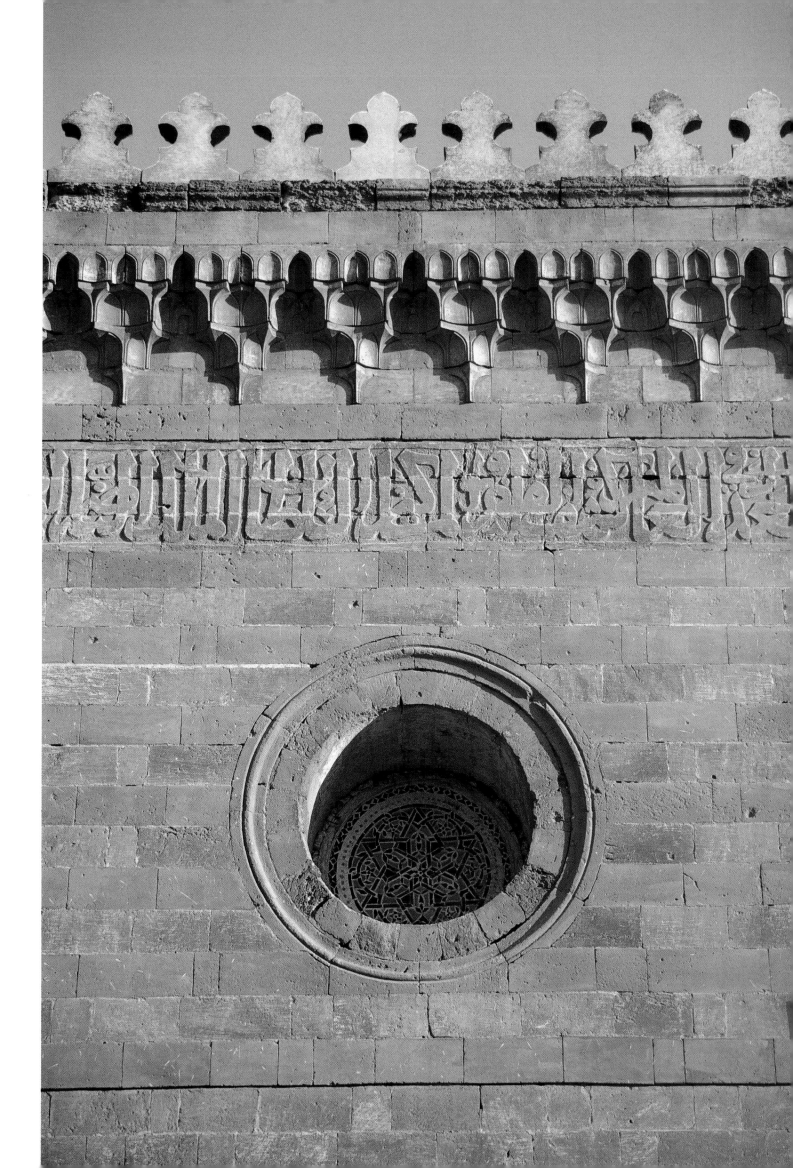

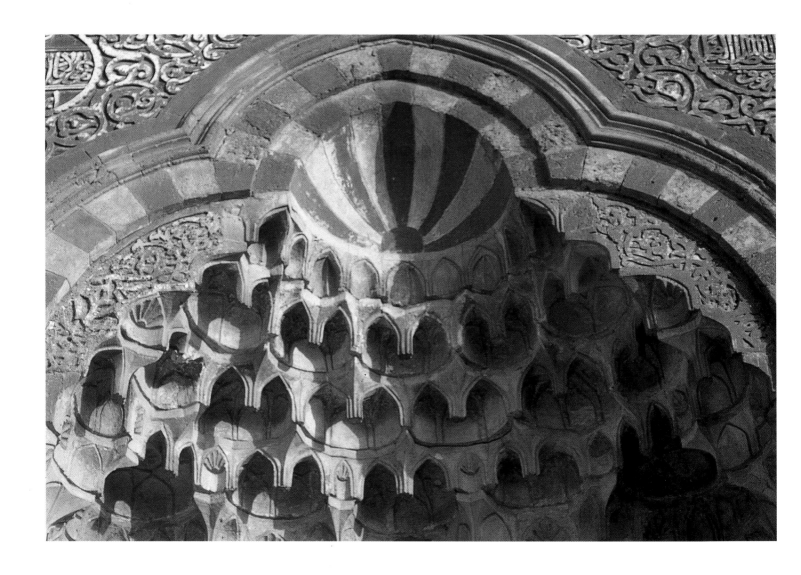

The brilliance of the Cairo craftsmen at decoration brought into being a particular type of dome, which became one of the characteristics of fifteenth-century architecture. From this time on, tombs were covered with a stone dome supported by a high drum. This unitary solution gave birth to a range of highly original decorative elements. Firstly, the dome, seen from outside, presents sculpted ornamentation covering the entire hemisphere: this may take the form of vertical ribs – as at Gur-e Mir, or the tomb of Tamerlane, built in 1404 at Samarkand, where the brick structure, patterned in this way, is completely covered in shining blue-green ceramic. It may use sculpted herring-bone motif (as here, in the mausoleums built by Farag), or finally stellar tracery (the mausoleum of el-Ashraf Barsbey in the same City of the Dead at Cairo), palm-leaf moulding and arabesques of increasing complexity.

The technical solution utilised to adapt the ornamental schemes to the spherical surfaces of the domes demanded great virtuosity on the part of the stone carvers, the more so since the curve of the cupolas is not truly hemispherical. In fact, on their high drums, often pierced with openings, the cupolas have a profile like a pointed arch. A vertical section reveals curves drawn

The trefoil niche of the doorway leading into the mausoleum of Barkuk has a covering of deeply concave polychrome stalactites, with hanging keystones.

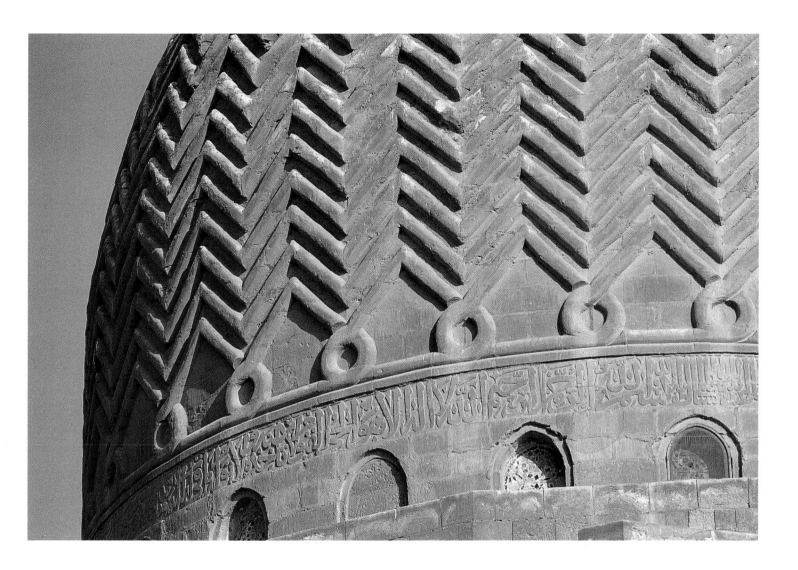

The two large domes over the tombs of the mausoleum of Barkuk are covered with the same motifs of large chevrons cut deeply in the stone: they cover the whole spherical surface. An epigraphic band runs all round the base of the dome. Some of the 24 windows which originally lit the room are now walled up.

from four geometric points: two vigorous curves define the shoulders of the dome, and two segments drawn on a more open diameter come together at the centre. We can only guess at the prodigious empiricism the artists employed to give the impression of a regular pattern circling the spherical surface.

There is another interesting ornamental zone in these Mamluk mausolea: the triangles which make the transition between the circular base of the drum and the square ground-plan of the tomb. There also, the craftsmen showed remarkable imagination. They used smooth pyramidal surfaces, or systems of 'Turkish pleats', with projecting and indented portions; the corners of the mausoleum are sometimes covered with flights of ledges, as in a stairway, or in diamond-point facets (tomb of Kansuh). But perhaps the most curious formula of all is that used for the two tombs built by Farag, and later used at the tomb of Kait Bey. The design consists of great hollow mouldings laid horizontally in rolls, one on top of the other at the corners of the mausoleum. These are developed on inclining triangular planes whose purpose is to unite harmoniously the square and the octagon on which the circular base of the dome sits. These surfaces, angled at 45 degrees at the four corners of the tomb resemble nothing to be found elsewhere.

Inside, the stone cupola also makes for a perfect continuity between the surface of the walls of the tomb and its roof. In the angles, the liaison is obtained by pendentives covered with skilfully carved *mukarna*s or stalactites. These cascade far down into the cubic structure, giving the impression that the stone is actually vibrating.

In reply to the double mass of the domes, the elegant flight of the two minarets is a statement of mastered audacity on the part of the builders. They stretch high into the sky from the top of the north west wall of the building. They are built in three sections, starting on a square plan; after a balcony, underhung with stalactites, they become cylindrical; higher up, another series of stalactites holds a second balcony, crowned with a ring of delicate columns supporting the last balcony, surmounted by the lightest of oval bulbs. At the very top a bronze spike carries the emblematic crescent moon. The marvellous finesse of the silhouette of these airy minarets creates a union between the architecture and the sky materially suggesting the presence of the moon. The lunar calendar governs the calculation of the Islamic year, which began with the Hijra. Today still, Ramadan, the Muslim period of fasting, is announced according to the appearance of the first quarter of the ninth lunar month.

As so often in the Mamluk architectural tradition, the route through the *madrasa* is not direct. The passageway from the entrance gate to the courtyard is narrow, confined and winding. But this only serves to increase the contrast, once the beautiful open space is reached. Encircled with porticoes on its four sides, with the corners of the building monumentally articulated by the domes and the minarets, this courtyard, strongly centred on its fountain, governs the entire centripetal space. It is a magnificent creation, and any visitor is instantly struck by the sense of peace and contemplation that predominates. Prayer, memory of the dead, the meditation of the sufis, and nature, symbolised by the miraculous presence of water, calling green plants into being, all

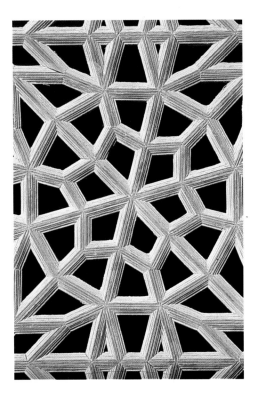 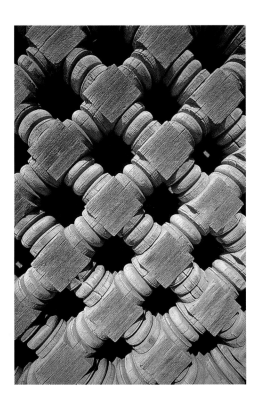

Open-work panels, after the fashion of *mucharabiehs*, separate the hypostyle mosque from the two tombs on either side. The geometric motifs used in the screens, based on octagons and hexagons, play subtly with light and shade.

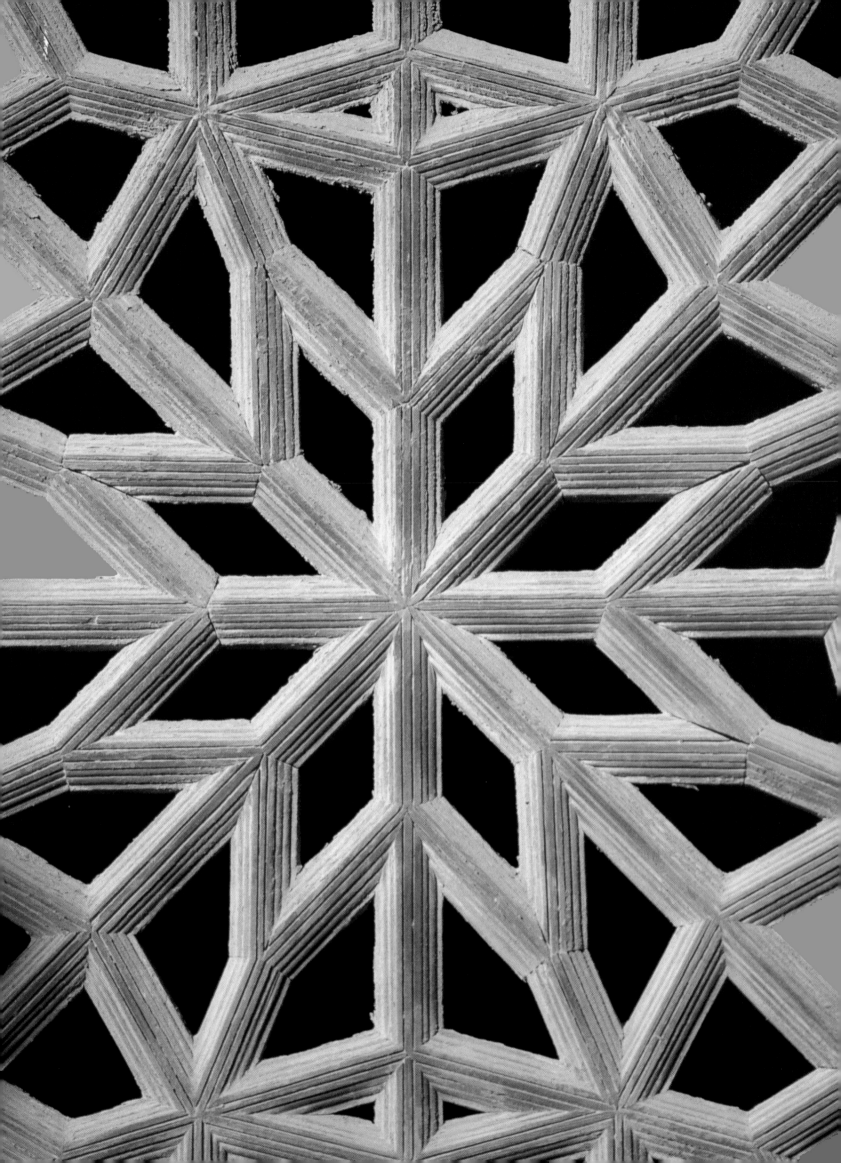

combine in this atmosphere. It is a space like an oasis, reassuring, soothing, a universe where each side of the courtyard is a reflection of the side it faces. Everything is ruled by a seemingly natural order, based on the right angle, as part of an all-pervasive orthogonal system.

Bathed in the light of the dawn or of evening, the porticoes are illuminated, rays of sun penetrate the funerary chambers, washing the walls with beams from the stained glass windows. The stone turns to gold, and imperceptible changes make it almost possible to pass from the brilliant heat of the courtyard, through the shady arcades before the *kibla*, and into the soft half-light of the tombs without realising it. This gradual falling off of illumination is still further marked by the shadows thrown by the networks of *mucharabieh*s that sift the last beams of sun: a final blazing of copper-toned light, filtering through the wooden screens, its piercing shafts reaching to the furthest corners of the funerary chambers. This is a magical form of architecture – neither totally open, nor totally closed, fully realising the potential given by the quality of light and dark, combining, in an art of majestic delicacy, intimate piety with imperial pomp.

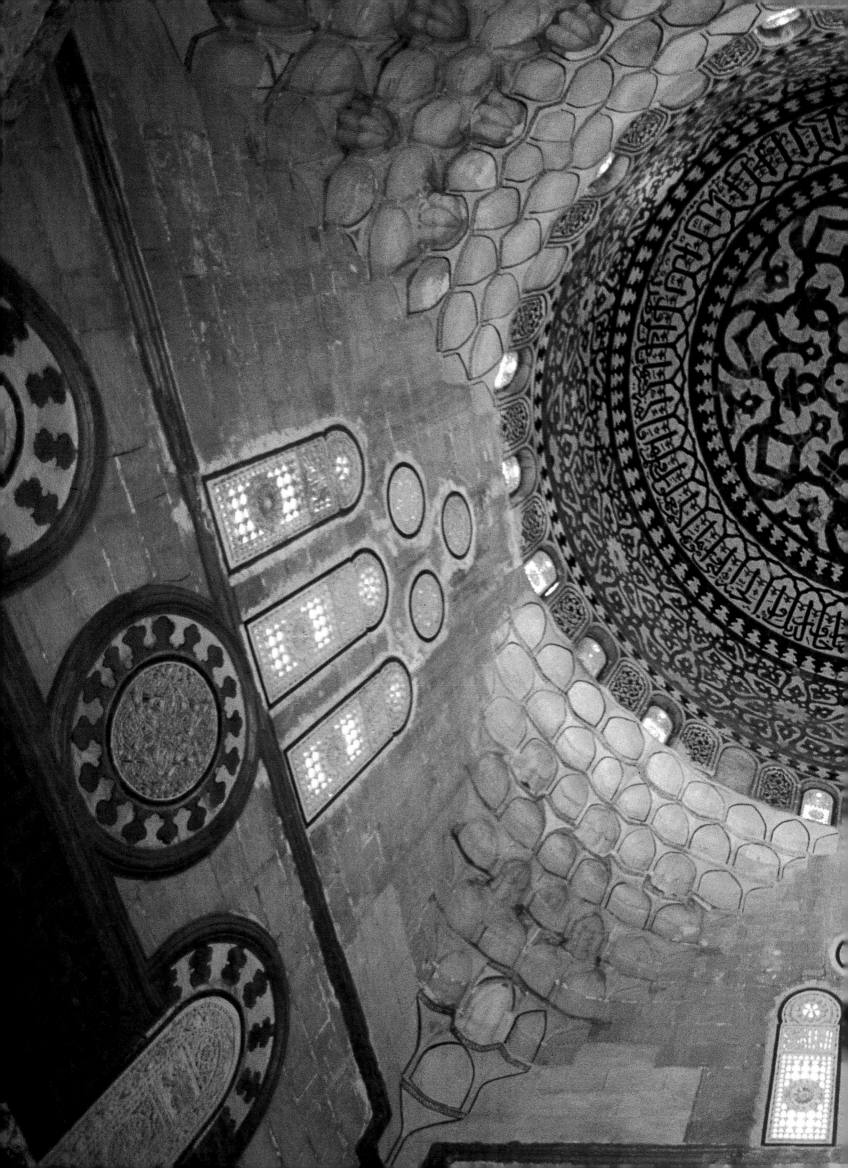

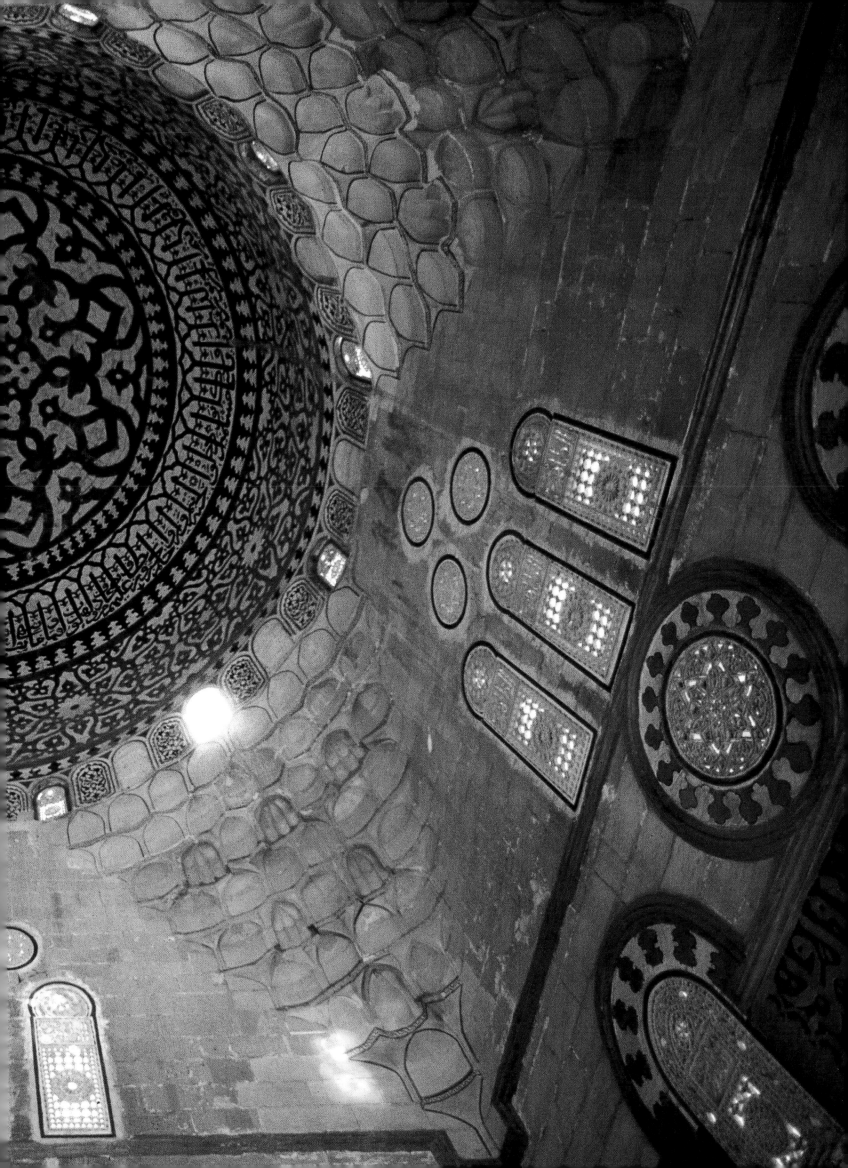

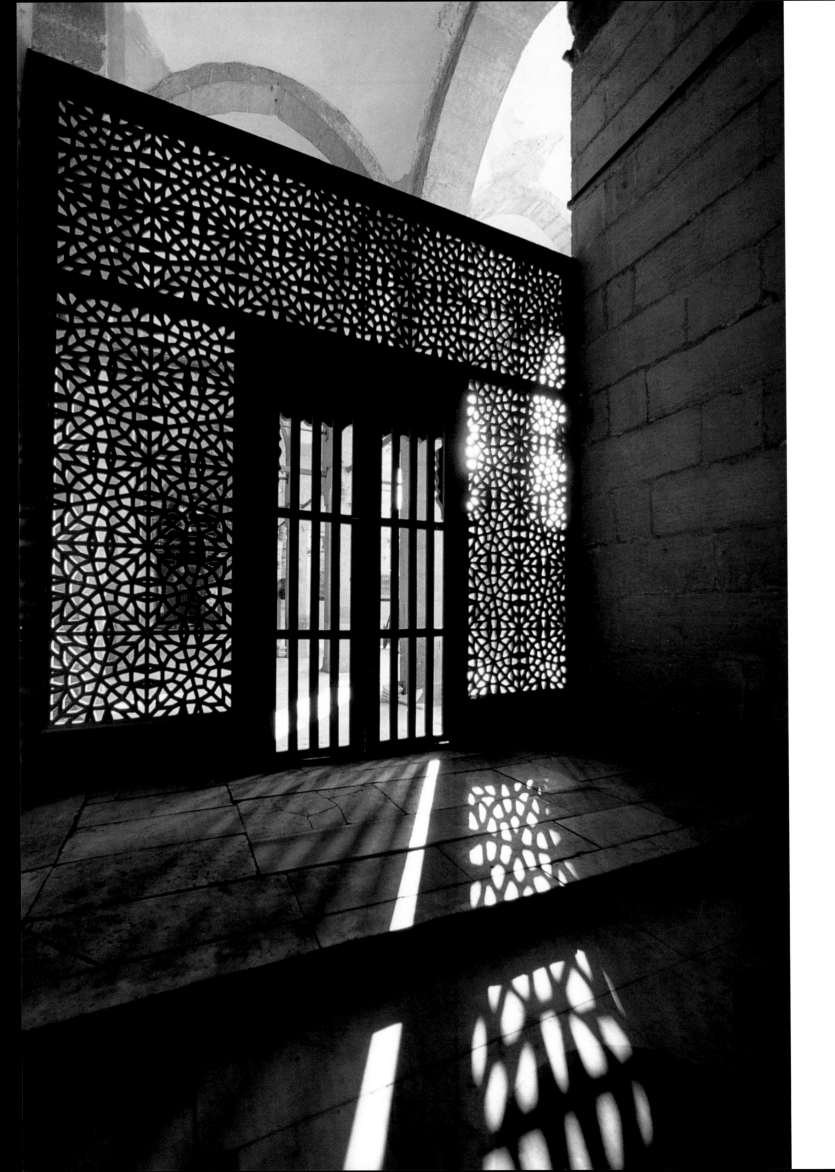

Facing page

Dusk descends on the west funeral chamber of the mausoleum of Barkuk, and the bright sunlight is filtered by the wooden screens.

Last rays of daylight fall softly through the shadows of the tomb of the sultan, caressing stone slabs trodden by a multitude of the faithful.

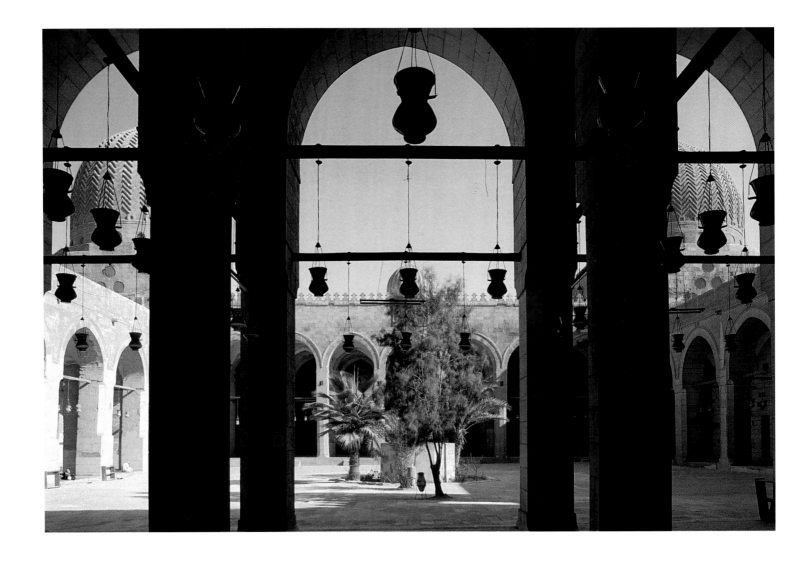

The funerary chambers The two funerary chambers lie symmetrically on either side of the hypostyle mosque; both are built to the same square plan, and are surmounted by a stone dome decorated on the outside with chevrons. Between the cascades of stalactites which cover the pendentives between the interior angles of the room, high triple windows, with triple *oeils-de-boeuf* above them (a mysteriously imported far-off Cistercian formula) let enter a soft clear light. Further illumination comes from a trio of intermediate bays and from pairs of large windows opening onto the exterior, quite low down. This multiplication of sources of light reflects an increasing tendency, which continued into the fifteenth century, in Ottoman architecture.

Without having the same sumptuousness of the funerary chamber built within the city walls by Barkuk, the *kibla*s of the two tombs built in the desert are still beautifully panelled in marble, in vertical strips. Light tones dominate about the *mihrab*, a very slender, graceful niche. The vertical quality of the forms is characteristic of this art – even if great horizontal masses link the high domes and minarets at the corners. The exterior walls spring straight upwards to their crenellated summit. The porticoes have no buttresses. The reach of the octagonal pillars of the hypostyle

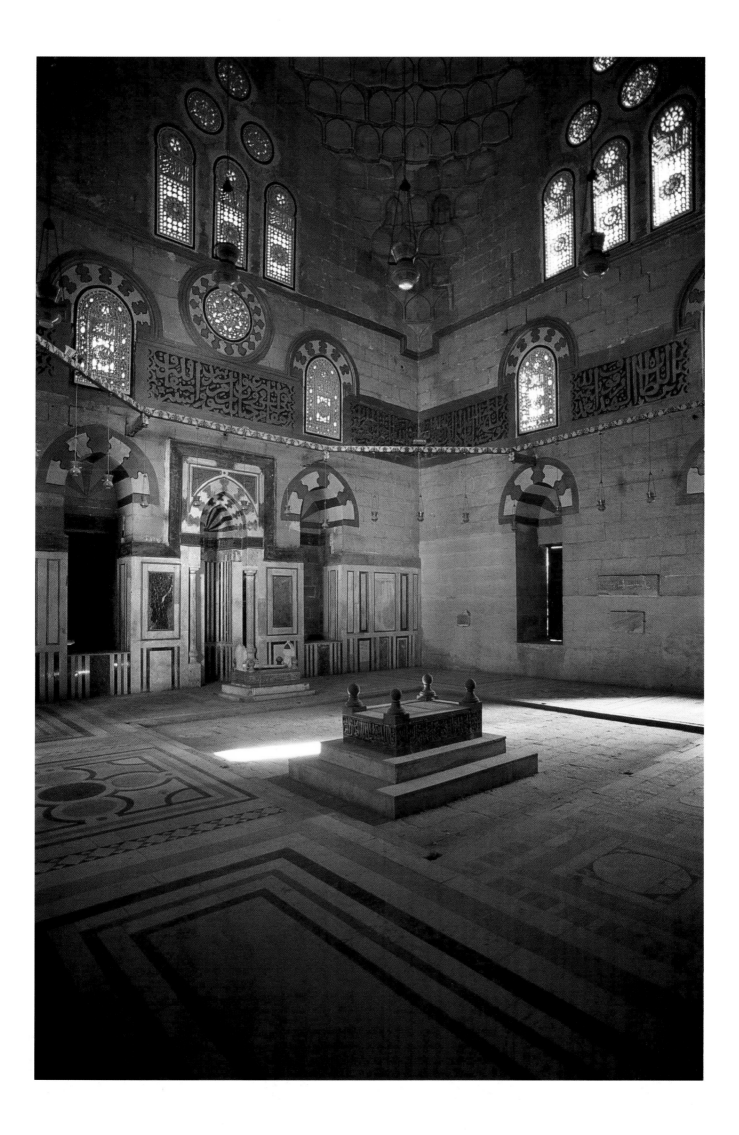

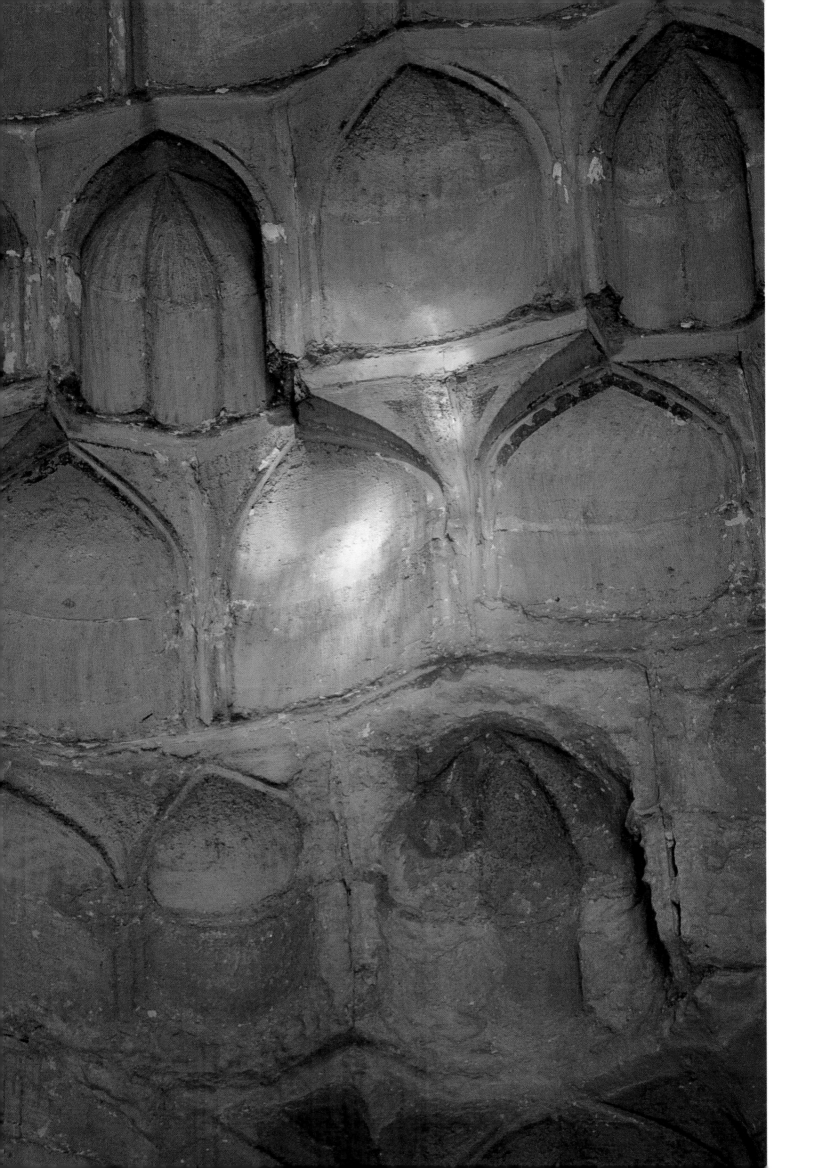

halls pursues its upward trajectory through a smooth transitional join to the raised arches holding the vaults. The interior surface of these vaults stretches, like an unruffled pale sky, the length of the hall.

In the tombs, the effect of the large cupolas, 15 metres across, is one of elegance: lightness and refinement rule. The arabesques decorating the interior surface with a large octagonal motif with numerous concentric borders have the effect of lightening the structure in stone, whose summit soars to 34 metres above the paving below. It is as if the hemispheric space is floating, weightless in a pale, diaphanous light.

Facing page:

Colours from the stained glass fall on the pendentives in the west funerary chamber in the mausoleum of Barkuk. Alternate rows of carved *mukarnas* underhang each other.

Detail of a stained glass window set in a stucco surround. The polychrome glass work of Mamluk monuments, like its contemporary Gothic equivalent, brings a warmth to the interior space.

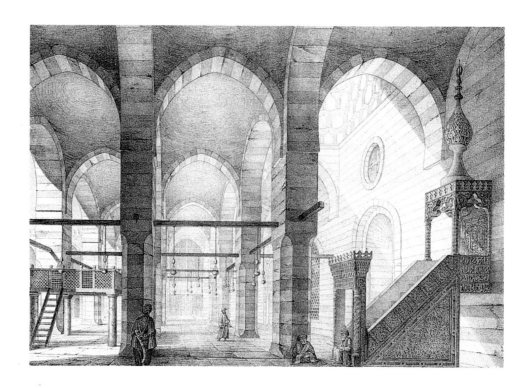

View of the prayer room and *minbar* from the mausoleum of Barkuk, built by Farag. From a drawing, between 1818 and 1834, by French architect Pascal Coste.

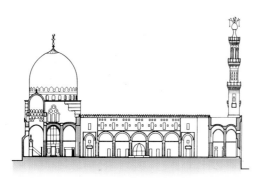

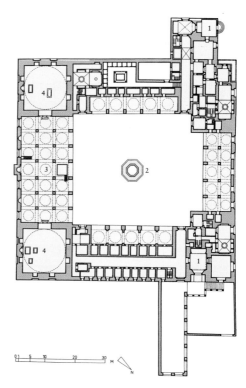

Lengthways section and ground-plan of the mausoleum of Barkuk in the City of the Dead. 1. Entrances.
2. Courtyard with central well.
3. Hypostyle mosque.
4. East and West funerary chambers.

Facing page:

Two examples of polychrome inscriptions, sculpted in stone, which decorate the mausoleum of Barkuk: above, a raised funerary text, in the Sultan's funerary chamber. Below, an invocation from one of the door-jambs on a doorway to the courtyard.

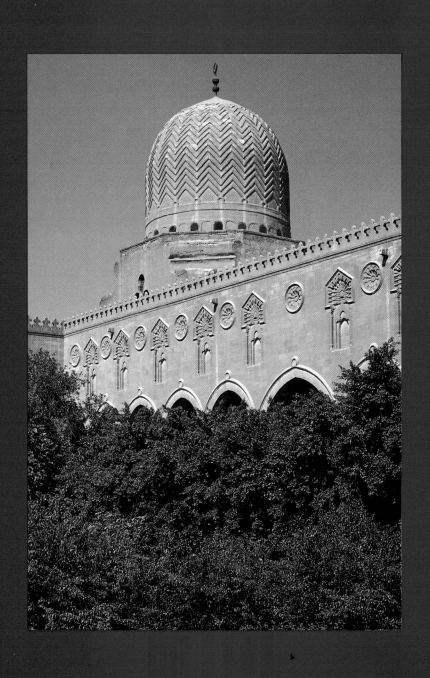

THE LAST FLOWERING
OF RELIGIOUS ART

The last century of the Circassian dynasty (1412–1517) covers the reigns of Sultan Muayyad, on the throne until 1421, then Barsbey (1422–1438), Ainal (1453–1461) and, above all, the long period when Sultan Kait Bey was in power, from 1468 to 1496. The century ends with el-Ghuri (1501–1516), who 'died in combat at over seventy-five' (Hautecoeur et Wiet).

This epoch, where diminishing Mamluk power was still concealed by an appearance of magnificence, was marked by the decline in the combat techniques developed by the Circassian slave-soldiers, obliged, from this time on, to face up to the Ottoman threat. From the capture of Constantinople, which became Istanbul in 1453, the rulers of the Sublime Porte had developed profitable contacts with the Occident: the relations between Mehmet II and the scholars of the European principalities are famous. The result of this was the early introduction, in the course of the fifteenth century, of artillery and firearms into the Ottoman army. The Sultans of Cairo did not understand the importance of this technological revolution, which was to reduce the striking power of the Mamluk forces, hitherto unbeaten on the battlefields of the Near East.

The last victory of the Sultans of Cairo over the Ottomans dates from the war which opposed Bayezid II and Kait Bey, from 1485 to 1491. The arrival of Selim I in Istanbul (1512) began the age of the irresistible expansion of the Ottomans, and also the fall of the Mamluks.

The mosque of Muayyad In artistic terms, and more especially regarding architecture, the imminence of the fall is not apparent in Cairo. Fifteenth-century Mamluk creation is as glorious as ever. Around 60 buildings were constructed, with 25 of them in Cairo (Meinecke) during the reign of Sultan Muayyad. The most important undertaking was unquestionably the construction of the mosque that bears his name. Building work began in 1415 on land situated behind the gate of Bab el-Zueila, to the south-west of Cairo, inside the Badr Gamali walls. Slightly elevated, on Muizz Street, the mosque of Muayyad is a building with a courtyard,

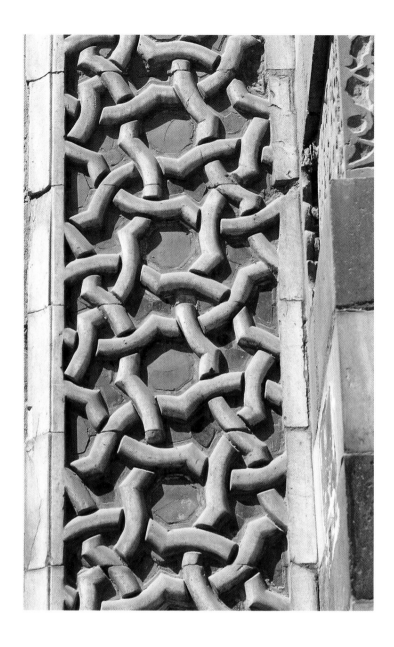

formerly surrounded by porticoes. It covers an area of 90 square metres. The three arcades of its prayer room are arranged between two tombs, much in the same manner as in Farag's mausoleum in the west necropolis. Nothing remains of the three double arcades of porticoes which ran around the courtyard of 50 square metres. Unfortunately, recent renovation work seems likely to compromise the authenticity of the building – the arcades are being reconstructed in reinforced concrete.

The great entrance door is treated in a remarkably original manner, with alternate layers of black and white stone (*ablak*) and twisting borders, with elements in blue and red ceramic. The bronze door itself, which, as mentioned above, came from the *madrasa* of Sultan Hasan, confers great richness on this high *pishtak*, capped by a tight network of stalactites carved in the stone. This imposing entry leads into a cruciform vestibule (as at Sultan Hasan). The prayer room is reached by crossing the tomb of the Sultan, lying along the west side of the *haram*. The tomb follows

Facing page:

A high doorway, or *pishtak*, marks the entrance to the mosque of Muayyad on Muizz Street. The facade, in *ablak* technique, surrounds a half-domed niche with a very finely worked network of stalactites.

154

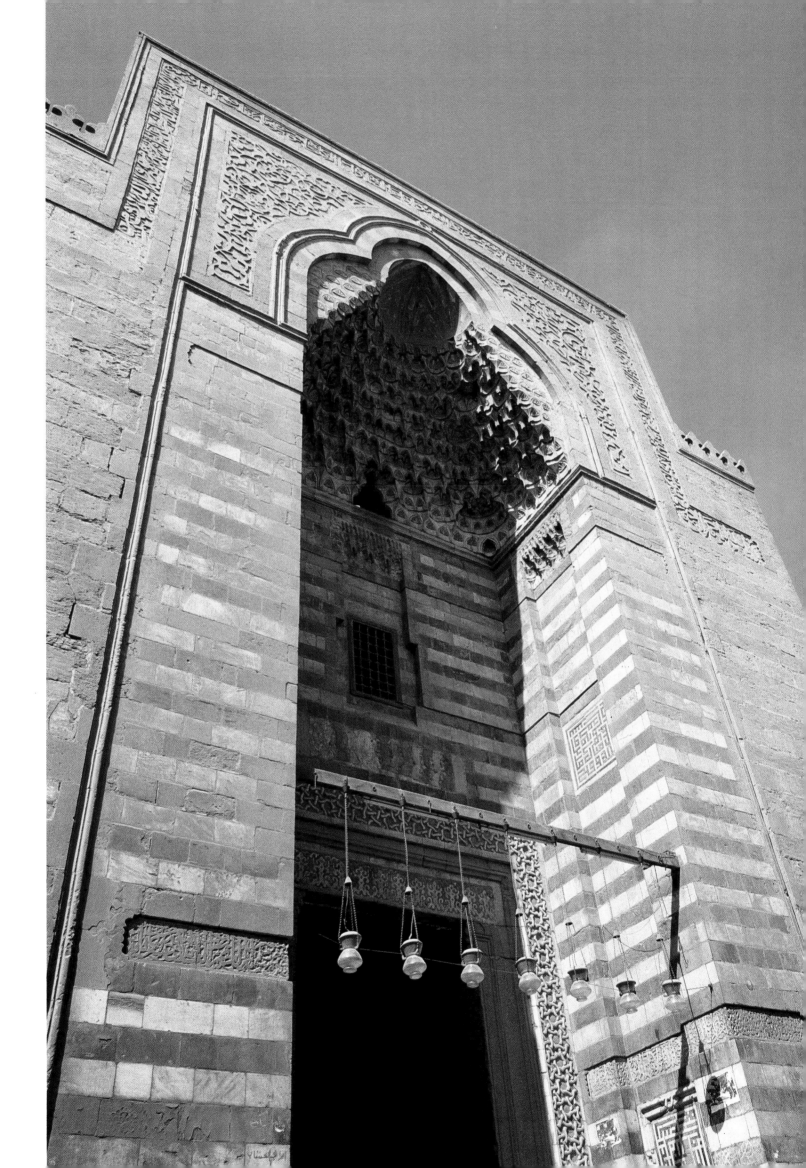

the now classic formula of a dome with angle pendentives carved with *mukarna*s cut into the masonry. Three rows of columns carry the arcades. These are either rehabilitated antique pieces, or high, graceful octagonal pillars. They carry beautifully light and elevated arches. Towards the top, the walls are pierced with a series of small bays, as in the mosque of Mohammed el-Nasir. But here all the proportions are drawn out, in a very pronounced upward motion (see pages 8 and 32).

The gilded wooden ceilings of the rows of arcades parallel to the *kibla* have a richness in harmony with the marble panelling. Multicoloured panels reaching high up the wall provide a magnificent surround to the *mihrab*. The niche itself, next to a *minbar* finished in wood with incrustations of ivory and mother-of-pearl, has infinitely complex voussoirs, treated alternately in black, red and white marble. An antique column in red granite stands on either side of the *mihrab*, topped with capitals carved with very restrained stalactites, similar in form to the creations of contemporary Ottoman art. One of the characteristics of the mosque of Muayyad is provided by its two airy minarets, which the Sultan

had constructed on top of the two semi-circular towers on either side of the Bab el-Zueila gateway. This was a bold undertaking, which required several attempts. The minarets were dismantled in 1418 since they were in danger of falling onto the crowds below – very dense at this south-west entry to the town. Muhammad ibn al-Razzaz supervised their reconstruction, which was only completed in 1420.

The creation of these two 'stone needles', as slender as obelisks, is a testimony to the skill of the Mamluk builders. The topmost level, composed of a ring of small columns holding aloft a little onion-dome, is made up of two octagonal levels separated by balconies underhung with ranges of stalactites. The slight distance between the two minarets – when compared with the space separating the minarets of Farag's *khanka*, accentuates still further the high, graceful effect. This reaching upwards, as though the forms were drawn up by the sky, is characteristic of the last phase of Mamluk art. It was a tendency which was to lead to abandoning the mosque built around a courtyard as such, in favour of more compact, higher buildings.

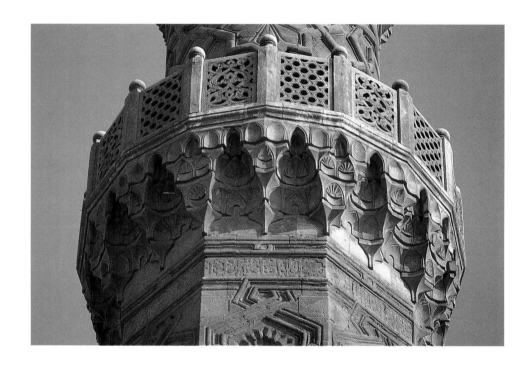

The mausoleum with *madrasa* of Sultan Kait Bey, constructed between 1470 and 1476 in the City of the Dead, to the east of Cairo: a close-up of the minaret, whose overhanging balcony is supported by deeply carved *mukarna*s.

Facing page:

Stone dome of the mausoleum of Kait Bey. Its exuberant decoration spreads over the whole of the high cupola, giving a baroque impression, often found in the final Mamluk period.

Double page overleaf:

Interior of the *madrasa* next to the tomb of Sultan Kait Bey (1468–1496). The courtyard, or *sahn*, covered with a ceiling capped by a lantern tower, has become an interior space preceding the prayer-room. Extremely rich decoration mixes *ablak* with golds and bright colours. Towards the end of the Mamluk period, the arches became taller and lighter.

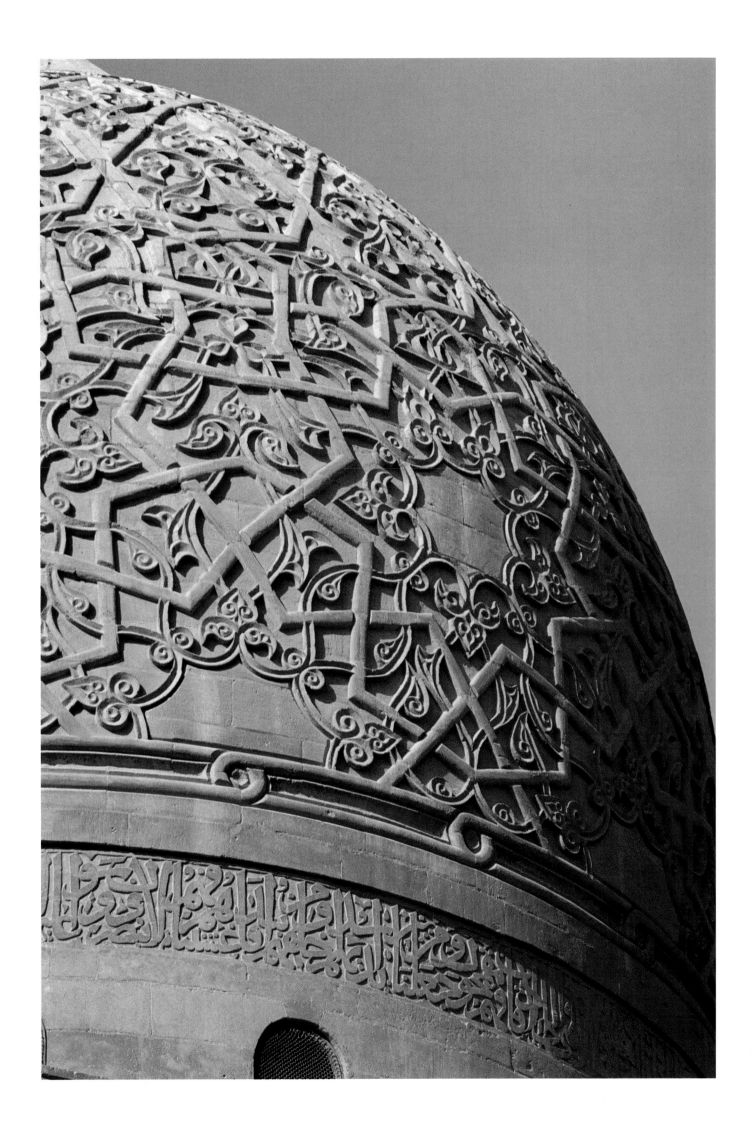

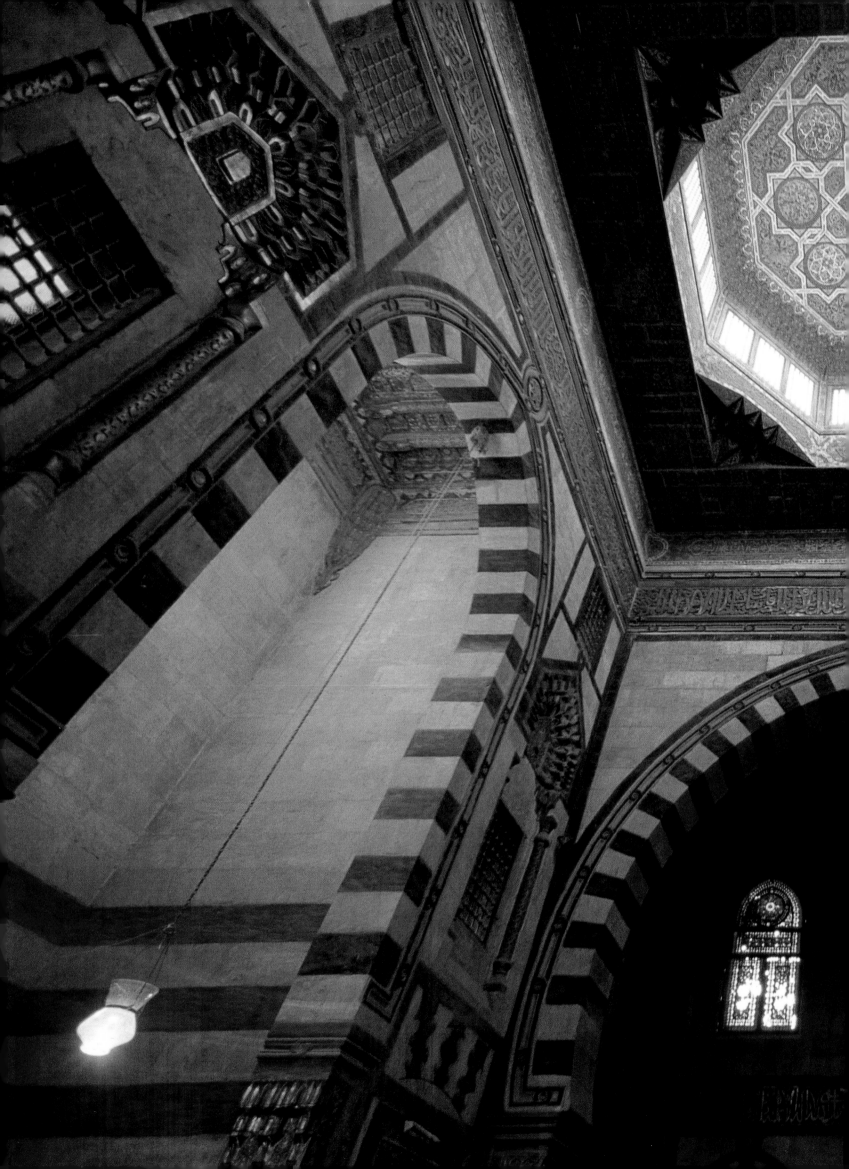

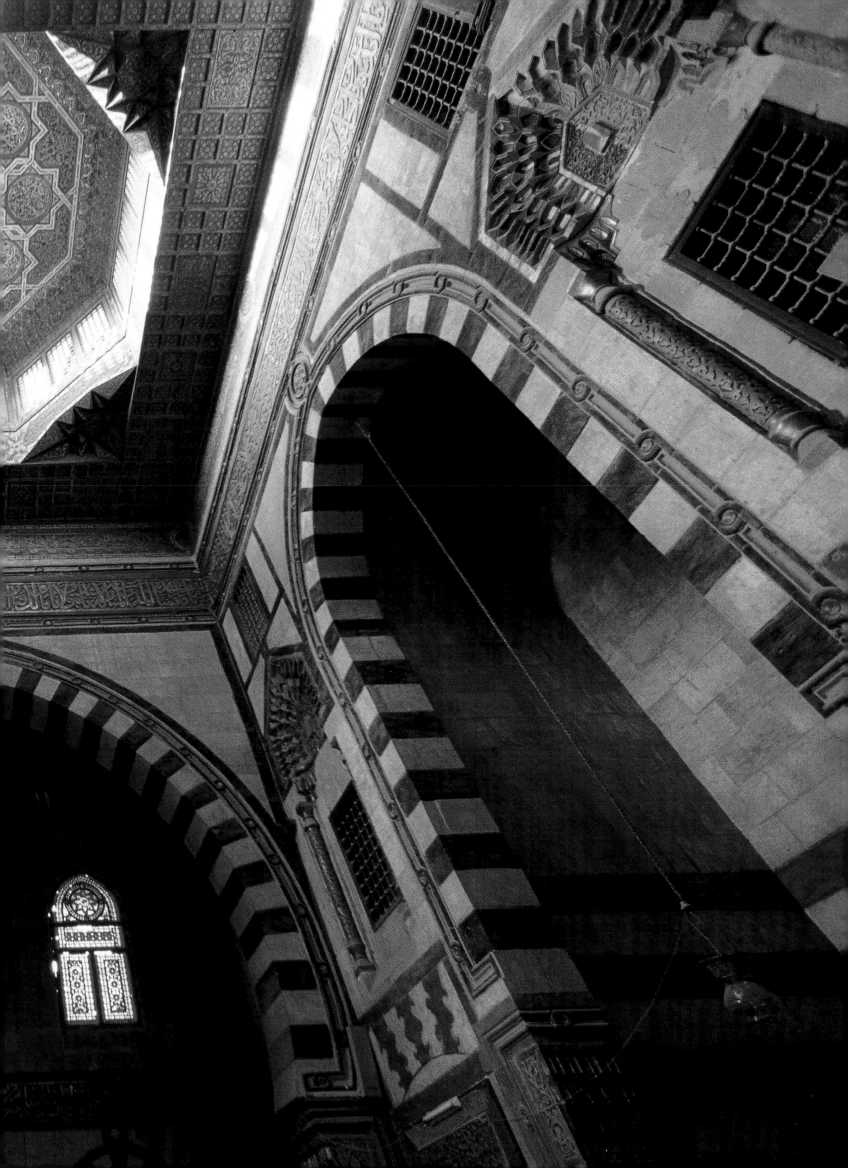

Indeed, from this time on, the vertical aspect of these constructions was stressed more and more, just as in High Gothic buildings in the west.

The Mausoleum of Kait Bey in the City of the Dead

Quite correctly, this building is considered to be a perfect example of the type of Circassian tomb to be found in Cairo's west cemetery. It was conceived on an asymmetric plan, similar to that of the mosque of Kigmas al-Ishaki, built in 1480–1481 by one of Kait Bey's equerries. Instead of being a hypostyle hall, the prayer room is now an oblong space, and the *kibla* wall is full of windows to light the interior. The open courtyard has been replaced by a square space, roofed in wood, with a central lantern tower to give the illusion of the traditional *sahn*, but without the disadvantages of sun, rain or sand-storms. This interior imitation-courtyard cuts the prayer-space in two: it lies between the main room, situated on the south-east, and its pair on the north-west (a system based on the two porticoes of the Prophet's house at Medina). It is a high space, covered by an octagonal lantern with ample fenestration to supply natural light to the building. A study of the mosque reveals the construction to be on a cruciform plan:

Gold leaf covers the stone in the *madrasa* of Kait Bey: the capitals of the pillars, with their stacked rows of stalactites, gleam among the other decorative elements treated in polychrome.

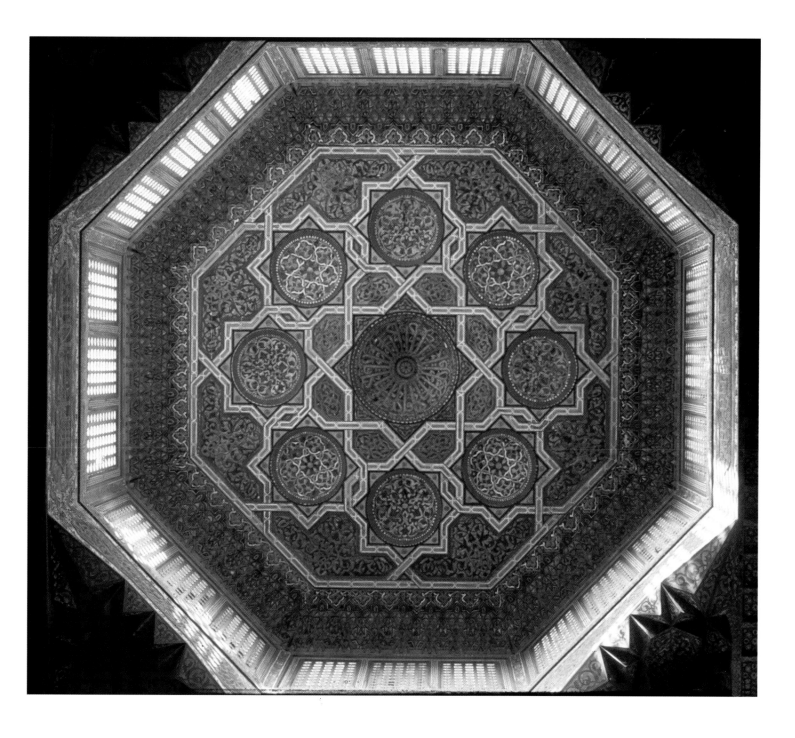

The lantern tower over the *sahn* in the *madrasa* of Kait Bey has been tastefully restored. The superb wood ceiling is amply lighted by a series of triple bays.

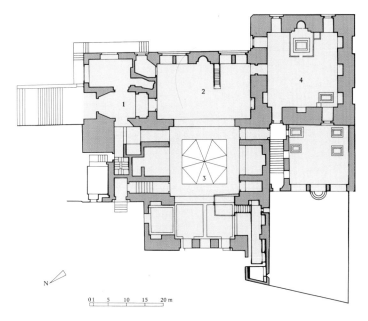

Plan of the mausoleum-*Madrasa* of Kait Bey in the City of the Dead at Cairo.
1. Entry.
2. Vestibule.
3. *Sahn*, or covered courtyard.
4. Prayer room.
5. Tomb.
The plan shows the asymmetric composition of elements which are themselves symmetric.

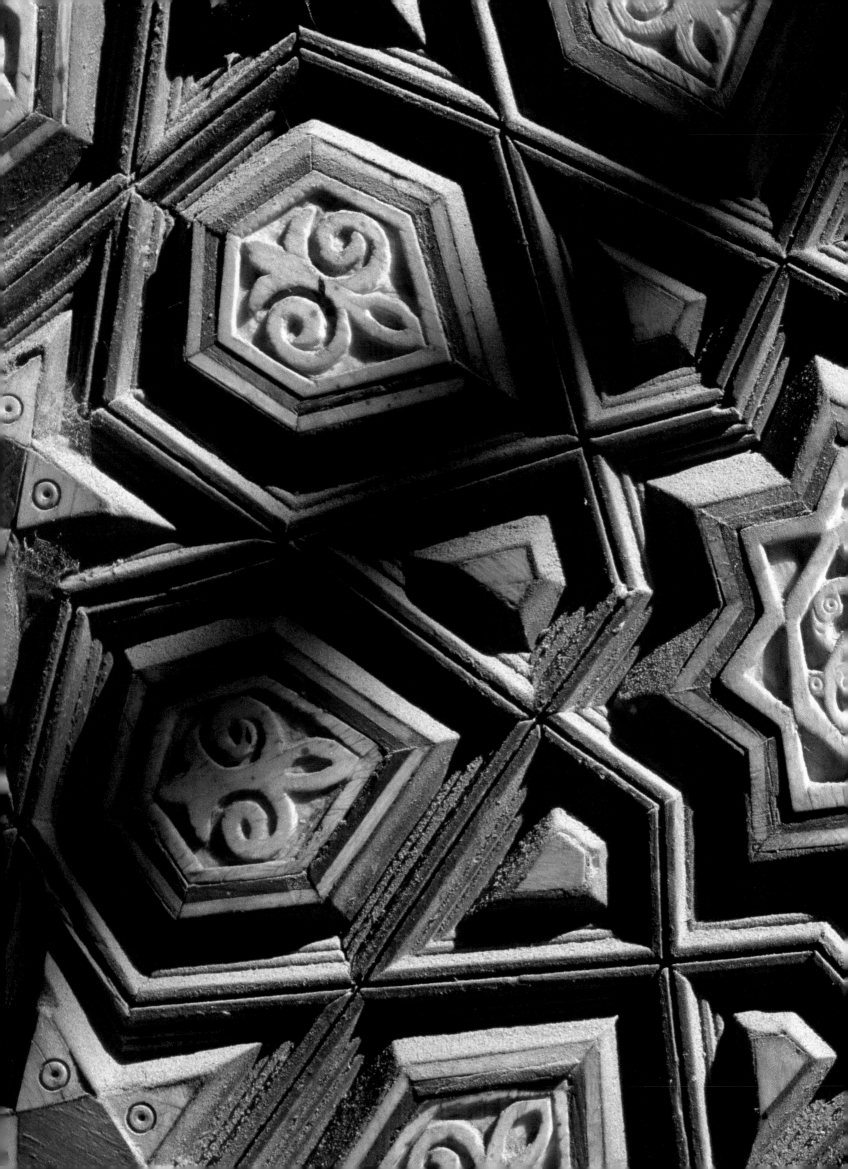

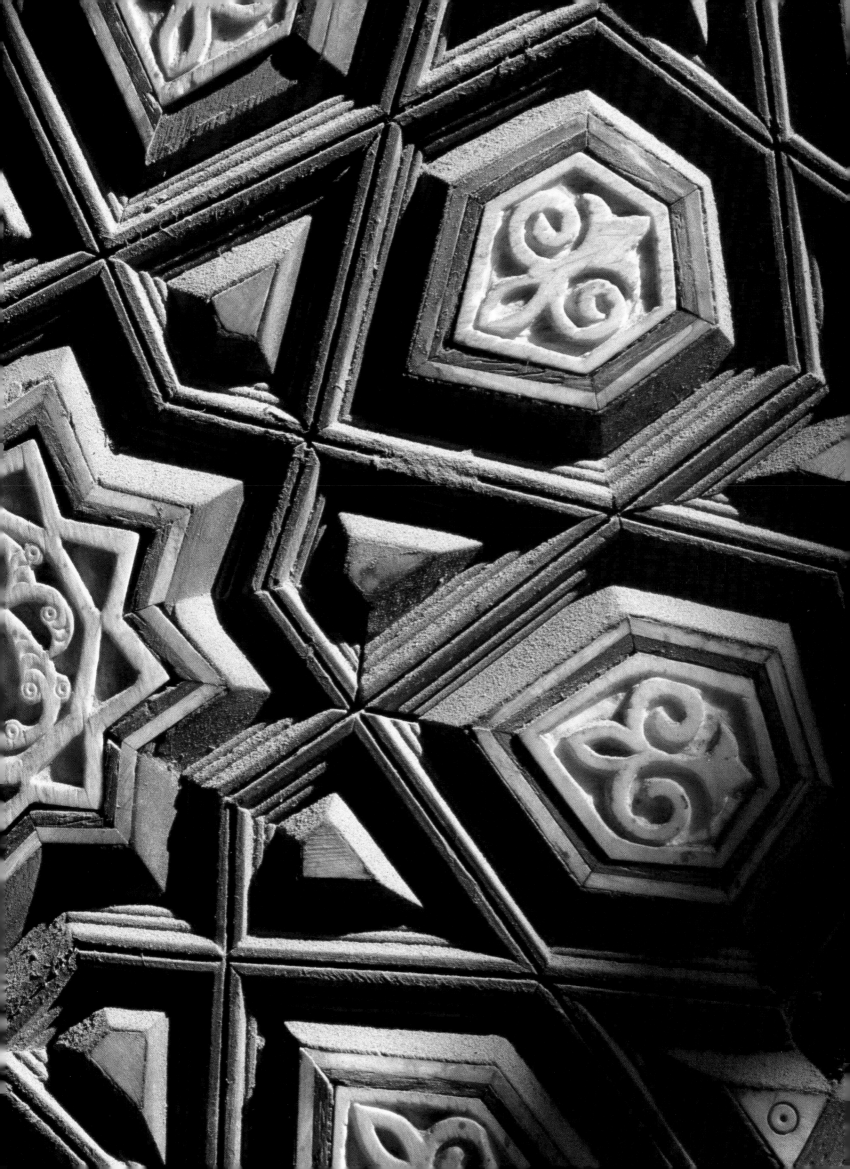

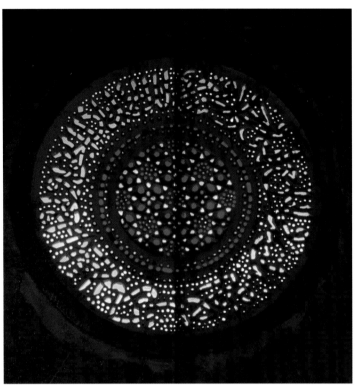

on the longditudinal axis, wide arches open onto the covered courtyard, while to the sides, two high niches represent the survival of the lateral *iwans* in *madrasa*s. It can thus be seen that at the end of the Circassian period, the four-*iwan* plan for Koranic schools developed into the model for places of prayer, whether funerary or not. The system replaced the formula of the mosque with courtyard. Similarly, Kigmas al-Ishaki demonstrates that the process also applies in mosques situated in the popular quarters. Since there was no longer a distinction between inside and outside spaces, the gold and polychrome decoration could now spread into the covered *sahn*, as well as over the walls of the *haram*. The whole building was transformed into a jewel case, glittering with colour, medallions, and gilded capitals, with glorious stained glass windows all around, and brilliantly colourful friezes in *naskhi* script. But while the double symmetry of the plan and its cruciform basis are apparent on the interior, outside the appearance is utterly asymmetrical. The architect has juxtaposed the various elements – entrance, vestibule, minaret, domed tomb – uniting the unequal volumes in as compact and dense a manner as possible, without concerning himself about symmetry, axes, or duplication. The result has a 'baroque' feeling to it – lively and surprising. By playing off the components against each other, the architect affirms the identity of each part – the cohesion of the domed tomb, the vertical stretch of the minaret, the clear volumes of the body of the main building, reached by the flight of steps leading up to the entrance niche of the doorway.

Above and facing page:

The stained glass in the *madrasa* of Kait Bey is of a quality not seen previously. The interplay of colours and geometric forms in the stucco reaches new heights.

Right:

Enamel ceramic tile (diameter: 30cm) representing Sultan Kait Bey's coat of arms. The inscription reads: 'Glory to our master, Sultan al-Malik al Asraf Abul-Nasir Kait Bey. May his victory be glorious.' (al-Sabah Collection, Kuwait).

Previous double page:

Close-up of the marquetry in ivory and precious wood decorating the chair, or *minbar*, in the prayer room of the *madrasa* of Kait Bey. Sunlight falls on the astonishing work of the fifteenth-century Mamluk cabinet makers, each competing with the other in the treatment of geometric systems. The basis here is a nine-point star

Syrian influences

The *madrasa*–mausoleum situated between the imposing mass of Sultan Hasan and the Citadel was constructed by Kanibey Kara al-Rammah, known as Emir Akhor, Master of the Horse to Sultan el-Ghuri, in the last years of independence, 1503–1504. This complex is also based on an asymmetrical plan, but benefits cleverly from the steeply sloping terrain. The alternate layers of stonework are no longer black and white but actually red and yellow, giving a warm tone to the exterior. While its dome fits into the Circassian tradition of mausoleums, the minaret, with its double summit, is square from top to bottom. These two square storeys, rather than cylindrical or octagonal segments, are the sign of a Syrian influence, which Meinecke also recognises in the formula of certain fan vaults found in the vestibule of the *madrasa*-mausoleum of Kait Bey, as well as in the el-Khali *khan* of el-Ghuri.

Was it the threat the Ottomans posed to the Syrian province of the Mamluk empire at the end of the fifteenth century that caused teams of stone-cutters and builders to arrive in Cairo, from

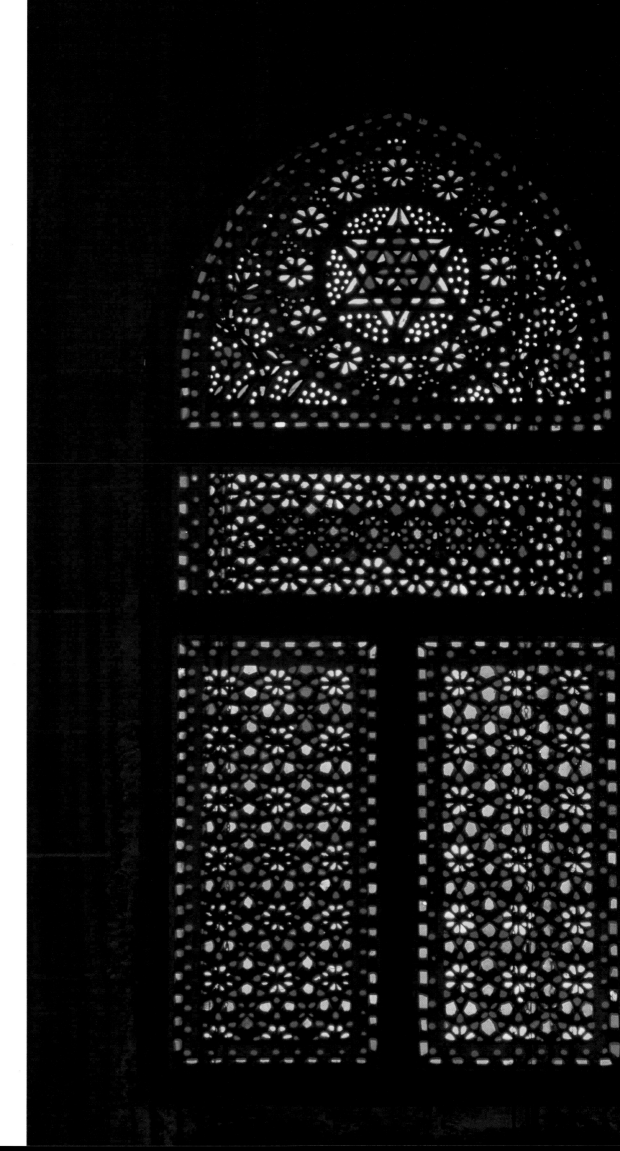

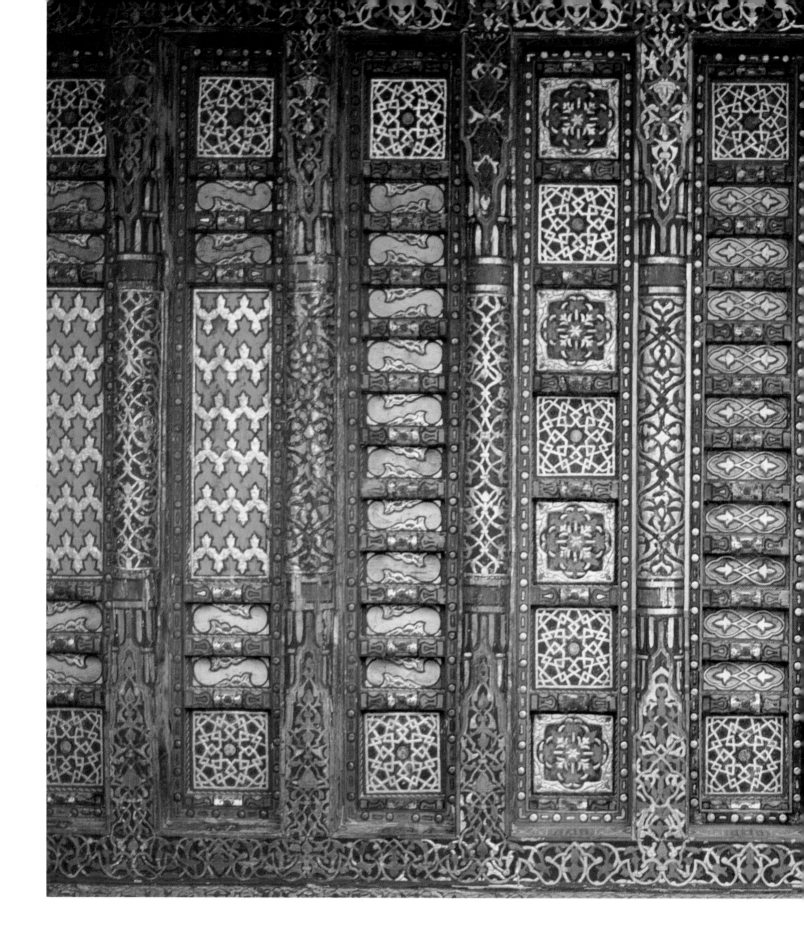

Beamed, coffered ceiling in gilded wood in the prayer room of the *madrasa* of Kait Bey. The ornamentation introduces multiple variations into the regular, beamed framework, in the mannerist style of the late Mamluk period.

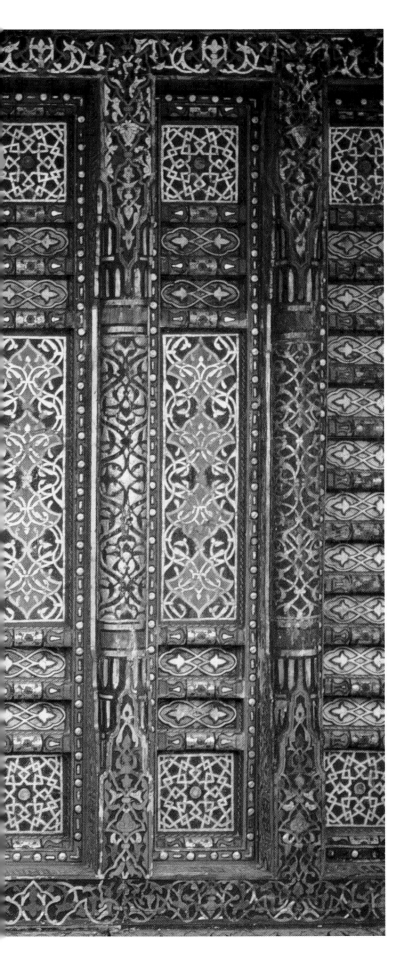

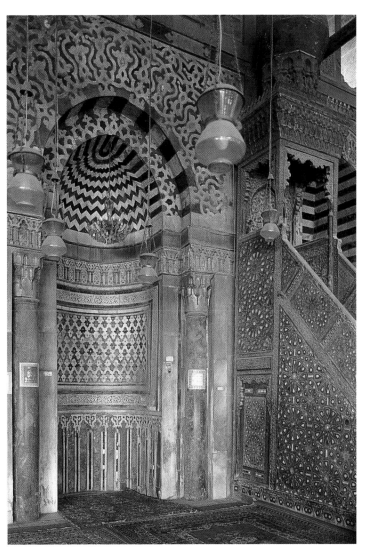

The *mihrab* and the chair, or *minbar*, in the prayer room of the *madrasa* of Kait Bey. The decoration of the niche attains an incredible richness and complexity. The *minbar* is covered with stellar motifs, heightened in ivory.

Aleppo or Damascus, thus introducing into Egypt their techniques and practices? The theory is not improbable. The development of Syrian technologies in the last phase of Cairo architecture can scarcely be explained without the massive intervention of artisans capable of importing new formulae. A number of foreign influences permeate this last period of Mamluk architectural activity, tending to accentuate still further the multi-cultural character of an art always open to exterior sources. Its faculty for assimilation was such that these influences were not slavishly copied but served to enrich and enhance a genuine style. Just as Egypt under the Mamluks was an international crossroad for supplies and business, so its art fused influences from the most varied horizons into a vigorous and harmonious whole. The mobility of workshops, ideas and people in the Islamic world is at the basis of the capacity of the Egyptian Sultanate to open to outside currents, a capacity which it turned to such good purpose.

The form of medieval Cairo architecture is recognisable, and typical; but it is neither regional nor shuttered by local traditions. The legacies from neighbouring lands, near and far, were adopted, synthesised in an original manner. Perhaps this astonishing ability to adapt stemmed from the Mamluk's lack of 'nationalism' – since they themselves were foreigners on the banks of the Nile – and also from a certain aesthetic tolerance, possibly due to the lack of any architectural tradition in their slave-sultan origins.

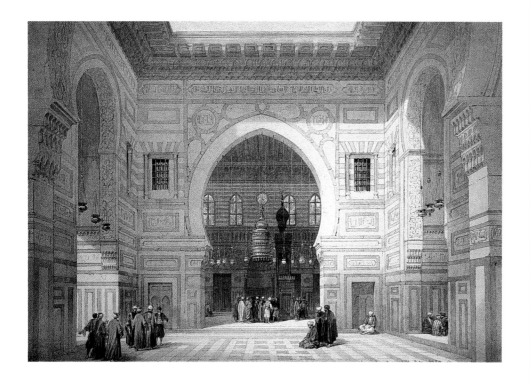

The *sahn* of the *madrasa* of Sultan el-Ghuri (1501–1516), from a painting by David Roberts. The building, begun in 1503, shows the lavish ornamentation so dear to the last sovereigns of Cairo, before the incursion of the Ottomans.

Facing page:

The tomb of el-Ghuri was begun in 1504, but not finished until 1516 – one year before the fall of the Mamluk empire to the Janissaries. Its vestibule is roofed with a highly-wrought wooden lantern tower.

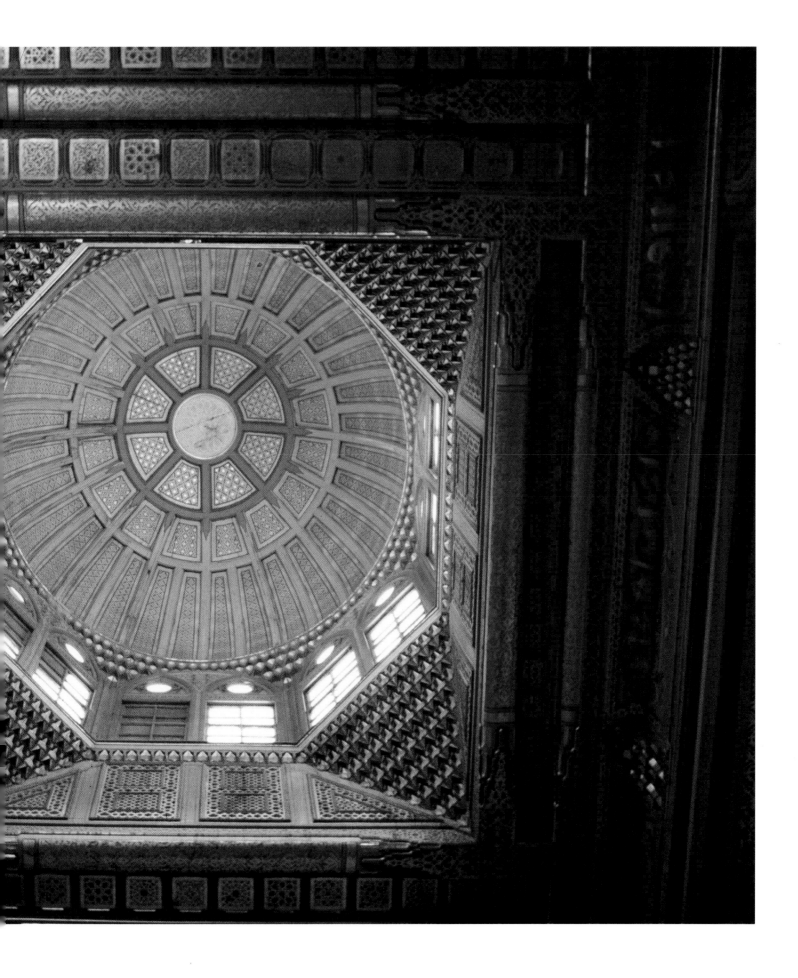

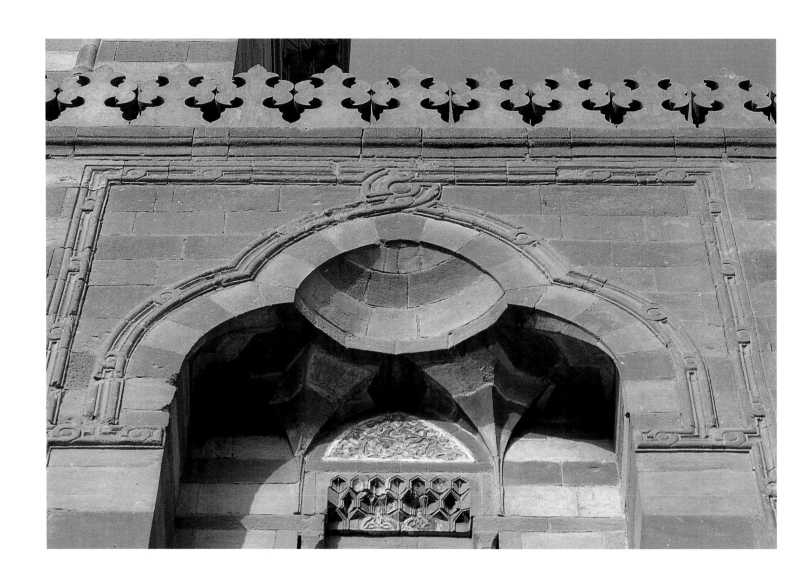

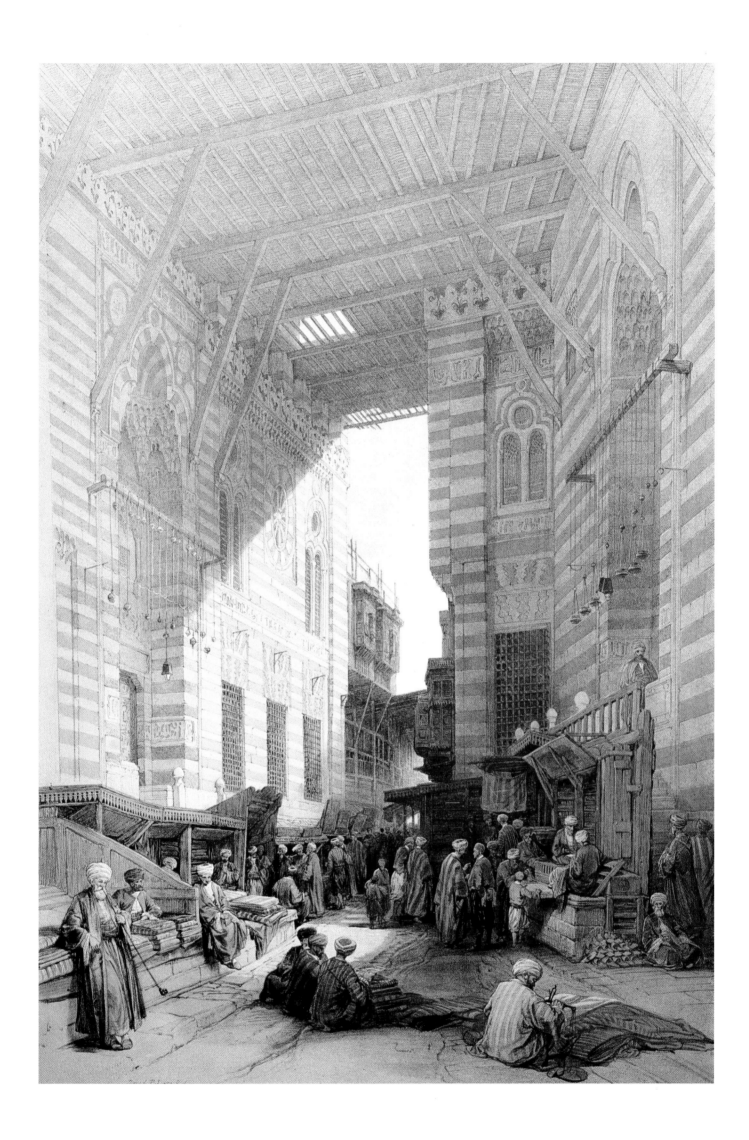

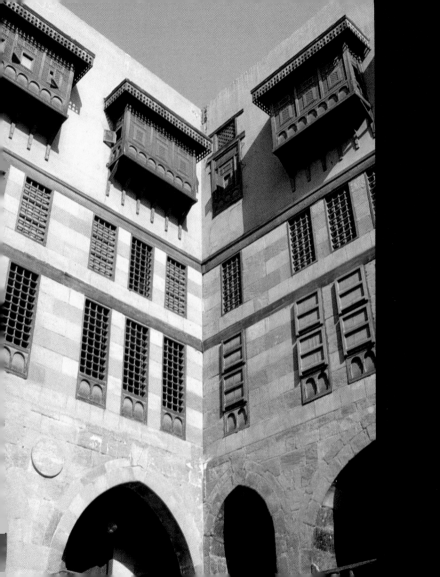

THE MAMLUK PALACES

So FAR, only the religious buildings constructed by the Mamluk Sultans have been considered. While the disappearance of the larger part of the dwellings of the period, as well as the demolition of the great palace of the Sultans, places civil construction somewhat in the shade of religious construction, it must not be concluded that there were no prestigious works at all. The Mamluks, like other Muslim sovereigns, surrounded themselves with an astonishing richness and magnificence, thereby proclaiming their authority over an empire which, for two and a half centuries, was at the centre of east–west relations. The great majority of the resources of this empire stemmed from the vibrant international commerce, over which Egypt maintained primacy in the entire Near East by the power of its army of slave-soldiers, from which the Mamluk chief himself issued.

The Sultan's Palace in the Citadel No trace remains of the great palace that the Mamluks built 'on the mountain', that is, on the first slopes of the Mokkatam, dominating the south of the city of Cairo. This is because after the Ottoman annexing of Egypt, these Palatine buildings fell into disrepair, and were then razed to the ground by Mohammed Ali, to make room for a pseudo-Ottoman style mosque dating from 1824. The descriptions by Arab authors, a few old engravings, as well as the all too rare archaeological excavations, combine to give a general picture of these palaces from *The Thousand and One Nights*. Sultan Baibars, with a view to marking his new power as the founder of the Mamluk authority in Cairo, constructed a vast palace called Dar al-Dahab (The House of Gold). He chose to do this in the Citadel of Saladin, and not in the main part of Cairo, as had the Fatimids: the building was inaugurated in 1266. The complex included a throne room, roofed with a green dome carried by 12 marble columns – an arcade of three arches on each side of a square space. The walls were decorated with frescoes showing hunting scenes, and another where the entire court follows the Sultan in a procession. It was here that the Sultan received foreign ambassadors and held official audiences; in 1286 he added a state-room to it, roofed with rows of domes supported by 94 columns. The walls were painted with landscapes, probably similar in style to the mosaics in the great mosque at Damascus, which were also the inspiration for the gold mosaics on the tomb of Baibars I at Damascus.

Vernacular architecture was not limited to palaces. Shown here, the *okella* of Sultan Kansuh, dating from 1504, is a building with a courtyard, which served as a shop, a bazar and a caravanserai. The *mucharabieh*s on the top floor are particularly fine.

Court ritual Although nothing remains of it, reference must none the less be made to the considerable work undertaken on the palace in the Citadel by Mohammed el-Nasir. He completed, embellished or replaced the constructions of Baibars I and his successors. He built the Great Iwan (1315), which Kalaoun was to use as a court of law. It was the room in which ambassadors were received, and where the Sultan reviewed his Mamluks during court ceremonies.

The Great Iwan – also referred to as the Diwan of Joseph in early nineteenth-century engravings – was made up of 32 columns of pink granite from Aswan, each eight metres high. These columns were rehabilitated ancient pieces and supported a dome on top of stone arches. This was, therefore, the throne room proper, or *diwan-i am* in Persian palaces, which was used in the court ceremonies of Muslim sovereigns as the room for public audiences.

In 1313 Mohammed el-Nasir also built the Qasr. This was another Palatine room, where the Sultan met with his councillors. It corresponded to the Persian *diwan-i khas*, a room for private audiences. The room was used, for example, for the ceremony of investiture of a new sovereign, before holding the magnificent court rituals aimed at a larger public in the Great Iwan. In Cairo this building was known as *kasr el-ablak* (the White and Black Palace), like the palace built by Baibars in Damascus. This entirely Palatine system, with its two courts, could be observed at the same time at the Nasrid Alhambra at Granada (see our study, *Alhambra*, Paris 1991), as well as at the court of the Ilkhanid Mongol sovereigns of Persia; it could subsequently be seen with the Grand Moguls of India

The *diwan-i am* and the *diwan-i khas* constituted the two poles of the Mamluk court. To them, the Sultan added his private dwelling, with his harem. He also carried out large-scale improvements on the hippodrome constructed by Saladin to the west of

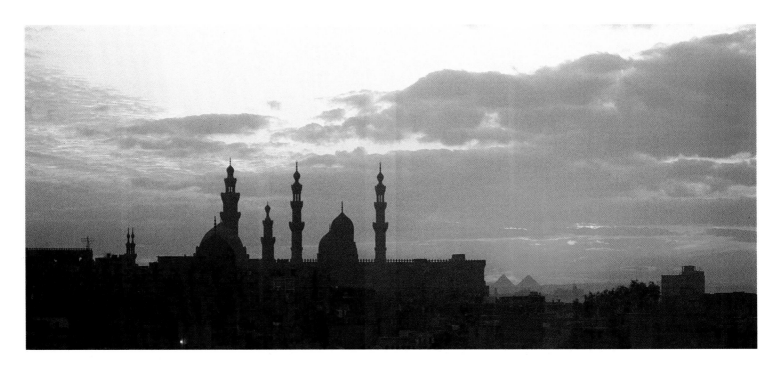

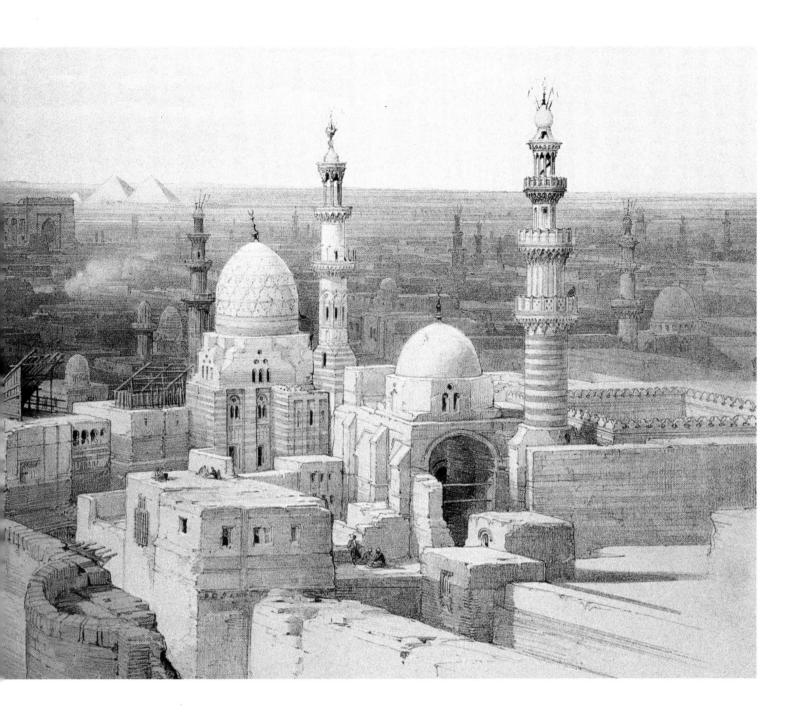

Just as when David Roberts was painting the scene a century and a half ago, the domes and minarets of Cairo's roofs stand out against the sky. The imposing bulk of the *madrasa* of Sultan Hasan, with the late nineteenth century el-Rifai mosque now facing it, rises up before the silhouettes of Chepren and Cheops visible on the evening horizon.

General view of Cairo, painted by David Roberts, from the western defences of the Citadel. It shows to the left, behind a forest of Mamluk domes and minarets, the bulk of the *madrasa* of Sultan Hasan, rising in front of the Pyramids of Giza on the west bank of the Nile.

175

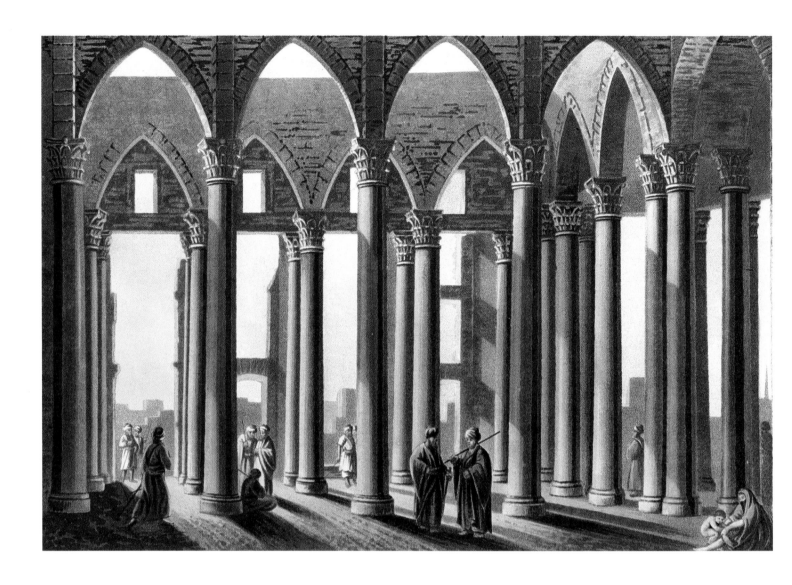

The columned room of the Mamluk palace on the Citadel: from a painting of the ruins of the Great Iwan, built in 1315 by Sultan Mohammed el-Nasir, by the artist Louis Mayer, whose works were published in 1802. These remains, referred to at that time as the 'Diwan of Joseph', were demolished in 1824 by Mohammed Ali, Pasha of Egypt, to make room for the late Ottoman-style mosque erected in the place of these palatine buildings.

the Citadel. In this way, he followed the fundamental elements of the palatine complex which was current with the Fatimids, inherited by them from the Abbasids of Baghdad and Samarra, who were in turn influenced by Byzantino-Sassanid traditions inspired by Imperial Rome. The hippodrome was not only used for great imperial displays (as at Constantinople), but also for the training of the Mamluk cavalry, various jousting matches, and also for polo, a game of Sassanid origin, which was the equivalent of Roman chariot racing. All these festivities were part of court ceremonials during the reign of the Mamluk sovereigns.

A survivor – the Beshtak Palace One of the rare remains of Mamluk palatine architecture is in the heart of Cairo, in front of the *madrasa*-tomb of Barkuk, on Muizz Street. Emir Beshtak, brother-in-law to Sultan Mohammed el-Nasir, built this palace between 1334 and 1339.

It is easier to grasp the significance of this building since its restoration (by the Swiss architect, Philipp Speiser, on behalf of the German Institute). There is a fine state room on the first floor, the main floor of the building. The complex is based on a cruciform plan, known as a *kaa*. In the middle is a square, sunk one step lower than the four *iwan*s around it. At the centre, a fountain murmurs in an octagonal basin, executed in mosaic and polychrome

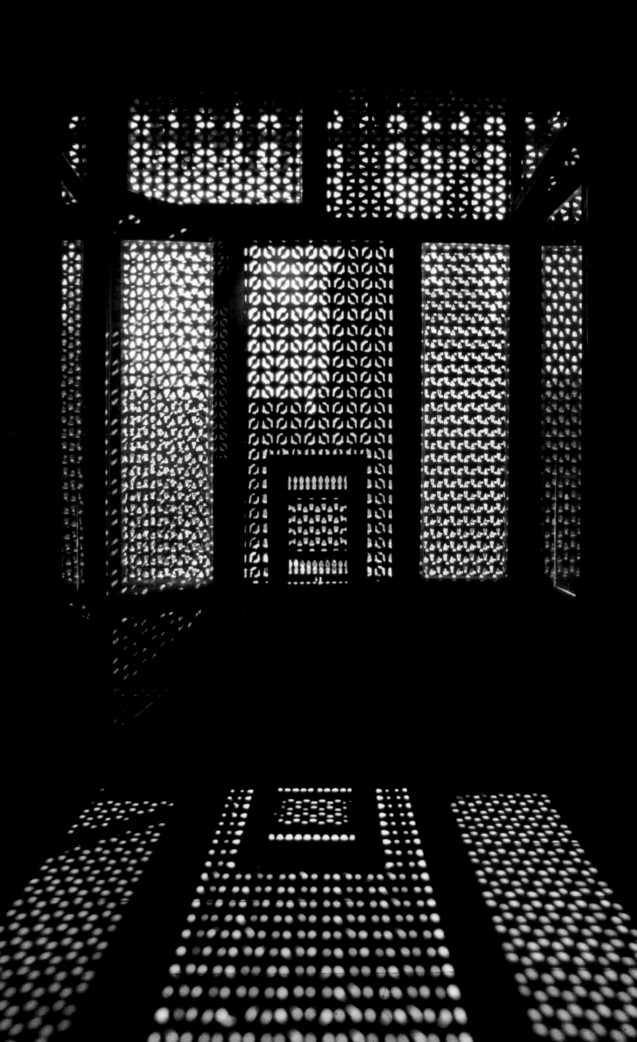

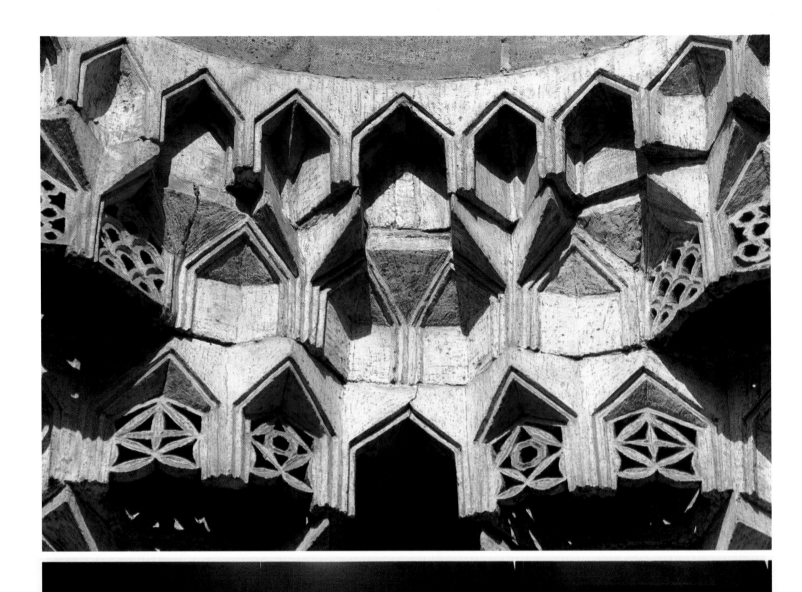

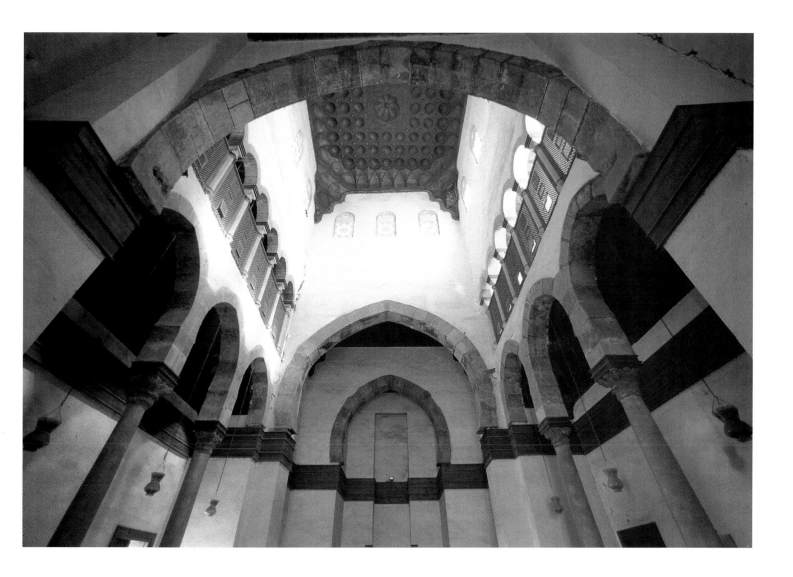

marble. This skilfully restored item in particular helps us to imagine the original ornamentation so admired by the Arab historian Makrizi.

The principal *iwan*, on the main axis of the room, has a deeper section, where the Emir and his close advisors sat. Opposite, another *iwan* provided space for visitors admitted for an audience. These two spaces, separated from the central zone, and dominated by the lantern tower held aloft by wide, pointed arches, have a wooden ceiling with octagonal coffering. The *iwan*s on either side are fronted by arcades made with pairs of rehabilitated columns. The three raised arches borne by these columns are of real elegance. On either side, above, runs a gallery formed from small pillars and covered with *mucharabieh*s, designed to enable women to be present at receptions without being seen.

The use of *mucharabieh*s was a specific element of Muslim buildings. In Cairo, this open-work in turned wood was generally the product of Copt artisans, who were skilled in carpentry, furniture and cabinet-making. This type of screen has the advantage of offering a protection from the full heat of the sun, while providing both a filtered illumination and the ventilation needed to keep the dwellings cool. The desire to provide agreeable temperatures also led to the construction of very high rooms, just as in the central part of the Beshtak Palace. This hall, lit by 12 stained glass windows high above, with its tinkling fountain below, is an example

The only authentic Mamluk palace to come down to us in relatively good condition in Cairo is the Beshtak Palace, named after one of Sultan Mohammed el-Nasir's Emirs, begun in 1334. It lies on Muizz Street, in front of the *madrasa*-tombs of Kalaoun and Barkuk. On the main floor, its high reception room has galleries provided with *mucharabieh*s, and a coffered wood ceiling.

of true palatine luxury. The receptions and audiences that took place against such a background must have been remarkable, with sofas and cushions, multicoloured rugs, low tables in engraved copper, basins and ewers decorated with silver and niello, and, of course, music played by the musicians who would have been attached to this lord's house.

Private houses One of the very last houses in the Mamluk style conserved in Cairo gives an impression of just such a warm and living background as this. Not far from the building known as the *madrasa*-mausoleum of Emir Akhor, near to Sultan Hasan, a private house, number 4, Darb el-Labban, can be found. This has been very finely restored and furnished so as to reproduce the possible atmosphere that must have reigned in a person of quality's dwelling in Mamluk society at the beginning of the sixteenth century.

As in the Beshtak palace, but on a smaller scale, the reception room is on the first floor. A courtyard hides the real dwelling from curious eyes. On the *piano nobile* there is a large room. This reception room is made up of two aisles on either side of a slightly sunken, square central space. Above, illumination comes from windows set in a wooden lantern. The two lateral *iwan*s hold the bulk of the furnishings, sofas, rugs, caskets and low tables. The beams of the ceiling are painted with decorative motifs. The windows have either *mucharabieh*s, or stained glass. The vestibule leading into this reception room also provides access to a shady terrace with a fountain. This sort of restoration makes it possible to imagine an entire lifestyle. Five centuries later, this dwelling provides a faithful evocation of the civilisation spread by the Mamluk world throughout the Islamic Middle Ages. Today, as then, the luxury of this refined habitat mixes *tiraz* cloths and hangings from Cairo, with rugs and kilims from Persia and Anatolia. These former Kipchak slaves, as they ascended the social hierarchy, gradually acquired the refinement and the taste of peoples of long, non-nomadic culture.

A window from the Beshtak palace, which gives onto the main Cairo street. Various geometric rhythms combine in the wooden open-work, filtering the rays of the sun.

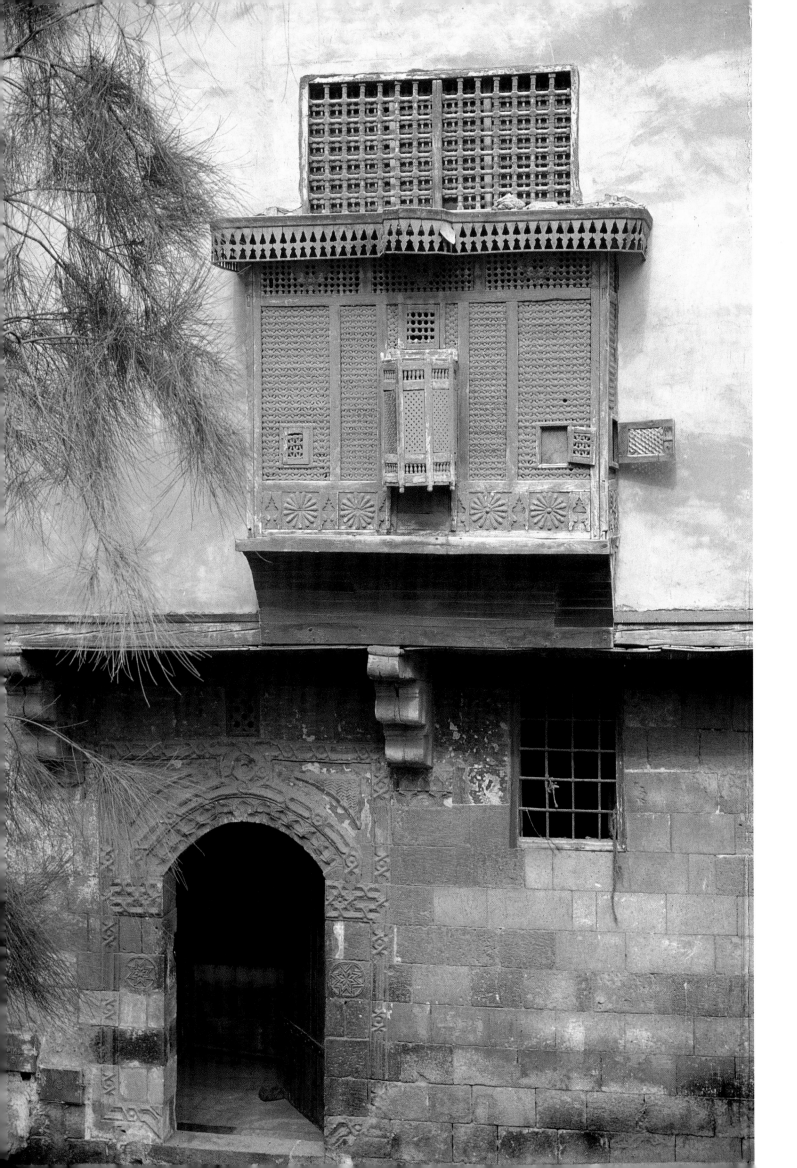

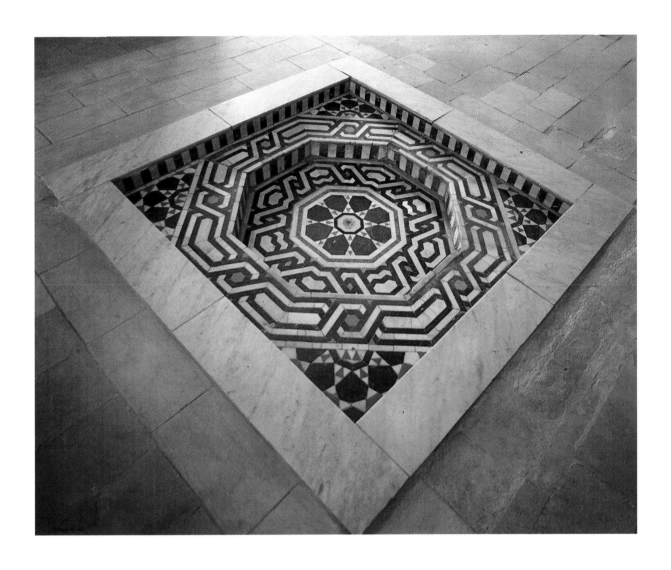

Facing page, top:

Stalactite carving above a door of the el-Khalili *Khan*, a bazaar built by Gaharkas el-Khalili (lieutenant to Barkuk) and continued by various Sultans after. These buildings were highly important in promoting commerce and organisation in the Mamluk capital.

Facing page, bottom:

The *mucharabieh*s of the al-Razzaz palace, built by Sultan Kait Bey in 1483 and altered in the eighteenth century by Ahmad Katkhuda al-Razzaz. The art of turned-wood open-work creates an atmosphere characteristic of Muslim life.

Above:

In the Beshtak palace, a basin with a fountain (*fiskiya*) murmured agreeably in the high space of the reception room. Beneath the beamed and coffered ceiling, the octagonal basin inscribed within a square lies at the centre of the state room.

Public service buildings The *art de vivre*, which developed under the Mamluks also presents other aspects, which, while more utilitarian, are none the less interesting. There were, for example, the public fountains, or *sebil*s, and above all, the baths, or *hammam*s. Unfortunately, although it is known that there were considerable numbers of *hammam*s in the city, the rare surviving examples are not in sufficiently good condition to be shown here.

The *hammam*s of the Islamic world descend from Roman thermal baths and included a whole series of rooms with specialised functions: changing-room, hot or cold bath, steam-room and spaces for exercise or massage, etc. In general this complicated programme resulted in vaulted spaces of genuine architectural quality. The remaining examples in the Ottoman world or in Persia show quite how regrettable it is that those from Cairo should have disappeared.

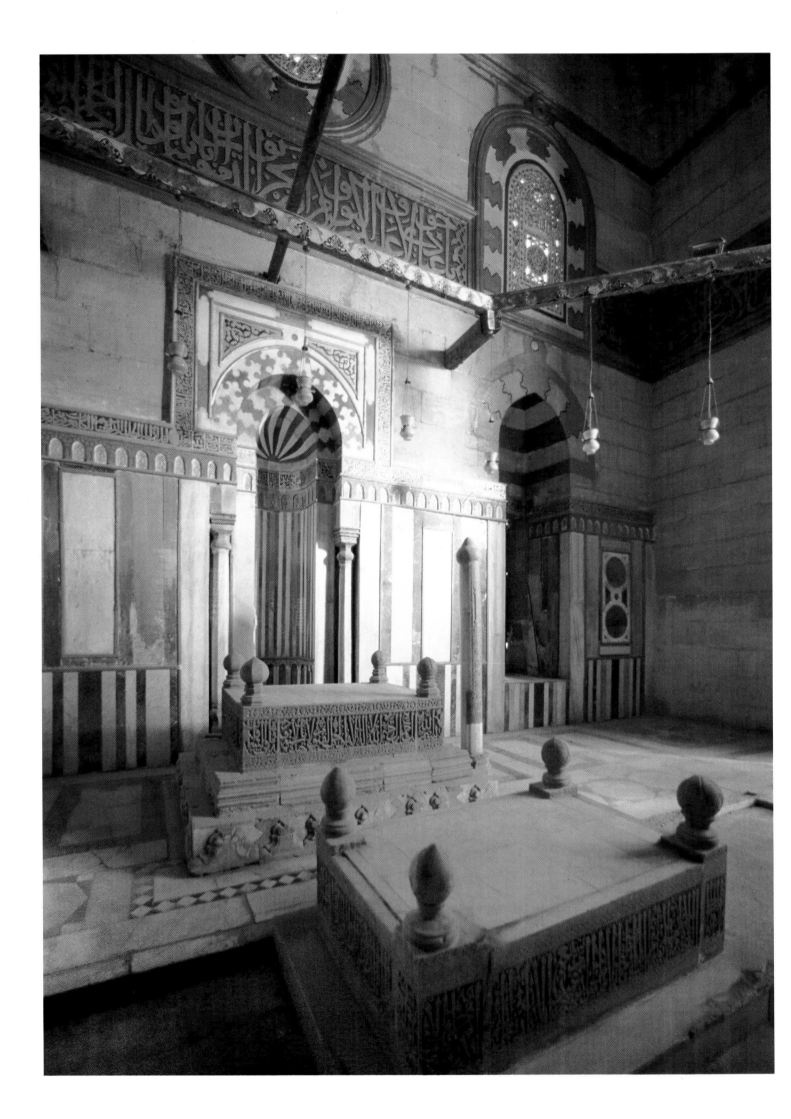

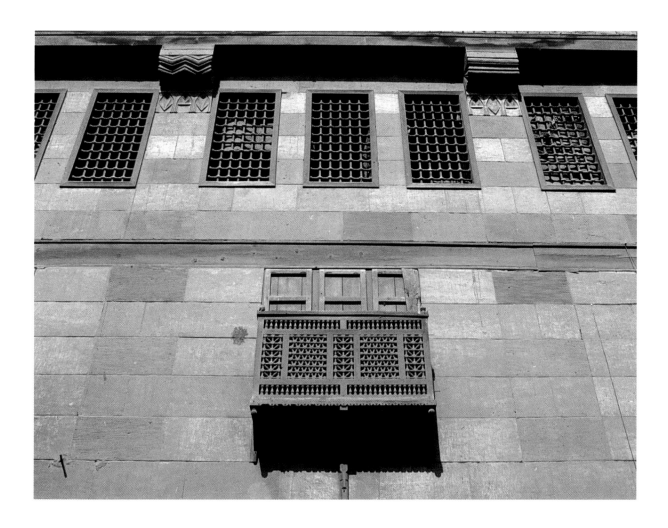

The street facade of a house situated on Darb el-Labban, with sculpted door and *mucharabiehs*. One of the rare dwellings in the Mamluk style still in existence in Cairo.

Some important hydraulic installations were also created, notably in the field of aqueducts. Sultan el-Ghuri constructed the great water supply system which provided water for the Citadel and surrounding areas, shortly before the rise of the Ottomans. An enormous hexagonal tower was built next to the river, and oxen were used to mount the water up, landing by landing, using chain loops and buckets.

There were also the caravanserais, or *khans*, which provided travellers and merchants with food and shelter, as well as other commercial buildings, known as *okellas* (*wikalas*), which consisted of a wide courtyard, surrounded by several floors of shops. El-Ghuri's *okella*, not far from his *madrasa* and tomb, was built in 1511.

A play of screens and grilles gives rhythm to the facade of the bazaar-caravanserai of Emir Kusun, in the western part of Cairo, near Bab el-Nasr.

185

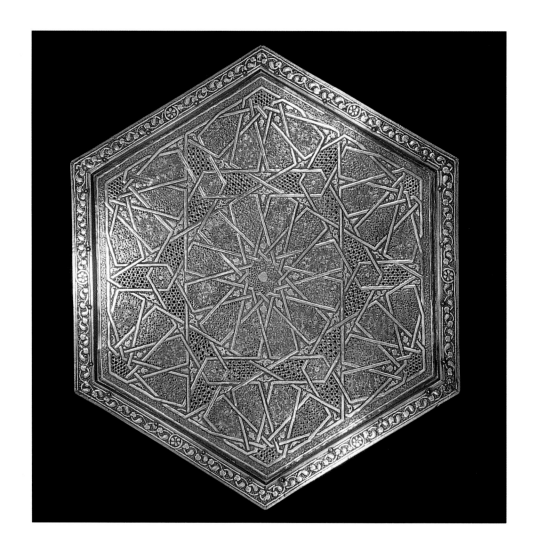

A pedestal table with cupboard to contain the Koran, finished in engraved and open-work copper and silver: a fine example of the decorative geometry developed by the Mamluks in place of figurative art. (Private collection)

APPENDICES

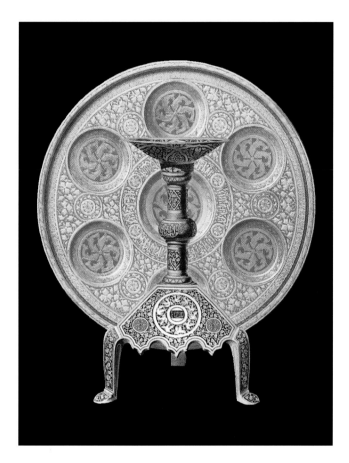

A candle-stick holder and a tray in engraved copper, from the furniture of Kalaoun (thirteenth century). From a drawing by Prisse d'Avennes, published in 1877.

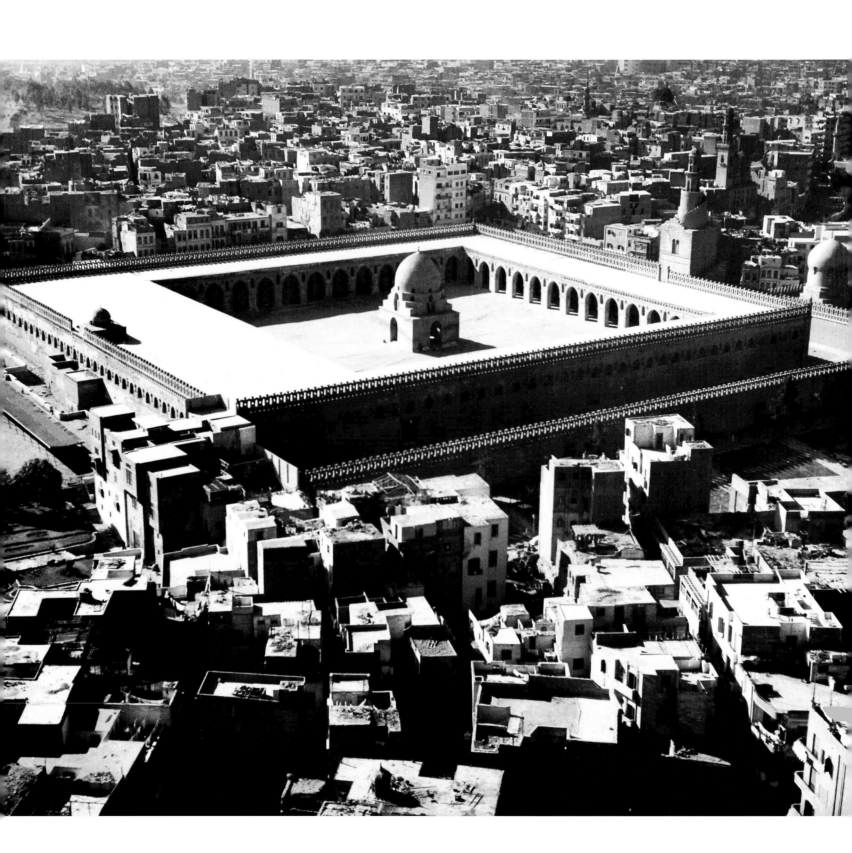

The Grandeur and Decadence of Mamluk Art

The richness and beauty of the constructions of the Mamluk Sultans of Cairo is extraordinary. This over-rapid review of the principal monuments allows an insight into the great quality of such marvellous constructions as have survived in the Egyptian capital.

These buildings have been saved as a result of scientifically conducted restoration programmes, carried out with taste and patience by talented craftsmen under the direction of rigorous institutes. However, mention must be made of the irredeemable loss of a certain number of glorious works. Equally, theft and plunder have removed from the constructions some of the magnificence they must have presented when first built, between 1250 and 1517.

The descriptions of early Arab authors would suggest that the destruction of the great palace is an especially regrettable loss. They speak of painted ceilings, mosaics of a thousand colours, a dais of gold and azure, and a green ceramic dome. The stained glass windows sent shafts of coloured light across the walls, as though the walls and vaults had been studded with jewels (Makrizi). The lamps were set with stones, the scented halls had marble floors and with their high ceilings were as cool as paradise. The splendour of the panels of red, white and black marble, inlaid with serpentine, porphyry and cornelian cannot simply be the product of the authors' imaginations. The Beisariat hall, built by Sultan Hasan in the Citadel, was apparently lit by 400 candelabras, so the writings say, and the throne was like a tower of ivory and ebony, which shone so brightly with gold that the Sultan himself was almost blinded (Makrizi).

Besides the mosques, *madrasa*s, *khanka*s and tombs that can still be admired, we must imagine the luxury of the installations of the *hammam*s, and the generosity of the Sultans in their palatine buildings, designed to give physical form to the power of a sovereign who commanded a wide empire and who, as guardian of the Holy Sites, directed the Islamic world.

Louis Hautecoeur and Gaston Wiet, writing in 1931, stressed the marvels of Mamluk art and architecture, insufficently recognised even today: 'No other Muslim town possesses as many interesting mosques as Cairo. Situated between Asia and Africa, on the route taken by caravans and by invasions, far enough from the sea not to be a Levantine port, but near enough to receive a western influence via the Mediterranean, the town has profited from all the

The tomb of Sultan Barkuk constructed by his son Farag, from 1399, in the City of the Dead in east Cairo. Behind the sovereign's burial place is the *mihrab* oriented towards the *Kaaba* in Mecca and sanctifying the funerary chamber. This mausoleum perhaps represents the peak of architectural achievement under the Circassian Sultans.

Following page :
Detail of the stone dome crowning the tomb of Emir Korkmaz built in 1506. Decorated with lozenges around the base of the spherical surface, then with a regular zigzag motif, at the four points which effect the transition between the square room and the circular base of the cupola are large horizontal mouldings.

189

experience of Persia, Mesopotamia, Syria and the Maghreb. It used artists from all these countries, and never ceased borrowing; but it combined these borrowings, and so doing, created a school that is distinct from other Muslim schools.'

However, this remarkable summary also has a dark side: 'We have visited all the mosques of Cairo; the majority are in a lamentable condition; many are rubbish dumps. As for the mosques that have been restored over the last few years, they are permanently disfigured.' In 1995, these words still ring true. Maintenance and restoration have not always been seriously conducted in the City of Cairo, apart from the work undertaken by archeological institutes, be they French, German, Polish or American. In the autumn of 1992, a fearful earthquake damaged around 100 fine buildings. It left dozens of monuments shaken, cracked, and in grave danger of falling. At present these are propped up, and beneath scaffolding which will undoubtedly remain in place for decades before the indispensable work is carried out. The phenomenon is by no means new. The ancient authors recount the earthquake of 1303, which demolished walls and minarets, obliterating many Fatimid buildings.

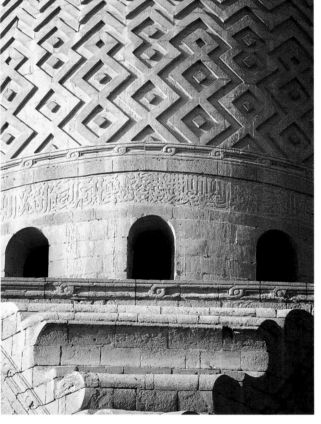

The Wakf system

In search of other reasons for the poor state of the Mamluk monuments in Cairo, Gaston Wiet and Louis Hautecoeur also pointed to the serious inefficiency of the Wakf system. Paradoxically, this legal system, aimed at the safeguarding of the buildings and at their maintenance, had quite the opposite effect. The institution was intended to block, in the form of inalienable foundations, funds or property given over to charitable ends. This meant that revenue from a portion of land, or from an 'industry', went to assure the functioning of a mosque – to ascertain that offices were performed, or to maintain the memory of a dead person, etc. The various funds were intended to ensure the operation of a pious institution.

Yet this legal system, which goes back as far as the ninth century in Egypt and could impose an inalienable status on an institution, had various deficiencies: if a famine or some other profound crisis should strike the country, or if the Sultan should decide to put a tax on the Wakf, the revenue generated would no longer be sufficient to pay the personnel, nor to maintain the building. It can be imagined also that it would not have been hard to show that the lands whose produce had be assigned to the support of a pious operation were no longer profitable, were, in fact,

even running at a loss. Since the building receiving these funds was inalienable, it had no commercial value. It was therefore purely and simply abandoned, until it fell in on itself and disappeared.

Already in 1881, the committee for the conservation of monuments of Arab art noted: 'So many monuments in Cairo are waiting for our attention, so many beautiful things threatened with ruin, there is indeed a growing number of ruins.' They were obliged to admit defeat and leave the government to sell the monuments, watch the Ministry for Public Works order the demolition of historic buildings, accept that the courtyards of *madrasas* should be filled up with refuse, and that certain mosques should be turned into public dumps, sometimes causing their doors to rot to pieces; and to agree that the caravanserais should be invaded by a thousand mixed trades, with everything represented from iron and leather-work through to wood storage and small industrial workshops.

Masterpieces in peril

The saddest part of all this is the increasing dilapidation, touching even the most beautiful examples of Islamic art in spite of efforts on many fronts. It is by no means rare to note that edifices studied and photographed half a century ago are in an infinitely more pitiable condition today than then. An example would be the *madrasa* of Ilghay al-Yusufi, from 1373, with its superb courtyard, which is slipping into decay; hardly a step away from Sultan Hasan, the *madrasa* of Sangar Gauli and Sallar, built in 1304, had still, at the beginning of the century, all its stained glass windows intact. Its bays are now sadly split open in an abandoned area. There is no need even to speak of the number of historic buildings occupied by squatters, disfigured or razed to the ground, or which have vanished without trace, though they are still included in guidebooks.

The commemorations surrounding the millenium of Cairo, about ten years ago, and the decisions taken by UNESCO, will be so many dead letters unless arrangements are urgently instigated, together with the funds necessary to intervene effectively, such as were found to secure the monuments of Nubia, at Abu Simbel or at Philae. A unique inheritance, belonging to all of us, is in peril. It is essential that the importance of the question should be clear: the medieval art of Cairo – and especially that of the Mamluks – is the equivalent of our Gothic. It is a creation of unparalleled beauty.

THE ISLAMIC ARCHITECTURE OF CAIRO BEFORE THE MAMLUK SULTANATE

In order have a better understanding of the development of Islamic arts, and in particular of architecture, in the Egyptian capital during the six centuries preceding the coming of the Mamluks, the principal monuments constructed on the site should be mentioned – whether they be in the Arab city of Fustat, the city of al-Katai of the Tulunids, or Cairo, al-Kahira of the Fatimids and the Ayyubids.

The Muslim town is built on a site grouping together a series of foundations. In front of the gigantic necropolises of Giza, Saqqara and Dashur, Cairo rises on the site formerly occupied by the venerable pharaonic capital – antique Memphis. It first became established not far from the Romano-Byzantine fortress of Babylon, or Kasr al-Sham, where there were Christian churches to be found. The place was determined at the point where the Nile splits into a series of arms, to form the Delta. Cairo played a unifying role at the junction of Lower and Upper Egypt, just as Memphis had five thousand years ago, when the power of the Pharaoh over the Two Lands was symbolised by the union of the red and white crowns, making the 'pschent'.

The founding of Fustat (*fossatum*: fosse, trench) in 642, twenty years after the Hijra, followed on from the conquest of Egypt in 640 by the Arab general, Amr ibn el-Ass. Islamisation of the populations began immediately: happy to escape from the probable return of the Byzantines, who had been pressuring them, and against whom they had risen in 619, the Christian Egyptians, or Copts (*Aiguptoi*), who are Monophysites, welcomed the Arabs as liberators.

Aerial view of the mosque of Ibr Tulun, at Fustat. Around a domed fountain from the Mamluk period, the courtyard, ringed with porticoes, forms the centre of a building occupying more than one and a half hectares, with its *ziyada* (or peripheral courtyard) isolating it from the bustling life of the Arab city.

The first mosque To mark the coming of a new religion, which he introduced to Egypt with the message of Mohammed, Amr founded a first mosque. Initially, this consisted of nothing more than an enclosure or a trench – the limit of the town just as much as the primitive place of prayer could have given Fustat its name. This mosque underwent numerous enlargements, in 698, 711, 750 and 791. It reached its fullest dimensions in 827, following

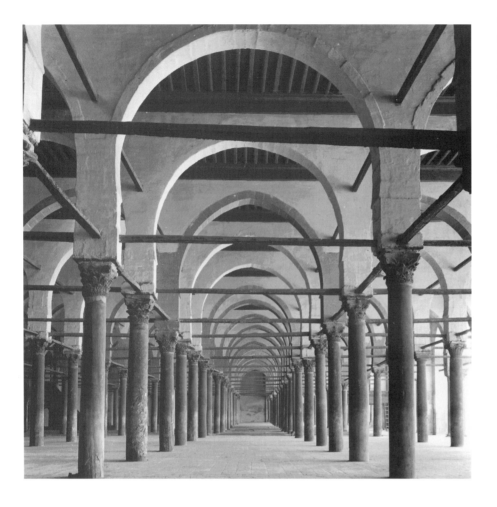

The most ancient hypostyle hall in Cairo, founded at the time of the Prophet, by General Amr Ibn el-Ass, the conqueror of Egypt. The building was initially modest in size, but was enlarged several times up to 827. The forest of rehabilitated antique columns carry arcades that run parallel to the *kibla*. These imported columns are linked with tie-beams.

A view by the draughtsman, Louis Mayer, of the hypostyle hall of the mosque known as Amr or Amri, before 1802, when it was partly in ruins.

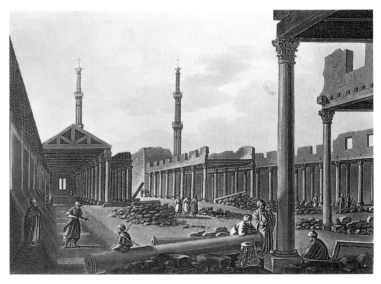

the alterations carried out under Abdullah ibn Tahir. This complex genesis is the result of the architectural formula proper to the earliest mosques: as the Prophet himself had done in his house at Medina, it was necessary to create porticoes along the south and north sides of a courtyard, so that the faithful could pray, shielded from the heat of the sun. From the outset at Fustat, use was made of rehabilitated elements. This was a solution which became general from the Maghreb to India. The first builders, instead of the trunks of palm trees employed by the Prophet, used antique columns in their hypostyle halls, thus creating one of the most original features of Islamic architecture.

At the mosque of Amr, the columns form arcades running parallel to the *kibla* wall. Above the capitals, the imposts are linked with tie beams, conferring an orthogonal structure to the space. This feature recurs in Mamluk buildings as well, appearing in most of the columned rooms. Such a space, with its multiplicity of supports, gives the impression of a forest of pillars. In the ninth century this aspect must have been more striking still, because of the lateral porticoes linking the hypostyles and setting up a spatial continuity that was apparently without limit. The central courtyard was surrounded by arcades. In this way, the capacity of the 'Friday mosque' – the name for the largest place of public prayer in Islamic towns – was increased. By now, the square edifice founded by Amr ibn el-Ass measured 120 metres along each side (1.5 hectares), and the *kibla* wall held three *mihrabs*. It belongs to the line of great mosques of Kairouan and Cordoba.

The art of the Tulunids In 836, the Abbasids of Baghdad, who held the Caliphate in Mesopotamia, founded a new capital of the Arab empire: Samarra, on the river Tigris. General Ibn Tulun, one of the sons of this vast city, was named governor of Egypt. Ibn Tulun, as a first-class administrator for Caliph al-Mutawakkil, ordered the construction of a nilometer. This underground construction in the form of wells was executed in 861 on the southern extremity of the Isle of Rawda.

As in the time of the Pharaohs, the purpose of the nilometer was to measure the height of the flood of the Nile, in order to fix the level of taxation on farming. For obvious reasons of solidity, the construction was carried out in cut stone: the walls sunk into the silt were of fine, and regular construction. The two upper

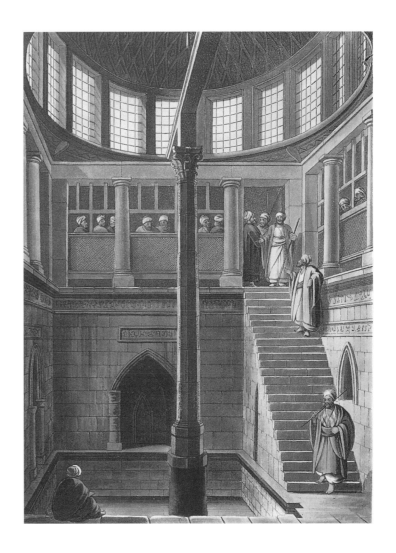

Lewis Mayer's representation of the surveyors who would visit the nilometer at Rawda, built in 861 by Sultan Ahmed ibn Tulun. The entire upper area with its circular cover is Ottoman. Only the well-shafts made of hewn stone with their three levels of steps and central column which served as a measuring device go back to the ninth century.

storeys of the well were square, and held a flight of stairs descending to the circular lower section, from which tunnels linked the device to the river. Niches, in the form of pointed arches were sunk into the walls of the upper level. These gave rigidity to the structure. At the centre, a graduated octagonal column, measuring twelve metres high, showed the height to which the waters rose at flooding.

Some years later, in 868, Ibn Tulun declared independence from Abbasid power. From 876 he began the construction of an enormous mosque at Fustat. This was based on the model of the gigantic places of prayer at Samarra, and built entirely in brick. The pillars were of masonry, since rehabilitated antique pieces were not available in Mesopotamia. The roof was in wood, as at Amr ibn el-Ass.

In a similar manner to the huge mosques at Samarra and Abu Dolaf, this structure measured 162 metre square, including the *ziyada*, or peripheral courtyard, designed to isolate the building from its urban environment. In total, therefore, Ibn Tulun's construction covers 2.5 hectares. The building itself (140 m by 116 m) has a prayer room with five arcades running parallel to the *kibla*. The three other sides of the courtyard, which measures 8000 square metres, are ringed with a double arcade.

All the arches are identical, based on a unitary module proper to Mesopotamian works, The perimeter of the courtyard alone consists of 52 arches – 13 down each side. The rectangular pillars have round columns at each corner, fitted flush to the mass of the structure. They carry pointed arches, and the central sections are lightened by a high bay, also in the form of a pointed arch, and supported by two small columns. On either side of the bays are two large roses, a motif which also decorates the frieze around the top of the arcades on the courtyard. The walls of the building are topped with an elaborate ring of merlons around the entire perimeter. The entire construction (arch borders, entrances to the arcades, friezes and windows) is decorated with repetitive motifs in moulded stucco. At the centre of the courtyard, the domed fountain dates from the Mamluk period. To the north west, a minaret with an exterior stairway has a square lower section, which then becomes spiral. This is a reproduction in stone of an earlier version in brick inspired by the Malawiya of Samarra. Above the *mihrab*, also dating from the Mamluks, a small brick dome marks the direction of

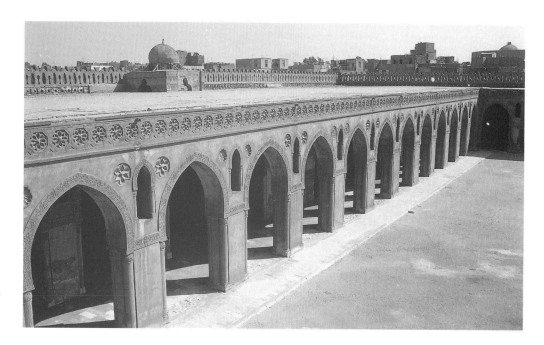

A view of the courtyard facade
of the Ibn Tulun hypostyle hall,
also showing the small cupola
rising above the *mihrab*.

In the foreground, the fountain
with its Mamluk dome from the
Ibn Tulun mosque. To the left,
the spiral minaret in stone,
which replaced a more primitive
structure in brick. Its winding
exterior stairway takes its
inspiration from minarets in
Samarra. On the right is the
Mamluk minaret from the
mosque of Sarghitmish (1356).

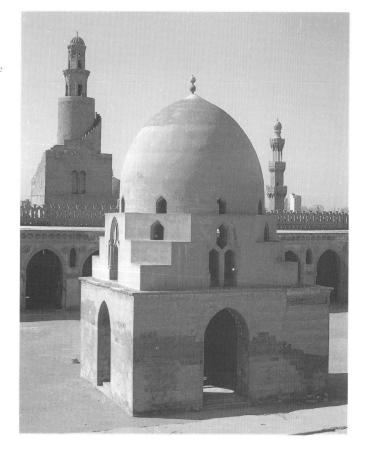

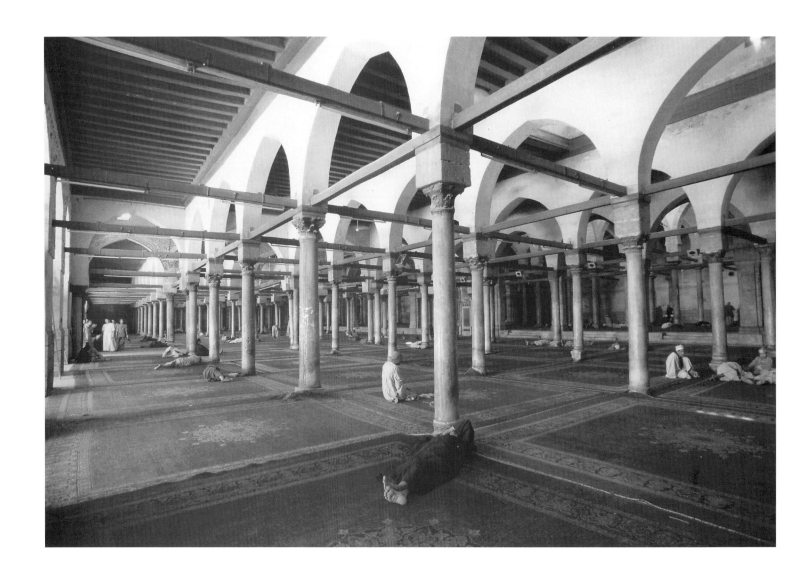

The hypostyle hall of the al-Azhar mosque, constructed between 970 and 972 by the Fatimid Caliph Gawhar, founder of the city of Cairo. This venerable building was enlarged several times subsequently. It was to become the principal Islamic theological school in Egypt. In contrast to Amri, here the arcades run parallel to the *kibla*. They are joined by wooden tie-beams.

Facing page:

The courtyard with arcades on monolithic columns of the al-Azhar mosque. The arches, with their marked shoulders and almost straight lines, are characteristic of the Fatimid period. The stuccoed decoration, including rosettes and false sunken bays, repeats techniques used at Ibn Tulun. A row of stacked merlons provides the top frieze. The minarets are from the Mamluk period.

Mecca. In this way, Ibn Tulun, while fully appreciative of fine stonework, also considerably developed construction in brick, following the example of the great mosques at Samarra, in his own country, on the eastern bank of the Tigris.

The Shiite Caliphate of Cairo In occidental Islam, the Fatimids were the upholders of the line of Fatima, Mohammed's daughter, and wife of Ali; they considered that only the line of the Prophet was worthy of assuming the role of Imam-Caliph, or the leader of all believers. This Shiite current, professed by the Ismailis, gave birth to a dynasty founded by Ubayd Allah (909–934), the first of 14 Fatimid Caliphs. In Kairouan, this person took the title of Mahdi. In Shiite theology, the Mahdi is the hidden Imam who has to return to earth at the end of time and free the world. Soon, all Ifrikiya, in 906, then Egypt in 969, and Damascus in 970 joined the Alid camp, forming an 'orthodox' Muslim group, in opposition to the Sunni movement. The Fatimids proved a remarkable cultural force in Egypt: it was they who founded Cairo, al-Kahira, the Victorious, after assuming the Caliphate.

The great mosque built by the Fatimids in Cairo is called al-Azhar, the Splendid. It is built according to the classic plan of a hypostyle prayer room, with a courtyard surrounded by porticoes, and became the university of Islam. Over the centuries many additions and alterations have been made, but the original elements that remain reveal that there was a strong similarity to the first mosque at Fustat, known as Amr Ibn el-Ass. There is the same use of rehabilitated columns, and arcades linked together with tie-beams to give a hypostyle hall with a flat wooden ceiling. There is the same courtyard surrounded by porticoes on its four sides. The courtyard facades are pierced with pointed arches. The columns raise the bays, and the arches run almost straight after sharply curved shoulders. Some have claimed that these arches are Persian in style, thereby revealing a lack of understanding of Iranian architectural forms; Persian arches are never so rigidly drawn. The decoration of the walls above the courtyard arcades consists of stuccoed niches, which recall the open bays in a similar position at Ibn Tulun. There are rosettes at the point of each arch. Along the topmost part of the walls runs a frieze of pierced, stepped merlons, the origin of which goes back a very long way, to the Mesopotamian and Achemenid past.

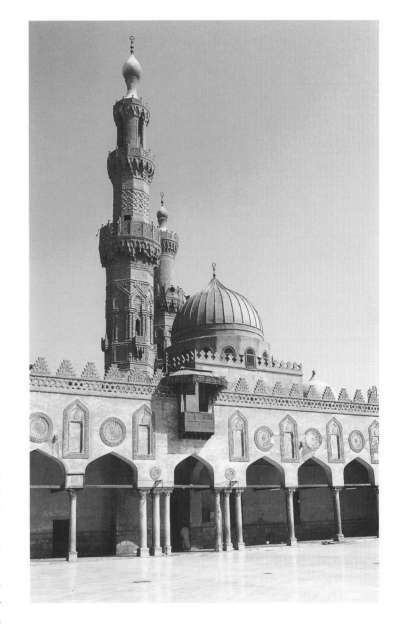

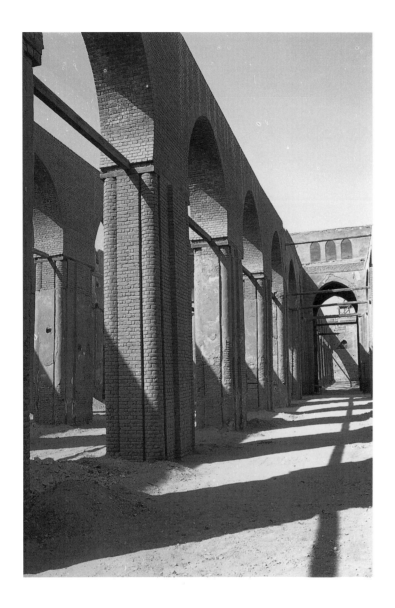

The mosque of Sultan Hakim

After the reigns of the Fatimid Caliphs, Muizz and Aziz, who were tolerant towards the Copt and Jewish communities, on whom they called to play an important role in the administration, Hakim introduced a more rigorous, fanatical attitude, which led to persecution of the Christian and Jewish minorities.

Around 990, Hakim built the large mosque that bears his name in the north-east corner of the town of Cairo. It is clearly inspired by Ibn Tulun's mosque and, like it, is built of brick. Rectangular pillars carrying pointed arches make up a hypostyle hall five arcades deep. On either side of the courtyard, the porticoes are three arcades deep, while on the north-west side there are two arcades, as at Ibn Tulun.

At the two ends of the facade, at the entries, are two squat, square and solid towers. They appear fortified. These towers are surmounted by minarets, a formula to be reactivated by the Mamluk Sultan Muayyad, when he crowned the Bab el-Zueila gate with a pair of high stone needles. Today, the mosque of Hakim has been over-restored and, covered as it is with shining marble, is almost unrecognisable. None of the atmosphere of this venerable building remains. An intelligent archaeological campaign could have saved it more effectively than this brutal rehabilitation, which shows no respect for either the original materials or the spirit of the monument, and, aside from all else, was extremely costly.

The wall of Badr Gamali

Mustanzir, the Fatimid anti-caliph, occupied the throne of Cairo for more than half a century, but without really reigning. This immobility plunged the country into disorder and anarchy. In 1074, in an effort to redress the situation, he called Badr Gamali, an Armenian who had previously been governor of Damascus and Prefect of Saint-Jean-d'Acre. No sooner was he in place, than Badr locked the Caliph in the royal palace, and seized real power.

Surrounded by a group of Armenians, who had sought refuge in Egypt three years after being defeated by the Seljuks at Mantzikert, Badr was also accompanied by a large group of architects and engineers, who were specialists in fortifications. These he employed to construct a new wall around the city, from 1087 to 1091. He wanted the city of Cairo to be able to resist enemy

Sultan Hakim's ruined mosque, built in 990, and modelled on Ibn Tulun. It is also built in brick, with arcades on rectangular pillars, with columns attached to each corner. The building measures 120 metres by 130 metres. Now entirely covered in white marble, the old prayer room has lost all character.

Facing page:

The north-west corner of the el-Hakim mosque. The minaret, with a heavy pyramidal base resembling fortifications, is a curious octagonal structure, capped with a ribbed cupola. The building flanks a portion of the Fatimid wall, between Bab el-Nasr and Bab el-Futuh, to the north-east of Old Cairo.

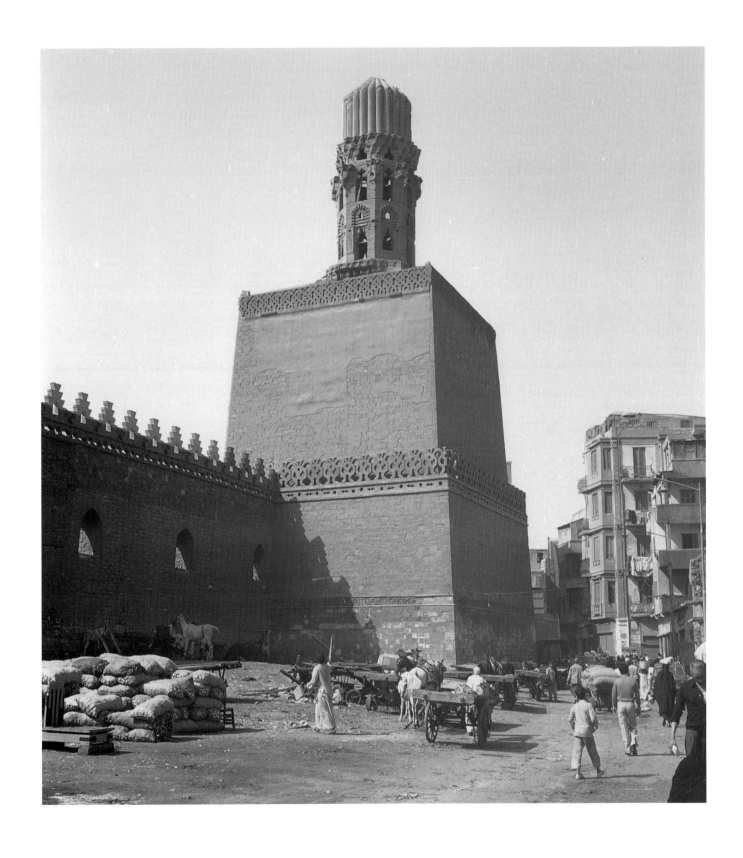

or semi-circular bastions provided the city with a powerful defence system.

This work surrounded a city covering an area of 165 hectares (1500 m by 1100 m). Its creation led to a profound technological revolution in Islamic architecture in Egypt. Fine stone-work was not restricted to battlements; it was soon to be used in the construction of mosques. While of more restricted dimensions, these mosques none the less make use of formulae already illustrated in the great mosque of el-Azhar, including the arcading and the decoration. This is the case with the small mosque of Akmar, built in Cairo in 1125. Its entrance combines a decoration of stalactites, with niches and rosettes analagous to those on el-Azhar. The principle of the prayer room with a courtyard is also upheld, just as in the mosque of Salih Talai (1160), which has a fine portico on its facade, with raised arches carried on small, slender columns. This mosque stand out by its clearly articulated geometric forms and, in its coherent and symmetrical plan, attains genuine lightness.

Under the banner of Saladin

The end of the Caliphate of the Fatimids of Cairo in 1171 followed a general regression of Islamic authority in the Near East: in 1099, the Crusaders had crossed Anatolia and taken Jerusalem. Internal divisions in the Muslim camp had helped them achieve victory. To reinforce their hold on the region, the Christians even tried to establish a protectorate in Egypt; but this undertaking failed. In the twelfth century, Islam rallied.

Muslim resistance began with Zengi, the Emir of Mosul, who captured Aleppo, then Edessa in 1144. After his assassination, his son, Nur el-Din, took over the jihad, or holy war. With a powerful army he penetrated Damascus in 1154, and his Kurdish adjutant, Shirkuh, occupied Egypt in 1167. Salah el-Din (Saladin) then acceded to power in Cairo and, on the death of Nur el-din, united Egypt, Syria and Upper Mesopotamia against the Christian invader, founding the Ayyubid dynasty. At the same time, he put an official end to the reign of the Fatimid Caliphs. From this time on, the Sultan sought to reduce the Shiite influence, and reestablish Sunni 'orthodoxy'. With this aim in view, he encouraged the construction of *madrasa*s, Koranic schools in which rigorous Islamic doctrine was taught. He adopted the formula of which the Seljuk Turks had become propagators, throughout the Middle East and in Anatolia.

attacks. Following the Turkish capture of Jerusalem in 1078, Fatimid Egypt was concerned by the possibility of an attack by the Seljuks, who were Sunnis.

Moreover, the entry of the Turks into the Holy City also set off military brouhaha in the west: Pope Urban II preached the crusade. War was in the air, and the construction of battlements is logical at such times. Cairo's fortifications and, in particular, the splendid gates of Bab el-Nasr, Bab el-Futuh and Bab el-Zueila, are in the Romano-Byzantine tradition of military construction. The builders, coming from Edessa after the fall of the town in 1086, brought their skill with them.

Unlike the Tulunid and Fatimid religious works built from brick, Badr Gamali's military architecture is entirely in cut stone, as are these constructions in Armenian territory. Great blocks are finely laid and precisely jointed. The towers jutting out at regular points along the curtain, and guarding every gate with their square

The gate of Bab el-Futuh in Cairo with its fine, regular stone-work, and jutting, semi-circular towers shows a clear Romano-Byzantine influence.

View of the battlements of
Cairo, constructed in 1087 by
the Armenian, Badr Gamali,
according to techniques used in
contemporary Byzantine military
architecture.

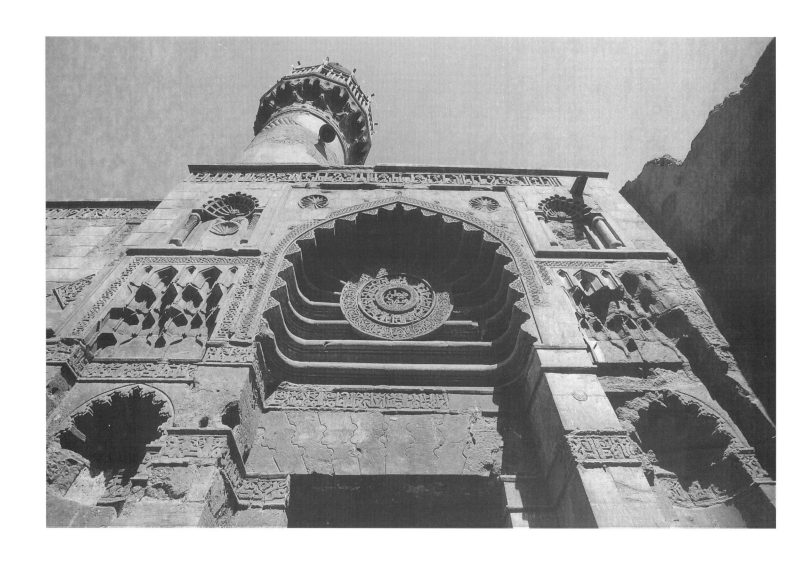

The stone facade of the small
Fatimid mosque of el-Akhmar,
built in 1125, is decorated with
stalactites, inscriptions and also
niches. These elements are
transposed from those
executed in stucco at al-Azhar
one and a half centuries
earlier.

Facing page:

A view by Louis Mayer
showing Saladin's vast
hippodrome, constructed at
the end of the twelfth
century, after his victory over
the Christians in the Holy
Land. It was there that the
Mamluk soldiers were to
train, practising polo.

In this way, Saladin became the defender of the Muslim faith, both in theological and military terms, though especially by his energetic action against the Christian forces occupying Palestine. After his victory over the Crusaders at Hattin in 1187, all the towns of the Frankish states fell into his hands, except for Tyre, Tripoli, Antioch and Saint-Jean-d'Acre. The city of Jerusalem was recaptured. On the death of Saladin in 1193, his kingdom was divided between his son and his brother. A number of small sultanates came into being. This situation favoured the Mamluk dynasty. As far as architecture was concerned, Saladin's main contribution in Cairo was essentially the construction of a new wall to protect the capital. It was of considerable size, since it ringed Fustat and al-Kahira in a loop almost 14 kilometres long. The key to the defence was the Citadel, dominating the southern side of the town on the slopes of Mokkatam. It was an immense enterprise, and the architects used not only the limestone available in this hilly region but also took supplies at hand, pillaging the pyramids of Giza, Saqqara and Abusir. A number of Christian prisoners, captured after Hattin, were set to work on this gigantic site. The Citadel of Cairo benefited from the most advanced military technology of the period: it combined the solutions of Crusader and Muslim builders. At its foot, to the west, Saladin constructed a huge hippodrome – after the fashion of the Byzantines and the Abbasids – where his troops trained and played polo. This then was the legacy that the Mamluks found when they took power in Cairo and founded their empire. It was in this inherited context, that they were to make Islamic architecture flourish, and give it some of its masterpieces.

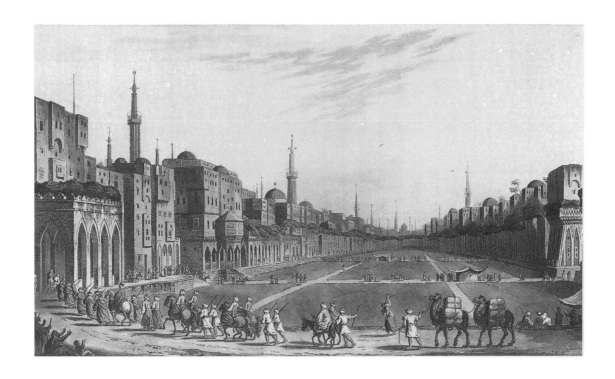

CHRONOLOGICAL TABLE OF POLITICAL AND CULTURAL EVENTS

EGYPT FROM THE FATIMIDS TO THE MAMLUKS

10th CENTURY
906 Fatimids (Shiites) in Ifrikiya (Tunisia)
969–1171 The Fatimid Dynasty of Cairo
970 The Fatimids at Damascus
970 Founding of the town of al-Kahira (Cairo)
970–972 Mosque of el-Azhar, Cairo
973 Fatimid (Shiite) Caliph al-Muizz (953–975) installed in Cairo
966–1021 Fatimid Caliph el-Hakim
966–1003 el-Hakim mosque, Cairo

11th CENTURY
1036–1094 Fatimid Caliph al-Mustanzir
1074 Mustanzir calls the Armenian Badr Gamali to Cairo
1087–1091 Walls of Cairo constructed

12th CENTURY
1101–1130 Fatimid Caliph al-Amir
1125 el-Akmar mosque, Cairo
1160–1175 Fatimid Caliph al-Adid at Cairo
1160 Sailih Talai mosque at Cairo
1169–1250 Ayyubid Dynasty in Syria, then Egypt
1171 Saladin (Salah el-Din, Kurdish Emir,
1137–1193) puts an end to the Fatimid dynasty in Cairo
1176 Saladin constructs the Citadel of Cairo
1183 Union of Syria and Egypt under Saladin
1187 Saladin defeats the Crusaders at Hattin and recaptures Jerusalem

THE SELJUK TURKS AND THE MONGOLS OF PERSIA

10th CENTURY
10th century Turkish tribes from Central Asia convert to Sunni Muslim faith
962–1040 Ghaznevid Turks in Khorasan
998–1186 Ghaznevid Dynasty in Ghazni (Afganistan)

11th CENTURY
1000 First Islamised Seljuk chiefs in the region of lower Syr-Daria
11th century Tribes of Kipchaks (Turkish tribes) settle between Syr-Daria and the Danube, to the north of Lake Balkhach (Kazakhstan). They are not Muslims
1032–1186 Seljuk Dynasty in Iran
1038–1063 Tugrul Bey, first Seljuk Sultan, capital at Nishapour
1051 Tugrul Bey takes Ispahan
1055 Seljuks defeat Buyids, take Baghdad and become protectors of the Caliphs
1063–1073 Alp Arslan, Seljuk Sultan, overcomes Aleppo and Armenia
1073–1092 Malik Shah, third Seljuk Sultan of Persia. He reigns over Syria, Palestine, Arabia, the Yemen. His minister, Nizam el-Mulk (Persian) turns Ispahan into a powerful capital
1088 Friday mosque at Ispahan. The Seljuks are Iranised, but remain nomadic. They hold Khwarezm, Afghanistan, Iraq, Tranoxiania, Kerman. In Persia, Seljuks create the *madrasa*, cruciform mosque, and *mukarna*s (stalactites)

12th CENTURY
1118–1157 Sanjar, Sultan of Persia
1141 Mongols in Transoxiania
 Four-*iwan* mosque at Ispahan
1156–1215 Ghurides in Afghanistan
1188 Gengis *Khan* unites Mongolia
1194 Khwarezm victorious over Seljuks
1199 Abbasid palace in Baghdad

THE SELJUKS OF RUM IN ANATOLIA

11th CENTURY
1063–1072 Alp Arslan, Seljuk Sultan
1067 Seljuks penetrate into Anatolia at Cesari
1071 Turks defeat the Byzantines at Mantzike Diogenes' army is destroyed, Basileus ta prisoner. Anatolia falls to the Turks
1078–1079 Seljuk Turks in Damascus and Jerusalem
1080–1086 Suleyman ibn Kutulmich, prince of Nica
1082 Seljuks definitively occupy Kayseri
1084 Turks take Antioch
1086 Suleyman falls before Aleppo
1087 Edessa taken
1091 Mosque of Diyarbekir
1092–1107 Kilich Arslan I

12th CENTURY
1103 Turks take Malatya
1116–1156 Kilich Arslan II unifies Anatolia
1156 Beginning of work on the Ala el-Din Ja of Konya
1176 Byzantines defeated at the battle of Myriokephalon
1190 Konya falls to the Crusaders (Barbaros
1192–1196 Keyhusrev I reunifies Anatolia, holds th trans-Anatolian route from Antalya to S

BYZANTINES AND ARMENIANS

10th CENTURY

913–959	Constantine VII Porphyrogenitus
915	Construction of the Armenian cathedral of Akhtamar
929	Armenian cathedral of Kars
963–1025	Basil II with Nicephore Phocas (until 969), with Constantine VIII thereafter
963	Byzantines take Cilicia and Aleppo
965	Conquest of northern Syria
975	Conquest of Palestine
986	Basil II defeated by Bulgars
989–1001	Armenian cathedral of Ani
999	Basil retakes Cesaria at Emese

11th CENTURY

1021	Byzantine success in Armenia
1025–1028	Constantine VIII
1028–1050	Empress Zoe, with Romain III Argyre, then Michael IV the Paphlagonian and Constantine IX Monomaque
1030	Cappadocian art flourishes
1041	Loss of conquered territory
1054	Schism with Rome
1055–1056	Empress Theodora
1059–1067	Constantine X of the Dukas dynasty. Seljuks attack in Cappadocia and Syria
1067	Turks sack Cesaria
1068–1071	Roman IV Diogenes
1071	Turks defeat Byzantines at Mantzikert
1080	Armenian migration into Cilicia. Founding of kingdom of Lesser Armenia
1081–1118	Alexis I of the Comnene dynasty
1081	Nicaea, Turkish capital in Asia Minor
1098	Crusaders take Antioch

12th CENTURY

1103	Malatya taken by Turks
1118–1143	John II
1137	Cilicia reconquered
1147–1180	Manuel I
1176	Disaster of Myriokephalon
1185–1195	Isaac II, dynasty of Angels (Anges)
1185	The Normans take Salonica
1187–1219	Lesser Armenia and Franks allies
1188	Frederick I (Barbarossa) lays siege to Constantinople
1195–1203	Alexis III

THE CRUSADES AND THE HOLY LAND

11th CENTURY

1078	Turks penetrate into Jerusalem. Uproar in the West. Gregory VII prepares Crusade
1095	Urban II decides to launch the first Crusade
1097	Crusaders in Armenia and Cappadocia
1098	Crusaders take Edessa, Antioch and Tripoli
1099	Crusaders take Jerusalem

12th CENTURY

1100–1187	Frankish kingdom of Jerusalem
1100–1118	Baudouin I, Count of Edessa, King of Jerusalem
1104	Saint-Jean-d'Acre taken
1109	County of Tripoli
1110	Beirut taken
1116	Baudouin attacks Egypt
1118–1131	Baudouin II of Jerusalem
1123	He is taken prisoner by the Turks, then freed
1131–1163	Baudouin III comes to agreement with the Byzantines, and marries Theodora, niece of Manuel I Comnene
1142	Crusaders defeated at Zengui on the Orontes
1144	Edessa falls to the Muslims. Pope Eugene III decides on the second Crusade. Saint Bernard preaches the second Crusade
1148	Crusaders rebuffed before Damascus
1154	Nour el-Din at Damascus
1171	Saladin (1138–1193) Ayyubid Sultan of Egypt
1174	Saladin reigns over Syria
1187	Defeat of Crusaders at Hattin. Saladin enters Jerusalem
1188	Saladin takes the Frankish States. Decision to organise the third Crusade, led by Frederick I (Barbarossa), Richard the Lion Heart and Phillip Augustus
1190	Accidental death of Barbarossa
1191	Saint-Jean-d'Acre captured. Jerusalem remains in Muslim hands
1192	Truce concluded with Saladin: the Crusaders masters of the coast from Tyre to Jaffa

THE NORMANS AND VENETIANS IN THE MEDITERRANEAN

11th CENTURY

1030	County of Aversa in Campania, first Norman territory in the Mediterranean
1046	County of Pouilles
1058	Principality of Capua
1072	County of Sicily
1081	Venice helps Constantinople against the Normans
1082	Byzantine concessions to Venice
1085–1111	Roger I Borsa, Duke of Pouille and Calabria
1098	Principality of Antioch

12th CENTURY

1101–1127	Roger II Count of Sicily
1115	Saracen art flourishes in Sicily
1127–1130	Roger II, Duke of Pouilles, of Calabria and of Capua
1130–1154	Roger II, King of Sicily, which is allied to the Saracens
1146	Roger II takes Tripoli and Kairouan
1147	Corfu taken by the Normans
1148	Venice supports Byzantium against the Normans at Corfu
1149	Normans lay siege to Constantinople
1154–1166	William I of Sicily, known as William the Bad,
1156	is pushed back by the Byzantines, before inflicting on them first a land victory, and then, in the waters of the Euboea, a naval defeat. He is recognised by the Pope
1166–1189	The Arab geographer Idrisi (1099–1164) lives at his court. William II, the Good, King of Sicily
1174–1177	William II's expeditions into the Egyptian delta
1185	Normans at Salonica. William supports Alexis Comnene, but is defeated by Isaak II Ange, at Demechissar, in Macedonia
1195–1250	Frederick II, son of Constance of Sicily, heir to the Hohenstaufen, brought up at the Court of Palermo, turns Sicily into a modern state
1197–1250	Frederick II, King of Sicily

EGYPT FROM THE FATIMIDS TO THE MAMLUKS

13th CENTURY

1244	The Kharezmiens take Jerusalem from the Christians
1245	Baibars victorious over Franks at Arbiyya, besiege Ascalon
1249	Franks take Damietta
1250	Muslims victorious over Franks at Mansurah Turanshah takes Louis IX prisoner
1250	The Turk, Aibak, slave of the last Ayyubid, takes power in Cairo
1250–1517	Mamluk Sultanate of Cairo
1250–1382	Bahrid Dynasty of Sultans
1255	Baibars' expedition against Egypt
1259	Mongols at Aleppo and Damascus
1260	Mamluks Kutuz and Baibars defeat the Mongol, Hulagu, at Ain Jalut Kutuz assassinated
1260–1277	Mamluk Sultan Baibars I at Cairo
1261	Baibars establishes the Caliphate in Cairo
1262	Baibars builds the first cruciform *madrasa* in Cairo, the Zahiriya
1263	At Mecca, Baibars orders prayers to be said in his name
1265	Baibars takes Cesaria
1266	Construction of Dar al-Dahab in the Citadel of Cairo
1268	Tripoli taken
1270	Krak taken from the Knights
1272	Baibars defeats the Mongols
1277	Baibars enters Anatolia and takes the Seljuk throne at Kayseri
1277	Baibars dies at Damascus, aged 56
1278–1279	Construction of the mausoleum of Baibars at the Zahiriya *madrasa*, Damascus
1279–1290	Sultan Kalaoun usurps Mamluk throne, recruits Circassians
1280	Kalaoun takes the Sultanate of Damascus
1284–1294	Construction of the tomb of Kalaoun at Cairo
1289	Kalaoun takes Laodicia and Tripoli. Mamluk expedition in Upper Nubia
1290	Death of Kalaoun
1291	Saint-Jean-d'Acre captured by el-Ashraf Khalil, Kalaoun's son: end of the Crusader states
1293	el-Ashraf Khalil murdered: political instability
1293–1294	Sultan Mohammed el-Nasir, deposed at 10 years old
1295	Famine in Cairo
1298–1308	Second reign of Sultan Mohammed el-Nasir

14th CENTURY

1300	Egyptians defeated by Mongols
1303	Mamluk victory over Mongols
1303	Completion of the *madrasa* of Mohammed el-Nasir
1308–1310	Sultan Baibars II el-Gashenkir, to be overthrown by Mohammed el-Nasir
1310–1341	Third reign of Sultan Mohammed el-Nasir
1312–1314	Aqueduct from the Nile to the Citadel of Cairo
1313–1315	Fiscal reform in Damascus and Cairo
1318–1335	Mosque of Mohammed el-Nasir in the Citadel. Circassians recruited
1341	Death of Sultan Mohammed el-Nasir, aged 58
1340–1341	Mosque of Maridani

THE SELJUK TURKS AND THE MONGOLS OF PERSIA

13th CENTURY

1206–1290	Dynasty of Turkish slaves (Mamluks) in India, Persian influence on Islamic India
1220	Gengis Khan's Mongols in Persia
1227	Gengis Khan dies
1256–1265	Hulagu, Ilkhan of Persia
1258	Hulagu takes Baghdad, executes Caliph Mutasim. Mongols end the Abbasid Caliphate
1295–1304	Mongol Ghazan Khan of Persia converts to Islam: capital Tabriz

14th CENTURY

1304–1316	Uldaitu Khodabendeh, Sultan of Persia
1307	Sultanieh founded, capital of Persia
1310–1320	Construction of Friday mosque at Tabriz
1366	*Madrasa* of Friday mosque at Ispahan
1370	Tamerlane at Balkh
1370–1502	Timurid dynasty
1370	Mosque of Yazd
1380	Tamerlane crosses the Oxus and lays waste to Ispahan (1386)
1390	Palace of Tamerlane at Samarkand
1399	Bibi Khanum mosque at Samarkand

THE SELJUKS OF RUM IN ANATOLIA

13th CENTURY

1204	Ala el-din Jami of Konya mosque
1204–1210	Second reign of Keyhusrev Mongol invasions
1210	Caravanserai of Evdir Han
1218	Caravanserai of Hekim Han
1219–1236	Keykobad I Seljuk Sultan at Beyshehir
1220	Ala el-Din Jami of Kanya by Ala el-Din Keykobad
1224	Ala el-Din Jami of Nigde
1229	Caravanserai of Sultan Han d'Aksaray
1230	Yivli Minare of Antalya by Ala el-Din Keykobad
1232	Caravanserai of Sultan Han of Kayseri
1237	Huand Hatun of Kayseri
1237–1246	Sultan Keyhusrev II
1242	Sircali *madrasa* at Konya
1243	Keyhusrev II defeated by Mongols, who control the sultanate
1251	*Madrasa* of Karatay at Konya
1253	Cifte *madrasa* at Erzurum
1260	Inje Minare *madrasa* at Erzurum
1272	Gok *madrasa* at Sivas
1275	Doner Kumbet at Kayseri
1284–1308	Keykobad III put to death: Ottomans are take over in west Anatolia
1296	Esferoglu mosque at Beyshehir
1298–1922	Ottoman Sultans' dynasty
1298–1324	Osman I creates his kingdom in Bythini

14th CENTURY

1312	Hudavend Turbesi at Nigde
1339	Kosk *madrasa* at Kayseri
1324–1260	Ottoman Sultan Orhan
1326	Brusa, Ottoman capital
1335	Ala el-Din Jami at Brusa
1360–1389	Ottoman Sultan Murad I
1361	Edirne (Adrianople) falls to the Ottoma
1365	Edirne Ottoman capital
1374	Ulu Jami at Manisa
1378	Yeshil Jami at Iznik
1389–1403	Ottoman Sultan Bayezid I
1391	Bayezid lays siege to Constantinople
1394	Ulu Jami at Brusa

BYZANTINES AND ARMENIANS

13th CENTURY

1203–1204	Isaac II and Alexis IV
1204	Venetians and Crusaders take Constantinople and pillage the capital
1204–1222	Theodore I of the Lascaris dynasty at Nicaea
1204–1222	Alexis I Comnene, at Trebizond
1222–1254	John III Vatatzes, at Nicaea
1228	Byzantines of Nicaea lay siege to Constantinople
1238–1263	Manuel I Comnene, at Trebizond
1243	Mongols in Anatolia
1259–1282	Michael VIII Paleologue, coemperor at Nicaea, from 1261, sole emperor at Constantinople
1261	Constantinople retaken by Latins
1265	Privileges granted to Venise
1266–1280	George, at Trebizond
1268	Treaty of Constantinople with Genoa
1282–1338	Andronic II at Constantinople
1295–1320	Andronic reigns with Michael IX
1299	Conflict between Venice and Genoa

14th CENTURY

1326	Brusa falls, to become Ottoman capital
1328–1341	Andronic III
1331	Fall of Nicaea
1341–1391	John V Paleologue: three interrupted reigns
1359	Ottomans lay siege to Constantinople
1362	Adrianople falls
1375	Mamluks take Sis; kingdom of Lesser Armenia ceases to exist
1391–1425	Manuel II
1393	Leon VI de Lusignan, last sovereign of Lesser Armenia dies in Paris

THE CRUSADES AND THE HOLY LAND

13th CENTURY

1201	Pope Innocent III wishes to reconquer the Holy Sites, and prepares the fourth Crusade
1202	Fourth Crusade begins
1204	With the help of the Venetian fleet, the Crusaders take Constantinople, and sack it.
1210–1225	Jean de Brienne, King of Jerusalem
1213	Pope Innocent III calls for a fifth Crusade
1218	Jean de Brienne attacks Egypt
1219	Saint Francis in Egypt, wishes to convert the Sultan el-Malik
1221	Disaster for Christians: the Crusaders re-embark
1223	Sixth Crusade preached
1228	Frederick II takes control of operations
1229	Treaty of Jaffa between Frederick II and the Sultan of Egypt, returning the Holy City to the Christians: co-dominion of the Holy Sites. Frederick II King of Jerusalem
1229–1244	Jerusalem capital of Frankish kingdom
1244	Christian forces annihilated at Gaza. Khwarezemians in the service of Saladin II recapture Jerusalem
1245	Seventh Crusade decided on at the Council of Lyons
1245	Saint Louis (Louis IX) leads it against Egypt
1249	The Crusaders take Damietta
1250	Louis IX captured after the defeat at Mansurah
1268	Sultan Baibars takes Antioch, causing the eighth Crusade, led by Saint Louis
1270	Saint Louis dies, laying siege to Tunis
1271–1295	Marco Polo travels in the East
1272	Truce in Palestine
1289	Tripoli falls
1291	Saint-Jean-d'Acre and Tyre fall. End of Crusades in the Holy Land

MEDIEVAL AND RENAISSANCE EUROPE

1294–1303	Pope Boniface VIII
1298–1306	Albert I of Habsburg
1303–1304	Benoit XI
1305–1314	Clement V
1307	Templars arrested in France
1308–1313	Henry VII of Luxemburg emperor
1314	Beginning of the Medici dynasty in Florence
1316–1334	John XXII, Pope at Avignon
1317	Peace of Naples: Guelfs and Gibelins of Tuscany
1328	Economic crisis in Florence
1332	Guelfs and Gibelins join forces
1346	Battle of Crécy
1347–1350	Hungarian invasions
1348	Great plague in Italy
1348	The Pope buys Avignon
1354	Venetian fleet defeated
1354	Charles IV emperor

THE NORMANS AND VENETIANS IN THE MEDITERRANEAN

13th CENTURY

1204	Venice obtains concessions in Syria and in Palestine: possessions at Zara, Ragusa, Cattaro and Corfu
1206	Venetian trading posts in the Greek archipelago and in Crete (Rhodes, Naxos, Negropont, and bases in Morea)
1215	Frederick II proclaimed king, his son Henry, King of Sicily
1220	Commercial treaty between Venice and the Seljuks
1220–1250	Frederick II, German Emperor; Henry, his son, becomes king
1227	Frederick II joins the Crusade, negotiates with the Ayyubid el-Malik al-Kamil, and obtains possession of Jerusalem and Nazareth
1229	He is crowned King of Jerusalem
1244	Crusaders definitively lose Jerusalem
1250	Frederick II dies at Castel Fiorentino
1265	Venice obtains privileges in the Near East
1268	Treaty between Constantinople and Genoa
1299	Conflict between Venice and Genoa

CULTURAL AND ARTISTIC HISTORY IN THE OCCIDENT

1293–1304	Palazzo Vecchio in Florence
1300	Giovanni Pisano at Pisa
1303–1305	Giotto's frescoes at Padua
1321	Death of Dante
1322	Giotto painting in the Santa Croce, Florence
1323	Canonisation of St Thomas Aquinas
1328–1333	Giotto working in Naples. Simone Martini at the Palazzo at Siena
1330	Gilded doors to the Baptistry in Florence by Andrea Pisano
1345	Facade of the Doge's palace, Venice
1377–1446	Brunelleschi
1385	Schifanoia palace at Ferrara
1386–1466	Donatello
1396	Beginning of work on the Carthusian monastery at Pavia

EGYPT FROM THE FATIMIDS TO THE MAMLUKS

1347–1351 First reign of Sultan Hasan, deposed aged 16
1348–1349 Black Plague in Egypt
1354–1361 Second reign of Sultan Hasan, assassinated
 aged 26
1356–1363 Construction of the *madrasa* of Sultan Hasan
1363–1377 Sultan Shaban II, assassinated aged 24
1365 Alexandria ravaged by Peter I of Cyprus
1368 *Madrasa* of Shaban
1374 New outbreak of plague
1382 Sultanate usurped by Barkuk
1382–1516 Dynasty of the Circassian Sultans
1382–1389 First reign of Sultan Barkuk, deposed
 aged 53
1384 Madras of Barkuk, Cairo
1390–1399 Second reign of Sultan Barkuk, dies aged 63
1399–1405 First reign of Sultan Farag, deposed aged 17
1399–1410 Farag constructs the mausoleum of Barkuk

15th CENTURY

1400 Tamerlane forces Farag out of Syria
1405–1412 Second reign of Sultan Farag, assassinated
 aged 24
1412–1421 Sultan Muayyad, dies aged 54
1415 Mosque of Muayyad
1422–1438 Sultan Ashraf Barsbey
1425 *Madrasa* and tomb of Ashraf Barsbey
1426 Cyprus conquered
1428 Barsbey introduces pepper-trade monopoly
1430 Outbreak of plague in Cairo
1453 Ottoman Mehmet II takes Constantinople
1453–1461 Sultan Ainal, dies aged 81
1460 Outbreak of plague in Cairo
1461 Mausoleum of Sultan Ashraf Ainal
1461–1468 Disorder in Egypt
1468–1496 Sultan Kait Bey, dies aged 86
1479 Mosque of Kigmas al-Ishaki
1485–1491 Naval battles against the Ottomans
1492 Plague returns to Cairo
1496 Mausoleum-*madrasa* of Kait Bey
1498–1500 Sultan Kansuh I

16th CENTURY

1500 Mausoleum of Kansuh I
1501–1516 Sultan el-Ghuri
1501–1504 *Madrasa*-mausoleum of el-Ghuri, Cairo
1503 *Madrasa*-mausoleum of Emir Kanibey Kara
1504 Caravanserai of el-Ghuri
1506 Tomb of Emir Korkmaz
1509 Mamluk fleet defeated by Albuquerque
1510 Mamluks create a unit of arquebusiers, and
 make canons; Portuguese threaten the Red
 Sea
1516 El-Ghuri defeated by Ottomans, dies in
 battle aged 75
1517 Second defeat of the Mamluks: Sultan el-
 Ashraf Tuman Bey hanged: Egypt under
 Ottoman control

THE SELJUK TURKS AND THE MONGOLS OF PERSIA

15th CENTURY

1400 Tamerlane in Syria: Aleppo, Hama and
 Damascus taken. Economic ruin
1401 Tamerlane decides not to attack Egypt, and to
 turn on the Ottomans in Anatolia
1402 Tamerlane defeats Bayezid I at Ankara
1405 Tamerlane dies
1405–1418 The Gur-e Amir at Samarkand, Tamerlane's
 tomb
1405–1447 Shah Rukh reigns at Herat
1408 Observatory of Samarkand
1447–1449 Ulu Bey at Herat
1453–1722 Shiite Safavid dynasty
1462 Blue mosque at Tabriz
1487–1524 Shah Ismail I reigns over Persia from Tabriz
1491 Conquest of Azerbaijan

16th CENTURY

1500 Baku, then Iraq, taken (1502)
1508 Fall of Baghdad
1510 Khorasan taken.
 Shah Ismail founds his capital at Khazwin

THE SELJUKS OF RUM IN ANATOLIA

15th CENTURY

1402 Ottomans defeated by Tamerlane at Ankara:
 Bayezid dies in captivity
1403–1421 Ottoman Sultan Mehmet I
1413 Yeshil Jami at Brusa
1421–1444 First reign of Murad II
1444–1446 First reign of Mehmet II
1446–1451 Second reign of Murad II
1446 Murad II Jami at Brusa
1451–1481 Second reign of Mehmet II
1453 Constantinople taken, Istanbul becomes the
 Ottoman capital
1463 Fatih Jami built by Mehmet II at Istanbul
1481–1512 Ottoman Sultan Bayezid II

16th CENTURY

1501 Mosque of Bayezid II at Istanbul
1512–1520 Ottoman Sultan Selim I
1516–1517 Selim takes Mamluk Egypt
1522 Construction of the Selimiye of Istanbul by
 Asjem Ali, at the beginning of Soliman the
 Magnificent's reign

BYZANTINES AND ARMENIANS	MEDIEVAL AND RENAISSANCE EUROPE	CULTURAL AND ARTISTIC HISTORY IN THE OCCIDENT
	1375 Revolt of the Church states	
	1378 Great schism	
	1379 War between Venice and Genoa	
	1386 Ladislas, King of Naples	

15th CENTURY

BYZANTINES AND ARMENIANS	MEDIEVAL AND RENAISSANCE EUROPE	CULTURAL AND ARTISTIC HISTORY IN THE OCCIDENT

15th CENTURY

1402 Constantinople saved by the Turkish defeat by Tamerlane
1422 Murad II lays siege to Constantinople
1425–1448 John VIII
1430 Salonica falls
1433 Walls of Constantinople restored
1446 Fall of Mistra
1453 Mehmet II takes Constantinople: the town is sacked, but not Haghia Sophia cathedral
1458–1461 David II, at Trebizond
1461 Fall of Trebizond; David II and his seven sons executed

15th CENTURY

1404 Venice occupies Padua, Verona and Vicenze
1407 Florence occupies Pisa
1415 Battle of Agincourt
1433 Cosimo di Medici in exile
1434 Cosimo di Medici in power in Florence
1440 Frederick of Habsburg
1452 Frederick III crowned emperor
1453 Constantinople taken by the Turks
1458 Turks occupy Athens
1461 Louis XI King of France
1464 Cosimo di Medici dies
1478 Sixtus IV excommunicates Lorenzo di Medici
1479 Ludovic the Moor in power in Milan
1483 Venice calls Charles VIII of France to Italy
1486 Maximilian of Austria
1489 Venice occupies Cyprus
1492 Ferdinand and Isabella take Grenada
1494 Fall of the Medicis in Florence
1495 Charles VIII takes Naples
1498 Louis XII, King of France
1499 Louis XII takes Milan and Genoa

15th CENTURY

1406–1470 Alberti
1408 Donatello in Florence
1410–1492 Piero della Francesca
1415 A manuscript by Vitruvius discovered at Saint-Gall
1421 Brunelleschi builds the cupola of the Duomo at Florence
1425 Ghiberti's doors to the baptistry at Florence
1426 Masaccio's frescoes in the Brancacci chapel in Florence
1430 Pizzi Chapel in Florence, by Brunelleschi
1434 Michelozzo's Villa Medici
1444 Work starts on the ducal palace at Urbino
1452 Fra Angelico's frescoes at Arezzo
1453 The Carthusian monastery at Pavia
1462 Medici palace completed in Milan
1471–1528 Albrecht Durer
1473 Sistine Chapel
1475 Palace at Urbino by Laurana and Francesco di Giorgio
1483–1520 Raphael

16th CENTURY

1500 Ludovic the Moor prisoner of the French
1504 The French lose Naples
1512 Maxmilian abandons Louis XII. Italy lost for France
1514 Death of Louis XII
1514 Accession of Francis I
1516 Accession of Charles V

16th CENTURY

1500 Leonardo da Vinci in Florence
1506 First stone laid of St Peters, Rome, by Bramante
1508 Ceiling of the Sistine Chapel by Michaelangelo
1512 Michaelangelo completes his frescoes in the Sistine Chapel
1514 Raphael at St Peters, Rome
1515 Castle at Blois
1517 Raphael paints Lorenzo di Medici's portrait

CHRONOLOGY OF MONUMENTS CITED

CAIRO AT THE TIME OF THE MAMLUKS : 1250–1517

DYNASTY OF THE BAHRID SULTANS

Mausoleum of the Abbasids	1242–1250
Madrasa of Baibars I	1262
Tomb of Baibars I (in Damascus)	1277–1279
Mausoleum of Khalil el-Ashraf	1288
Madrasa and tomb of Sultan Kalaoun	1284–1294
Madrasa of Mohammed el-Nasir	1296–1303
Mausoleum of Salar and Sanjar	1303
Khanka of Baibars II el-Gashenkir	1307–1310
Beshtak Palace	1334
Mosque of Mohammed el-Nasir	1334–1336
Mosque of Maridani	1338–1340
Mosque of Gawar el-Lala	1340
Mosque of Sirghitmish	1356
Madrasa of Sultan Hasan	1356–1361

CIRCASSIAN DYNASTY

Madrasa of Barkuk	1384–1386
Mausoleum of Barkuk, by Farag	1399–1410
Mosque of Muayyad	1415–1419
Ashraf Barsbey Gate	1423
Mausoleum of Barsbey	1431–1432
Madrasa-mausoleum of Ainal	1451
Mausoleum-*madrasa* of Kait Bey	1470–1476
Mosque of Kigmas al-Ishaki	1479–1483
Al-Razzaz palace	1483
Mausoleum of Kansuh	1500–1504

Mosque of Emir Akhor	1503
Mausoleum-*madrasa* of Korkmaz	1506–1510
Madrasa-tomb of el-Ghuri	1503–1516
Darb el-Labbana private house	early 16th century
Interior of the Al-Razzaz palace	17th century

BEFORE THE MAMLUKS

Mosque of Amr ibn el-Ass (from 642)	827
Nilometer of Rawda	861
Mosque of Ibn Tulun	868–876
El-Azhar mosque	970
El-Hakim mosque	990
Walls and gates of Cairo	1087
El-Akhmar mosque	1125
Salih Talai mosque	1160

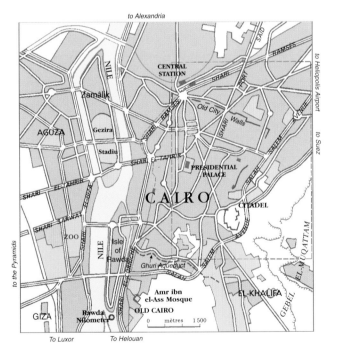

CAIRO STREET-PLAN, SHOWING PRINCIPAL MAMLUK MONUMENTS
(FACING PAGE: ENLARGEMENT)

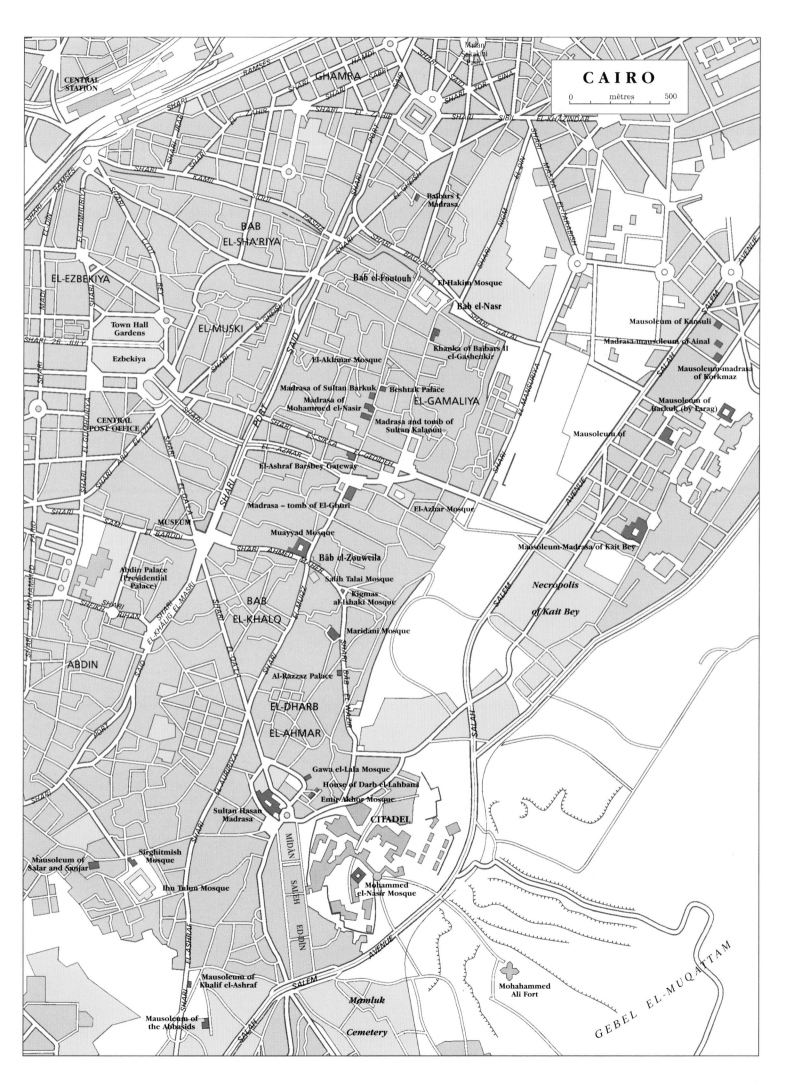

CENTRAL
STATION

GHAMRA

BAB
EL-SHA'RIYA

EL-EZBEKIYA

Town Hall
Gardens

Ezbekiya

EL-MUSKI

CENTRAL
POST OFFICE

MUSEUM

ABDIN

Abdin Palace
(Presidential
Palace)

BAB
EL-KHALQ

EL-DHARB

EL-AHMAR

Sultan Hasan
Madrasa

Sirghitmish
Mosque

Mausoleum of
Salar and Sanjar

Ibn Tulun Mosque

Mausoleum of
Khalif el-Ashraf

Mausoleum of
the Abbasids

Baibars I
Madrasa

Bâb el-Foutouh

El-Hakim Mosque

Bâb el-Nasr

El-Akhmar Mosque

Khanka of Baibars II
el-Gashenkir

Madrasa of Sultan Barkuk

Beshtak Palace

Madrasa of
Mohammed el-Nasir

EL-GAMALIYA

Madrasa and tomb of
Sultan Kalaoun

El-Ashraf Barsbey Gateway

Madrasa – tomb of El-Ghuri

El-Azhar Mosque

Muayyad Mosque

Bâb el-Zouweila

Salih Talai Mosque

Kigmas
al-Ishaki Mosque

Maridani Mosque

Al-Razzaz Palace

Gawa el-Lala Mosque

House of Darb el-Lahbana

Emir Akhor Mosque

CITADEL

Mohammed
el-Nasir Mosque

Mohahammed
Ali Fort

Mamluk

Cemetery

GEBEL EL-MUQATTAM

Mausoleum of Kansuli

Madrasa-mausoleum of Ainal

Mausoleum-madrasa
of Korkmaz

Mausoleum of
Barkuk (by Farag)

Mausoleum of

Mausoleum-Madrasa of Kait Bey

Necropolis

of Kait Bey

CAIRO

0 mètres 500

213

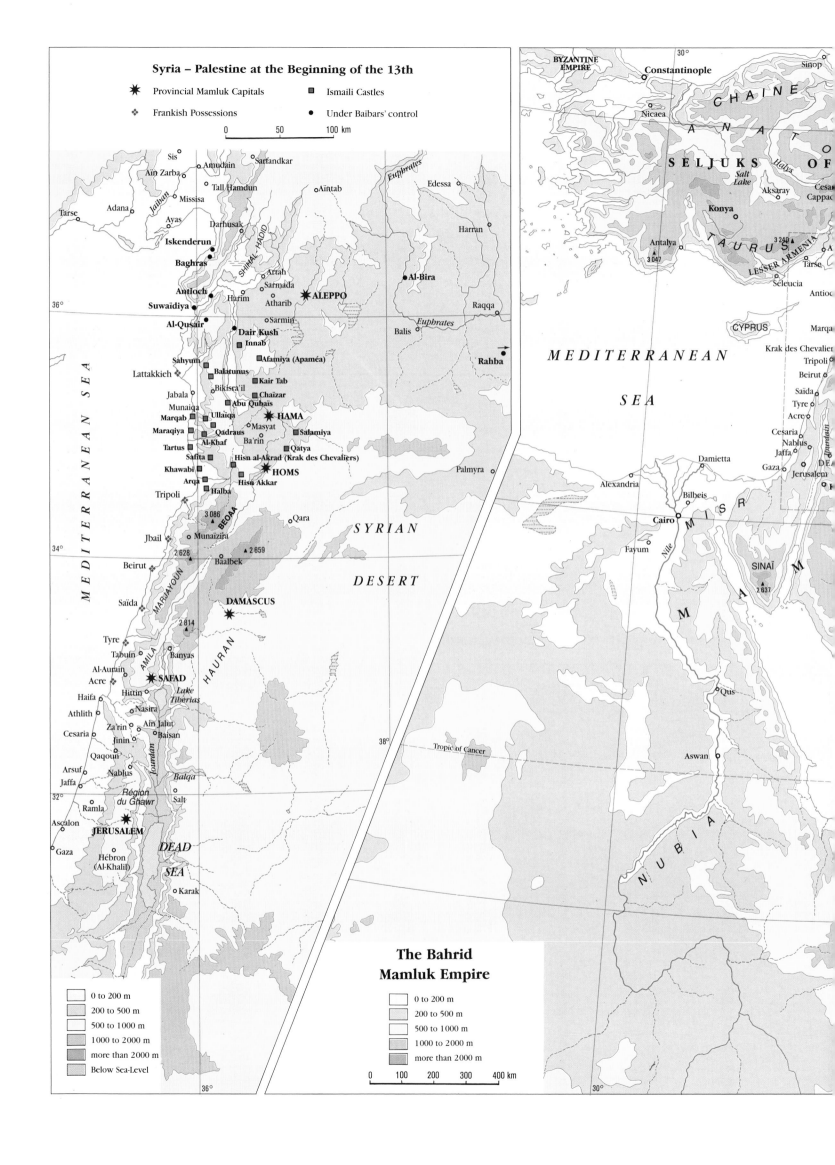

Syria – Palestine at the Beginning of the 13th

- ✶ Provincial Mamluk Capitals
- ◆ Frankish Possessions
- ■ Ismaili Castles
- ● Under Baibars' control

0 50 100 km

BYZANTINE EMPIRE

Constantinople Sinop

CHAINE

Nicaea

ANATO

SELJUKS *Salt Lake* *Habis* **OF**

Konya Aksaray Cesar

Antalya 3 240 Cappad

3 047 *TAURUS* LESSER ARMENIA Tarse

Séleucia

Antioc

CYPRUS Marqa

Krak des Chevalier

Tripoli

MEDITERRANEAN Beirut

Saïda

SEA Tyre

Acre

Cesaria

Nablus

Damietta Jaffa

Gaza Jerusalem

Alexandria DE

Bilbeis

Cairo *MISR*

Fayum *Nile*

SINAÏ *M*

M 2 637

M *A* *M*

Qus

Aswan

NUBIA

Sis Amudain Sarfandkar

Ain Zarba Tall Hamdun Aïntab Edessa

Missisa Jalban Darhusak *Euphrates*

Tarse Adana Ayas Harran

Iskenderun SHIH AL-HADID Artah Al-Bira

Baghras Sarmada Raqqa

Antioch Harim Atharib **ALEPPO**

Suwaïdiya Sarmin *Euphrates*

Al-Qusair Dair Kush Balis Rahba

Innab

Sahyum Afamiya (Apaméa)

Lattakkieh Balatunus Kair Tab

Jabala Bikisra'il Chaïzar

Munaiqa Abu Qubais

Marqab Ullaiqa Masyat **HAMA**

Maraqiya Qadraus Salamiya

Tartus Al-Khaf Ba'rin Qatya

Safita Hisn al-Akrad (Krak des Chevaliers)

Khawabi **HOMS**

Arqa Hisn Akkar Palmyra

Tripoli Halba

3 086 *BEQAA*

Jbail Munaizira *SYRIAN*

2 628 2 659

Beirut Baalbek *DESERT*

Saïda *MARJAYOUN* 2 814

Tyre *AMILA* **DAMASCUS**

Tabuin Banyas

Al-Aurain *HAURAN*

Acre **SAFAD** *Lake Tiberias*

Haifa Hittin Nasira

Athlith Ain Jalut

Za'rin Baisan

Cesaria Jinin

Qaqoun *Jourdain*

Arsuf Nablus *Balqa*

Jaffa *Région du Ghawr* Salt

Ramla

Ascalon **JERUSALEM**

Gaza Hébron (Al-Khalil) *DEAD SEA*

Karak

Tropic of Cancer

- ☐ 0 to 200 m
- ☐ 200 to 500 m
- ☐ 500 to 1000 m
- ☐ 1000 to 2000 m
- ☐ more than 2000 m
- ☐ Below Sea-Level

The Bahrid Mamluk Empire

- ☐ 0 to 200 m
- ☐ 200 to 500 m
- ☐ 500 to 1000 m
- ☐ 1000 to 2000 m
- ☐ more than 2000 m

0 100 200 300 400 km

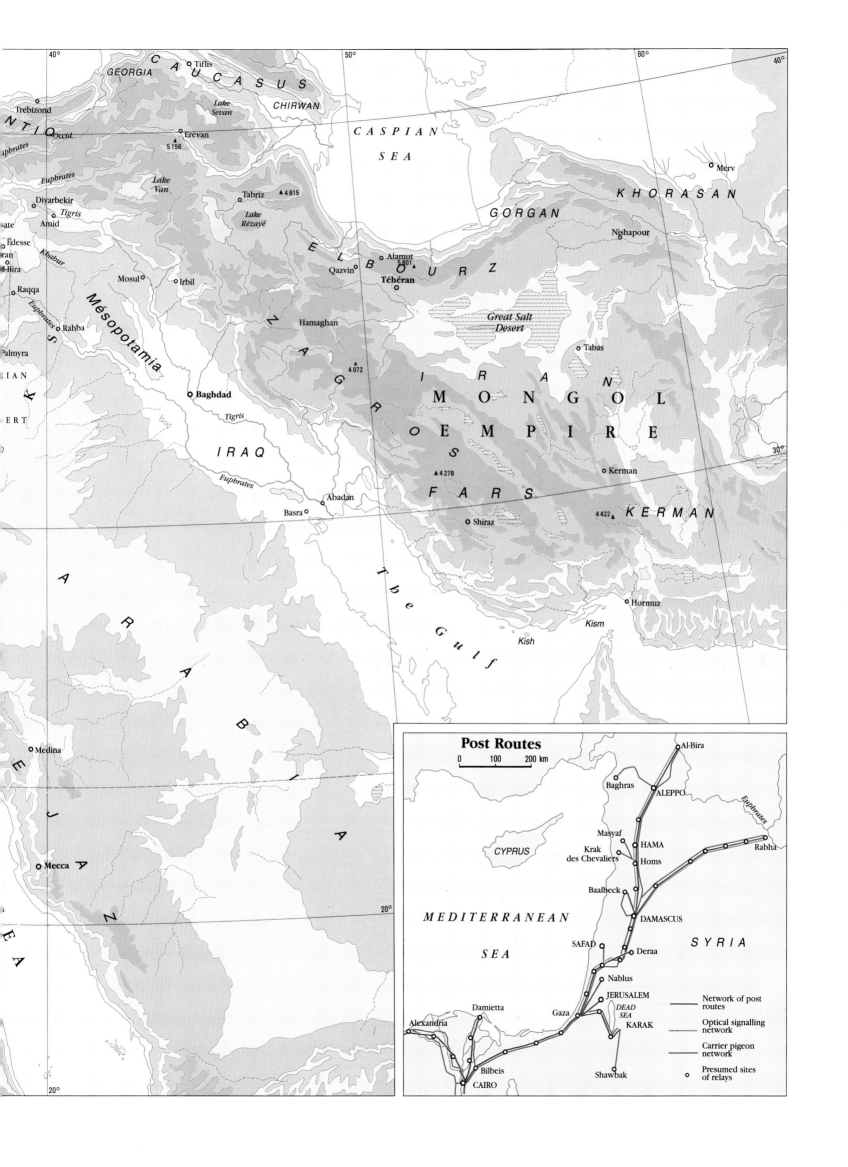

GEORGIA

CAUCASUS

CHIRWAN

Trebizond

NTIQ Occid.

Euphrates

Lake Sevan

Erevan

▲ 5 156

CASPIAN

SEA

GORGAN

KHORASAN

Merv

Euphrates

Diyarbekir

Tigris

Amid

ate

Édesse

ran

l-Bira

Khabur

Mosul

Raqqa

Euphrates

Euphrates

Rahba

Palmyra

RIAN

ERT

Mésopotamie

Lake Van

Tabriz ▲ 4 815

Lake Rézayé

Irbil

ELBOURZ

Alamut

Qazvin

Téhéran

Nishapour

▲5 601

Great Salt Desert

Tabas

Z

A

G

R

O

S

Hamaghan

Baghdad

IRAQ

Tigris

Euphrates

Abadan

Basra

▲ 4 072

I R A N

MONGOL

E M P I R E

FARS

Kerman

▲ 4 276

Shiraz

▲ 4 422

KERMAN

Hormuz

The Gulf

Kism

Kish

A

R

A

B

Medina

I

A

E

J

A

Mecca

Z

Post Routes

0 100 200 km

Al-Bira

Baghras

ALEPPO

Euphrates

Masyaf

HAMA

Rabha

Krak des Chevaliers

Homs

Baalbeck

CYPRUS

DAMASCUS

SYRIA

MEDITERRANEAN

SEA

SAFAD

Deraa

Nablus

JERUSALEM

DEAD SEA

KARAK

Damietta

Gaza

Alexandria

Bilbeis

Shawbak

CAIRO

Network of post routes

Optical signalling network

Carrier pigeon network

○ Presumed sites of relays

GLOSSARY

ABLAK Architectural decoration based on alternating bands of dark and light coloured stone blocks.

ALFIZ Raised rectangular framework around the upper part of bays or *mihrab*.

ALIDS Descendants of Ali, who married Fatima, the daughter of the Prophet. For the Shiites, the Alids are the spiritual and religious heirs of Mohammed.

ATABEG Initially the princes' personal tutor, then, from the thirteenth century, a high dignitary of certain Islamic kingdoms.

DIKKA Platform from which the officiant leads the prayer in the mosque.

HADITH Entire Islamic tradition, and all words and acts attributed to the Prophet.

HANBALISM Islamic theological school created by Ahmad ibn Hanbal, based exclusively on the Koran and the Sunna.

HAMMAM Bathing establishments in Islamic countries. They perpetuate the tradition of Roman baths.

HANEFITE Islamic school of theology and law founded on the teaching of Imam Abu Hanifa.

HARAM Sacred ground, or, more generally, prayer room or courtyard of mosque.

ILKHAN Chief of the dynasty of the Mongols of Persia (1256–1335), founded by Hulagu.

IMAM Firstly, the person who directs prayer; by extension, amongst Shiites, the upholder of tradition and chief of the Muslim community.

ISMAILI Adept of septimian Shiite beliefs. Ismailism identifies seven sacred imams. It is a particular characteristic of the Fatimid Shiite current.

IWAN Large vaulted room, open onto the mosque courtyard. A form appearing in the Islamic architecture of Persia, and rapidly spreading through the entire Muslim world.

KASR (QASR) Castle, fortified palace.

KHAN Caravanserai, resting stage for travellers and merchants.

KHANKA Convent for religious Muslims, especially *sufi*s.

KIBLA (QIBLA) The wall running perpendicular to the direction of Mecca and containing the *mihrab*.

KUFIC Angular Arabic script, used in decorative inscriptions.

MADRASA School for Koranic instruction.

MAIDAN Large square – by extension, hippodrome.

MALIKITE Term describing a legal and theological school based on the teaching of Malik ibn Anas, in Medina. A doctrine followed in Upper Egypt and North Africa.

MARISTAN Hospital, a place dispensing care for the sick, and medical instruction.

MIHRAB Niche let into *kibla* wall, indicating the direction of the *Kaaba*, or Black Stone, in Mecca.

MINBAR Stepped chair, from the top of which the preacher addresses the faithful in the mosque. Generally placed to the right of the *mihrab*.

MUKARNAS (MUQARNA) Stalactites covering a vault or decorating an overhang in an Islamic building.

NASKHI Curved Arabic script. Type of calligraphy used throughout the Islamic world.

OKELLA (WIKALA) Term used in Egypt to denote a *khan* or caravanserai. In towns, the term also applies to a building used as a warehouse.

PENDENTIVE Architectural area in the form of a concave triangle, used to make the joint between a circular dome and its square base.

PISHTAK (PISHTAQ) Iranian term denoting a large entrance in the form of an *iwan*, giving access to mosques, as well as *madrasa*s and mausolea.

QUBBAT Cupola, and by extension, mausoleum, tomb.

SAHN Interior courtyard of mosque or *madrasa*.

SEBIL-KUTTAB Building including a public fountain and a primary school. In general a pious donation.

SERAGLIO Palace, Sultan's residence, castle.

SHAFIIT Term describing an Islamic legal school founded by al-Shafi.

SHIITE Adept of the tradition founded on Ali, husband of Fatima, daughter of Mohammed, and heir to the doctrine of the Prophet.

SOUR Bastions, walled town.

SUNNA Religious practice and theory regulating the existence of Sunni Muslims. An ethic based on the whole of the Prophet's message.

SUNNITE Follower of Islamic orthodoxy, recognising the first four Caliphs as leaders of the Muslim community, then the Omayyads and the Abbasids.

TEMENOS Greek term describing a holy area. In general corresponding to the space occupied by a temple.

TURBE Turkish term meaning a tomb, generally surmounted by a conical dome, or a cupola.

WAKF Pious foundation, often intended for the maintenance of a building, and having an official character.

WIKALA Like *okella*, designates a civil building that is simultaneously caravanserai, bazaar and shop.

ZIYADA Peripheral courtyard separating a mosque from the town around it.

BIBLIOGRAPHY

ABEL, ARMAND "Le Khalife, présence sacrée", in *Studia islamica*, VII, Paris, 1957.

ATIL, ESIN *Islamic Art & Patronage, Treasures from Kuwait*, Exhibition of "The al-Sabah Collection", Washington, D.C. 1990.

ATIL, ESIN *Renaissance of Islam : Art of the Mamluks*, Exhibition at the Smithsonian Institution, Washington, D.C. 1981.

AYLON, D. *Studies on the Mamluks of Egypt* (1250-1517), London, 1979.

AYLON, D. *The Mamlouk military Society*, London, 1979.

BOURGOIN, JULES *Les Arts arabes*, Paris, 1873.

BOURGOIN, JULES *Précis de l'art arabe et matériaux pour servir à l'histoire des arts musulmans*, Paris, 1892.

BRANDENBURG, DIETRICH *Islamische Baukunst in Ägypten*, Berlin, 1966.

BRANDENBURG, DIETRICH *Die Madrasa*, Graz, 1978.

BURGOYNE, M.H., *Mamluk Jérusalem, An architectural Study* Jerusalem, 1987.

BURLOT, J. *La Civilisation islamique*, Paris, 1982.

CAHEN, CLAUDE *Orient et Occident au temps des Croisades*, Paris, 1983.

CASANOVA, PAUL *Histoire et description de la Citadelle du Caire*, Mémoires IFAO, Cairo, 1891-1892.

COSTE, PASCAL *Architecture arabe, Monuments du Kaire*, Paris, 1839.

CRESWELL, K. A. C. "The Works of Sultan Bibars", *Bulletin IFAO*, XXVI, Cairo, 1921.

DARRAG, A. *L'Égypte sous le règne de Barsbey*, 1422-1438, Institut français, Damascus, 1961.

Encyclopédie de l'Islam 1ère édition, Leiden, 1913-1938; 2ème édition (in progress), Leiden, 1960 ss.

FRANZ PASCHA, JULIUS *Die Baukunst des Islam, Handbuch der Architektur*, 3 vol. Leipzig, 1896.

FRANZ PASCHA, JULIUS "Die Grabmoschee des Sultans Kait-Bai bei Kairo", in *Die Baukunst*, Heft 3, Kairo/Leipzig, 1903.

GARCIN, JEAN-CLAUDE, ET ALII *Palais et maisons du Caire*, 2 vol. Paris, 1983.

GARCIN, JEAN-CLAUDE *Espaces, pouvoirs et idéologies de l'Égypte médiévale*, Cairo, 1987.

GIRAULT DE PRANGEY *Monuments arabes d'Égypte*, Paris, 1846.

HAUTECOEUR, LOUIS ET GASTON WIET *Les mosquées du Caire*, 2 vol. Paris, 1932.

HERZ PASCHA, MAX *La mosquée de Sultan Hassan au Caire*, Comité de conservation des monuments d'art arabe, Cairo, 1899.

HERZ PASCHA, MAX *Die Baugruppe des Sultan Qalaoun in Kairo*, Abhandlungen des hamburgisches Kolonialinstitut XLII, Hamburg, 1919.

HOAG, J. D. *Western Islamic Architecture*, London, 1963.

HUMPHREYS, R. STEPHEN "The expressive intent of the mamluk Architecture of Cairo, A preliminary Essay", in S*tudia Islamica*, vol. 35, 1972.

JENKINS, MARILYN, *Islamic Art in the Kuwait National Museum, The al-Sabah Collection*, London, 1983.

LAPIDUS, I. *Muslim Cities in the Later Middle Ages*, Cambridge Mass., 1967.

MAKRIZI *Histoire des sultans mamelouks de l'Égypte*, traduite par M. Quatremère, 2 vol. Paris, 1832.

MASSIGNON, LOUIS "La Cité des Morts au Caire", *Bulletin de l'IFAO*, Cairo, 1958.

MEINECKE, MICHEL *Die mamelukische Architektur in Ägypten und Syrien*, 2 vol. Abhandlunen des deutschen archäologischen Instituts Kairo, Islamische Reihe, Gluckstadt, 1992.

Millénaire du Caire (Le) in *Annales islamologiques*, VIII, IFAO, Cairo, 1969.

Millénaire du Caire (Le) 969-1969, Cairo, Ministry of Culture, 1969.

PAUTY, EDMOND *Les hammams du Caire*, Mémoires publiés par les membres de l'IFAO, LXIV, Le Caire, 1933.

QUATREMÈRE, ÉTIENNE *Histoire des sultans mamelouks par Makrizi*, Paris, 1837-1845.

RAYMOND, ANDRÉ *Le Caire*, Paris, 1993.

SPUHLER, BERTOLD *Les Mongols dans l'histoire*, Paris, 1961.

STIERLIN, HENRI *Architecture de l'Islam*, Fribourg, 1979.

STIERLIN, HENRI *Architecture islamique*, Que Sais-Je ?, Paris, 1993.

STIERLIN, HENRI ET ANNE *Alhambra*, Paris, 1991.

SUBLET, JACQUELINE *Les trois vies du sultan Baïbars*, Paris, 1992.

VOLKOFF, OLEG V. *1000 Jahre Kairo, Die Geschichte einer verzaubernden Stadt*, Mainz, 1984.

ACKNOWLEDGEMENTS

The editor and the author/photographers would like to thank the Egyptian Authorities for all the facilities granted during the production of this work. They are especially grateful to the Office of Information and Tourism of the Arab Republic of Egypt in Geneva, which organised the trip and the stay in Cairo necessary for the photographs.

The Mamluk artefacts and manuscripts on pages 33, 38, 78, 82, the bottom of 164, and 182 are reproduced by permission of the Directors of the Kuwait National Museum, the al Sabah Collection, who kindly made available a series of photographic documents.

For the watercolour by Henry Salt, showing a *View of Cairo*, 1820, appearing on page 98, thanks are due to the Bibliothèque Nationale, Paris. The map on pages 214–215 is taken from *Les trois vies du sultan Baibars*, by Jacqueline Sublet.

Finally, the antique engravings reproduced in this work are taken from: Jules Bourgoin, *Les Arts arabes*, Paris 1873, and *Les éléments de l'art arabe*, Paris, 1879; Pascal Coste, *Architecture arabe ou Monuments du Kaire, mesurés et dessines de 1818 a 1825*, Paris 1839; Louis Mayer, *Vues en Egypt*, London, 1802; Achille Prisse d'Avennes, *L'Art arabe*, Paris, 1877; David Roberts, *Egypt and Nubia*, London, 1849. These works were photographed at the Bibliothèque d'Art et d'Archéologie, Geneva, the Bibliothèque publique et universitaire, Geneva, and the Bibliothèque cantonale et universitaire de Lausanne-Dorigny. We extend our warmest thanks to the directors of these establishments for their active cooperation.